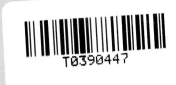

On Tropical Grounds

The publication of this series is supported by the International Consortium of Critical Theory Programs funded by the Andrew W. Mellon Foundation.

Series editors: Natalia Brizuela, Victoria J. Collis-Buthelezi and Leticia Sabsay

Mário Pinto de Andrade, *The Revolution Will Be a Poetic Act*
Leonor Arfuch, *Memory and Autobiography*
Paula Biglieri and Luciana Cadahia, *Seven Essays on Populism*
Aimé Césaire, *Resolutely Black*
Victoria J. Collis-Buthelezi and Aaron Kamugisha, *The Caribbean Race Reader*
Bolívar Echeverría, *Modernity and "Whiteness"*
Diego Falconí Trávez, *From Ashes to Text*
Malcolm Ferdinand, *Decolonial Ecology*
Celso Furtado, *The Myth of Economic Development*
Eduardo Grüner, *The Haitian Revolution*
Francisco-J. Hernández Adrián, *On Tropical Grounds*
Ailton Krenak, *Ancestral Future*
Ailton Krenak, *Life is Not Useful*
Premesh Lalu, *Undoing Apartheid*
Karima Lazali, *Colonial Trauma*
María Pia López, *Not One Less*
Achille Mbembe and Felwine Sarr, *The Politics of Time*
Achille Mbembe and Felwine Sarr, *To Write the Africa World*
Valentin Y. Mudimbe, *The Scent of the Father*
Pablo Oyarzun, *Doing Justice*
Néstor Perlongher, *Plebeian Prose*
Bento Prado Jr., *Error, Illusion, Madness*
Nelly Richard, *Eruptions of Memory*
Silvia Rivera Cusicanqui, *Ch'ixinakax utxiwa*
Suely Rolnik, *Spheres of Insurrection*
Tendayi Sithole, *The Black Register*
Maboula Soumahoro, *Black is the Journey, Africana the Name*
Javad Tabatabai, *Ibn Khaldun and the Social Sciences*
Dénètem Touam Bona, *Fugitive, Where Are You Running?*

On Tropical Grounds

Avant-Garde and Surrealism in the Insular Atlantic

Francisco-J. Hernández Adrián

polity

Copyright © Francisco-J. Hernández Adrián 2025

The right of Francisco-J. Hernández Adrián to be identified as Author of this Work has been asserted in accordance with the UK Copyright, Designs and Patents Act 1988.

First published in 2025 by Polity Press

Polity Press
65 Bridge Street
Cambridge CB2 1UR, UK

Polity Press
111 River Street
Hoboken, NJ 07030, USA

All rights reserved. Except for the quotation of short passages for the purpose of criticism and review, no part of this publication may be reproduced, stored in a retrieval system or transmitted, in any form or by any means, electronic, mechanical, photocopying, recording or otherwise, without the prior permission of the publisher.

ISBN-13: 978-1-5095-6166-7
ISBN-13: 978-1-5095-6167-4(pb)

A catalogue record for this book is available from the British Library.

Library of Congress Control Number: 2024933222

Typeset in 10.5 on 12pt Sabon
by Fakenham Prepress Solutions, Fakenham, Norfolk NR21 8NL
Printed and bound in Great Britain by CPI Group (UK) Ltd, Croydon

The publisher has used its best endeavours to ensure that the URLs for external websites referred to in this book are correct and active at the time of going to press. However, the publisher has no responsibility for the websites and can make no guarantee that a site will remain live or that the content is or will remain appropriate.

Every effort has been made to trace all copyright holders, but if any have been overlooked the publisher will be pleased to include any necessary credits in any subsequent reprint or edition.

For further information on Polity, visit our website:
politybooks.com

Para Antonia y Francisco
en el mismo mar

Contents

Figures ix
Acknowledgments xi
Foreword – Richard Rosa xv

Introduction: On Tropical Grounds 1

Part I. Atlantic, Hispanic, Avant-Garde: Archaic Places / Non-European Regressions

1 Around the Atlantic Avant-Garde: Insular Dreamworlds / Archaic Islandscapes 21

2 Male Regressions: The Non-Europeans 56

Part II. Caribbean, Colonial, Avant-Garde: From *Poesía Negra* to Carceral Romances

3 Islands of Desire: A Poetics of Antillean Fragmentation 101

4 Carceral, Island, Nation: Cuban Romances in Photography and Fiction 134

Part III. Surrealism after France: Crime and Desire from the Canary Islands to the Americas

5 Surrealism and the Islands: The Practice of Dislocation 171

6 Difficult Dialogues: Surrealism in the Francophone and Hispanic Caribbean 206

Epilogue: Preface to the 1950s 246

Notes 255
Index 299

Figures

1.1 The family nursery. Douglas Sirk, *La Habanera*, 1937. Film still courtesy of Friedrich-Wilhelm-Murnau-Stiftung, Wiesbaden 22

1.2 Dr. Nagel's hands. Douglas Sirk, *La Habanera*, 1937. Film still courtesy of Friedrich-Wilhelm-Murnau-Stiftung, Wiesbaden 23

1.3 Astree sails to Sweden. Douglas Sirk, *La Habanera*, 1937. Film still courtesy of Friedrich-Wilhelm-Murnau-Stiftung, Wiesbaden 27

1.4 The "Puerto Ricans" attending a bullfight. Douglas Sirk, *La Habanera*, 1937. Film still courtesy of Friedrich-Wilhelm-Murnau-Stiftung, Wiesbaden 55

4.1 Walker Evans, *Citizen in Downtown Havana*, 1933. Gelatin silver print, 24.0 x 13.4 cm. (9 7/16 x 5¼ in.). Gift of Lincoln Kirstein, 1952, 52.562.2 © Walker Evans Archive, The Metropolitan Museum of Art, New York/Art Resource/Scala, Florence 140

4.2 Walker Evans, *Woman Behind Barred Window, Havana*, 1933. Film negative, 16.5 x 21.6 cm. (6½ x 8½ in.). Walker Evans Archive, 1994, 1994.256.260 © Walker Evans Archive, The Metropolitan Museum of Art, New York/Art Resource/Scala, Florence 145

4.3 Walker Evans, *Beggar with Outstretched Arm on Street, Havana*, 1933.
Film negative, 6.4 x 10.8 cm. (2½ x 4¼ in.). Walker Evans Archive, 1994, 1994.251.746 © Walker Evans Archive, The Metropolitan Museum of Art, New York/Art Resource/Scala, Florence 147
4.4 Walker Evans, *Mother and Children in Doorway, Havana*, 1933.
Gelatin silver print, 9.8 x 16.8 cm. (3 7/8 x 6 5/8 in.). Gift of Arnold H. Crane, 1971, 1971.646.9 © Walker Evans Archive, The Metropolitan Museum of Art, New York/Art Resource/Scala, Florence 147
4.5 Walker Evans, *Havana: Country Family*, 1933.
Gelatin silver print, 16.5 x 22.4 cm. (6½ x 8 13/16 in.). Gift of Arnold H. Crane, 1971, 1971.646.7 © Walker Evans Archive, The Metropolitan Museum of Art, New York/Art Resource/Scala, Florence 148
5.1 The Paris surrealists pose with Domingo Pérez Minik, Tenerife, 1935.
Image courtesy of Archivo Histórico Provincial de Santa Cruz de Tenerife, Fondo Eduardo Westerdahl-Gobierno de Canarias 175
5.2 Domingo López Torres and Domingo Pérez Minik pose with the Paris surrealists, Tenerife, 1935.
Image courtesy of Archivo Histórico Provincial de Santa Cruz de Tenerife, Fondo Eduardo Westerdahl-Gobierno de Canarias 176
6.1 "A group of artists posing in the grounds of the Villa Air-Bel near Marseilles," 1941.
David M. Rubenstein National Institute for Holocaust Documentation, United States Holocaust Memorial Museum, Washington, DC, courtesy of Cynthia Jaffee McCabe 208
6.2 Wifredo Lam, *The Jungle*, 1943.
Gouache on paper mounted on canvas. 239.4 x 229.9 cm. (94¼ x 90½ in.). Inter-American Fund, MoMA. Digital image © 2023, The Museum of Modern Art, New York/Scala, Florence 237
6.3 Surrealists and friends at Pierre Matisse Gallery, New York, 1945.
Image courtesy of Association Marcel Duchamp, Paris 241

Acknowledgments

For their invaluable comments on parts of this book at different stages of drafting, I owe thanks to Iris Bachmann, Meg Greer, Alice Kaplan, Walter Mignolo, Claudia Milian, Marc Schachter, and Erna von der Walde. I am forever indebted to Michael Dash's inspiring teaching and intellectual generosity in his NYU seminar, "Haiti in Caribbean Context," and beyond. I thank the Caribbean Studies Working Group that was born in Michael's seminar: Iris Bachmann, Christina Kullberg, Emily Maguire, Belkis Ramírez, Adam Silvia. I thank Susan Buck-Morss for her generosity and fruitful conversations around the time of "Hegel in Haiti," and Denis Hollier for welcoming me to his seminar on Michel Leiris.

In Tenerife and Madrid, I have enjoyed the friendship and inspiration of those whose words and works are woven into the fabric of this book: José Carlos Andrés Maté, Rafael-José Díaz, Ágata Gallardo, Gonzalo González, José Herrera, José Luis Medina Mesa, Miguel G. Morales, Alejandro Mylonás Leegstra, Nilo Palenzuela, Javier Pérez-Alcalde Schwartz, Goretti Ramírez, José Antonio Ramos Arteaga, José Ángel Rodríguez Ribas, Carlos A. Schwartz. I had the privilege of meeting and learning from Alexander Pérez Heredia in Havana, Jean Casimir in Kingston, Pedro Adrián Zuluaga in Bogotá, María Fernanda Arias Osorio in Medellín, and Agnes Lugo-Ortiz and Lydia Platón Lázaro in Barranquilla. For conversations, projects, friendship, and walks in Durham and London, I thank Erna von der Walde and Marc Botha. Special thanks to Cécile Balavoine for long conversations, conviviality, and close friendship;

Jean-Christophe Groffe for friendship and conversations on French Surrealism, avant-garde music, humor, and art; Sonia Gourévitch for warm sympathy and a very personal experience of Paris; and Jean-Luc Vilard for friendship and hospitality in Toulouse and Saint-Cirq-Lapopie.

For their bold and brilliant engagements with some of the early discussions that inform this book, I thank my students in undergraduate seminars I taught at Duke and Durham, "Spanish Avant-Gardes / Kino-Texts," and "Kino-Texts: Atlantic Avant-Gardes and Visual Cultures." I am indebted to graduate students at Duke, Durham, La Laguna, and beyond for many discussions on islands and avant-gardes: Benedetta Panisson, Rhodri Sheldrake Davies, Eva Corchado, Adán Rocío Palmero, Carolina Hayes Vidal-Quadras, Beatriz Llenín Figueroa, and Alvis Ka I. Sio. For transforming discussions, ideas, support, and a dialogue that extends beyond this book, I am grateful to my teachers and friends at NYU: Gerard Aching, Gabriela Basterra, Natalia Brizuela, Lena Burgos-Lafuente, J. Michael Dash, Ana Dopico, James D. Fernández, Ada Ferrer, Gabriel Giorgi, Licia Fiol-Matta, Arnaldo J. López, Gorica Majstorovic, Lina Meruane, Sylvia Molloy, Ronnie Perelis; and Erna von der Walde and Óscar Montero (CUNY Graduate Center). It was Gerard Aching's teaching and mentoring that inspired the design of my PhD thesis at NYU, and the initial steps toward an Atlantic immersion in avant-garde poetics, racial politics, and insular difference. Gabriela Basterra's theoretical acumen and critical boldness altered my ideas and informed my writing. Her example and work have left a deep trace in my practice as a critical Hispanist. I remain forever grateful to Gerard and Gabriela for their generosity and support.

My colleagues at Duke energized and inspired the long view and the concrete challenges of this project: Michaeline Crichlow, Roberto Dainotto, Luciana Fellin, Esther Gabara, Meg Greer, Alice Kaplan, Karen Krahulik, Anna Krylova, Walter Mignolo, Claudia Milian, Gabriela Nouzeilles, Richard Rosa, Marc Schachter, Laurie Shannon, and Priscilla Wald. Meg Greer's and Walter Mignolo's mentoring remains a source of inspiration and strength to this day. To have had Roberto Dainotto as an interlocutor is a privilege that continues to affect my ideas about islands, regions, and seas in political and philological perspective.

I am grateful to my colleagues at Durham for conversations, community, and comradeship: Ashar Aftab, Yael Almog, Kathryn Banks, Marie-Claire Barnet, Samuel Bootle, Alexandre

Burin, Andy Byford, Qing Cao, Lexie Cook, David Cowling, Miguel Domínguez Rohan, Catherine Dousteyssier-Khoze, Heather Fenwick, Santiago Fouz Hernández, Abir Hamdar, Manuel Hijano, Claudia Hopkins, Hansun Hsiung, Fusako Innami, Viktoria Ivleva, Penélope Johnson, Laura León Llerena, Noam Leshem, Dario Lolli, Jonathan Long, Lucia Luck, Ita Mac Carthy, Gerald Moore, Daniel Newman, Claudia Nitschke, John O'Brien, Tina O'Donnell, Manus O'Dwyer, Kerstin Oloff, Yarí Pérez Marín, Axel Pérez Trujillo, Alexis Radisoglou, Dušan Radunović, Nicholas Roberts, Zoë Roth, Nicholas Saul, William Schaefer, Richard Scholar, Rosi Song, Janet Stewart, Adam Talib, Simon Ward, Katrin Wehling-Giorgi, Julian Williams, Thomas Wynn, and Binghan Zheng.

I thank the staff at Biblioteca Nacional de Cuba José Martí, Havana; British Library, London; Biblioteca y Centro de Documentación, Museo Nacional Centro de Arte Reina Sofía, Madrid; Biblioteca Nacional, Madrid; Bibliothèque Nationale, Paris; New York Public Library; Lit & Phil, Newcastle upon Tyne; Bibliothèque Kandinsky, Centre de Recherche du Musée National d'Art Moderne, Centre Pompidou, Paris; Isidro Hernández Gutiérrez and Biblioteca Municipal Central, TEA (Tenerife Espacio de las Artes), Santa Cruz de Tenerife; Médiathèque José-Cabanis, Toulouse; David M. Rubenstein National Institute for Holocaust Documentation, United States Holocaust Memorial Museum, Washington, DC; Perkins and Lilly libraries, Duke University; Bill Bryson Library, Durham University; Langson Library, University of California, Irvine; Biblioteca Universitaria, Universidad de La Laguna; Elmer Holmes Bobst Library, New York University; Senate House Library, University of London; Museum of Modern Art, New York; Julie Zeftel and Walker Evans Archive, The Metropolitan Museum of Art, New York; Séverine Gossart, Association Marcel Duchamp, Paris; Carlos Rodríguez Morales, Archivo Histórico Provincial de Santa Cruz de Tenerife; Fabio Quade and Marcel Steinlein, Friedrich-Wilhelm-Murnau-Stiftung, Wiesbaden, and MALBA (Museo de Arte Latinoamericano de Buenos Aires).

I am grateful to Natalia Brizuela, Lena Burgos-Lafuente, Amarilis Carreño Peña, Belén Castro Morales, Charles Forsdick, Gabriel Giorgi, Yasmin Gunaratnam, Christina Kullberg, Bill Marshall, Thenesoya Vidina Martín de la Nuez, Andrea Noble, Birgit Scharlau, Carmen M. Rivera Villegas, and Yoke-Sum Wong for opportunities to speak and write about various detours of the insular avant-garde and the visualities of the sea. I thank Liverpool University Press for permission to publish revised versions of passages from "Liquid

visuality: Douglas Sirk's *La Habanera* and insular Atlantic studies," *Journal of Romance Studies* 14:2 (Summer 2014): 62–77.

Teacher, activist, and dear friend José Antonio Ramos Arteaga has provided a spiritual and intellectual home on the island – words are not enough. I am immensely grateful to my dear friends Iris Bachmann, Matthias Baudisch, and Benjamin Baudisch-Bachmann for their support and hospitality, long friendship, conversations, exhibitions, and much more. Juana Suárez has been a dear friend, ally, and inspiring interlocutor since time immemorial. Marc Schachter, colleague, friend, and brother in arms, has been a critical reader and interlocutor in comparativism for more than two decades. Claudia Milian continues to blow my mind and warm my heart with her critical brilliance, political commitment, and sustaining friendship. Erna von der Walde, teacher and dear friend, has inspired and challenged me during long walks and a meandering conversation that started around the turn of the century.

Through his uncompromising commitments and visionary spirit, Walter Mignolo, mentor and friend, reminds me constantly of the broader stakes. Nilo Palenzuela, teacher, friend, and accomplice in thought, has been a guide through the routes of insular fragility and intelligence beyond the limits of Hispanism. I am immensely grateful to José Luis Medina Mesa – Ángeles y José Luis – for sharing a unique view of the avant-garde at home in Tenerife and Madrid, and for love and friendship, always. For love and friendship, hospitality and support, and a decades-long dialogue, I thank Ágata Gallardo Darias, sister in joy and arms; and José Manuel Jiménez Martín and Miguel Ángel Trancón Muñoz, for loving friendship in the long adventure. I thank Mark Colley for his listening friendship, laughter, and freedom. I am grateful to my anonymous readers, and the editorial team at Polity, in particular John Thompson, Helena Heaton, Sarah Dancy, Neil de Cort, and the brilliant Critical South series editors, Natalia Brizuela, Leticia Sabsay, and Victoria Collis-Buthelezi.

To those who left or went and whose presence persists, I dedicate this book: Antonia y Francisco, Jordan Marcus, Paco Vidarte, Andrea Noble, Patricia Roberts, Belén Castro Morales, Leslie Damasceno, Michael Dash, Sylvia Molloy.

Foreword

Richard Rosa

The name "avant-garde" that came to define a series of iconoclastic and radical artistic movements in Europe at the beginning of the twentieth century entails many tensions and even contradictions that could be traced to the meaning of the word itself. The word, which has a spatial dimension, referring to being ahead as part of an advancing military force, simultaneously becomes a temporal one, as in being ahead in time. And yet, being ahead here also implies transcending a condition of temporality, advancing beyond its constraints and conditions; but the word also reasserts that condition. Further, the avant-garde emerges as a movement that is essentially European, but at the same time one that reappears, replicates, and is reproduced elsewhere, everywhere. It reveals the idiosyncratic nature of its origin, but also its cosmopolitan signature; the different movements are rooted in "national" venues, while at the same time claiming a universal, cosmopolitan status. This is why the avant-garde has been an important point of reference for recent trends focused on "world literatures": the "avant-garde" has even become a measure for determining how close to recognition by literary institutions a particular (national) tradition is. The "avant-garde" can be described as a radical rupture and a burst of disenchantment, but can also be constructed as a consecrating, mystifying gesture, both a destabilizing and a policing force. Hence, it reveals the paradoxical environment in which it emerged. The active, messianic gesture that is emblematized in the typical "manifesto" is countered by the

erasure of the line separating art from everyday life, its dissolution into the biological and even the physical.

To study the avant-garde (as a literary, artistic, and cultural movement) is to navigate through those many contradictions and perhaps risking deactivating the political potential behind them. This is particularly true with regards to what has been called "peripheral" or "global" avant-garde movements, happening in sites where the "denial of coevalness" was such a fundamental colonial strategy. And of course, it is particularly challenging when we are confronted with the Atlantic insular space that is the object of this book by Francisco-J. Hernández Adrián.

As in other parts of what is now called the Global South, literary and art histories, associated with the managerial nation-state and its narrative of modernity and modernization, attempt to administrate and accommodate cultural production in the Caribbean to a predetermined script. Many of these narratives restricted their scope to the relationship between the European producers, their products, and their after-effects in the region, or they focused primarily on adjusting local aesthetic innovations to a World or Global paradigm, where they could circulate and be consumed as stable representatives of their respective polis or ethnos. Less attention was granted to the multiple political and economic connections between the islands themselves or the complex cultural articulation between islands and metropolis. The Atlantic insular spaces link Europe with Africa, the Caribbean, and Latin America, and were historically determined by experiments with global, mercantile capitalism, slave trade, land grabbing, the plantation system, extractive economies, and then more recently by the extractive tourist industry that capitalizes on the biopolitical view imposed by colonizers. During the timespan of the historical avant-garde, the region became a site of experimentation with a new kind of governing debt intersected by racial capitalism that would then be extrapolated to the rest of the world. An area marked by historical upheavals, yet resistant to unitary narratives that suppress its diversity, and resistant as well to the temporal policing implied in every literary and art history. Periodization, we could say, comes to die on the shores of these islands in the Atlantic.

Hernández Adrián's approach to a diverse and fascinating corpus of Caribbean and Atlantic avant-garde texts is far from conventional. It certainly fits within the critical tradition established by an impressive group of authors who in recent years have recast the way in which Caribbean and Atlantic literature has been

read. Spearheaded by Édouard Glissant's concepts of relation, errancy, and the archipelagic, Michel-Rolph Trouillot's reworking of the archive, and Sylvia Wynter's rearticulation of the flesh/spirit dichotomy, authors such as David Scott, Paul Gilroy, and Gary Wilder, among others, have moved beyond the physical and political constraints imposed by the imperial nation-state by asserting the important insular nature of these societies. *On Tropical Grounds: Avant-Garde and Surrealism in the Insular Atlantic* builds upon these conceptual innovations in order to read and interpret literary works and images that communicate their insular nature. In each chapter, the author puts together a group of texts that engage or miss each other, that try to reach to other islands and then form archipelagos and gravitate towards new forms of complicity and empathy.

Chapter 1 is, perhaps, a radical example. In it, Hernández Adrián combines different media and materials that range from the 1937 German film *La Habanera*, written by Gerhard Menzel (a famous Nazi screenwriter) and directed by Douglas Sirk (who fled Nazi Germany after this film), which is staged on the island of Puerto Rico but filmed in Tenerife, Canary Islands, during the Spanish Civil War; a critical essay by canonical poet and essayist Pedro Salinas; the poetry of two writers from the Canary Islands (Josefina de la Torre, Domingo López Torres) and one of the most important representatives of pure poetry in Cuba (Mariano Brull), as well as the ideas of jurist and political philosopher Carl Schmitt, whose important works spanned the period of the avant-garde. All these references converge on the idea of the island, and the condition of tropical insularity, articulated in diverging and even opposite directions. In hindsight, we can say that these materials all point toward a polarization that was present at the origin of the historical avant-garde but also notable at the political and cultural development of the insular Atlantic. On the one hand the articulation of a regulative order, a mechanistic self-referentiality, and then, on the other, the decisionism, the assertive modality that has a certain messianism behind it. This first chapter of the book focuses in part on how the three insular writers, de la Torre, López Torres, and Brull, fit or do not fit into a "Republic of letters" as understood in the avant-garde, but also how this ideal is conditioned by colonial conceptions of space, the tropics, and capitalist investments. The works of these three writers, in different ways, short-circuit the disciplining gaze or voice coming either from the images of the German film or from Pedro Salinas's critical essay, and they do so in different ways. In

the case of de la Torre, her early book of poetry defied stereotypes of the tropics found not only in the Nazi film, but also in the introductory essay by Salinas, who invokes traditional colonial notions of the island which he tries to impose upon her work. In contrast, Domingo López Torres builds his littoral poetics around images of precariousness and dispossession grounded on his insular condition. López Torres develops what Hernández Adrián calls a *littoral sensorium* that is based on an insular immediacy and a "solar perspective." In contrast, in the poetry of Mariano Brull, the utmost representative of elite, lettered culture in Cuba, who navigated between Afro-Cubanism and "pure poetry," the island is viewed as a vanishing point, a dislocation, a space of pure potentiality, where the image of a child appears as a locus of enunciation. In Brull's poetry, landscapes become vehicles of transcendence, but they also refuse a specific historic or ethnic content. In all these works, and despite their differences, we see a movement where the drive to turn the island into a target and object of artistic or aesthetic experimentation, economic exploitation, exoticizing gaze, political discipline, or biopolitical regulation, is intersected, appropriated, and countered by a voice, a material, a nature that suspend or bracket its effectiveness. In that sense the avant-garde is not exempt from the same colonial aspirations present in other epistemological, political, or economic projects coming from Europe, but at the same time, it provides some of the strategies that will be useful to undermine its most overwhelming effects. Two distinctive sets of memories associated to conquest and plundering or to work and resistance are deployed against each other in continuous friction. At the end, the insular avant-gardists present their search for a generative locus of political affirmation and creative agency against the stereotypical representation of insularity seen in the film by Sirk.

Hernández Adrián connects Mariano Brull's Eurocentric universalism/cosmopolitanism, particularly the fantasies of maritime expansion present in his poems, to Hispanism as a civilizational ideology that had become hegemonic in the region by the 1920s and 1930s. Hernández Adrián highlights the role that Hispanism had as a specific imperial, colonial, and postcolonial project and how it intersects and collides with other colonialities enabling or hindering some emancipatory projects in the Atlantic. This in part is made clearer by his inclusion of the Canary Islands as a central site necessary to understand the Atlantic avant-garde movements. The Canary Islands became a point of articulation between continents: geographically located in Africa, it is yet an integral component

from which the Iberian empires were built, and where slavery and the plantation complex assumed its actual form while connecting to Orientalist geographical fantasies.

Agustín Espinosa, one of the main representatives of the Canary Islands' avant-garde, is an important author not only because of his two great works studied here, *Lancelot 28°–7° [Guía integral de una Isla Atlántica]* (1929) and *Crimen* (1934), but also because of his personal and professional bonds to peninsular writers who were themselves exploring Spain's Oriental past as well as the fantasies of Orientalism related to Spanish imperial projects. Espinosa's seminal book, *Lancelot 28°–7°* displays the connections between those different layers of colonial and imperialist fantasies that are constructed around the small island of Lanzarote, showing how the intervention of a certain kind of Hispanism in relation to other imperialisms led the author to invoke and to summon, but at the same time to exclude, the historical population of the island. This population, like that of other Caribbean islands, had been part of a biopolitical project that started with colonization, the introduction of slavery, the plantation system, etc.

Espinosa's focus on biology and geography, the physical space and the life that thrives on it, and the name, the symbols that seem to be needed to submit them under a particular history, will resonate with other authors discussed in the book. Lanzarote is in a state of infancy until an epic, European mark is imposed upon it. The site, as well as its inhabitants, gravitate around that possibility, while they are pulled as well into the Orient, into Africa. In the context of European thought, "life" had become a debated issue in the schools of philosophical phenomenology, existentialism, psychoanalysis, hermeneutics. Life, finite life, was to be elevated through the spirit or culture, or economy (rationalization) in order to be meaningful, becoming part of a civilization inextricably linked to a place. In *La Habanera*, the character of Don Pedro de Avila, in contrast to the Swedish (Germanic) characters, seems to incarnate the civilizational decadence of *Hispanidad*, as it devolves into a tyrannical regime in the tropics while manipulated by the capitalists in the United States. For Puerto Rican Antonio S. Pedreira, in contrast, the island is figured as a small child traumatized and docile, for whom regression into a Hispanic "stage" became a way of partial or minor salvation from its almost pathological condition of "insularismo."

If a forward movement, progression, and advancement, was a signature of the avant-garde, Hernández Adrián identifies these authors (Pedreira) with a regression, and that regression with their

male identity and their "Hispanism." Regression appears as not only a refusal of the future, a negation of the present, and even a refutation of time itself, but it also points to the topic of primitivism that was so present in debates regarding social sciences, particularly anthropology and the arts. Regression in Freudian psychoanalytic language is an unconscious defense mechanism against the effects of a traumatic event. Among writers like Pedreira or even the young Carpentier, regression could be a response to the effects of new forms of commodification and imperialism, which are seen by mainstream economics (and statistics) as a certain change of direction in economic growth. Since 1898, as a new US plantation complex with its white burden and its white supremacism emerged triumphant from its defeat at the American Civil War, reference to a Hispanic race resisting their depredations became a signature of cultural resistance. It is at this moment that the geopolitical and the biopolitical become points of contention through the distinct configuration of the island and the tropics, and where the prevailing discourse of civilization goes adrift into less stable coordinates. The confrontation between "northern" and "southern" races took place in the scenery of the insular and tropical spaces, themselves marked by disease, natural disasters, overabundance and sometimes (imaginary) overpopulation. These unstable sceneries, representing a plasticity at times unmanageable to the foreign metropoles, were inhabited by dark and darkening bodies and by the web of materials and discourses they had built around them, including avant-garde artistic works that were missed or misunderstood by their European counterparts. It is in that zone of partial blindness and misunderstandings that Hernández Adrián finds the specific core of insular Atlantic avant-gardism. European sites here are not places of origins or sources, but rather, as he phrased it, "a dynamic of insular and cosmopolitan interconnectedness where modes of non-European relation resonate across the archipelagic and littoral spaces of the modern Atlantic."

In the poetry of Luis Palés Matos, and even more so in that of Nicolás Guillen, Africa and Africanness become sites of memory and struggle that now oppose an imperial or post-imperial Europe or America. They both construct bridges and passages between the Islands, and between these islands and Africa. Most prominently, there has been a fundamental critical approach centered on the unifying thread represented by "negrista," "negritude" or "Afro-Caribbean" poetry that assumed different forms from the early experiments by Palés Matos and Guillén, pointing to the

groundbreaking projects pioneered by Aimé Césaire and Suzanne Césaire, which constituted in itself a fundamental opening establishing connections between African-American, Caribbean, and African poetics prefiguring the future Black Atlantic and Global South configurations. In the case of poets Guillén and Palés Matos, male regression is associated with the construction of a threatening/liberating African or Afro-Caribbean woman upon which a nationalist, anticolonial project is half-built. "Hispanism" consolidates and then retreats from its own approaches to Africa, from the recognition of the "pueblo negro" that constitute its "self."

In contrast, we are also shown how contacts between Afro-Caribbeans, Andalusians, and African Americans are taking place simultaneously, and how, in the case of Puerto Rican poet Julia de Burgos, according to Hernández Adrián, "race does not flee to a utopia of cosmic integration of races and cultures." Rather, he argues, "it reaches the water and suggests a fluid Caribbeanness that transcends insularity without effacing the impact that traces of slavery and racism have on island lives." Julia de Burgos is able to assert an anticolonial stance that at the same time eludes any kind of potential ethnocentrism. The creature that in Pedreira was a traumatized child haunted by visions of natural and political disasters, racial mixings, and geographic limitations, longing for a paternal savior, becomes in Burgos's poetry a voice that fuses with the material and spiritual dimensions of the island, and, instead of longing for a father, it (the voice) extends its fluvial currents to the land and the spaces that contain the memories of a past marked by racism and colonialism. This reading of Burgos, in which life and symbol become inextricably entangled, is connected to another famous Caribbean writer and anthropologist Lydia Cabrera, from Cuba, who facilitated connections between Afro-Caribbean, Mediterranean, Martinican, and US anticolonial poetry. In her life and in her poetry, Burgos emblematizes a fluidity and a plasticity that allow her to project a Caribbean persona that extends to nature and matter, and which contrast with the photographs and narratives of carceral subjects and male anxiety in the chapter that follows.

Through the photography of Walker Evans, the novel *¡Écue-Yamba-Ó!* by Alejo Carpentier, and *Hombres sin mujer* by Carlos Montenegro, we contemplate a carceral space within the context of Cuba's Gerardo Machado's dictatorship and US sugar imperialism, in which Black Cubans' labor and sexuality are coerced and contained in a sort of island within the island. The lives (of Black bodies) contained in these photographs and narratives

reflect a suspended time that is in tension with either the gaze or the corporal movements of the subjects in the photographs and the novels, while they also constitute the matter upon which the promise of a future "emancipated" republic can be constructed. The birth of the "new" Menegildo Cué at the end of Carpentier's novel returns to us this creature that seems to announce a new beginning, and new connections throughout the Caribbean, particularly to the neighboring Haiti, which will be made more explicit in the last chapter of the book, where growing and intensifying political upheavals move writers from one place to the other, translating them in both senses of the word. Inspired by Surrealism, Martinican Aimé Césaire writes his famous *Cahier d'un retour au pays natal* in the Mediterranean, and through it facilitates all kinds of connections between insular spaces. Surrealism was the most long-lived of the movements of the avant-garde, and the one that was most radical in its criticism of Western rationality, and its bureaucratic, administrative impositions and routinization. At the center of Surrealism's claims lay the idea of freedom and the important role of the imagination as two conditions that could liberate human beings from the constraints that kept them (mostly "him") tied to a conventional universe. The sites of the tropics and the islands became spaces identified with that mission, although it required a redeployment of many traditional Western colonization and masculinist tropes. This ambivalence was picked up by the insular representatives of the avant-garde who contested it promptly.

Agustín Espinosa revisits the image of the Island in his novel *Crimen* (1934), although this time he subverts the conventional views related to traditional Western exoticism, while surrealist painter Óscar Domínguez will use surrealist techniques to excavate the Canary Islands' past, invoking its ancient inhabitants. The image of Africa (or the Orient) contained in and constrained by the representations of Europeans will now reappear in the reassertion of a politically charged racial identity within a transnational and multilinguistic framework developed in different ways across the Atlantic. This framework took place within networks of exchange that went beyond or against the colonial structures imposed on the islands: these encounters, framed by fringe situations such as wars, exile, and migration, enabled the emergence of conversations and works of art that were not subdued to the colonial imperative, although closely related to it. The diverse encounters with André Breton and Surrealism had an important role within this development, but it was in the process of appropriation, contestation,

and translation that it became a notable literary and artistic practice that challenged the traditional or conventional approach to World or Global literature. The unveiling of Wifredo Lam's *The Jungle* after an itinerary through the Caribbean that ended up in Port-au-Prince closes the book with an interrogation about the intersection between Surrealism and the Atlantic, and particularly the new role that Haiti will have in the articulation of a new geography of the south that Alejo Carpentier and Maya Daren will develop further in the 1940s.

On Tropical Grounds challenges us to move beyond *terra firma* into a more unstable and liquid view of things. Insular avant-garde poetry is a response to that challenge. Hernández Adrián finds various and divergent strategies for asserting an insular material and spiritual presence, incarnate and sensuous, that yet refuses colonial ethnographic appropriations. Instead of reading these works in order to build or construct a tradition that would compete with other traditions, he expands upon the concept of constellation originating from Walter Benjamin's early work on the *Trauerspiel*. Instead of being drawn or driven to a specific location or particular reading, the works discussed here gravitate around each other and around other manifestations of the avant-garde, reinscribing the meaning of their colonial forerunners: constellational and archipelagic, but also intimate and precarious, they contest the ethnographic colonial grasp that is extended over them and they interrupt the flow of pleasure yearned at by the colonial capitalist and extractive gaze attempting to appropriate and commodify the islands' tangible and/or intangible goods.

Introduction: On Tropical Grounds

Articulating Islands

What are the grounds for speaking of an insular avant-garde? Most definitions of the avant-garde emphasize a desire for transformation and a drive to destroy "the Powers of old Europe," as Marx and Engels declare in the Manifesto of 1848.[1] Writing about a textual genealogy that claims the 1848 Manifesto as precursor, Martin Puchner argues that "the transportation, transmission, and adaptation of avant-garde manifestos indicate how these texts formed an international avant-garde, an avant-garde at large."[2] This book approaches the archipelagos of the Hispanic and Francophone Caribbean and the Canary Islands as the scenarios of important discussions whose attentiveness to local histories of the present are worth understanding and relating in today's changing perceptions of the global Atlantic.[3] Contrasting ideological and aesthetic displacements within local avant-garde movements, I propose to look at the modernist Atlantic from an insular viewpoint. I contend that insularity can act as the geopolitical location of postcolonial island societies whose cultural production offers a unique critical viewpoint on the modern Atlantic, while posing a critical challenge to Eurocentric approaches to the insular avant-garde.[4]

After the era of colonial expansion, dominion, and exploitation that we know as Atlantic modernity, the long-term consequences of the old European powers are felt persistently in the first decades of the twentieth century. Yet the Atlantic "space" remains

inadequately modern in this period, the colonial imagination representing a negative foundation among insular avant-gardists who often draw on modern forms of universalism to provisionally or tactically adopt, if not "unite" with, an expansive metropolitan avant-gardism. For these avant-gardists, an underlying reality has to be excavated out of thick layers of *nesophilia* (a love of islands), romantic exoticism, and a novel touristic fascination with islandscapes. In the Caribbean and Atlantic spaces this book discusses, metropolitan and continental attitudes are the objects of conflict, negotiation, and compromise. The attraction forces of the distant or bordering continent translate as predatory, universalist, cosmopolitan, or internationalist emancipatory projects. But while the islands remain dependent and in some cases expendable on the level of metropolitan imaginary and political projections, they are rarely passive recipients of these projects.

On Tropical Grounds does not offer a seamless panoramic view of the avant-garde–Surrealism continuum in the Hispanic and Francophone Atlantic. I propose instead a local-bound and historically situated investigation into the Atlantic experience in dialogue with what Édouard Glissant calls "a field of islands." This book embraces the idea of a plurality of islands that extends like a field across connecting seas, in a construction that maintains a fundamental tension between the apparently irreconcilable extremes of extension and instability, on the one hand, and fragmented diversity, on the other. In Michael Dash's appreciation, the poems in Glissant's *Un Champ d'îles* (*A Field of Islands*) (1953) constitute "evocations (*traversées*) in which a central and obsessive drama is enacted between the dreamer, the sea and the shore."[5] The following chapters show that an analogous dramatic instability of island spaces represents fertile grounds for the modern emergence of national, regional, and insular aesthetico-political demands. As we shall see, critical constructions of place and political change are periodically rearticulated in the decades of avant-garde effervescence that the book considers. What role, then, do these islands play in avant-garde figurations of soil, field, and future-bound spaces? Conversely, what role does the avant-garde perform in the formation of new modes of insularity?

Throughout this book, I employ the expression *avant-garde* instead of its inexact equivalent *modernism*, more common in English-language contexts. I am concerned with the Hispanic and Francophone islands of the Atlantic, hence my choice of *avant-garde*, a term with spatial connotations that Spanish and other

European languages adapted from the French *avant-garde*. While *vanguardia*, *arte nuevo*, and *ismos* are widely used in the Spanish-speaking world during the first half of the twentieth century, *modernismo* remains the name of an international symbolist style associated with José Martí, Rubén Darío, Julián del Casal, Tomás Morales, Alfonsina Storni, Gabriela Mistral, Miguel de Unamuno, and the young Juan Ramón Jiménez, among others. At stake in the insular avant-garde are the rhetoric and experience of location and, concurrently, the arbitrariness of colonial articulations of malleable "space." The insular avant-garde groups I discuss participate in international avant-gardism while engaging in critical efforts to transform the colonial experience of location. In her ground-breaking study of the Latin American avant-garde, Vicky Unruh characterizes the early decades of the century as

> an epoch of contentious encounters manifesting the challenging alliances that accompany shifting economic, social, and political conditions. Latin American nations experienced the impact of World War I era economic changes, of political hopes generated by the Russian revolution and international workers' movements, and of the pervasive postwar disillusionment with European culture epitomized in Oswald Spengler's *The Decline of the West* (1918–22).[6]

In the 1920s, insular journals, manifestos, and aesthetico-political commitments demonstrate an awareness of the impact of Cubism, Italian Futurism, Dada, northern European Expressionism, Soviet avant-gardism, and the Black internationalism spreading from New York's Harlem and Paris. Yet in what precise sense might we consider Unruh's principle of the avant-garde as "an epoch of contentious encounters" across the Hispanic and Francophone islands? There are those in the various groups who mimic international trends in derivative manifestos and other ephemera, for the most part short-lived calls for rebellion and transformation in island societies that survive in the grips of well-established oligarchies and systemic neocolonial exploitation. But the most daring form activist communities, produce bodies of poetic, essayistic, and artistic works, and publish manifestos and journals that define them as avant-garde formations with local, national, and international profiles. At the heart of their activities lies a preoccupation with social change, a deep commitment to the transnational call to liberate "the wretched of the earth," and an unprecedented desire to assert a communal awareness of their geopolitical location.[7] Expanding Unruh's Latin Americanist perspective, this book questions one-way

and nation-to-nation expressions of the insular Atlantic as a cartographic and iconic geography located southwest of the European subcontinent, and south and southeast of the United States. My aim is to delineate how insular avant-garde practices contest colonial cooptation through strategies of individual and communal introspection, reorientation, and dislocation. I do this by situating my arguments in the context of multiple avant-garde critiques of colonizing modernization.

While universalist discourses of the Atlantic reinscribe the cultural superiority of the West, the archipelagic Atlantic that emerges in this book questions the very idea of "old Europe" and its colonial extensions as an exclusive domain of modernizing and modernist practices.[8] On the contrary, the critical spaces of avant-garde insularity grow out of a consciousness of political and cultural asymmetries between situated experiences of modernization and culturally embedded discourses of Eurocentric supremacy. For this reason, I find that Chantal Mouffe's distinction between antagonism and agonism apply to the Atlantic locations of insular avant-gardism. Mouffe defines antagonism as "a we/they relation in which the two sides are enemies who do not share any common ground," and agonism as "a we/they relation where the conflicting parties, although acknowledging that there is no rational solution to their conflict, nevertheless recognize the legitimacy of their opponents. They are 'adversaries' not enemies."[9] While Mouffe's conceptual analysis responds critically to Carl Schmitt's friend/enemy opposition, she underlines the boundaries between conflict and relation and maintains that in agonism, "while in conflict, [the conflicting parties] see themselves as belonging to the same political association, as sharing a common symbolic space within which the conflict takes place."[10] I see agonism not antagonism as the preferred space where avant-garde experiences develop and flourish, even as the historical period is fragmented by multiple crises.

The texts and contexts I discuss in this book merit a nuanced and expanded analysis of the notion of agonism. If agonism, relation, and contentious cosmopolitanism can describe aesthetic optimism and political ambition among insular avant-garde groups, there is also an undeniable dimension of adversarial attitudes that are bound by colonial, postcolonial, and decolonial efforts. These attitudes would be best described as antagonistic, oscillating from the early 1920s to the late 1930s between conservative, antidemocratic, authoritarian, and fascist extremes. In Mouffe's analysis, "political association" and "common symbolic space" are panoramic abstractions that

will arguably come undone under the perspectival acuity of archipelagic thinking, and be tested in multiple expressions of Glissant's "field of islands." Yet, it remains important to ask how Mouffe's "common symbolic space within which the conflict takes place" would translate into the three decades of Atlantic avant-gardism. I argue that such a symbolic space unfolds in multiple inscriptions and rearticulations of longstanding antagonisms between nation and colony, region and archipelago, and island and cultural location. Furthermore, which kinds of antagonistic and agonistic relations can we discern among insular avant-gardists? We certainly see them moving beyond superficial appropriations of the vocabularies of their European counterparts and adapting grammars of aesthetico-political disruption. But do these attitudes amount to evidence that, as Mouffe states, "they see themselves as belonging to the same political association, as sharing a common symbolic space"? This book investigates the conditions of antagonism and agonism that shaped the varieties of insular avant-gardism as these authors strive to make cultural difference and geographic distance intelligible to themselves and others through formal experiments and political demands.

In *On Tropical Grounds*, I contend that the Canary Islands are a central enclave in an Atlantic politics of location that distinguishes between national literary and cultural histories on one hand, and hemispheric and trans-Atlantic relations on the other. If the Canaries are exceptional for their peripheral location within Atlantic national mappings post the "disaster" of 1898, they are no less dependent in a broad colonial sense.[11] Therefore, my contention seeks to neither force an Americanist reading of the Canaries nor obfuscate the evidence of political and cultural formations that constitute them as Spanish. Nor do I posit an Atlantic comparativism of creole and colonial cultural forms. Instead, I read the Canaries as an exterior frontier of Caribbean culture, and as a revealing mirror and margin of Hispanism's Atlantic meta-archipelagos.

This book explores textual, visual, and conceptual *constellations* that, while speaking to local and national avant-garde canons, seek to articulate the specific textures of a displaced international avant-gardism. In Walter Benjamin, as Fredric Jameson observes, "the word 'constellation' is a destructive weapon, an instrument to be wielded against system and above all against systematic philosophy: it is meant to break up the homogeneity of philosophical language (and thereby to undermine the very order it seems itself to promote among the stars)." Jameson proceeds to comment on "the historical situation" during Benjamin's formative years "as the moment of

the hegemony of neo-Kantianism, a moment in which academic philosophy was almost exclusively epistemological and dominated by the sciences and by the ideal of knowledge as the only kind of truth with which philosophy, and thinking in general, should be concerned."[12]

Gary Wilder adopts a different perspective that displaces the locus of conceptual thinking from Benjamin's neo-Kantian and Marxist speculation to a Caribbean and Atlantic reabsorption of historical materialism. He observes that for Benjamin (and Theodor W. Adorno) "thinking entailed arranging concrete objects of enquiry into particular constellations through which the elements, and the hidden relations among them may be illuminated ... Especially important was their idea that constellations are actually existing arrangements that must, nevertheless, be arranged." Among Wilder's interlocutors, David Scott's *Conscripts of Modernity* offers a critique of temporality in the colonial Caribbean that, as Wilder notes, "powerfully challenges the nationalist orthodoxies of anticolonial thinking and demands that scholars attend to historical temporality as an analytic and political problem."[13] This book's insistence on the insular location of avant-garde and surrealist practices attends to Wilder's and Scott's injunctions to return to and rethink the interwoven dimensions of anticolonial resistance, aesthetico-political experience, and the production of island-bound temporality. In Wilder's wide-ranging discussions of African and Caribbean Negritude, and in Scott's engagement with Koselleck's notion of "futures past" to reinterpret C. L. R. James's *The Black Jacobins* (1938), critical reckonings with postcolonial and decolonial thinking *take place* in the fragmented temporalities and cultural displacements of Afro-Atlantic, European, and contemporary politics.

Clearly, the priorities of any historical situation are beholden to geopolitical locale and changing political climate. But the distance separating the centers of neo-Kantianism and other universalist genealogies from the Atlantic archipelagos is not insurmountable, and the circulation, reception, and tropicalization of those ideas is far from anecdotal. José Ortega y Gasset's books and *Revista de Occidente*, the influential journal he published between 1923 and 1936, are examples of neo-Kantian engagements from the South.[14] The spirit of other journals, like *La Gaceta Literaria* (1927–32) in Madrid, *Revista de Avance* (1927–30) in Havana, *Gaceta de Arte* (1932–36) in the Canary Islands, and *Tropiques* (1941–45) in Martinique, is generally cosmopolitan and centers on epistemic, scientific, and culturally heterogeneous debates. These publications

contain an eclectic repertoire of reflections, chronicles, and discussions on not only neo-Kantian ideas, but also Marxism and Hegelianism, ethnography, psychoanalysis, and the natural sciences. The ideas of Leo Frobenius, Hermann von Keyserling, and Oswald Spengler resonate with force across these journals, energizing the avant-garde and intellectual circles that animate them.

In Jameson's hermeneutics of the Benjaminian text, constellations reverberate across dialectical images and profane illuminations by emphasizing experiences of figural distancing and connectivity. In Michael Löwy's view, Benjamin's "objective is to discover the critical constellation formed by a particular fragment of the past with a particular moment of the present."[15] Thus, "translated" into archipelagic vocabulary, Benjamin's "critical constellation" of *particular fragments and moments* rejoins Glissant's vision and lived experience of "a field of islands" where performative images like the panorama, photography, and cinema resonate with avant-garde narratives of colonial inequalities and emancipatory aspirations. As Glissant explains, "Roots make the commonality of errantry and exile, for in both instances roots are lacking. We must begin with that." And in a note he elaborates: "The Caribbean is a land of rootedness and of errantry. The numerous Antillean exiles are evidence of this."[16] This perplexing beginning suggests a flexible notion of Caribbean and Atlantic archipelagos, where images of soil are tempered by the historical experiences of exile, diaspora, and uprootedness that Glissant calls "errantry" (*errance*). Celia Britton elucidates the meaning of the word, observing that "the totality can never be fully known by any individual; Glissant describes it as a *force field* of possible trajectories, along which people move in a new, non-imperialist kind of traveling, which he calls 'errance.' The 'errant' explores the world, aspires to know it in its totality, but realizes that he [sic] never will"[17]

The Glissantian tropology of land, field, rootedness, uprootedness, and *errance* is neither exclusively metaphorical nor consistently literal. There is a profound commitment in Glissant's texts to remember and redress the biopolitical and necropolitical dimensions of Atlantic colonialisms as they persist in the present.[18] His conceptual grids remain attentive not only to historical time, but also to what Michaeline Crichlow and Patricia Northover name "the practices and politics of accommodation, dwelling, or homing" that express "a liminal politics of disarticulating and rearticulating given places, given spaces, and their cultures of power."[19] The memory and consciousness of the slave trade, the

middle passage, and plantation and post-plantation arrangements constitute a dynamic "field of islands" as the unsurpassable plurilocation of archipelagic thinking. Therefore, this book seeks to spell out rather than reduce the theoretical purchase of important discussions around biopower, biopolitics, and necropolitics.[20] Terms such as "politics," "political," and "aesthetico-political" will appear *disarticulated* and *rearticulated* across the polysemy of the *tropical grounds* mentioned in the title to incorporate the critical density of avant-garde practices of locality, displacement, and *errance* in Glissant's sense.

Examining written and visual production from the islands of the Hispanic and Francophone Caribbean and from the Canary Islands, as well as critical debates involving the deployment of discourses of insularity in both insular and metropolitan spaces, this book considers notions of imitation, appropriation, cosmopolitanism, relation, originality, and self-exoticism to trouble the idea that historical avant-garde practices were pre-eminently urban and metropolitan cultural forms. My argument departs from traditional comparative work in the field of Caribbean studies in that it challenges the necessity of national and monolingual textual communities as obvious models for interpreting cultural politics and aesthetic practices. Thus, I examine diverse insular Atlantic locations to account for cultural phenomena that resist containment within exclusively national or regional boundaries. I consider the cosmopolitan antagonisms inscribed in the work of such insular authors and artists as Julia de Burgos, Lydia Cabrera, Alejo Carpentier, Aimé Césaire, Suzanne Césaire, Óscar Domínguez, Agustín Espinosa, Nicolás Guillén, Wifredo Lam, Domingo López Torres, Clément Magloire-Saint-Aude, Carlos Montenegro, Luis Palés Matos, Domingo Pérez Minik, Antonio S. Pedreira, and Josefina de la Torre. As a diverse community of protagonists, their constellated works illustrate how insular avant-garde practices participate in metropolitan modernity, challenging and nuancing influential studies of literary and artistic avant-gardism.[21] I address a series of direct engagements between local avant-gardists and metropolitan authors, including André Breton, Luis Buñuel, Maya Deren, Walker Evans, Federico García Lorca, Eugenio Granell, Langston Hughes, André Masson, Pedro Salinas, and Douglas Sirk, among others. Furthermore, I contend that insular avant-garde groups insist on being recognized as communities of cultural exchange and critical debate. Decisively, I seek to understand a variety of local perspectives through sustained analyses of instances of self-recognition,

political resistance, and creative self-fashioning that stand in tension with both local and external forms of colonialist dependence.

In this book, I do not map out a unified discourse of insularity or a theory of Atlantic islands. Instead, I claim that insularity is a material condition that in Atlantic contexts cannot be extricated from mythical, geopolitical, and performative dimensions where shared experiences of slavery and diaspora, trans-Atlantic trade, and colonial institutions underlie the cultural and political geographies of these islands.[22] Chris Bongie writes: "Depending upon one's perspective, the island can be viewed in either a negative or a positive light," and "As a negative figure, the island becomes the site of a debilitating or dangerous isolation." He adds: "However, the figure of the island also beckons in another more positive direction, offering the prospect of defined boundaries and a desirable self-sufficiency."[23] What remains of the islands and archipelagos of avant-garde and surrealist experience? Islands are small worlds, enclosed universes where the effects and dynamic actions of the body, culture, and social and political life may seem to be more transparent to observation than in more extended spaces. But the projected specter of continental utopia shaped modern representations of the Atlantic's islands. This book "reads" the avant-garde period from the fragmented field of cosmopolitan exchanges, while reflecting on how islanders conceptualize their own locations in the modern Atlantic.

"The archipelagic trope" figures abundantly in postcolonial critical discourses.[24] I start from the premise that various discourses of insularity – ways of thinking (through) islands – figure at the core of avant-garde cultural production in the archipelagic Atlantic. Partially grounded on Jean-François Lyotard's *The Postmodern Condition*, Antonio Benítez Rojo's *The Repeating Island* adopts a "postmodern perspective" or "paradigm" that questions the validity of "any single truth." As Román de la Campa states with finesse in his critique of Benítez Rojo's book, we can envisage "the postmodern as Caribbean destiny." But while Benítez Rojo exposes a potentially liberating transnational utopia, he reproduces a "truth" of Cuban nationalism that is indebted to patriarchal and masculinist identifications. This critical narrative and genealogy of the Cuban nation parades Columbus, Las Casas, Guillén, Fernando Ortiz, and Carpentier as heroic figures; meanwhile Alexander von Humboldt, Fanny Buitrago, Edgardo Rodríguez Juliá, Wilson Harris, Gabriel García Márquez, and Derek Walcott pale in comparison, as do alternative versions of an archipelagic Caribbean.[25]

On Tropical Grounds argues that interpreting avant-garde cultures through an archipelagic frame does not require an engagement with postcolonial or "postmodern" discourses through the lens of an "ekphrastic exoticism" that would filter islands through the *first approach* of visual experience.[26] In Glissant's poetics, "archipelagic thinking" is not exclusively a geographic trope, but an intellectual practice and an ethico-political manifesto. Glissant's deconstructive analyses speak from the Caribbean of pluralities and singular enclaves when he writes: "Archipelagic thinking suits the pace of our worlds … The thinking of the archipelago, the archipelagos, opens these seas up to us."[27] Drawing on Glissant for the suggestiveness of this meta-archipelagic scope or "field," I do not posit archipelagic insularity as a definition containing a clearly identifiable set of characteristics. I engage instead multiple perspectives where non-European avant-gardists mobilize modernizing discourses (or images that evoke those discourses) to intervene in the construction of islands as archaic, regressive, and "primitive" spaces. Their interventions adopt or circumvent cosmopolitan strategies of exploration and mapping that measure historical and territorial differences. While tropicalist and exoticist discourses are widespread in the first half of the twentieth century, avant-garde practices do not entirely repudiate continental constructions of landscape, ethnographic knowledge, and folklore. Indeed, issues of representation traverse local avant-garde texts and fuel ongoing debates on regional and national identity. In some cases, in the works of Carpentier, Guillén, and the Césaires, for example, irony and humor are the preferred strategies. For other authors, including Josefina de la Torre, Mariano Brull, and Magloire-Saint-Aude, the adoption of transnational avant-gardism is necessary to neutralize the nativist discourses that they experience as complacent, reactionary, or insincere. These strategies enter into illuminating negotiations with "primitive" modernism, sometimes reproducing the stereotypes they aspire to overcome.

Cosmopolitan *Ismos*

On Tropical Grounds is divided into three main parts, bookended by this Introduction and an Epilogue. In the first two, a recurrent theme is a reflection on the specific location and orientation of avant-garde movements, trends, and groups that can be seen as a field of *ismos*. These *ismos* received detailed critical attention among Caribbean

intellectuals like Carpentier, Suzanne Césaire, Aimé Césaire, Pedro Henríquez Ureña, René Ménil, Ortiz, Palés, and Pedreira; and by Ramón Feria, Pedro García Cabrera, López Torres, Pérez Minik, and Eduardo Westerdahl in the Canary Islands. In one of the most polemical texts of Puerto Rican nationalism, Pedreira's *Insularismo*, the suffix suggests a familiarity with the diverse *ismos* that the Spaniards Ramón (Ramón Gómez de la Serna) and Guillermo de Torre discuss in a variety of publications. While *modernismo*, *cubismo*, *futurismo*, and *surrealismo* enter critical discourses instantaneously upon their manifestos and proclamations, *ultraísmo* and *creacionismo* excite long debates among members and critics.[28] Torre's *Literaturas europeas de vanguardia* (1925) chronicles a comprehensive repertoire of movements and groups in breathtaking depth, while Ramón's *Ismos* (1931) announces "numerous engravings" on the front cover, and "numerous illustrations" on the inside cover – a sign that critical immersion into the growing number of *ismos* requires an appreciation of visual strategies. As protagonists of an ongoing sequence of avant-garde ruptures, both authors draw substantially from personal anecdotes, and Ramón's attentiveness to images extends a tradition of paratextual and intermedial practices in avant-garde books, journals, and textual ephemera.[29]

The *ismos* of the Hispanic and international avant-garde spell out a discontinuous field of projects and antagonisms that confront the metropolitan irradiation of European ideas and practices. Although not exclusively concerned with Caribbean avant-gardism, the Dominican-born Pedro Henríquez Ureña inaugurates a Latin American form of cosmopolitan criticism that would remain influential a century later. In *Seis ensayos en busca de nuestra expresión* (1928), he posits the notion of *expresión* as an organizing principle around which a history of trends, changes, movements, and ruptures informs philological, historical, and critical methods. Like the Mexican writer Alfonso Reyes, Ureña is a critical Hispanist with strong ties to Madrid and the circle of Ortega's *Revista de Occidente*. He boldly establishes the coordinates for a vibrant practice of literary criticism that engages historical and contemporary reflection. In a piece from 1925, he writes: "We are entitled to all the benefits of Western culture [*la cultura occidental*]."[30] In a lecture he delivers in Buenos Aires in 1926, commenting on the *modernistas* Rubén Darío and José Enrique Rodó, he proffers a rare comment on the Latin American avant-gardists: "again in Spanish America [*la América española*] a restless youth [*juventudes*

inquietas] has become irritated with its elders and offers to work seriously in search of our genuine expression." He distinguishes between the Francophile "Europeanizers" [*los europeizantes*], and "Hispanizers [*los hispanizantes*] who suffer from a grammatical malady [*locura gramatical*] hypnotized by all things from Spain that have not been transplanted to these soils."[31] In the conclusion to the Charles Eliot Norton lectures he delivered at Harvard in 1940–1, there is telling commentary on Mexican *muralismo*. "'By 1925,' so it is explained in the Foreword of the Museum of Modern Art to the catalogue of the exhibition of Twenty Centuries of Mexican Art held in New York in 1940, 'rumors of the Mexican Renaissance began to reach the United States ... The Mexican influence did not extend only to the United States – all of our hemisphere caught fire from it.'"[32]

On Tropical Grounds stages a series of situated discussions around *ismos* and islands to understand the contours of specific avant-garde expressions, and to investigate resonances between *ismos* and isthmus. But this book does not indulge Gilles Deleuze's distinction between "*continental*" "accidental, derived islands," on the one hand, and "*oceanic*" or "originary, essential islands," on the other. Instead, "the island" emerges as a non-originary geocultural construction with strong continental derivations that resonate materially and metaphorically with *continental* islands: "They are separated from a continent, born of disarticulation, erosion, fracture; they survive the absorption of what once contained them."[33] In Deleuze's playfully "scientific" sense, the interconnected islands of Caribbean and Atlantic avant-gardism are isthmoid spaces, if by isthmus we understand not an isolated landmass, but a littoral passage or connective zone where mixed notions of enclave and exclave give way to broader discussions around colonial exploitation, economic dependence, and cultural and political emancipation.

Part I, "Atlantic, Hispanic, Avant-Garde: Archaic Places / Non-European Regressions," explores the emergence of two complementary experiences and textual assemblages during the experimental 1920s that do not yet register a commitment to Surrealism. Focusing on avant-garde texts from the 1920s and early '30s in the Caribbean and the Canary Islands, the first two chapters argue that scrutinizing the figure of the non-European in these texts can help us understand some of the defining characteristics of insular avant-gardism in this period. In Chapter 1, "Around the Atlantic Avant-Garde: Insular Dreamworlds / Archaic Islandscapes," I study

the emergence of an experimental aesthetics in poetic works by two Canary Islanders, Josefina de la Torre (*Versos y estampas*, 1927) and Domingo López Torres (*Diario de un sol de Verano*, 1929), and by the Cuban Mariano Brull (*Poemas en menguante*, 1928; *Canto Redondo*, 1934; and *Poëmes*, 1939). The chapter unfolds as an ironic response to Douglas Sirk's tropical melodrama, *La Habanera* (1937). This phantasmagoric vision of deviant insularity was partly filmed in Tenerife during the Spanish Civil War, yet Sirk's German fantasy of the colonial island portrays a fictional Puerto Rico. The film's cynical obliviousness to the cultural life of both islands prompts questions about the potential (or inability) of local authors to transform colonial dreamworlds into expressions of lived resistance. I conclude that local variations on archaic island spaces deploy a complex topography of avant-garde expression where new visions of insularity emerge as a central concern, deviating in critically suggestive ways from metropolitan tropes of the exotic Atlantic.

While the first chapter centers on subjective uses of the archaic island, Chapter 2, "Male Regressions: The Non-Europeans," takes up gendered discourses of Africa and related notions of race, subjection, and emancipatory potential in three prose texts. I focus on the plasticity with which non-European writers from the Canary Islands and the Caribbean seek to model progressive avant-garde projects around discourses of literary universalism, historical determinism, and organicism. Expanding the discussions of the previous chapter, I turn to the uses of the mythopoeic and ethnographic gaze. Alejo Carpentier's Afro-Cuban ballet, *El Milagro de Anaquillé* (1927), Agustín Espinosa's *creacionista* text on the island of Lanzarote, *Lancelot 28°–7° [Guía integral de una Isla Atlántica]* (1929), and Antonio S. Pedreira's influential essay on Puerto Rican nationalism, *Insularismo* (1934), form a fascinating assemblage of genres, perspectives, and styles of approaching displaced constructions of Africa and Africanness as subjects of avant-garde debate. I argue that these texts negotiate regional, national, and cosmopolitan registers of insularity even as they distort, elide, and evict cultural and biopolitical obstacles.

Part II, "Caribbean, Colonial, Avant-Garde: From *Poesía Negra* to Carceral Romances," centers on the Caribbean 1930s. Chapter 3, "Islands of Desire: The Poetics of Antillean Fragmentation," traces discourses of insularity in three avant-garde poets, the Cuban Nicolás Guillén, and Puerto Ricans Palés and Julia de Burgos. Their experimental efforts to represent Black experiences echo

contemporary debates around race, geographic and biological determinism, and local visions of the insular region. In Guillén's *Motivos de son* (1930), *Sóngoro Cosongo: Poemas mulatos* (1931), and *West Indies Ltd.* (1934), poetic "characters" interpellate readers through expressive "dialogues" that foreground, question, and ultimately foreclose idyllic tropicalizations of Afro-Cuban culture. Palés's anguished vision of Puerto Rico in *Tuntún de pasa y grifería* (1937) projects an organicist view of the Africanized island-nation that registers the ethnocultural theories of Spengler. Finally, Burgos's *Poema en veinte surcos* (1938) intersects with Guillén and Palés through the articulation of a gendered voice that identifies with an entrenched progressive republicanism during the Spanish Civil War. These three takes on the Afro-Caribbean reveal strategic uses of the gendered island as nation, region, and space of ethno-racial tensions at a time when US imperialism fueled critical debates among Caribbean intellectuals.

Chapter 4, "Carceral, Island, Nation: Cuban Romances in Photography and Fiction," considers cultures of incarceration and US economic dependence in Cuban and pan-Caribbean contexts. Building on discussions of race and economic colonialism in the previous chapters, I turn to the Minorista group and related contexts to examine three accounts of the island during the Great Depression. The chapter opens on Walker Evans's Cuban portfolio, a series of photographs he made during the last days of President Gerardo Machado's regime and which appear in Carleton Beals's anti-imperialist essay *The Crime of Cuba* (1933). I ground my argument in a discussion of Evans's photographs to highlight documentary coincidences and dissonances that characterize hemispheric avant-gardism. In subsequent sections, I turn to two partially autobiographical prison novels, Alejo Carpentier's *¡Écue-Yamba-O!* (1933), and Carlos Montenegro's *Hombres sin mujer* (1938). These works unfold uneasily across contrasting repertoires of inter-American, pan-Caribbean, and minor cosmopolitanisms, yet share a passionate investment in Afro-Cuban entanglements and intercultural dialogues. At stake in this chapter are the interlocked dimensions of colonial violence and political resistance, racial segregation and incarceration, and sexual deviance and marginal masculinities.

Surrealisms

On Tropical Grounds contextualizes the interaction of insular self-representations and continental fantasies of islands in the work of avant-gardists from Cuba, Puerto Rico, Martinique, Haiti, the Dominican Republic, and the Canary Islands. On the one hand, the book's arguments foreground the importance of contextualizing Atlantic encounters to better understand cultural and political negotiations around avant-garde practices in insular contexts, examining in the three final chapters how Surrealism reorients a critique of European civilization by seeking a radical shift in insular-metropolitan relations. On the other hand, my analyses move beyond the meandering surrealist story, with its emphases on primitivism, exoticism, and the perpetual quest for the marvelous. Part III, "Surrealism after France: Crime and Desire from the Canary Islands to the Americas," turns to those insular contexts where Surrealism flourishes from the early 1930s until the cataclysmic events of the Spanish Civil War and World War II.

André Breton's trip to Tenerife with Benjamin Péret and Jacqueline Lamba, where they participated in the Second International Surrealist Exhibition in 1935, exceeds the subtropical anecdote, compelling us instead to think about the interlocked functions of visual culture and discourses of insularity in decentered international avant-gardism. I attend to some of the ways in which this experience can be revisited and refocused by locating it firmly on the fragmented grounds of local archives, keeping in mind what Michel-Rolph Trouillot cautions in a discussion of the Haitian Revolution and slave plantation records: "By archives, I mean the institutions that *organize* facts and sources and *condition* the *possibility of existence* of historical statements ... Archives assemble. Their assembly work is not limited to a more or less *passive* act of collecting."[34] Agnes Lugo-Ortiz and Angela Rosenthal further elucidate the meaning of Caribbean archives in the context of their edited collection on *Slave Portraiture in the Atlantic World*: "The archive is understood here in a Foucaultian sense: the sum of texts that a culture gives itself as testimony of its past and its identity and the institutions that preserve them, but also the law of what can be uttered, the rules of cultural decidability." Displaced across multiple Atlantic exclaves, insular archives solicit the critic of avant-garde pasts, demanding an active *disassembling*, so what remains half-said and latent can find unexpected echoes of recognition in other archipelagic enclaves.[35]

During the 1935 trip, French Surrealism's rhetoric of authentic island encounters met with attentive and passionate resistance. Chapter 5, "Surrealism and the Islands: The Practice of Dislocation," contextualizes the Tenerife surrealist group through two protagonists, the artist Óscar Domínguez and the writer and critic Agustín Espinosa. This chapter engages Domínguez's paintings from the early 1930s before centering on Espinosa's surrealist text, *Crimen* (1934). Reading Benjamin's "Surrealism Essay" (1929) and "The Author as Producer" (1934), I chart tensions around surrealist uses of islands in the Paris/Tenerife axis. Inspired by the Bauhaus and Central European discourses on social hygiene, rationalist architecture, and radical politics, the Tenerife surrealist group assembles around the journal *Gaceta de Arte* and contemplates an ambitious program of social and political transformation for the Canary Islands and republican Spain.

Chapter 6, "Difficult Dialogues: Surrealism in the Francophone and Hispanic Caribbean," contextualizes the Caribbean and North American phase of the French surrealist diaspora. Centering on texts by Aimé Césaire, Suzanne Césaire, André Breton, André Masson, Eugenio Granell, Helena Holzer, and Lydia Cabrera, this chapter focuses on the displacement of the Paris surrealist circle from Marseille to Martinique and New York in 1941. I discuss Lydia Cabrera and Wifredo Lam's Spanish-language version of Césaire's *Cahier d'un retour au pays natal* (1939), Lam's emergence as an international icon of "tropical" Surrealism, and surrealist texts by the Haitian poet Clément Magloire-Saint-Aude. I outline a critical geography of the port cities that form a new archipelagic scenario for surrealist experiences and debates in the 1940s: Fort-de-France, Port-au-Prince, Havana, Santo Domingo, and New York.

"Epilogue: Preface to the 1950s" considers a final constellation of literary, ethnographic, and visual production to capture a new avant-garde and surrealist Caribbean instability at the dawn of the Cold War. Carpentier's notion of *lo real maravilloso* in a polemical and influential 1949 text, and Maya Deren's documentary film, *Divine Horsemen: The Living Gods of Haiti* (United States, 1954), provide contrasting responses to the surrealist moment in the French–Caribbean–US triangle. These and other works of the late 1940s and early 1950s elicit fresh critical questions around the future paths of international Surrealism and its diverse offspring, now flourishing across three continents in new cosmopolitan entanglements, collaborations, and "contentious encounters." What remains of the insular imagination of

the fractured avant-garde, and of Surrealism's Atlantic adventures in the previous decade? How do the new Caribbean and North American orientations affect the movement's hegemonic views on avant-gardism, progressive politics, and anti-fascist resistance? *On Tropical Grounds* concludes by restating the urgency of revisiting the islands as spaces of aesthetico-political energy and exclaves of multiple avant-garde experiences that to this day resonate with and interrogate hegemonic and simplifying vistas of the tropical South. This book ends with an ambivalent gesture of narrative closure and critical openness – an injunction to entertain fresh detours through a period that haunts our present, and to continue questioning the places and senses of Atlantic insularity.

Part I
Atlantic, Hispanic, Avant-Garde: Archaic Places / Non-European Regressions

1
Around the Atlantic Avant-Garde: Insular Dreamworlds / Archaic Islandscapes

La Habanera

In 1927, a young Swedish woman called Astree Sternhjelm (Zarah Leander) visits Puerto Rico with her elderly, sensible, and prejudiced aunt Ana Sternhjelm (Julia Serda), a formidable aristocrat from Stockholm.[1] Astree falls in love with the tropical island, as the leitmotif of a habanera sung in German indicates from the beginning. The corrupt and powerful local caudillo, Don Pedro de Avila (Ferdinand Marian), seduces the impressionable Astree who, determined to break free from family ties, stays on the island at the last minute, marries Don Pedro, and bears him a child whom they name Juan – a suitably Hispanic name that resonates with vague romantic notions of the hot-blooded southerner. But Astree grows unhappy in the oppressive paradise, and Juan becomes ill with a mysterious tropical fever. It is now July 1937 and Astree's life centers on her nine-year-old half-Swedish son. The old colonial mansion, the marriage, and the island feel like the birdcages lying around on the port in the film's opening and final scenes. Ten years have elapsed (half an hour into the film), and Astree tells Don Pedro: "What I've suffered here! What I've had to put up with! This country is still foreign to me, just as you're still foreign to me. I've been abandoned by everyone, left all alone." Astree's plight and existential alienation are perhaps a reaction to the disorders of social reality on the island. Don Pedro, a caricature of the tyrannical

oligarch, embodies the symbolic force of an Atlantic world where genealogies of obscurantism, violence, and ethnic degenerescence logically produce such archetypal figures of cultural antagonism and political enmity. Astree must escape and save Juan, the non-native and non-European *mestizo* whose unlikely ethnic purity the film emphasizes. Thus the idyllic island turns into Gothic backdrop to Astree's romantic drama (Figure 1.1).

Some twenty minutes into the film, we see Ana Sternhjelm entertaining at her grand home in Stockholm. A butler introduces two epidemiologists, the Swedish Dr. Sven Nagel (Karl Martell), and the Brazilian Dr. Luis Gomez (Boris Alekin), members of the Tropics Institute founded by Ana through her Sternhjelm Foundation; they are on their way to Puerto Rico. Once on the island, the two scientists will aim to develop a "serum" to cure the Puerto Rico fever, eight years after the Rockefeller Institute's failure to do so. The corrupt Puerto Rican authorities are portrayed as actively countering any headlines about the fever, as that could damage business interests on the island. Thus, various international actors allegorize the contested ground of the island's political economy, and the leitmotif of the serum encapsulates antagonism between two scientifically advanced modern states, Sweden and the US.

Katie Trumpener presents an accurate reading of the plot: "According to the economic logic Don Pedro invokes at several points in the film, it is neither his style of government nor even the

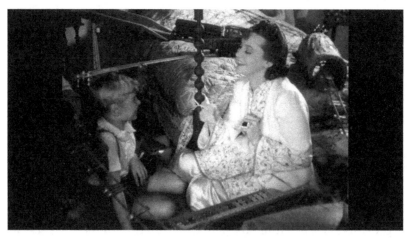

Figure 1.1: Surrounded by European toys, Astree tells Juan about Sweden in the artificial universe of the family nursery. Douglas Sirk, *La Habanera*, 1937

Puerto Rico fever itself, which is stifling the island – but rather the larger economic system to which it finds itself bound and which prevents it from being self-sustaining."² In a poignant scene in the second half of the film, Dr. Nagel accesses the lively waterfront at night. Aided by an intermittent lighthouse flash, he witnesses the exact moment a military guard becomes ill with the windborne seasonal fever. When the guard collapses and falls into a coma, Dr. Nagel takes a blood sample that will allow him and Dr. Gomez to develop a vaccine (Figure 1.2). The plot reaches a denouement when Don Pedro falls prey to the tropical fever he has denied and Dr. Nagel tries to save his life with an "antitoxin" injection, only to learn that Don Pedro had ordered the destruction of the foreign scientists' laboratory materials.

In *La Habanera* and other Nazi films, the material islands are foreshortened and deprived of perspectival complexity. But they retain an archival dimension of pleasure and chaos, a kind of *archive fever*, to recall Jacques Derrida's expression, that brings into focus a cinematic fantasy of the archive as a literal space of pure and unmarked beginnings. In these films, the interplay of entertainment, "the enchantment of reality," and "the Third Reich's hyperstylization of collective will" would allow for the illusion of exploring distant lands and thrilling emotions.³ The archive is also a place or home: "The meaning of 'archive,' its only meaning, comes to it

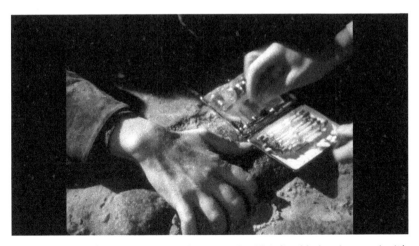

Figure 1.2: In a dramatic expressionist scene, Dr. Nagel's able hands save the life of an infected native who collapses and falls into a coma. Douglas Sirk, *La Habanera*, 1937

from the Greek *arkheion*: initially a house, a domicile, an address, the residence of the superior magistrates, the *archons*, those who commanded."[4] Thus conceived, the archive is an illusion of archaic authority or tyranny. The attraction force of island beginnings proves difficult, never quite delivering on the promise of pure, pre-industrial commencements – the island remains distant and holds *secrets* that make it opaque and occlusive, refracting Astree's desire for unmediated identification. Duped by a fantasy of the South, she will be punished for pursuing a mirage, but redeemed by the good will and scientific superiority of her native Sweden. Reconciled with the ethnic values of her homeland, she escapes to the safety of Stockholm. Her departure from the archaic island feels like a return to the true European *arkhē*, the origins that command her to exchange the primitive Caribbean for the archipelagos of the North.

This story has echoes of Prosper Mérimée's romantic novellas, with Astree posing as a tropicalized version of Carmen. It is actually a succinct plot summary of *La Habanera*, the last film that Detlef Sierck (known as Douglas Sirk from the 1940s) makes for the Berlin Ufa studios in Nazi Germany. As Reich Minister in charge of the *Propagandaministerium*, Joseph Goebbels wants the popular feel and effectiveness of an American industrial film. *La Habanera* fulfills these requirements and becomes a Nazi-era blockbuster. Premiering in Berlin on December 18, 1937, the movie is a dramatic tale of longing for the snow-covered North in a mercilessly hot tropical island.[5] That it was partly filmed on location on the Spanish island of Tenerife, at that time under control by a fascist army, is a sinister anecdote and, as I argue below, an important one. While Sirk is filming in Tenerife on commission for Ufa, the Spanish Civil War rages in the mainland. As Eric Rentschler explains:

> The film production became implicated in the Spanish Civil War as the German government threw its support to Franco's forces. Location shooting took place in the Spanish-controlled Canary Islands, Tenerife and Palma [sic]. Everywhere one went, producer Bruno Duday reported, people cheered "Viva l'Allemania" and "Viva l'Ufa" [sic]. Members of the Spanish Falangists proved especially helpful: "In the country's interior, on the large banana plantations, we could feel the war's effects more strongly. Particularly here because all men who were capable of bearing weapons had followed Franco's call to arms." For the film team from the North, this southern landscape had "an enchanting appeal," claimed Leander. Nonetheless, reported the star, the constant heat soon made paradise unbearable. "So you can understand that I soon had only one desire, to return to Germany and my home in Berlin."[6]

We can speculate that Leander's discomfort with the filming conditions signals her identification with Astree, but we can also infer from her desire to return to Berlin that there is an unspoken response to the visible signs of the unfolding military conflict on Tenerife. From the small hours of July 18, 1936, the day the military coup initiates the Spanish Civil War, the island remains under the jurisdiction of the insurgent fascist forces, all resistance in defense of the Spanish Republic is violently suppressed, and thousands of detainees are sent to the local prisons, where many become ill with typhus and other illnesses. In the port city of Santa Cruz de Tenerife, thousands are jailed in boats in the harbor and in the warehouses of Fyffes, a British fruit export company whose bosses collaborate with the fascist authorities, while the Swedish and German consuls support the fascist regime.[7] Sirk, however, had a different take years later: "We went to Tenerife, which was in Francoist hands, to shoot it. It was in the middle of the Spanish civil war. It was terrible what was going on there: there was an enormous concentration camp – something I hadn't seen in Germany. It was just horrible." His recollections are detailed:

> I put a bullfighting scene into the picture, but the bull they produced was cross-eyed – which, as you may know, is very dangerous. I think the bullfighter was trying to tell me this, but it didn't get through. I didn't speak Spanish, and had to work through an interpreter. The bullfighter was killed, gored to death by this cross-eyed bull. This has lain on my conscience all my life.[8]

It is interesting that the plot in *La Habanera* occurs as avant-garde culture has been brutally removed from the Canary Islands and cultural space is being recolonized by a fascist regime. There was much more than a tragic anecdote that "didn't get through." Indeed, there was more to the island than its generous repertoire of scenic vistas and colorful architecture. Like other period melodramas, *La Habanera* fulfills the requirements of the tropical romance genre, including accents of dangerous adventure, ethnographic pastiche, and colonial comedy. Mary-Elizabeth O'Brien notes that, "boasting some of the most successful films produced in Nazi Germany, the melodrama was an immensely popular genre, especially in the waning years of the Second World War."[9] In the waxing decade of European fascism, the Great Depression, and international political crisis, films like *La Habanera* captured degrees of longing for escape and distraction, creating plots where romance is interwoven with larger narrative and geopolitical stakes. Thus, the remote places

of the colonial imagination could contribute to what O'Brien, writing about the historical musical, calls "the social construction of happiness in Nazi Germany."[10] While most critics have focused on Sirk's uses of romance, gender roles, and political allegory, my own emphasis is on the insular "subtexts" and subplots that form the anecdotal backdrop to the story, such as elements of the gangster and "combat movie" genres, and accents of Gothic horror. Other traits, such as scientific heroism, colonial masculinity, and conventional tropes of tropical illness, corruption, and entrapment, are characteristics of popular and usually "hybrid" island films from the first half of the twentieth century.[11]

In *La Habanera*, the clichéd atmospheres of Caribbean romance and cultural subjugation translate as discourses of technological supremacy and imperial control. Embedded in the politics of Nazi propaganda, the film edits out the ravages of the Spanish Civil War while reinforcing Germany's will to instill fascist ideals and advance colonialist dominion across the Atlantic. While Nazi Germany wages war against the Spanish Republic, and all leftist political formations have been suppressed in the Canary Islands, "Puerto Rico" appears on screen as a simulacrum of deprived isolation, subjected to the networks of pan-American economic liberalism and political control. The conflation of Canarian extras appearing as Puerto Rican *"jíbaros"* (country folk) and "Black" subjects effectively proves a historical reality: that there is no political dissent in this fictional Puerto Rico. The materiality of social and political life is only vaguely insinuated through the marginal appearances of potentially contagious and concentrationary islandscapes. That the Nazi film industry selected the island of Tenerife to locate exteriors may seem coincidental. That Puerto Rico, the island that was there in its materiality in 1937 is so grotesquely distorted can be explained away in the name of poetic license. But Puerto Rico and the Canary Islands had local cultures in 1937 that the German film neither registers nor engages. In a groundbreaking study, Luis Hernández Aquino divides the *ismos* that form the Puerto Rican avant-garde period into seven distinct groups and subperiods between 1913 and 1948. These "literary movements and attempts at movements" aspired to "a total aesthetic renovation."[12] Referring to the print culture of the period, Malena Rodríguez Castro comments: "Although ephemeral, journals facilitated agile zones of transit and encounter between the country's production and artistic events and the region's, notably Cuba and, to a lesser degree, the Dominican Republic, and the Latin American,

European, and North American worlds, in a dialogue that would become subsequently impoverished."[13]

Ignoring, repressing, and eliding the "agile zones of transit and encounter" of local avant-garde cultures on both sides of the insular Atlantic, the uses of islands in *La Habanera* are not innocent, but strategically evoke imaginaries of the sea and ideas of ethnocultural inferiority and dependence that are embedded in the fabric of Nazi ideology.[14] Therefore, *La Habanera* is not only scripted as romantic melodrama, it also plays on a contemporary geopolitics of imperial desire on a deeper level that requires the construction of the tropical island as an outmoded space. When Astree and Juan escape the island at the end of the film, a melancholy view of the receding boat plowing the tropical waters underscores a return to the safety and stability of modern European time (Figure 1.3) Writing from the viewpoint of Leander as one of the Nazi film and propaganda machine's most valued stars, Rentschler observes that, "in the final moments of *La Habanera*, Astree says she has no regrets. She looks out to the harbor, listens to the singers, and, with a dreamy look in her eyes, sighs, 'La Habanera.' The end of the film shows her longing gaze – and a call to order, for Sven grabs her arms and pulls her in a different direction."[15] At this point, the idyllic island scenarios turn into a phantasmagoria of ambivalence and loss, as a new man steers Astree and Juan's destiny by returning them to their

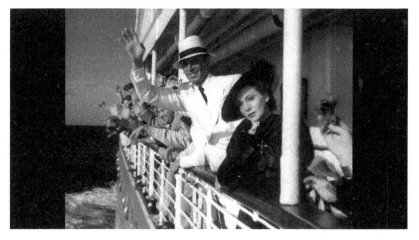

Figure 1.3: Dressed in mourning attire for the recently deceased Don Pedro, Astree sails away to Sweden with the valiant Dr. Nagel. Douglas Sirk, *La Habanera*, 1937

true origins. Astree carries within her a European longing for pure origins, but the desired *arkhē* of tropical innocence turns to painful immersion in the reality of a diseased social (dis)order.

La Habanera suggests that archaic islands must be properly managed and by extension remodeled by an advanced and powerful European nation, and far from questioning colonialism or exploitation, it caricatures outmoded forms of colonial power.[16] This is the limited reach or scope of the traveler's perspective, and the intent of the film's creative manipulation of the physical, cultural, and historical islands – an attitude that rejoins Derrida's exploration of an *archive fever* that spells out "the desire and the disorder of the archive."[17] Yet *who* could have resisted and questioned the spell of the island dreamworld when *La Habanera* was first projected in Berlin in 1937? After all, the film was primarily Nazi entertainment for German audiences. What it leaves unseen, unsaid, and unheard incites the analyses of insular avant-gardism in the Atlantic 1920s I propose in the following sections.

Taking Place: Elisions, Angles, Frames

This chapter discusses what La Habanera erases and mystifies through cinematic pastiche and cultural stereotyping. The film's telescopic editing of historical context provides us with a counterintuitive viewing point to access the spaces of avant-garde insularity at the time of the film's production and exhibition. But in looking at the peripheral frames of insular avant-garde practices, I am interested in how the stereotypical island of cinematic pastiche conceals a complicated and symptomatic insularity. The anecdotes and subplots of *La Habanera*'s production provide an initial frame to revisit the story of insular avant-gardism through a series of discussions of their practices. I will argue that the film conveys a vision of insularity that must be confronted with its less anecdotal historical contexts. The following sections stage this confrontation by engaging with the cultures of avant-gardism that the fascist regime repressed and systematically erased during the war. I read *La Habanera* as complicit with that destruction, and the cultural production of the Atlantic 1920s and '30s as evidence of that elision. By privileging genealogies of cultural self-awareness, material inequalities, and ideological transformation during the period when the fictional Astree arrives in Puerto Rico, this chapter begins with a film and examines some of the abundant poetic production of the period

from the Canary Islands and Cuba. Another aim of this chapter is to expand the locations of insularity through discussions of historically situated archives, protagonists, and contexts to complicate the conventional hegemony of a narrowly continental perspective. I hope to achieve this by calling attention to local avant-garde cultures where different visions of Atlantic modernity unfold in the Canary Islands and the Caribbean, the regions where *La Habanera* was filmed in part, and where it "takes place" in fiction.

La Habanera elides the material conditions that make its production possible. For this reason, reading insular avant-garde cultures from the margins of this Nazi film allows us to discern two colonialist angles – or two combined versions – that fulfill the requirements of a single perspective. The first of these angles reinscribes a tropical imaginary of European expansionism in the eighteenth and nineteenth centuries that naturalized the previous age of discovery and imperial power. In this imaginary, invasion, occupation, and conquest are often adorned by an aura of discovery, mystery, and myth. In Sirk's film, the explicit leitmotif of the habanera weaves an indirect connection with the romantic South through the reverberation of Bizet's *Carmen*.[18] A stereotypical discourse on "Spanish" gender hierarchies is equally present in the film through the prominent tropes of bullfighting and of Don Pedro as the "toreador" who charms, seduces, and eventually "kills" Astree's innocent longing for the tropics. This perspective evokes a Northern European fascination with Spanish imperial culture that is at once alluring, decadent, and decayed. The musical leitmotiv of the habanera encapsulates a bundle of cultural and sensory stereotypes that performs a subtle map of fabulous connections. Like the wind in the song, music brings a sense of connectedness with as remote a place as fabled and exotic Puerto Rico – in Trumpener's eloquent expression, "the nameless desire for a pure emotion unfettered by language, rationality, or convention can for a moment be given metaphorical voice in the sound and force of the wind, pure noise without meaning or purpose."[19] Through the expansive simplicity of the song's tropology, the wind carries exotic and sensory remoteness, an ominous sense of archaic, pre-scientific resignation, and a youthful desire for travel and romantic adventure.

The second colonialist angle asserts the self-evident superiority of modern visuality and technological capacities of the European West, where historical progress effectively *takes place* and radiates to colonial peripheries. In *La Habanera*, a cinematic contrast between tropical backwardness and scientific superiority evokes

the imperative of a new oceanic and territorial configuration of the Earth, while extending Eurocentric self-reproduction and globalizing exploitation.[20] In this light, the cinematic object and its cultural intertexts can be read as elements in a changing world-system where islands are uncomprehending protagonists and outliers of connectivity, witnesses in geopolitical transformation, and passive objects of aesthetic and technological modernity. The imbrication of these colonialist angles reduces insularity to availability, dependence, and disposability. In *The Nomos of the Earth*, Nazi jurist Carl Schmitt identifies an approach within international law that he calls "global linear thinking," describing its various "lines" as a kind of historical and spatial inevitability, and tracing the development of the process from 1492 to the twentieth century:

> Only after the new spatial order based on states had been achieved in Europe did the third and last global line of the Western Hemisphere appear ... Yet, the practical effects of this global line of the Western hemisphere did not begin until the 19th century. Then they developed fully and irresistibly in the 20th century.[21]

For Schmitt, writes Jan-Werner Müller, "Localisation, or *Ortnung*, order, or *Ordnung*, and meaning became inextricably connected – while the separation of *Ortnung* and *Ordnung* would, necessarily, not only cause (literal) dislocation, but also political and moral disorientation ... The proper conjunction of place, law and order, Schmitt termed nomos."[22] In *La Habanera*, Schmitt's "practical effects" expand "fully and irresistibly" in the fascist production conditions of the Spanish Civil War. The tale of Astree's naive enthusiasm rejoins the geopolitical scenario through the inscription of what Schmitt sees as a politics of enmity that seeks to annihilate partisan subjectivities. However, production anecdotes and historical records "remember" this scenario by relocating the film's archival amnesia in an antagonistic position to politics, ideology, and memory. Stephen Legg observes that "Schmitt provided a jurisprudential and political account of the rise of Europe as a world-ordering force ... [that] spread through the French and British empires, faltered while resolving the 'scramble for Africa' at the Berlin Conference of 1884–5, and finally capitulated during the Versailles Peace Conference of 1919." Legg comments further:

> Unlike other commentators of the right, Schmitt's nostalgia is not for a heterogeneous, rural past/milieu ... Rather, it is a form of "postcolonial

melancholy" ... for the age of European exploration and discovery, in which the rise of anti-colonial nationalism is associated with the demise of Man himself ... This elegiac tone runs through Schmitt's earlier work in the 1920–30s on decisionism, exception, sovereignty and politics, through to his 1940–50s work on the spatial dimensions of politics, the nomos and the land–sea relation ... all of which condemn the League of Nations.[23]

If island spaces are historically embedded in precise cartographies or "lines" of expanding civilization and progress, the historical perspectivism of the colonizing powers also constructs these spaces as decaying islandscapes in need of frequent, permanent, or indefinite control. Reflecting on the recurrence of islands as narrative and spatiotemporal tropes in European and Western literary traditions, Margaret Cohen observes: "Island time resets the historical clock to zero, enabling protagonists to establish their ideal society working from this new origin. Yet the vision of that origin is as historical as the specific vision of island society, and both shift with social context."[24] These "protagonists" tend to be either non-islanders or domesticated islanders who turn to the island to *commence*. But there are also those islanders who approach the world from an insular viewing point that requires neither historical resetting nor an idealized return to origins. In *La Habanera*, this second category is entirely excluded, despite (and precisely because of) their differing historical "vision" of themselves and for their communal future. Both visions coincide in the cultural construction of island space as an idea that takes shape in pre-industrial and pre-modern spaces such as faraway tropical islands. But the archaic, like related notions of primitive, wild, and pure spaces, is also an insular and peripheral avant-garde construction. Of course, by 1937, the production year of *La Habanera*, the imaginary of insular docility bore little resemblance to the realities of colonized and dependent island territories. Even mainstream representations of islands in films like Robert J. Flaherty's *Moana* (United States, 1926), Henri Étiévant and Mario Nalpas's *La Sirène des tropiques* (France, 1927), W. S. Van Dyke's *White Shadows in the South Seas* (United States, 1928), and F. W. Murnau's *Tabu: A Story of the South Seas* (United States, 1931), relied on humor, caricature, and racist and sexist stereotyping to portray fantasies of unchanging island spaces that appeared immersed in modernizing processes.

Building on Peter Osborne's *The Politics of Time: Modernity and Avant-Garde*, Susan Buck-Morss discusses a "politics of

conflicting temporalities" at work in Soviet avant-gardism, where a difficult accommodation between avant-garde practices and party politics results in the rejection, demise, and, eventually, annihilation of the former: "Already by the mid-1920s, the avant-garde of suprematism and futurism was spoken of in Russia as passé."[25] From the early 1920s, different aesthetico-political attitudes emerged across the Hispanic Atlantic, where temporal and territorial experiences had been conflicted since the fifteenth and sixteenth centuries. A post-World War I economic bonanza, a renewed sense of internationalism, and the initially experimental cultural production of the Russian Revolution resonated with the emergence or renewal of strong currents of archipelagic relationality: Afro-Antilleanism, Cuban nationalism, and partisan and non-partisan expressions of postwar cosmopolitanism that found political expression partially in what Stella Ghervas calls the "spirit" of the League of Nations.[26] These attitudes are informed by translations and discussions of Cubism, Cubo-Futurism, Futurism, Dada, Ultraism, *creacionismo/création purism*, and early Surrealism.

In tension with the typecast islanders in *La Habanera*, the selection of three avant-garde "island types" I discuss in this chapter forms a diverse set of generations and socioeconomic backgrounds. The first two, Josefina de la Torre and Domingo López Torres, are "minor" authors whose work was centrally defined by their peripheral status on the rims of an expanding cosmopolitan avant-garde in the Canary Islands. The third, Mariano Brull, occupies a different position in a version of the Atlantic "republic of letters" that gravitated naturally toward Parisian avant-gardism. Although little studied today, Brull remains an acclaimed Cuban poet and diplomat, while de la Torre, as one of the few recognized Spanish avant-garde women writers, has received the most critical attention in recent times.[27] We find de la Torre and Brull coinciding in a poetry reading in Madrid in the spring of 1926, although there is no mention of the two poets' physical presence at the reading. The literary and musical event is announced and described in two consecutive chronicles or notes in the "Literatura y Bellas Artes" section of the liberal daily *Heraldo de Madrid*. The venue, in the elegant Barrio de Salamanca, is the salon of Polish artist Victoria de Malinowska, and the occasion is an exhibition of works by the Belgian Pierre Flouquet. In the first note, the anonymous chronicler details the presence of socialites, politicians, and intellectuals. Among the latter are members of the avant-garde circles of the

Residencia de Estudiantes, including Pedro Salinas, Federico García Lorca, and the critic Díez-Canedo.[28]

The second note reports that de la Torre's poems would soon be published in book form and mentions the usual clichés of her young age, precociousness, and provincial origins: "... known in her Canarian homeland and in a few literary journals of the Spanish mainland for her initial childhood production, so personal and remarkable." About Brull, the note observes: "Unknown to the broader public, the other is however well known among the select group of friends who have demonstrated the great esteem the young Secretary of the Cuban Embassy enjoys in every literary and artistic circle he has been able to frequent, from Lima to Brussels, in the short years of his career."[29] The insularity of the two poets is not mentioned explicitly, but the contrast between the precocious girl "known in her Canarian land" and the cosmopolitan *homme de lettres* who is "unknown to the broader public" reveals a gendered dynamic. One of them is clearly grounded in space and time; the other's mobility spans countries and continents. Both are known in Madrid at this time, and their exotic provenance seems to compensate for the lack of reflection on their writing. But the event was supported by the group from the Residencia who would soon meet in Seville and be named as the "generation of 1927."

Nascent Gaze: *Versos y estampas*

World War I left an imprint in the lives and texts of the Canary Islands, represented in this chapter by Josefina de la Torre Millares's childhood reminiscences in Versos y estampas ("Sketches and verses") (1927).[30] De la Torre's poems construct visually suggestive snapshots that often invoke the act of seeing. These reconstructions of a child's viewpoint are elaborate autobiographical explorations of acts of seeing and sensing on an island shore that foreclose readers' expectations of a tropical island imaginary. Adopting gendered, minimal, and relatively static perspectives, they elide the male adventure traditions of Defoe and Stevenson. The aesthetics of "the futurist moment" that Marjorie Perloff discusses in her analyses of early avant-garde production take on an intimate tone in de la Torre's slow and stilled images. In Blaise Cendrars and Sonia Delaunay's *La Prose du Transsibérien*, for example, there is "joint penetration, simultaneity, speed, color, constant motion" in a simultaneist construction that transports us to the aesthetics

of avant-garde collage and early film experiments: "Everything whirls, spins, undergoes metamorphosis."[31] In de la Torre's poems, centripetal motions operate from a subjectively local standpoint. Her attention to the minutiae of childhood memories captures "the charged landscape of the avant guerre, which technology has created, a landscape that surpasses the poet's wildest fantasies."[32] But de la Torre's "landscape" during the distant war of 1914–18 expresses a littoral viewing point that appears arrested by childhood experiences, class privilege, and peripheral location.

Versos y estampas was the first book by a young Canary Islander known to Madrid avant-garde circles as the talented younger sister of Claudio de la Torre Millares, playwright and scholar, and winner of the National Literature Prize in 1924. Claudio's friendship with some of the poets and artists of the Residencia in Madrid cleared the way for Josefina's immersion in that intellectual milieu. As a trained pianist and singer, she participated in the musical life of the Residencia, where she met two poets from the Spanish south with whom she shared attitudes to place and atmosphere, Rafael Alberti and Lorca.[33] Alberti, through his friendship with Claudio de la Torre, may have mediated in the publication of Josefina's book in the collection of a new avant-garde journal from the Spanish south, *Litoral* (Málaga, 1926–9). Edited by Emilio Prados and Manuel Altolaguirre, *Litoral* became one of the central journals of the "generation of 1927."

Two seemingly diverging scenarios frame the book. The first catalogs memories of a sheltered childhood experience during World War I, a relatively carefree upbringing as part of a well-heeled family of traders and intellectuals, where de la Torre grew up in intimate proximity to the palpable signs of an economy in crisis and a provincial society in the thrall of scarcity and deprivation. The second is defined by the effervescence of avant-gardism in mainland Spain. De la Torre's personal experiences of the cultural moment center on the Residencia, and on the friendships and exchanges that mediate her participation in the activities of the "generation of 1927" group. In 1934, the poet and critic Gerardo Diego published an anthology of contemporary poetry, *Poesía Española. Antología (Contemporáneos)*. A landmark collection and a major reference point for criticism on the period, the volume includes work by members of the "generation of 1927" group. The last name in the list is Josefina de la Torre. In the biographical note preceding her poems, she highlights her precocious beginnings (a first poem when she was seven), and success as a music performer and amateur

theater director. She continues: "I first visited Madrid as a young girl [*siendo aún niña*] in 1924, and although I made other trips in the following years, I only went back to Madrid in 1927, visiting Paris then for the first time." Showcased in this prestigious national anthology, de la Torre prefaces poems from her two published books and an unpublished third collection with a list of personal achievements. The last lines of the self-portrait are revealing: "I enjoy sketching. I play tennis. I love driving my car, but swimming is my favorite sport. I was the president of the first Swimming Club in my region [*mi tierra*]. Other hobbies: the cinema and dancing."[34]

De la Torre tried to live up to a reputation that her poetry neither confirms nor denies, as an athletic, modern woman embracing glamorous *flapper* and other ostensibly emancipated types of metropolitan modernity.[35] But she stands at a distance from new images of politically engaged working women and radical female intellectuals. She combines the traits of a privileged upbringing and a certain provincialism (references to Madrid and Paris are *de rigueur*), and refers to *mi tierra* twice. Remembering herself as "a young girl" aged seventeen in 1924, de la Torre refigures her precocity as exemplarity. As Lázaro Santana notes: "The *ideal* portrait of a typical avant-garde woman could appear there."[36] De la Torre's artistic talents, musical training, and family connections define one of those ideal types. Other kinds of "avant-garde" women gathered in rare institutions like the prestigious and relatively progressive Residencia de Señoritas in Madrid, where female university students enjoyed a program of intellectual and recreational activities that was comparable to those held at the all-male Residencia de Estudiantes, with which it often shared guest speakers and events.[37] The precocious talent and the *ideal* vanguard woman compete anxiously for a stellar appearance in the self-portrait, and for justified inclusion in a male-dominated gallery of "contemporary" poets. While *Versos y estampas* can be read as an example of the late *modernista* or *postmodernista* transition to avant-gardism, its referential and thematic registers, with thinly veiled allusions to religious imagery and devout affect, express above all a personal album of the provincial world where de la Torre grew up.[38] This small world is marked by World War I, the Rif War (or Guerra del Rif), the reign of Alfonso XIII, and the dictatorship of Miguel Primo de Rivera. If this world is confusedly conservative and at times reactionary, de la Torre's class milieu is neither conservative nor particularly religious, and her book demonstrates a bold flight beyond *postmodernista* aesthetics.

Versos y estampas rejects postromantic and *modernista* iconographies of local color. As Catherine Bellver writes: "Emotions encroach upon [de la Torre's] impersonal, often sun-drenched maritime scenes. Description gives way to colorless reflection as playful gaiety surrenders to melancholy."[39] A sympathetic contemporary, the avant-garde critic Juan Manuel Trujillo describes de la Torre's poetry as "*the purest* that has been written on the island."[40] Framing insular experience through a novel kind of visuality, de la Torre adopts a self-consciously gendered point of view. But her practice of "pure poetry" does not offer tropical renditions of the exotic island for European consumption. Her poems suggest a singular preoccupation with island-bound time; structures of distance, separation, and perspective; and an astute investigation of a sensual, gendered, and conflicted childhood. But there is little of the experimental attitude in the book. Instead, these mournful *estampas* reflect on the isolation experienced in the Canary Islands during World War I, and on childhood experiences of temporal and affective suspension on the margins of the armed conflict. Indeed, what Alan Kramer describes as a "dynamic of destruction" driving the European empires and their satellites into ruinous carnage constituted an abrupt collective experience of uncertainty and isolation across the European islands of the Atlantic. As Kramer writes: "The doubt whether the sacrifice had been worthwhile gnawed at the consciences of millions of Europeans."[41] In the Canary Islands, war brought to a dramatic halt what had been a booming economy based on banana exports to the United Kingdom and other European countries. The port city of Las Palmas also suffered from the virtual blackout of British, German, and, in general, European maritime traffic – banana export sales across the Islands decrease by 83 percent between 1914 and 1919.[42] The city must have felt rather desolate throughout de la Torre's childhood.

Versos y estampas comes backed by two influential literary figures: de la Torre's brother Claudio, and the poet and critic Pedro Salinas. In a prologue to the book, Salinas explores Josefina's poetics, enlisting her as a Spanish example of French "*poesía pura*," and locating her writing in the orbit of Stéphane Mallarmé and Paul Valéry. Antonio Blanch discusses this poetic ideology, identifying a "Spanish generation of pure poetry" and a "pure poetry group" in the 1922–8 period. While Juan Ramón may have initiated this "movement" in 1922, its members are the younger poets of the "generation of 1927," Jorge Guillén, Diego, Salinas, Lorca, Alberti, and Luis Cernuda.[43] But Salinas's prologue says

more about metropolitan perceptions of the Canary Islands than about the poems. Titled "Isla, preludio, poetisa" ("Island, prelude, poetess"), it is dedicated to Josefina and starts with a quotation from Mallarmé's enigmatic "Prose pour des Esseintes" (1885). The opening and ending of the text frame the book with variations on a tautological appreciation: "That island was entirely surrounded by water."[44] Indeed, the sea figures as a protagonist in de la Torre's poems, although not as the isolating immensity Salinas suggests.

Salinas reads these poems as examples of *"poesía pura,"* describing the island of *Versos y estampas* as a space *admirably* arrested in a kind of infancy or existential latency: "Admirable and exact world, without repetition, all essay and aspiration" (103). Yet, de la Torre's early poems achieve a reorientation of that imaginary of timeless insularity by revisiting and reframing fragmentation, loss, and nostalgic variations of encounters, places, and moods. Writing against the grain of the textual evidence, Salinas locates the poems within a fantasy of archaic insularity that is accented with gross colonialist tropes, in passages such as this: "Boats of poetry. Boatloads of raw, exotic, and aromatic poetry, freshly extracted by an illiterate ebony proletariat in the meridional continent that would have discovered aviation and where the basic component is poetry." Extracted poetry is then taken to the "Old continent" in colorful boats "where in a flashy new factory [*en una manufactura novísima*] it would be transformed into pure poetry, to be then exported to the other nations of Europe" (105).

Salinas's critical outlook is not only paternalistic, and the scope of his continental perspective is not merely geographic. In his deployment of racist and colonialist tropes, "boatloads of raw, exotic and aromatic poetry" stand in material and epistemic opposition to an "illiterate ebony proletariat." Spain (and the insular poet) mediates between backward Africa and technologically advanced Europe, extracting and exporting "pure poetry." The precocious poet-child benefits from the discovery of aviation, a technological advancement that allows Europe to extract and manufacture a cultural commodity. In this colonial fantasy of cultural commodification, the elements are kept safely distant from each other, but tensions between "race, money and sexuality" or "gender, race and class," the generic categories that Anne McClintock applies to British colonialism in Africa, are latent under the surface of the fairytale discourse. These tensions resonate with Spain's own cultural defensiveness and insecure gender politics during the colonial wars of Cuba and Morocco.[45] In Sebastian

Balfour's discussion of the Spanish invasion of Morocco in 1908 and the ensuing colonial war, these categories signal loss and nostalgia for the long-gone imperial hegemony:

> The new venture in Morocco was a direct result of the insecurity felt by the Spanish political elites after the Spanish-American War. Spain had lost the scattered possessions of its once extensive empire after colonial wars in Cuba and the Philippines had turned into a disastrous military confrontation with the United States ... After the Disaster, Spain had sought to reinsert itself securely into the changing network of international alignments in order to protect its metropolis and islands and enclaves from the increasing competition between the Great Powers.[46]

In his polarizing evocations of Europe and Africa, Salinas melds colonial tropes of European technological superiority with tropical backwardness, unlikely modernity, and Atlantic cosmopolitanism: "a flashy new factory"; "exported to the other nations of Europe." The prologue ends on an allegory of poetic inspiration that combines a virile attentiveness with colonialist innuendo. Lifting its prey (the inspired poet-girl), a powerful eagle recognizes de la Torre's talent as *the chosen island girl*. "The eagle darted unflinchingly. Imprecise contour, half-naked land, half-awake between the liquid and the dark – island" (107). But is this resort to the language of exoticist surfeit only playfully allegorical? Encircling de la Torre's poems from above, the image suggests a colonial fixation with the imaginary of the tropical island. The text concludes by locating this isolated talent in the vastness of the sea. "It folded its wings; it dove inertly, fatally, inevitably, sharpening its claws – in the rest of the world, time for inspiration, time for poetry, the poets awaited it in vain – above the girl, above the island that was entirely surrounded by water" (107). The colonial overtones of Salinas's text invite a comparison with contemporary tropicalizations featuring another *niña*, Josephine Baker, in the uncanny spaces of her first silent film, *La Sirène des tropiques*. But de la Torre's world is as distant from these fictional scenarios as it is from *La Habanera*.

In a review of de la Torre's first two books of poems, Trujillo appreciates the author's medium-like qualities as a child-seer: "The verses and the images had been written by a child whose eyes were so innocent, so terribly innocent, that they had caught the world in the age that predates all ages, in the miracle of an eternal rose dawn, all present, with neither past nor future."[47] De la Torre's early commentators conflate poet with poetic voice, infantilizing

her overtly, but curiously not eroticizing her directly. Salinas speaks of her as a "*doncella*" and "*niña*," and Trujillo implies that the book was written *by*, not *about* a child ("*una niña*").[48] De la Torre, in turn, extends this trope confusedly into a projected literary persona, striking the pose of an elusive subjectivity, and seeking accommodation with cosmopolitan, class-conscious images of modern femininity. Writing about the Argentine poet Alfonsina Storni, Sylvia Molloy argues that an aura of "*aniñamiento*," "*nenidad*," and "*anenamiento*" enabled Storni's father and a series of male critics to fix her in an infantilized position. Tracing this attitude through a series of Latin American women poets of the *modernista* period, Molloy describes this effect as "*aniñamiento ideológico*" (ideological infantilization).[49] She sees in this adoption of a protracted childhood persona the fashioning of a protective mask that incites a certain male desire and simultaneously fends off demands for a more mature female subjectivity. Like Storni, who was also known as La Nena (The Girl), de la Torre contributes to her own *aniñamiento*, an ambivalent trait of her cosmopolitan island performance.

A less reductive reading rectifies de la Torre's position in terms of her affirmative choices of physical location, characters, and poetic pose in scenes where, from beginning to end, children and adults haunt portscapes and islandscapes. In prose poem III, for example, the poetic voice seeks embodiment through seeing: "I imagined him browned by the sun, half-naked, hidden behind the woods of those docks that exhale the midafternoon odor of the day's catch. Once or twice on that particular night when I got to the corner in my meandering walk, I had the urge to call out" (7). The gaze summons its objects into existence from memory, through a series of spectral *estampas* of usually anonymous characters, residents of the port city of Las Palmas who traverse the thin borders between the commercial districts (British, German, and Nordic-inflected neighborhoods), and the encircling seascapes and countryside. De la Torre remembers and "sees" these characters who hail from the working or impoverished classes, identifying with them through a logic of nostalgic recuperation. But they are not the picturesque subjects of ethnographic and tourist exoticism. They are poor children, the sick, old, and destitute; and mentally and physically suffering people. Far from a catalog of the grotesque and the abject, they are the protagonists of childhood remembrance and loss. Each of these encounters reveals a thread in a fragmented reflection on

class-consciousness, and each presents the reader with variations on sensuous desire and undertones of sexual longing.

In poem I, "Today the afternoon was serene, with a sun of gold; tomorrow – the same, every day, all summer long. ... The game began with a girl in the center. Then the circle would start to turn slowly, undulating lightly. The wheel passed over the sea" (3). The slowly gyrating ensemble appears to challenge the high-speed attitudes of prewar avant-gardism yet captures the nascent experimentalism of *Versos y estampas*. The poet remembers the spaces of a littoral childhood through animal and child figures that are invested with distant echoes of the war. The dark accents of Poem II contrast with the timeless innocence of the opening poem: "That big black dog, how he made us suffer! ... He'd come running up to us, menacing, his long red tongue between sharp fangs ... I watched him from my window." When the bored dog falls asleep, she concludes: "That afternoon I would have gladly stayed at his side" (5). In prose poem III she evokes a boy: "I imagined him browned by the sun, half-naked, hidden behind the woods of those docks that exhale the mid-afternoon odor of the day's catch" (7); and in poem VIII: "There was a crazy person on the beach. He was a child, a small boy. We call him 'the mad kid'." The older child frightens the young children, and sometimes "the kid's flashing eyes and the tanned face appeared from behind mountains of seashells." The poetic voice then declares: "I saw *el loco* some afternoons back." As the boy sits on the beach, digging in the sand by the waterline, the poet feels *recognized*: "Those large smoldering eyes recognized me" (16–17). This instance of recognition does constitute an interpellation across class boundaries, but adds a note of erotic titillation that borders on wonder.

Versos y estampas stands at a great epistemic distance from Salinas's colonialist optics. His appreciation of a budding poetic talent is grounded in an imaginary of the insular Atlantic that disavows local differences and inscribes an ideal of poetic universalism that is tainted by colonialist ideology. His fantasy of insular space fails to relate to an emerging Atlantic avant-gardism. He overrides de la Torre's intellectual and discursive location, typecasting her and her lived experiences as a parody of dependent island minority in need of European recognition. Yet, de la Torre's simultaneous presence on the periphery and at the center of the cultural moment in 1927 tells an alternative story of Atlantic cosmopolitanism. In *Versos y estampas* visions and vistas are artfully enmeshed in a poetic suite that alters Mallarmé's idealization of a timeless island and projects

instead a material, sensory, and relational experience of insular spacetime. There is nothing particularly exotic in these poems for readers who might have expected to find tourist snapshots or picturesque etchings. The plaza de San Bernardo in poem XV remains an opaque reference to the port city of Las Palmas where de la Torre spent her childhood, and the island she remembers and visualizes is not reconstructed as abstract or "pure" space, but as a sequence of places experienced and imaged from a gendered viewpoint.

Gesturing toward the limits of tropical landscape on the shorescapes of her city, de la Torre speaks back to a genealogy of insular introspection that suggests a change in the exoticist dynamics of symbolist and *postmodernista* aesthetics. Salinas's text reduces de la Torre's avant-garde experiments to a "minor" lyrical register that evades the transcendence of the visionary child in "pure poetry."[50] Like Astree in *La Habanera*, Salinas suffers from an allergic reaction or critical hypersensitivity to insular difference, while de la Torre's early poems affirm the widespread intelligibility of avant-garde experiences that *connect* the archipelagos of Hispanic avant-gardism. Her location on the port city of Las Palmas challenges Salinas's Eurocentric universalism and peninsular angles. The minimal perspectivism of *Versos y estampas* resists the occluding omissions of Salinas's colonialist clichés. It constitutes instead the fearless affirmation of a nascent island gaze, an individual reckoning with the experiences of growing up on the periphery of a distant war, and a remarkable expansion of the limited representational regimes available to women of de la Torre's milieu and generation.

Sensuous Awakening: *Diario de un sol de verano*

Across the narrow stretch that separates the islands of Gran Canaria and Tenerife, Domingo López Torres's life revolves around the port city of Santa Cruz de Tenerife. In his poems, atmospheric scenes and immersive physicality project imagined figures of avant-garde internationalism. The adolescent male gaze at work in these poems disavows regional and colonial stereotyping, and, in surprising ways, López Torres's poetic persona recalls de la Torre's *estampa* of a boy with "flashing eyes" and "tanned face" who "appeared from behind mountains of seashells." But in one of the parenthetical stanzas in poem 23 of Diario de un sol de verano ("Diary of a summer sun"; c. 1929, henceforth *Diario*), López Torres evokes a *learned*, parenthetical point of view: "(I departed spelling out maxims and proverbs / about

the mountains and the learned seas)."[51] His adoption of a radiant and sun-drenched pose reconstructs the island as an experiential reverse of the *Robinson Crusoe* and *Treasure Island* imaginaries. For the young poet is a member of the Spanish Socialist Workers' Party and writes in its weekly, *El Socialista*. Born into a working-class milieu in Santa Cruz de Tenerife, López Torres is an eccentric member of the avant-garde intelligentsia of the Spanish Republic.

In *Diario*, the strength and energy of youth are sunlit and maritime, bursting out rhythmically in fragmentary expressions of summer plenitude. A similar enthusiasm informs López Torres's political journalism and avant-garde criticism, as well as his whole-hearted embrace of continental Surrealism before André Breton visits Tenerife in 1935. The fashionable celebration of a healthy and athletic youth appears frequently in Futurist images, such as: "The sea: stadium / of international professionals, / of dynamic guts" (67); and there are echoes of *popularismo* or *neopopularismo*, a trend within the "generation of 1927" group that Guillermo Díaz Plaja defines as a "return to the popular" in "young Spanish poetry … precisely when poetry seemed bent on the complex spectacle of the feverish life of the city, machines, or war."[52] But *Diario* resonates more closely with Vicente Huidobro's *creacionismo* and Pierre Reverdy's *création* than with Marinetti and Mayakovsky. While attention to multiple referents and models is evident, the solar eye/I attitude mirrors Huidobro's project to write an epic poem that he imagined tentatively in 1919 as *Voyage en parachute* and culminates in *Altazor* (1931): "While the waves turn around / The moon a child of light escapes from the high seas."[53] Fragments of *Altazor* might have inspired López Torres for his choice of an aerial, solar perspective. However, there are no traces in *Diario* of the terrifying downwards spiraling of Huidobro's poem. In a short text titled "Notas: Maiakovsky," published in *El Socialista* on August 17, 1931, López Torres writes: "A time for sincerity and enlightenment. A time for realities. The class struggle is the reality."[54] Identifying with Mayakovsky, the self-taught orphan who had committed suicide in April 1930, he writes: "Henceforth, Mayakovsky, young, poet, and revolutionary, is the poet of the people, the poet of the Russian people's misery, despair and hatred" (110). For López Torres, Mayakovsky, who writes about making "the streets … our brushes and the squares our palettes," is the hero of proletarian art and agitprop tactics.[55] He is a model for an engagement with the everyday that is poetic and visionary, narcissistically inflected, and driven by a commitment to revolutionary politics.

Martin Puchner's observation about the coincidence of Mayakovsky's untimely death with the decline of Russian avant-gardism echoes López Torres's exultation: "Mayakovsky's eventual suicide in 1930 epitomized for many the death of Russian futurism and of the Russian avant-garde more generally."[56] Paradoxically, López Torres portrays the dead Russian avant-gardist as a heroic model for himself and for the youth of the Spanish Republic – an ideal shaped by the utopian values and political aspirations of international Socialism. "Young and strong is his poem 'Youth'," he concludes, citing this text as a kind of manifesto (110). The Republic had been proclaimed on April 14, 1931, three months before López Torres published the Mayakovsky piece, and exactly one year after his suicide. Quoting the German artist and caricaturist George Grosz, "of pure Marxist ideology," López Torres states plainly: "Art is either bourgeois or proletarian" (109). He proceeds to illustrate his radical stand with a more familiar example: "Mayakovsky did not care for Art, for him poetry was accessory, as is painting for Picasso" (110). Writing for the socialist cause and for the cause of the Republic from his port city of Santa Cruz de Tenerife, the young critic expresses a fraternal identification with Mayakovsky when he states:

> The Revolution ignores what it owes Mayakovsky. Mayakovsky placed his strong nature and his youth at the service of the revolution – not as a student youth that only confronts the public powers in politics, but as a lower-class youth who suffers all the weight of a privileged class. His best impulses were tried in the harsh discipline of hatred. (110)

López Torres fetishizes Mayakovsky as a symbol of international revolutionary politics and aesthetic modernity. But his identification with the Russian poet is grounded on a shared dialect of socialist cosmopolitanism – an international language of lyrical fervor and political commitment that combines aesthetic rupture, youthful revolutionary passion, class-consciousness, and anti-bourgeois resentment. López Torres's distinction between "a student youth" and "a lower class youth" resonates with the obvious class differences at the core of the "generation of 1927," made up in José-Carlos Mainer's assessment of "a group of university students from bourgeois families" (Lorca and Alberti), "alumni of Jesuit schools" (Alberti, Dámaso Alonso, and Emilio Prados), and "literature professors" (Alonso, Salinas, Guillén, Cernuda, and Diego).[57] The aesthetic and political divides of the Spanish Republic fractured

the broadly described "generation of 1927" and became an international rift around the First Congress of the Writers' Union, held in Moscow in 1934, and the International Congress for the Defense of Culture that took place in Paris in 1935.[58] For López Torres, writing and activism are practical ways to intervene in what Buck-Morss calls a "politics of conflicting temporalities."[59] As a member of the less than privileged majority of the Republican youth, he builds his littoral poetics around personal experiences of precarity and disadvantage, and hopes for social and political equality in the Islands and across the national territory.

Diario chronicles adolescent games on an island shore. Like *Versos y estampas*, *Diario* often relies on intimate and elemental compositional materials: rocks, sun, and sand; boats and fishermen; and boys and girls. The poems summon vividly remembered spaces of sensation and affect that appear to exist in the off-frame of postcards and tourist catalogs from the period, a great distance from continental Europe. The poetic voice filters experience through a poetic idiom that reflects the fading influence of *ultraísmo* and the currency of *creacionismo*, two avant-gardes that had influenced other poets from the Spanish south, the Andalusians Juan Ramón, Lorca, and Alberti.[60]

The first poem reads deceptively like a celebration of idleness, "Always, always on the beach" (65), describing a dynamic scene of waves and rocks and initiating a series of open-ended fragments. C. B. Morris notes that this poem "announces a physical situation and a primordial scenario made of sky, rocks and stones that underlines the harmony of sky and water, foam and rock."[61] The elements and bodies interlock and disperse in these fragments through an optics of corporeal contact that inscribes the idealized physicality of the late 1920s – a cosmopolitan awareness of elemental nature, and an expansive sensuousness that transcends abjection or prudishness. The poems evoke a new Republican avant-garde attitude of liberation from bourgeois repressiveness that we see in Soviet avant-garde cinema, and in the nudity and erotic playfulness of the Germanic *Jugendkult* (cult of youth).[62] But while the nineteen-year-old López Torres chronicles an adolescence on the beaches around Santa Cruz de Tenerife, *Diario*, as a diary or journal, is primarily a libidinal fantasy of political possibility, not a realist representation of the island. If the elemental simplicity of island life suggests a primitivist version of islandness, *Diario* differs fundamentally from other island "diaries" – a flexible genre that includes travelogues, notes, sketches, notebooks, and artist's books. Gauguin's Tahitian journal,

Noa Noa (1893, 1901), Stevenson's *In the South Seas* (1900), and Ricardo Güiraldes's "journal" of a trip to Jamaica via the Panama Canal in *Xaimaca* (1923) all narrate encounters with islanders and immersions in island spaces. *Diario*, however, celebrates a revolutionary sensuousness of the immediate present.[63]

In *Diario*, island time is bound with a sociohistorical subjectivity that remains alert to myths and tropes of origins but is decisively on the move, nuancing Cohen's understanding of the island as a space of temporal origins: "Island time resets the historical clock to zero."[64] Like de la Torre, López Torres centers occasionally on individual characters: "a boy who never goes to school," "fisher-boys," or "old fishermen" (69, 77); but there are also intricate choreographies that indicate a preoccupation with extra-insular reality. Poem 10, for example, under the epigraph "(*With the German training ship*)," composes a strangely homoerotic scene: "All white like an iceberg, / a frozen-north ice floe." The sailor apprentices are cast negatively as empty and absent: "Hard profile of 'there is not.' / (Lacking in fiery stares / and outlined hips.)" (70); and the view from the shore feels like an aesthetic border: "Frozen distances. / Petrified seas / like in a Dutch painting" (70). By contrast with this northern apparition, a stanza in poem 28 eroticizes the *balandro* (a sloop or sailboat): "In need of beautiful forms / I learned how to model hips / in the curves of a sloop" (81). Elsewhere, in poems 2 and 12, we are invited to participate voyeuristically in playful acts of homoerotic intimacy and fraternity, and in games that involve a sexually ambiguous physicality: "Today, like a brown-skinned fifteen-year-old, I'm rolling with the boys on the beach until they're all golden" (66); "How the boys covered their bodies with algae!" (71).

The last poem, "Landscape with camels," is an ironic *estampa* that reifies an insular interior with Orientalist overtones of local color. Receding from the sun-lit scenes of *Diario*, its introspection signals a potential new direction in López Torres's writing and a transformation in the direction of Surrealism. The pictorial accents of this poem echo the voyeuristic and descriptive intensity of the "German training ship": "There is not enough sun for land / so barren. / Nor sky." The camels move imperceptibly in the distance, as in a slow-motion scene: "Barely passing, passing slowly" (82). The immediacy of the volcanic landscape contrasts with the memory-making focus of *Versos y estampas*. But López Torres, too, reduces physical features to a minimum: "Hollow lava sand" (82). The final couplet forms an enigmatic image: "Camel

eyes / search in the shadows" [*Los ojos de los camellos / buscándose sombra adentro*] (82). This displacement of the act of seeing to a mysterious animal interiority projects an insular space in which scopophilia can be deferred and reoriented. The image's unexpected suggestiveness is perhaps a manifesto in itself – a telling gesture in a field of fluid reflections on the practical possibilities of island avant-gardism. That López Torres published relatively little during his short life suggests that these poems are a kind of intimate diary, not because they were not made for publication, but because of the affective and sensory experiences they evoke. Before he went on to publish reviews of avant-garde and surrealist artists in the local press, López Torres experimented freely in this first collection, absorbing elements from various national and international *ismos*, and sketching an experimental approach to island sensuousness and the littoral sensorium. The adolescent poet who senses the world through his immediate environment is a figure of sensuous awakening and revolutionary hope.

Lettered Island: *Poesía Pura*

The search for what French and Spanish literary histories identify in the mid-1920s as *poésie pure/poesía pura* exceeds the localized expression of a European import. In Cuba, it amounts to possibly the most extensive discussion of the concept beyond Europe. Mariano Brull is the most influential among Cuba's "pure" poets, anticipating a full-blown trend that flourishes across the Hispanic Caribbean in two journals and literary groups, *La poesía sorprendida* (1943–7) in Santo Domingo, and *Orígenes* (1944–56) in Havana.[65] Ricardo Larraga argues that "the 'pure' and the 'black' [*lo 'puro' y lo 'negro'*]" converge in the quest for pure poetry among Cuban avant-gardists, while Klaus Müller-Bergh sees Brull as a nexus between the two main generations of Cuban avant-gardism, the Minoristas of the journal *Revista de Avance* in the 1920s, and the Origenistas that gathered around José Lezama Lima *Orígenes* in the 1940s.[66] Reading Brull's books, *Poemas en menguante* (1928), *Canto redondo* (1934), and *Poëmes* (1939), against the background of Cuban avant-garde politics, this section extends the previous discussion of de la Torre and Salinas to explore the politics of island representation in non-European "pure poetry."

In 1923, "a group of young Cubans" published "Protesta de los Trece" ("Protest of the thirteen"), a patriotic pamphlet denouncing

political corruption and socioeconomic stagnation in the Cuban Republic. Some of the protesters become known as *minoristas* after they publish a manifesto, "Al levar el ancla" ("Lifting the anchor"), in the first issue of *Revista de Avance* (Havana, March 15, 1927); followed by a "Declaración del grupo minorista" in the illustrated magazine *Social* (Havana, May 7, 1927).[67] Black cultural politics occupy Minorista debates around national and cosmopolitan projects and figure often in *Revista de Avance*. Entrenched in resistance to the US-supported regime of President Gerardo Machado (1925–33), the Minoristas broadly embrace *"lo negro"* as a central dimension of their commitment to the aesthetics of modern art, *"el arte nuevo."* While participants and critics differ in their understanding of the Minoristas' racial politics, I locate them in dialogue with the wider frames of Caribbean, inter-American, and trans-Atlantic Black cultures that Brent Edwards calls "black internationalism." Edwards cites "My Mission," an important text by W. E. B. Du Bois, to lay out a perspective that

> means not only tracking the contours of black expression between the world wars, but also accounting for the ways that expression was molded through attempts to appropriate and transform the discourses of internationalism that seemed to center "the destinies of mankind," as Du Bois put it in 1919 – the discourse of international civil society as embodied in the League of Nations, the counter-universalism of proletarian revolution envisioned by the Communist International, and the globe-carving discourse of European colonialism.[68]

As a poet, translator, and diplomat, Brull practices a prestigious form of cosmopolitan universalism that places his literary practice in tension with the politics of "black internationalism" and "counter-universalism." He frequents intellectual and political circles in Europe and translates the French poet and critic Paul Valéry into Spanish. As Pascale Casanova reminds us, "universal capital increases, as Valéry observed, thanks to the activity of the great consecrating translators."[69] By the 1920s, Valéry hardly needs consecrating in the Spanish-speaking world; he is abundantly translated and read in French by Latin American and Spanish intellectuals.[70] Brull, however, enhances his own cultural capital by trading in a universalist discourse of trans-Atlantic *belles-lettres*, an "exchange market" of literary periodicals, musical seasons, lecture tours, and social mixers. This generally elitist "culture without borders" grew from maritime travel, the railway, photography,

and other technologies of mobility and transaction that developed during the long nineteenth century.[71]

Writing at the turn of the twenty-first century, Müller-Bergh proclaimed: "With more than a hundred years of hindsight, we can clearly appreciate that Brull was an ecumenical Cuban who enriched the poetic discourse of the Spanish language within the main current of the thought of his time, with the desire to express in Spanish what had only been said in English, French, and German."[72] This description of Brull as an "ecumenical Cuban" indicates to what extent Cuban attitudes to cosmopolitanism and nationalism have been articulated in critical discourses as opposites that inform colonial, postcolonial, and nationalist debates. When Müller-Bergh evokes "the main current of the thought of [Brull's] time," he refers implicitly to the brand of French universalism that Valéry's renown as a defender of *belles-lettres* came to represent, and to the postwar liberalism of the League of Nations. Yet Brull's status as a member of Cuba's political elite and as an intellectual or *letrado* is not singular, but an example of wider changes within class and institutional politics across an increasingly urbanized and democratic Latin America. Ángel Rama sees this transformation taking place from the turn of the twentieth century until the 1940s and beyond: "Wherever these changes occurred, the new generation of intellectuals – with their confident vision of a future society inspired by modern European models but adapted to local conditions – had set about using their political influence to orient the rest of society." As José Eduardo González explains:

> For the *letrados* to activate the social power that comes from writing, they have to associate themselves with the political power, which in Latin America has been linked to the city since colonial times. In Rama's theory, the city becomes a central entity in shaping the history of Latin America from the conquest to the twentieth century.[73]

Brull combines the figures of the Latin American *letrado* and the cosmopolitan *homme de lettres* that are frequently associated with the social status of a political or diplomatic career.

Oscillating between Madrid and Paris, the two capitals of the "pure poetry" movement, Brull's work bridges the internationalist aesthetics of much of the Cuban avant-garde and the ambivalent disavowal of Black nationalist politics that was also part of that avant-garde. His second book, *Poemas en menguante* ("Waning poems"), appears in Paris in 1928. The following year, the Mexican

writer Alfonso Reyes coins the term *jitanjáfora* in reference to Brull's idiosyncratic use of lexical and phonic experiments.[74] Brull's cosmopolitanism gravitates toward a cultural center that appears to be devoid of ethnic self-reflexiveness, yet his idiosyncratic practice of *poesía pura* participates in the avant-garde experiments of the 1910s and '20s, as his use of *jitanjáfora* indicates. His books of the 1920s and '30s adopt the symbolist and "pure" poetics of Valéry and Juan Ramón; his poems are often atmospheric meditations that recall the latter's *Diario de un poeta recién casado*.[75] He cultivates the formal nuances of traditional Hispanic verse that are broadly associated with Lorca's *Romancero Gitano* (1928) and the Spanish *neopopularista* trend.

A poem in *Poemas en menguante*, "Mi eternidad y el mar" ("My eternity and the sea") mobilizes a field of cosmic referents to dramatize a series of metaphysical subject–object analogies: "My eternity and the sea / My eternity and the star. // My eternity – sea- / child – child-sea: / oh my son! / – Father sea!"[76] In musicality and attitude, the poem evokes works by Juan Ramón, Valéry, and the Spanish mystic Juan de la Cruz, who was influential among the "generation of 1927" and the *Orígenes* and *La poesía sorprendida* circles. Inscribing a primordial poet-world duality, this deceptively simple poem deploys a vertiginous depth of intertextual resonances and tropes (childhood, a disembodied experience of light, the sea) that are grounded in Christian, romantic, and mystical traditions. The interplay of childhood and the elements suggests a luminous timelessness that resonates with the romantic trope of the child-seer in Mallarmé and Valéry.[77]

Another poem, "Ojos niños" ("Infant eyes"), posits infant visuality as a transcendental experience of reality. Through a series of questions, the poetic voice faces "the world" precisely as it appears: "What are those infant eyes saying / about the world that is being born because of them [*del mundo que, por ellos, nace*]? / What is eternal in them, in a light / that is still from yesterday?" Seeing and saying are part of an existential attitude that foreshortens lived experience, reducing it in the last verses to "the eternal gaze [*mirar eterno*] of a dawn / that is already dead in life." A parallel poem, "Old eyes," varies this reflection, playing the obverse of the same paradox: "In the light, already setting / of old eyes ... what far-away proximity [*en qué lejano próximo*] are they entering?"[78] Projecting an experience of visuality at the limit, "Old eyes" evokes abstractly an eternal return of vision and time. In Vicky Lebeau's compelling definition, "the small child tends to be discovered at the limit of

what words can be called upon to tell, or to mean."[79] But the small child is also a sensuous being, as J.-B. Pontalis reflects: "The one we refer to wrongly as speechless – *in-fans* – while in my eyes, these eyes that were once my own, he has access through all his senses ... to an entire world, the sensory world, which is not only that of sensations, but also that of our immediate perceptions ..."[80] The child as *infans* represents a paradoxical locus of enunciation that is uniquely situated to capture the poetic experience that the poet strives to express.

In the 1950s, Cintio Vitier, a member of Lezama Lima's *Orígenes* group, discussed Brull's metaphysics of purity in somewhat psychoanalytical terms: "Mariano Brull's central poetic intuition ... takes place on the eve of reality." This "eve" "is two-faced": on one hand, "epiphany, the pristine and continuous birth of what is"; on the other, "the regressive power of chaos, which incessantly reduces everything to ruins." Vitier conceptualizes Brull's poetics in terms of temporality, defining his "poetic intuition" as a phenomenological structure. Indeed, he identifies a regressive scenario where the poetic persona enters a space of primeval latency "on the eve of reality." He comments further: "The child's gaze necessarily holds a great fascination for Brull. It is the human gaze that is closest to the dawn, the least polluted by the logical and vital *after*, fatally chained to a corrupting fatalism."[81] Vitier's analyses inscribe the fantasy of pure sensuousness in a temporality that we often find in Western projections of virginal (and colonial) islands as archetypes or *loci* of exotic alterity. As Chris Bongie argues:

> As a project, exoticism necessarily presumes that, at some point in the future, what has been lost will be attained "elsewhere," in a realm of ad-venture that bypasses the sort of contemporary present that a symbolic form such as the bildungsroman, by contrast, prepares us for ... Because of this vicious circle that draws the future and the past together, the exoticist project is, from its very beginnings, short-circuited: it can never keep its promise.[82]

Through his masterful use of cosmic symbols and atmospheric spaces, Brull's poems imagine sensory plenitude and articulate a desire for the exoticist promise Bongie identifies – the accomplishment of a messianic perfection that elides *what has been lost*. Encoded in the certainty that "pure poetry" accounts for transcendental experience rather than lived reality, Brull's poems make sense, but not necessarily *Cuban* sense. "Isla de perfil" ("Island in profile"), a poem in

Canto Redondo ("Round song" or "Rounded boulder"), stands out as a meditation on insularity. The first verse reads: "Unharmed, untouched island" (*Ilesa isla intacta*). Of course, Cuba had been not only harmed, but also corrupted by persistent US interventions both before and after the signature of the Platt Amendment of 1901, an addendum to the Cuban Constitution that was written and imposed by the occupying United States. In Ada Ferrer's unironic words:

> They said they would leave once the locals proved themselves capable of self-rule. But as evidence of that capacity they would accept only Cuban endorsement of the Platt Amendment, which (among other things) granted to the United States government the right to intervene in internal Cuban affairs to preserve Cuban independence and to protect, read the text, "life, property, and individual liberty." And so, on May 20, 1902, with the Platt Amendment approved, the Americans left, though they retained the power to return at will.[83]

The alliterations and indexical suggestiveness of the opening verse of "Isla de perfil" resonate with the poem's title: *isla / perfil / ilesa / isla*. Hinting at the trope of the virginal island, the adjectives *ilesa* and *intacta* form a referential circle around the island-sign. For this spectral evocation of the Western imaginaries of maritime expansion and colonialism, Brull relies on lexical and syntactic polysemy. His pure island portrait is the kind of fantasy object that we associate with the French symbolist dreamworlds of Mallarmé and Valéry. The relationship with the material island is obliquely sensory, a distorted rendition of Caribbean tropicality. If we take Cuba to be the material and historical referent of the poem, the "unharmed" island is at best an ironic gesture. The island is invested with an indexical force that only a defamiliarized or depreciated object of the kind we find in Cubist, Cubo-Futurist, and *creacionista* compositions could refract. Brull's oblique recognition of Cuban difference suspends the problematic materiality of the island-nation. His response to a Western imaginary of the tropics eludes bodies, commodities, and stereotypes of the colonial Antilles. He writes as a universal Latin American for whom culture is not an expression of difference, dissidence, or resistance, but an affirmation of pan-European universalism.

In "La liberté de l'esprit" (1939), in a passage that echoes Salinas's prologue to *Versos y estampas*, Valéry observes that "A civilisation is a form of capital ... whose increase may continue for centuries, like that of certain other forms of capital, and

which absorbs into itself its compound interest."[84] Through the deployment of mercantile tropes across modern and historical time, Salinas and Valéry channel a universalist logic of investment, circulation, capital accumulation, and hermeneutic *interest*. Extending this logic, Casanova comments on Valéry's text:

> The immense profit that writers from literarily impoverished spaces have obtained in the past, and still obtain today, from being published and recognized in the major centers – through translation and the prestige conferred by imprints that symbolize literary excellence, the distinction that accompanies a formal introduction of an unknown writer by an internationally renowned author, even the award of literary prizes – supplies evidence of the real effects of literary belief.[85]

Valéry concludes his essay on a note that measures the intensity of the encroaching political hurricane as the Spanish Civil War gives way to World War II: "Perhaps circumstances are too difficult, economic, political, and material circumstances, the state of the nations, interests, nerves, the stormy atmosphere in which we even breathe anxiety. But at least I shall have done my duty by having said it."[86] A similar sense of duty animates Valéry when he prefaces Brull's *Poëmes*, a bilingual collection published in Brussels on September 20, 1939, just weeks after the German invasion of Poland.[87] In the first poem, "Piedra" / "Grèle," hail falls on the ground "with childish glee." Other poems introduce the wind, rain, palm tree, and river. Surprisingly, "Palma Real" / "Palme Royale" condenses the elemental landscape into a powerful evocation of Afro-Cuban rhythm and, one can argue, historical consciousness. With characteristic ambiguity, Brull images the palm tree as a musical instrument and lightning rod that shelters the possibility of cultural polyphony beyond "*lo 'puro' y lo 'negro'*": "The enslaved plant chains a rhythm / of clouds, winds, and rains / to the earth – assonant with rhythms – a string of muted resonance."[88] The palm tree's semantic generosity as living locus of Cuba's physical environment and repository of childhood memory resonates with Derrida's dual notion of the archive as:

> [a concept that] shelters in itself, of course, this memory of the name *arkhē*. But it also shelters itself from this memory which it shelters: which comes down to saying also that it forgets it ... In a way, the term indeed refers, as one would correctly believe, to the *arkhē* in the *physical*, *historical*, or *ontological* sense, which is to say to the originary, the first, the principal, the primitive, in short to the commencement.[89]

Valéry's "Preface" celebrates the "music of the meaning of words" and marvels at "I don't know what force of possible expression, mission and propagation."[90] But Valéry remains elusive about the cultural sources of Brull's universe, perhaps preferring to shelter his own discourse and Brull's poetry from what "force" might mean in Caribbean terms, or what it might mean for Brull, a Cuban poet writing in Spanish. While this omission does not necessarily betray a conscious decision to silence cultural provenance or linguistic difference, it highlights what the literary and visual cultures of the avant-garde period so often reproduce: a generous yet ambivalent inclusion of complicated "others" in transactional discourses of metropolitan universalism. As *Poëmes* comes out, Aimé Césaire's *Cahier d'un retour au pays natal* – a defiantly Afro-Caribbean poem that denounces colonialist notions of ethnic and cultural purity – appears almost simultaneously in Paris. The spiritual and cultural capital that these works by "literarily impoverished" Caribbean poets would eventually accrue in metropolitan exchange markets escapes the logic of Valéry's Eurocentric calculations.

As doyen of Caribbean "pure poetry," Brull embraces an aesthetic ideology that represses its own complicated alignment with the universalist demands of Atlantic colonialism. Brull's commitment to *poesía pura* finds validation in the universalist assumptions that subtend the belief in a transhistorical *Occidente*, an ideology that structures various discourses of *hispanidad* (Hispanicity) and Occidentalism in the 1920s and '30s.[91] His poetic materials outline visions of *the* island, perhaps an image of vaguely primordial Mediterranean resonances, but not the materiality of a Caribbean or Atlantic place. His poetic images compose shimmering still lifes that are the obverse of the colonial island paradise – avant-garde montages of fragmentary sensation that occlude Cuba's political and historical conditions.

Tropical Allergies

The word "allergy" entered European medical lexicons through the German language. It was coined in 1906 by the Viennese pediatrician Clemens von Pirquet, who combined the Greek prefix *allos* (other, different, from elsewhere) with *ergon* (work, activity) to form the German neologism *Allergie*, an extravagant or foreign activity. Hence the expression *allergische Reaktion*, allergic reaction. This chapter opened on the historical perspectivism of *La Habanera*,

a Nazi propaganda film that reached German-speaking audiences during the Spanish Civil War. My discussion of the film interrogated some dimensions of the construction of the Atlantic islands as a scenario of cultural and political antagonisms in the 1927–37 period. I approached the plot, historical context, and production anecdotes of *La Habanera* as a pathogenic atmosphere where the evident outsiders – the contagious and victimized islanders – are cast as cultural allergens, a well-known register of Nazi propaganda films. If allergy is an immune reaction to what organisms perceive as a potential pathogen, then *La Habanera* displays clear signs of an allergic reaction to the atmosphere of tropical excess, archaic social life, and political disorder suggested in the colonial trope of a seasonal fever. On the one hand, the seasonal cycle of an endemic airborne virus mobilizes political and affective reactions that prove uncontrollable for Astree, the main object of sympathy and identification for German audiences. On the other hand, the plot exposes an alarmingly decaying, degenerate, and infectious Caribbean locale and, by extension, a corrupt Puerto Rican elite in need of ideological rectification. Indeed, the fascist film's cultural "sensitivity" constitutes a commitment to geopolitical prophylaxis, a preventative tactic that anticipates not only disease and infection but also potential pathogens lurking in the opaque recesses of an oppressed and pauperized island society. What could this mean for the cultures of avant-gardism that the film elides and this book explores? The Canary Islanders who worked as extras in the film were made to look like vague specimens of Puerto Ricanness. The film stereotypes these extras, and the anonymous characters they play, as diseased and docile; not entirely "savage," but possibly beyond civilizing on account of their ethnic difference (Figure 1.4).

Priscilla Wald's insights on "surveillance and containment" in early twentieth-century New York warrant an analogy, if not a comparison, with Sirk's fictional Puerto Rico. Wald dissects the famous case of "Typhoid Mary" in a context where "undocumented women, immigrants, and carriers, all in their fashion, posed a distinct danger to the reproduction of white America."[92] Astree's immersion in a Hispanic tropical atmosphere shows an initial parodic receptiveness to islandscapes and local color, but she perceives "a distinct danger" to the reproduction of the values of ethnic and technological superiority that ultimately redeem her and her son in the film. *La Habanera* justifies this defensive reaction on the moral and ideological grounds of Schmitt's logic. In this fictional construction of fascist propaganda, local avant-gardism is

an *allos-ergon*, an anomalous and seditious activity that sabotages Schmitt's vision and complicates other defining discourses of the 1920s and '30s that, as we observe in Spengler and Ortega, cannot account critically for the evidence of non-European avant-gardism.

As a microcosm of tropical corruption, the fictional island of *La Habanera* mirrors Schmitt's elaboration in the late 1920s and early '30s of "the concept of the political," the state that results from the fundamental principles of enmity and antagonism.[93] Torn by political antagonisms that exacerbate the islanders' vulnerability, Puerto Rico is a parody of tropical insularity – a disorderly social space where Atlantic genealogies of colonial violence justify representational and political enmity. The corrupt liberal values that constitute Puerto Rico as a colonial appendix of the US empire pose a threat to the scientifically advanced values of the European North. In sum, the Hispanic island's *archaic* social order is oppressive or tyrannical, a sinister reverse of the pure *arkhē* that lures Astree into the depths of island life. Obliquely, the islanders are not only the historical subjects of Spanish colonialism and US occupation, but also the recently defeated partisans and avant-gardists of the Spanish Republic. My discussions of texts from the Canary Islands, Cuba, and Puerto Rico in the next chapter complicate this scenario by turning to Spanish and Caribbean fantasies of a distant Africa, and by examining regressive notions of "the non-European" in Hispanic avant-gardism.

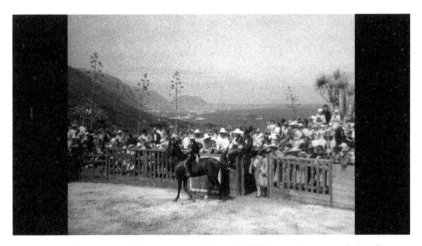

Figure 1.4: The "Puerto Ricans" attending a bullfight at the start of the film are local extras, an example of tropical pastiche and generic Hispanic atmosphere. Douglas Sirk, *La Habanera*, 1937

2
Male Regressions: The Non-Europeans

Minor Hispanists

In Agustín Espinosa's avant-garde text, *Lancelot 28°–7° [Guía integral de una Isla Atlántica]* (1929), Alejo Carpentier's ballet libretto, *El milagro de Anaquillé* (1927), and Antonio S. Pedreira's essay, *Insularismo* (1934), the institutional and cultural discourses of Hispanism enable the configuration of regressive insular attitudes. Known mainly as the author of transgressive avant-garde and surrealist proses, Espinosa was a researcher, teacher, and critic educated at the universities of Granada and Madrid. He collaborated with the influential bi-weekly *La Gaceta Literaria*, directed in Madrid by Ernesto Giménez Caballero, and in the Tenerife-based *Gaceta de Arte* group. A major international figure in Cuban intellectual circles, Carpentier was a journalist, music critic, and writer with strong cultural ties to France and progressive avant-garde circles in Havana. Before *Insularismo*, Pedreira published *Aristas* (1931), *Hostos, ciudadano de América* (1932), and *Bibliografía puertorriqueña* (1932). He was a founding editor of the journal *Índice* (1929–31), and, after 1933, wrote a chronicle, "Aclaraciones y crítica" ("Clarifications and critique"), in the Puerto Rican daily *El Mundo*.

Among Pedreira's contemporaries were several Puerto Rican avant-gardists, including Luis Palés Matos and José I. de Diego Padró. But unlike other "men of letters" of his generation, Pedreira

did not commit to Hispanic avant-gardism. He became Director of the Department of Hispanic Studies at the University of Puerto Rico in 1927, and in 1928–9 met Ángel Valbuena Prat, a peripatetic Spanish academic and critic who was then a visiting professor in Pedreira's department. Valbuena Prat participated in *Hostos*, a "journal of letters, criticism, and social action," where Luis Lloréns Torres, Diego Padró, and Palés published their poems. Having taught at La Laguna in Tenerife in 1926–8, Valbuena Prat must have told Pedreira about his involvement with the *La Rosa de los Vientos* group, and about Espinosa and the avant-garde scene in the Canary Islands. He taught Spanish Literature at Cambridge University in 1933–5.[1]

Hispanism, a unifying ideology that radiates from mainland Spain to the entirety of the Spanish-speaking world, forms an amalgam of discursive ruptures and reactionary gestures. It envisages a renewed post-imperial identity capable of uniting the peoples of the former empire across multiple geographies, national boundaries, and protonational projects. The simultaneously constitutive and disavowing effects of Hispanism cast the former colonies in the Caribbean and the outlying Canary Islands as regressive spaces or, in a developmental sense, *stages* in a logic of geocultural development where *the island* appears often as a varying figure of mythical splendor, primitive immaturity, and premodern deficiency.[2] In this context, what do the gender identifications expressed by Espinosa, Carpentier, and Pedreira suggest about their peripheral positions as insular Hispanists? How do their texts respond to the aesthetico-political demands that characterize Atlantic Hispanism and avant-garde networks during the late 1920s and early 1930s? I will argue that these texts display distinct ways of relating to Hispanism that reveal self-consciously regressive attitudes to the discursive construction of insular locations as "minor" examples of Hispanic literary culture.

In his polemical reading of identity and alterity in Freud, Edward Said elaborates on the notion of "the non-European." Discussing "the problems of the Other" he mentions the Martinican writer Frantz Fanon ("surely Freud's most disputatious heir"), and comments on *The Wretched of the Earth*: "First of all, [Fanon] notes that to the European, the non-European world contains only natives, and 'the veiled women, the palm trees and the camels make up the landscape, the *natural* background to the human presence of the French.'"[3] Invested in the master signifiers of the colonizing West ("European," "the French"), this native "other" would exist as an orbiting attachment and take on the form of a negative adverb.

In the aftermath of the "disaster" of 1898, insular intellectuals traded in evolving varieties of Hispanism. Avant-gardists like Espinosa and Carpentier, and liberal intellectuals like Pedreira, saw themselves as islanded "non-Europeans" who lived in a "non-European world." They were not "only natives," but members of creole elites of mixed European descent. Their texts negotiate the centripetal impulses of the Madrid/Paris axis of institutional Hispanism, illustrating a series of intellectual alliances and ideological tensions around regional and national identities, cultural agency, and insular avant-garde projects. Another aspect of my argument consists in highlighting the constitutive role that geographic and cultural difference play in such negotiations. In other words, what is the place of Africa in these texts? Constructed on multiple levels as a threat to Atlantic versions of Europeanness, Africa appears (and disappears) as a symptom of dangerous cultural and ethnic intimacies, but also as an energizing source and promise for Afro-Caribbean nationhood. Yet the Africa signifier, and the material realities of displaced Africanness in the diaspora, remain difficult to locate in relation to avant-garde practices that are traversed by regressive forms of Hispanism.[4]

My aim in this chapter is to show that scrutinizing the figure of the *regressed* "non-European" in these texts can help us understand differently some of the characteristics of insular avant-gardism in the late 1920s and early 1930s. Espinosa's text, for example, explores *creacionista* images to forge a "modern" myth of the island of Lanzarote in textual composites of the material and imagined island. Carpentier's experimental libretto "transports" Cuban experience to Paris, the world capital of the avant-garde. And Pedreira's essay splinters into multiple "takes," deploying a tropology of imposed minority, colonial dependence, and existential isolation. In these insular texts there is a tension between, on the one hand, the lure of the archaic that lies at the core of distinctions between the tropes of purity and regression, and, on the other, demands for greater modernization and autonomy that ought to reorient the negative adverb of non-Europeanness. While Espinosa and Carpentier can help us investigate the complex semantics of "Africa," Pedreira's disavowal of the Afro-Caribbean present provides an influential example of regressed Hispanism that contrasts with contemporary avant-garde attitudes on both ends of the insular Atlantic.

Pedreira's positions recall a generation of Latin American *letrados* who had come of age in the previous half century propelled by Caribbean patriots like Eugenio María de Hostos and José Martí.[5]

Insularismo derives an occasionally erudite Germanophilia from Ortega and the *Revista de Occidente* circle, as references to Spengler and Keyserling suggest. Spenglerian attitudes, for example, are a salient characteristic of the intellectual climate of the late 1920s and early 1930s, and Pedreira turns repeatedly to images of organic development that can be found in Ortega's essays.[6] Beyond Pedreira's Hispanophilia, his attachment to the moral authority of the historical and philological sciences appears to incline him to doubt the viability of an avant-garde Hispanism. Deprived of political vision, Pedreira's Puerto Rico is suspended between the two symbolic poles of Madrid and Washington, oppressive past and future-facing present. A related opposition between white country folk and *juventud letrada* further illuminates the historical perspective.[7]

The "minority" that situates the non-European status of these texts by Espinosa, Carpentier, and Pedreira as examples of peripheral literature resonates with Deleuze and Guattari's observations around Kafka's literary and personal writings. Yet the insular texts' varying relationships with international (that is, metropolitan) avant-gardism complicate the Deleuzian/Guattarian approach to European "minor" literatures. Tricontinental latitudes express more than a direct cultural dependency on national or continental literatures, if by "tricontinental" we understand in a literal sense geopolitical location in relation to different areas of Africa, Europe, and the Americas.[8] As "non-Europeans" from an insular South, these authors negotiate their ostensible minority through returns to the (is)land and peripheral insertions within available discourses of Hispanism. Tensions between brains and brawn in their appraisals of material realities and uses of avant-garde tactics represent differing approaches to the construction of politico-literary island environments. In all of them, the "non-European" author and his non-European subjects inform the literary imagination of avant-garde and avant-garde-resistant forms of insularity.

In the Hispanic contexts I discuss here, Deleuze and Guattari's "minor" perspective becomes deterritorialized (and creolized) in a long colonial process that Iris Bachmann defines as follows:

> The linguistic phenomenon called creole languages came to prominence as a consequence of European expansion from the fifteenth century. The languages of the European colonial powers generally provide most of the lexicon of these languages, while the affiliation of the grammatical structure has been a hotly debated issue in theories of creole genesis.[9]

Writing from an anthropological angle, Michel-Rolph Trouillot observes:

> Afro-American cultural practices emerged on the edges of the plantations, gnawing at the logic of an imposed order and its daily manifestations of dominance. Filtering in the interstices of the system, they conquered each and every inch of cultural territory they now occupy. In that sense, the plantation was the primary cultural matrix of Afro-American populations. But it was so against the expectations of the masters. It was an imposed context, and quite a rigid one at that, an institution forced upon the slaves but one within which they managed their most formidable accomplishment, that of creating what has indeed become a New World.[10]

As outlying territories of a European power, dependencies of a new hemispheric hegemon, or recently independent nation-states, the islands that are the subject of this chapter (Lanzarote in the Canary Islands, and Cuba and Puerto Rico in the Caribbean) are enclaves and *exclaves* in the Hispanic cultural imagination. As contemporary cultural enclaves, these islands are constituted by a multiplicity of historical processes that involve Indigenous Caribbean, European, African, and Asian protagonists. Their centuries-long associations with those cultural sources draw maps of political control, economic exploitation, and racist infantilization. As exclaves, the islands are dynamic agents of aesthetic and economic transactions with metropolitan Hispanism. And the very notion of Hispanism implies ethnic, religious, and linguistic attachments that carry an implicit sense of historical debt across the Hispanic "family." In this ideological construction, Spain persists as the generous mediator and guardian of an expanded postcolonial community of non-European peoples, cultures, and former subjects. Discussing Marcelino Menéndez Pelayo's *Historia de la poesía hispano-americana* (1911–13), Arcadio Díaz Quiñones argues that, after 1898:

> During the same years when the hegemony of the Antilles and the Philippines was lost, the *beginnings* of a different project were announced in Spain – the renewal of a discursive imperialism in which the poetic archive of the lost colonies turned to reinforcing the value of the metropolis. Menéndez Pelayo's work aspired to producing a totality that had become irreparably fragmented.[11]

The texts I discuss in this chapter can be seen as examples of a fragmented totality of "minor transnationalism," for their location

within Hispanic and European literatures amounts to an ambivalent cosmopolitanism under national and international forms of colonial control.[12] I read this scenario as a form of regression that obstructs local deviations from what Díaz Quiñones sees as "the renewal of a discursive imperialism" that reinforces "the value of the metropolis." Given the gendered character of these texts, my readings will be particularly attentive to symptoms of male regression in constructions of islands as ethnic, political, and historical borders where the Hispanic "non-European" struggles to constitute himself and his excluded others.

"La isla africana": *Lancelot 28°–7°*

On April 1, 1927, an avant-garde group published a "first manifesto" in Tenerife, succinctly titled "Primer manifiesto de *La Rosa de los Vientos*." The journal La Rosa de los Vientos ("The wind rose") (1927–8) rejected modernista poetics and combined universalist rhetoric with a new discourse of insularity that opposed nineteenth-century *regionalismo*: "We are sailors of all the seas, workers of Universality. Forever: Universalism above regionalism."[13] This exalted rhetoric is a period trait, a sublimation of postwar propaganda and forward-looking internationalism that extends into the 1930s. Only two weeks earlier, the Cuban Minoristas had used a similar register in their manifesto, "Al levar el ancla" (Lifting the anchor): "We are sailing to a (mythical, uncertain?) port, an ideal of plenitude; a mirage of citizenship perhaps, of more exacting manliness."[14] While the Minoristas demanded citizenship and "manliness" independent of US intervention in Cuban affairs, the cultural atmosphere in Spain absorbed the military coup and dictatorship of General Miguel Primo de Rivera (1923–30), and the African war, a political event that defined the depressing post-1898 period and affected the Canary Islands in particular ways. As Nigel Townson writes: "In September 1925 the Spanish army, in tandem with the French, defeated the Rif tribes at Alhucemas. A few months later, their leader, the infamous Abd el-Krim, was captured. By July 1927 the war was over." Primo de Rivera's regime not only benefited from victories against the colonial insurrection, but also harnessed popular opinion against Morocco, depicting it as a cultural threat. Townson explains further: "The pacification of Morocco generated such an upsurge in support for the regime that the dictator, despite having promised to rule for just ninety days, was encouraged to

undertake the institutionalization of the regime, starting with the replacement of the Military Directorate by a Civilian Directorate in late 1925."[15]

Writing in this atmosphere of nationalist self-affirmation against the Canarian archipelago's North African neighbor, Espinosa is second in the list of ten male signatories of the "Primer manifiesto," between Juan Manuel Trujillo and Ernesto Pestana Nóbrega. In October 1928, Espinosa took up a teaching position at the Instituto Local de Segunda Enseñanza in the port city of Arrecife on the island of Lanzarote. He explored the island by car and wrote an avant-garde text that he titled, intriguingly, *Lancelot 28°–7° [Guía integral de una Isla Atlántica]* (1929) (henceforth *Lancelot 28°–7°*).[16] A contemporary poet and critic, Ramón Feria, describes *Lancelot 28°–7°* as "the first mythical-geographical contemporary interpretation of the island [*la primera interpretación contemporánea mítico-geográfica de la isla*]. This book breaks with all the previous fake lyricism [*falso lirismo*], and a new assessment of physical and psychological elements emerges."[17] The slim volume is a curious travelogue (for lack of a better word) that to some extent chronicles Espinosa's impressions of Lanzarote, an island that borders the North African coast at the eastern limit of the archipelago. But other displacements and projections inform the text's novel *creacionista* perspective. Combining playful irreverence with intellectual sophistication, Espinosa displays a critical and at times mordant attitude to what Feria calls "falso lirismo." Indeed, *Lancelot 28°–7°* "creates" the island of Lanzarote through a difficult negotiation between the nationalist and fascist avant-gardism of Giménez Caballero in *La Gaceta Literaria*, the liberal cosmopolitanism of *Revista de Occidente*, and the universalist explorations of *La Rosa de los Vientos*.[18]

Nilo Palenzuela writes that *Lancelot 28°–7°* "participates ... in the universalist project of what we have called *creacionismo*'s differential reading."[19] But how does this project mobilize a *creacionista* practice, and what is the text's investment in a "differential reading" of Lanzarote? An opening quote by the Belgian poet Paul Dermée sets the aesthetic tone for *Lancelot 28°–7°*: "To create a work that lives beyond itself and its own life [*fuera de sí, de su propia vida*], that figures on a special sky like an island on the horizon" (3). The spatial note, *fuera de*, is important. The *living* work of art must become islanded within a newly distant perspective. That is Espinosa's vision for a self-consciously *non*-European avant-gardism. The first fragment, a note in italics, combines poetic images

of the island with curious geocultural observations: "Lanzarote is the most eastern island of the Canarian archipelago. An (islanded) piece of Africa. A Moroccan outpost," he writes, before concluding in a striking image: "The horse of Lanzarote faces Africa." Inspired by Cubist and Dada collages that "isolate" and reorient the cultural semantics of the written press, Espinosa uses empirical trivia that evoke European Baedekers: "Salt is its maximum output, at 20,000 tons per annum." The note concludes on a self-reflexive gesture: "On this island, Agustín Espinosa has written a book: a comprehensive guide. Its learned title: *Lancelot, 28°–7°*" (5).[20] A 1911 Baedeker of Mediterranean and Atlantic routes explains that "The Canary Islands ... in 27° 30' to 29° 26' N. lat., and 13° 15' to 18° 2' W. long., lie off the coast of Mauretania, the nearest point being Cape Juby. There are in all thirteen islands, forming a Spanish province of a total area of 3305 sq. M., with a population of 364,000." The guide reduces the eastern islands to these lines:

> In the almost treeless islands of *Lanzarote* and *Fuerteventura* (62 M. to the N.W. of Cape Juby) years sometimes elapse without rainfall, while the dreaded *tiempo del sur*, the hot and extremely dry wind from the Sahara, covers them with dust and sand and often brings swarms of locusts. Even more disastrous for agriculture are the sandy dunes or coast-hills, thrown up by the currents off the African shores, the sand of which is driven inland by violent N. winds.[21]

The tourist guide typecasts these islands as implicitly colonial territories, and orientalizes the archipelago by highlighting an atmospheric contiguity with Africa. But Espinosa's desire to rewrite the island in relation to continental coordinates further complicates the African orientation of Lanzarote, constructing it as a Moroccan outpost through ambiguous references to Spanish and French colonialism.[22] In the opening section, "Lancelot and Lanzarote," Espinosa regrets a dearth of unheroic representations of the island. He complains that "Lanzarote has been explained anecdotally and without affect" (9) to justify the need for a *creacionista* rewriting of the island. "My aim is to create a new Lanzarote. A Lanzarote I've invented. Following the broadest tradition of universal literature." Seeing no contradiction between subjective and "universal" invention, Espinosa focuses on producing a new chorography, a new writing of place: "I substitute the concrete with the abstract. The mold with the module [*módulo*]. The whole with the comprehensive. The object with its sketch. The subject with its essence. The

Island with its poetic chart. Learned. I build the insular geography of Lanzarote" (10). The *módulo*, a small measure or moveable part, affords the production of the author as explorer, cartographer, and privileged broadcaster of a unique viewpoint. This archaic empowerment of the mapper as world-maker echoes Svetlana Alpers's comments on the Dutch "art of describing" as *descriptio*, "one of the most common terms used to designate the mapping enterprise":

> Mapmakers or publishers were referred to as "world describers" and their maps or atlases as the world described ... The aim of Dutch painters was to capture on a surface a great range of knowledge and information about the world. They too employed words with their images. Like the mappers, they made additive works that could not be taken in from a single viewing point.[23]

As an avant-garde maker of "additive works," Espinosa's text complies with Huidobro's requirements in one of his manifestos, "Le Créationnisme" (1925), not to describe from nature, but strictly apart from nature, to construct, invent, or create poetic objects whose claim to universality derives from a capacity to transgress linguistic and cultural borders.[24] Espinosa substitutes Lanzarote, a toponym, with Lancelot, a *learned* name with Arthurian resonances, thus suggesting the "universal" character of the project. He then imagines how the mythical knight sails across the Atlantic to reach the "*isla africana*": "For Lancelot, the African island was South [*Mediodía*] and Orient at once. This suited his adventurous appetite. The historical and geographic supplement to his West and North. His hall of senectitude as well ... It was also, perhaps, his island of penance" (11). In passages like this, a logic of disorientation explains the island for the hypothetical visitor. Mediodía or Levant *and* Orient (South and East), the African island complements an originary West *and* North prosthetically (historically and geographically).

Espinosa supplements the North African coordinates with ideological gestures that locate the island on a map of colonial ambivalence. His claims that the book is a "*guía integral*" and "*mapa poético*" betray an evident anxiety around the geopolitics of Spanish and European colonialism that resonate with Susan Martin-Márquez's notion of *disorientation*.[25] Espinosa's silence on the European conquest and colonization of the Americas is eloquent, given the direct implication of the Canary Islands in this process and in Spain's imperialist ambitions for Africa. This

attitude reflects perhaps a generational discomfort with the cultural legacies of *regionalismo* and *modernismo* that the *La Rosa de los Vientos* group views as reactionary. But in this discursive allergy, avant-garde discourse veers towards a fantasy of postwar cosmopolitanism that de-historicizes peripheral cultural experiences. Although *Lancelot 28°–7°* displaces colonial violence onto the quasi-mythical domain of "universal literature," it struggles to fully repress a troubling colonial past (and present), of Castilian dominance, Atlantic expansion, and African subjugation. This calculated amnesia requires a select redeployment of island symbols and material referents.

Several *creacionista* images of the island structure the book. They are featured in short sections and occasionally are occasionally introduced by the word *"elogio"* (praise), in a running Unamunian reflection on the noble hardships of agricultural work on the volcanic island. They are interspersed with historical allusions and chosen places – Nazaret, Ye, Mozaga, Tinajo, Tao, Teguise, Puerto de Naos, Janubio, and Arrecife. Each image relates to an external object, attribute, or atmospheric element. One of these images, the plowing camel, looks like a "retired general": "How handsome you are, camel from Lanzarote! You are, without a plow, the ugliest among animals! For you are ugly, and nakedness is more apparent in you than in any other animal." The camel, however, is also a New York film star, a ludicrous transformation that humorously balances peasant life with a patina of urban modernity: "You would work with Buster Keaton and Mary Pickford, with Charlie Chaplin and Harold Lloyd" (21).[26]

"In praise of the windswept palm tree" (37–9) presents the striking plant (*Phoenix canariensis*) as a metaphorical epiphany. Espinosa skirts the conventional exoticism of the African species as a generous fruit-giver and food-provider to exploit the modernity of its material aspect: "You let your green arms turn in the wind. You exert pure sportsmanship. You are – today – the only propeller, the only carousel" (39). Another fragment, "In praise of the sunny cistern" (57–9), resembles a "pure" prose poem: "There you are, sun-drenched Lanzarote cistern, next to the palm tree turning its arms, next to the camel drawing the plow – on the comprehensive chart of an island of moorlands, trade winds, and sun" (59). This symbol of the notorious difficulties of managing water on the island complements other earth symbols, the gyrating palm tree and plowing camel. But while Espinosa humanizes the working camel, in so doing he appears to forget the *lanzaroteños* or *conejeros*, the

islanders who attract little aesthetic or historical commentary in the text.

A ubiquitous presence in the eastern Canary Islands, the wind provides an interpretive clue to the textual assemblage. It blows into Espinosa's hotel room in Arrecife and playfully disorganizes his papers: "Enter through the ajar window of room no. 5 at Hotel Oriental in Arrecife and conduct the ballet of sheets on which Agustín Espinosa writes about your sorrowful values" (36). The wind allegorizes a connection between Canarian literary tradition and avant-garde literature. Like the camel and the palm tree, it is a metonym for the activities of young insular avant-gardists and Espinosa's alter ego: "The Lanzarote wind has a winning summer track for the great Africa-Canaries long jump" (35). But in "Wind biology in Lanzarote" (31–6), *biology* denotes the intellectual climate of the Germanophilic 1920s, the period when Ortega supports the publication in Spanish translation of works on biology and other scientific disciplines by Jacob von Uexküll and Leo Frobenius in *El Sol*, *Revista de Occidente*, and different book series. Citing the circulation of the ideas of Lamarck, Darwin, Marx, and Engels, Jorge Aguiar Gil observes that, "in Spain, from the second half of the nineteenth century, the use of the biological analogy became one of the most common literary devices in the fields of thought and art ... Thinkers like Spengler, Unamuno, and Ortega ... favoured the biological analogy to express their ideas."[27] Strangely associated with a non-living being or entity, biology interpellates rhetoric and tradition; atmospheric phenomena that, like the wind, occur around the island. In a Homeric sense, as Espinosa explains in a critical reflection: "The wind in Lanzarote is a strictly seafaring hero. Its action area lies exclusively above the sea. This phenomenon coincides with Canarian lyric, according to the fortunate teachings of Valbuena Prat – the first rigorous theoretician of our poetry" (35).

Through these playful distortions of geography and biology, Espinosa reflects on contemporary *Stimmung*, a perceptive response to the aesthetic climate or "tone" that is encoded in the situatedness, materiality, and formatting of imaginative texts. Hans Ulrich Gumbrecht posits *Stimmung* as a reading practice in opposition to a practice of representation: "'Reading for *Stimmung*' always means paying attention to the textual dimension of the forms that envelop us and our bodies as a physical reality – something that can catalyze inner feelings without matters of representation necessarily being involved."[28] In *Lancelot 28°–7°*, the notions of

geography and biology function as ironic engagements with the perceived scientific and discursive authoritativeness of European *Stimmung*. The simultaneous montage of an "integral guide" and an "integral map" of the island transforms contemporary scientific discourse into Cubist humor, Futurist hyperbole, and *creacionista* self-awareness. By exploring these changing metaphorical conditions, Espinosa reacts to a political climate on edge, an intellectual enterprise that is prompted in part by his personal circumstances of near-exile. In *Lancelot 28°–7°*, the *Stimmung* of these varying atmospheric conditions dovetails with numerous references to the Orient. In *Orientalism* (1978), Said explains that, "strictly speaking, Orientalism is a field of learned study." He contends that "any account of Orientalism would have to consider not only the professional Orientalist and his work but also the very notion of a field of study based on a geographical, cultural, linguistic, and ethnic unit called the Orient."[29] The Orient's borders are contentious and contingent, yet the cultural logic of epistemic erasure, exploitation, and reconfiguration persists in the definition. However, Said writes:

> Neither imperialism nor colonialism is a simple fact of accumulation and acquisition. Both are supported and perhaps even impelled by impressive ideological formations that include notions that certain territories and people *require* and beseech domination, as well as forms of knowledge affiliated with domination: the vocabulary of classic nineteenth-century imperial culture is plentiful with words and concepts like "inferior" or "subject races," "subordinate peoples," "dependency," "expansion," and "authority."[30]

Martin-Márquez discusses "the unique positioning of Spaniards within Orientalist discourse ... Although Orientalism is of fundamental importance to the modern trajectory of identity formations in Spain, there is surprisingly little precedent for the reading of Spanish cultural practices and texts through this particular theoretical lens." Addressing the pre-modern and modern location of Spain regarding its "others," she argues that "Spain is a nation that is at once Orientalized and Orientalizing. The dynamic resembles a Möbius strip, calling into question the possibility of any location 'outside' Orientalist discourse. For Spaniards, this positioning on both 'sides' of Orientalism – as simultaneously 'self' and 'other' – may bring about a profound sense of 'disorientation'."[31] Espinosa's project mobilizes cultural, geopolitical, and historical "disorientation" astutely, exploiting a self-exoticist imaginary of the African *and*

Southern European archipelago that reflects colonial genealogies of adventure and travel literature, cultural hybridity, and ethnic miscegenation. But more complicated than the ambiguous location of Lanzarote on an Afro-Atlantic border zone is the articulation of a universalist perspective with the material realities of the Islands as military outposts of the Spanish colonial enterprise in Morocco.

Like Prospero in *The Tempest*, Lancelot reads books and brings the knowledge and cultural practices of Brittany to the island, but, unlike Shakespeare's play, *Lancelot 28°–7°* does not reflect on the different sensibilities afforded by Miranda, Ariel, and Caliban. Indeed, there are few traces of ethnic and cultural differences. For a text that explores the mythical expansion of Northern Europe in the Atlantic, the literal spaces of colonial violence are remarkably absent, as if they had been evacuated from the domains of learned inventiveness and "universal literature." *Lancelot 28°–7°* sublimates the historical record, inscribing cultural encounter and colonialism only marginally through Orientalist accents and oblique references to Africa, Morocco, and the Orient. Espinosa's interest in the insular eighteenth century may account in part for this amnesia. In "Teguise and Clavijo y Fajardo," he lectures on the marveled rediscovery of José Clavijo y Fajardo and José de Viera y Clavijo, two Enlightenment authors who became important referents among local avant-gardists. Espinosa had written a dissertation on Clavijo y Fajardo, a cosmopolitan writer whose ties with Lanzarote dissolved after he left his native Teguise for Las Palmas and Madrid. Unlike Valbuena Prat, author of *Historia de la poesía canaria* (1937), Espinosa does not seek to systematize the literary history of the Canary Islands. Indeed, the hero of *Lancelot 28°–7°* interprets "universal literature" from a position of insular solitude. In a bewildering accumulation of geohistorical and cultural referents, the narrator invites us to travel down literary routes, not to decipher them:

> Isola-tion [*a-isla-miento*] made him a hurried reader of Virgil and Homer; of Lucan and Apollonius of Rhodes. These authors were requested centuries later by another great oceanic isola-ted: the Napoleon of Saint Helena: a pure-lineage Lancelotic hero: son of the octogenarian Lancelot, drunk with epic, from another African island in the Atlantic. (13)

The juxtaposition of Lancelot, Napoleon, and Espinosa forms an all-male *creacionista* alignment, an epistemic montage of Arthurian

and French, Hispanic and Canarian, Atlantic and Mediterranean expansions and settlements. In "Epic muse," Lancelot transforms Lanzarote into a phantasmagoria of literary references that recalls Prospero's demiurgic activities in *The Tempest*: "On his African island, Lancelot read large volumes of ancient adventures ... Thus, Lancelot Homerized and Mediterraneanized his island. Another stage. The last one for him. The one where one boards the death coach" (15). The African island is a remote outpost in an Odyssean narrative of European expansion, a cultural extension of "universal literature" that stretches out from northern France to the Mediterranean and the subtropical Atlantic.

Espinosa's philological attention to Lanzarote's toponyms separates the mythical and universalist island from the material present. Place names pepper the text, combining pre-Hispanic and colonial traces, but the islanders figure only anecdotally in the rather deserted map. Their mythic presence is felt in indirect references to villages, architectural oddities, and poetic evocations: "Lanzarote turned its fields into steppes to force its people onto the sea" (69). Rather than compose individual or group portraits, *Lancelot 28°–7°* investigates the island's cinematic and archaic components. In a few generic sketches of islanders, "some workers" (36) and "the men of the Island" (102), the narrator poses in turn as eighteenth-century antiquarian, nineteenth-century folklorist, and twentieth-century ethnographer. Unlike Lorca's construction of *lo mitológico gitano* (Romani legends), *Lancelot 28°–7°* mythologizes a selection of spatial, historical, and cultural traits but omits the inhabitants, who effectively disappear from the text yet remain as spectral dwellers of the volcanic island.[32] This textual vagueness obscures the harsh realities of squalor and immigration to the Americas in the decades that follow the Spanish-American war of 1898, the high numbers of fugitives and deserters from compulsory military service during the African war, the forced levies and Canarian opposition to that war, and popular repudiation of the massacre of Indigenous and other *rifeños*, the people of the Rif.[33]

In *Lancelot 28°–7°* the trope of the subtropical island garden re-emerges obliquely in the image of a decayed island tomb, a silent volcanic monument that elides but only partially forgets the "Desastre de Annual" and other memories of colonial trauma. Geography and biology are not the sciences that study Lanzarote and measure its isolation from continents. Instead, in Espinosa's *creacionista* poetics of space, metropolitan discourses bind the Canary Islands with the North Africa of Spanish and French

colonialisms, providing a composite or "integral" panorama, and editing out politically complicated materials. Espinosa's aesthetic quest forecloses any serious confrontation with the lived realities of the *lanzaroteños*, the abstract islanders that *Lancelot 28°–7°* constructs as isolated and silent others. There are neither individuals nor communities here, only a barren silence that resists incorporation into the poetics of *creacionismo* yet defines the limits of Espinosa's avant-garde practice by its selective erasure or inclusion "by means of an exclusion," in Giorgio Agamben's words. If, to evoke Agamben's much-discussed formulation, theirs is a form of *nuda vita* (bare life), we can ask with him "why Western politics [and the politics of the non-European avant-garde text] first constitutes itself through an exclusion (which is simultaneously an inclusion) of bare life. What is the relation between politics and life, if life presents itself as what is included by means of an exclusion?"[34] In *Lancelot 28°–7°*, the same aesthetico-political regime that authorizes Espinosa as a non-European example of *homo sacer* insinuates itself in the form of an unheard, unseen, and evicted island population. Is it excessive to claim that Espinosa (dis)figures this biopolitical witness, and in so doing forges a disposable obstacle to his aesthetic project? The following section turns to a different form of avant-garde relation with Africa in *El milagro de Anaquillé*, a ballet libretto that mobilizes cultural difference to perform playful acts of anticolonial resistance.

Staging the Banana Wars: *El milagro de Anaquillé*

In 1921, the Spanish poet and critic Jorge Guillén published two pieces, "Negritos" and "Más negritos," two of his weekly Parisian chronicles for the Madrid progressive daily *La Libertad*.[35] A champion of *poesía pura* in Spain, Guillén lectured in Spanish literature at the Sorbonne from 1917 to 1923; he figured in the "generation of 1927" group and produced a vast poetic cycle, *Cántico* (1928–81). In "Negritos," describing a performance by the "American Southern Syncopated Orchestra" at the Théâtre des Champs Élysées, he laments: "Poor Blacks [*pobres negros*] who enter civilization through that nocturnal little door lit by the moonlight!" (72). Guillén explains the presence of "poor Blacks" on the Paris stage as a contemporary trend: "Today's poets, musicians, and painters invoke black art [*arte negro*] as a source of renewal" (69). Characterizing *arte negro* as a parody of authentic

Black culture, the chronicles capture Guillén's ambivalent status as a cultural interpreter who watches others watch. His observations underscore his critical role as a foreign observer of frivolous Parisian performances, but the trope of racial difference as lack permeates his coverage of Parisian *variétés*. He describes the forced performance with the intellectual irony and moral superiority of someone who knows Cuba's place in the world. In his text, the word "negro" (and its diminutive, "negrito") has no emancipatory force, but is inflected with the traits of a cultural devaluation. "Negrito," in particular, carries colonial and racist connotations that are particular to Spanish and European imperialism in Asia. As Sandra Khor Manickam explains,

> The terms "Negrito" or "Negrillo" were first applied by Spanish missionaries who came to the Philippines to apparently small(er) statured and dark(er) peoples on those islands in the seventeenth century … These terms were copied and used by other European travellers and colonial officers in Southeast Asia to label various peoples considered to be small(er) and dark(er) compared to other people thought to be more widespread on the islands of Southeast Asia such as the Malays.[36]

The characters Guillén describes are "wretched" [*infelices*], and, in an analogy that reveals a "realistic" (though largely outdated) understanding of Caribbean race relations, he compares them to "hunchbacks." At the end of the chronicle, he returns to a register of sober paternalism: "Let's hope, let's hope, little Blacks [*Ojalá, ojalá, negritos*], that one of yours, a poet from your race, will one day teach you to sing something like: 'Damned, damned the one who took off our paint! Damn the one who whitened us!'" (72). In the follow-up piece that bears the ironic title "Más negritos," Guillén's attitude to Black avant-gardism is amused and condescending: "Therefore, it is logical that current avant-garde art, so friendly with Black art [*tan amigo del arte negro*], eventually results in comic, puppet theater vulgarity – the most childish mechanical materialization" (76). This reactionary dismissal could have targeted other artistic expressions of the immediate postwar period, if we change "negro" and "*arte negro*" to "Dada" and "surrealist."

The conflation of avant-garde art and *arte negro* as puerile and "mechanical" echoes Ortega's narrowly rationalist critique of European avant-gardism – a phenomenon that privileges artificial and material invention over the human element in art and expresses a crisis at the heart of European civilization. In *La deshumanización*

del arte (*The Dehumanization of Art*) (1925), Ortega states that "the new sensibility pretends to feel a suspect sympathy towards the most temporally and spatially remote art, prehistorical and primitive exoticism. In truth, more than the works themselves, what it finds satisfying in these primeval works is their *simplicity*, that is, the absence of a tradition that is yet to be formed."[37] Guillén's chronicles are intended for a public that can measure the distances separating Paris *nouveautés* from a self-contained image of Spain, a country that still aspires (and generally fails) to project a hegemonic sphere of influence across its former domains through the reactionary discourses of *hispanidad* or Hispanicity.[38] In the two previous decades Spain had struggled to readjust its political and cultural compass to navigate a new geopolitics of territorial loss and colonial nostalgia, as images of Cubans, Puerto Ricans, Filipinos, Guineans, Moroccans, and Canarians became increasingly obsolete.

In Cuba, Machado's dictatorship, also known as the *Machadato*, determined the fate of a young avant-garde critic and journalist, Alejo Carpentier. After signing up as one of the editors of the journal *Revista de Avance* in March 1927, Carpentier was arrested and jailed for forty days. He traveled to France in a legendary escape that involved borrowing a French passport and impersonating a French citizen – fellow journalist and surrealist Robert Desnos. From 1928 to 1939 Carpentier wired numerous Parisian chronicles to two illustrated magazines in Havana, the weekly *Carteles* and the monthly *Social*.[39] Guillén and Carpentier seek to satisfy educated Spanish and Cuban readerships avidly interested in Parisian and European novelties. But while Guillén's comments appear detached and sometimes cynical, Carpentier's are emotional and stylized. In a 1928 chronicle, "The confirmation of our rhythms," Carpentier writes: "What could be more current in Paris these days than the sudden, almost unexpected vogue of Cuban music? One only hears – with regard to frivolous matters – about *son*, *rumba* and Moisés Simons. After taking over the *dancings* and *music-halls* stages, our dances are entering popular dances."[40]

Where Guillén laments the superficiality of Black performances, Carpentier's tone is ecstatic; his position as an observer is underlined by an enthusiastic implication in the Afro-Cuban performances he attends: "Thunderous applause marked the logical culmination of a night that might be recalled in the future as a key date in the history of Cuba's popular music." While Guillén worries that this avant-garde "fashion" is a symptom of European cultural decadence, Carpentier celebrates national projections of colonial

Cuba on the international stage and envisions a bright future for Cuban popular performances in Paris. He concludes: "A great week for our rhythms" (216). In his role as a cultural critic, Carpentier witnessed the emergence of modern and popular images of the Republic of Cuba in the cultural life of France's capital. He had met the French-born, Cuban-Spanish composer Amadeo Roldán in Havana in the early 1920s, an encounter that marked his attitudes to Afro-Cuban and other Black cultural expressions in music and performance. As Robin Moore remarks,

> Roldán's interest in Afrocuban subject matter dates from approximately 1923. At this time he began to frequent *santería* and *abakuá* ceremonies with Carpentier, where he hand-transcribed melodic and rhythmic fragments later used in compositions ... Roldán's upbringing and studies abroad seem to have led to a greater willingness to investigate Afrocuban subject matter than was demonstrated by his colleagues. Experience in other countries allowed Roldán to view Cuban social interactions from a new perspective and to address subjects that had rarely been studied or even discussed previously.[41]

By the mid-1920s, Afro-Cuban avant-gardism found inspiration in two metropolitan poles, Harlem in New York, and Montmartre in Paris. David Luis-Brown contextualizes the period in these terms: "The U.S. domination of the sugar industry and its willingness to use military force against Cuba are main ingredients in representations of the political scene in negrismo [sic]. But negrismo also insisted that the problem of neocolonialism was matched by the particular oppressions endured by Afro-Cubans."[42] However, as Emily Maguire notes: "While Afro-Cuban culture was in a position to contribute significantly to the idea of Cubanness being constructed by the island's intellectuals, it was also a problematic, stigmatized element."[43] Indeed, in Cuban and international contexts, Black cultural practices are often subjected to vaguely ethnographic and overtly racist interpretations. Carpentier, for his part, reported frequently from Paris on events that included Cuban musicians and artists. Roldán had moved to Havana in 1919, and his *Obertura sobre temas cubanos* (1925) had a powerful impact on Carpentier. Between 1928 and 1932 Carpentier collaborated with other young composers, the Cuban Alejandro García Caturla, the Brazilian Heitor Villa-Lobos, and the Paris-based Darius Milhaud and Marius-François Gaillard. Carpentier recalled: "That time was marked by a great interest for Afro-Cuban folklore, which had been

recently discovered by the intellectuals of my generation."[44] While some of these intellectuals and musicians were members or sympathizers of the Minorista group and *Revista de Avance*, Afro-Cuban discourse developed substantially in response to the work of Cuban criminologist and ethnographer Fernando Ortiz. Ortiz's work responded in turn to genealogies of *fin-de-siècle* decadence and criminal violence, around what Stephan Palmié calls "Lombrosian criminal anthropology":

> Pioneered in the Americas by the Brazilian Raimundo Nina Rodrigues, and popularized in Cuba in the early work of Fernando Ortiz, theories proclaiming a positivistic solution to the racial and cultural problems impeding Cuba's national progress centered on analogies between Lombroso's conceptions of individual atavism and the collective attribution of deficient moral evolution to members of "lower races."[45]

Ortiz's ethnographic studies of Afro-Cuban social deviation and "folklore" informed the Minoristas' interest in Black culture and cultural politics. His work furnished the group with an authoritative scientific perspective on contemporary social problems, aesthetic avant-gardism, and the struggle for political transformation. Carpentier wrote several Afro-Cuban poems and librettos for ballets in the exploratory years of his involvement with *Revista de Avance*, before the publication of his first novel, *¡Écue-Yamba-Ó!* (1933).[46] These texts build on popular Afro-Cuban music and performance genres, and on the visual imaginaries of different nineteenth-century moments at the height of slavery in the Cuban plantation complex. They recuperate the national imaginary of the *guajiro* or peasant, responding to US imperialism in the first decades of the twentieth century, and reflecting on the intersection of sugar and film technologies in the case of *El milagro de Anaquillé*.

There is a strong sense of the burlesque *teatro bufo* in this text, a tradition that Robin Moore sees as "the most popular genre of nineteenth-century Cuban stage entertainment." By the late 1860s, "the phenomenal appeal of blackface ... seems to have resulted from the fact that they incorporated local customs, singing, and dancing that defined the genre as Cuban rather than Spanish. Blackface characters continued to be buffoons, but many audience members also read them as symbolic representations of the Cuban people."[47] Reviving theatrical elements and tropes from this tradition selectively, Carpentier's librettos for ballet feature music and dance performances as a means of investigating Afro-Cuban

sensuousness through an ethnographic lens; a discursive strategy that ultimately seeks to stage a politics of Afro-Cuban consciousness, a horizon of political emancipation in the age of US pan-Caribbean imperialism known as "the banana wars."[48] Clearly, the aesthetico-political potential of Afro-Cuban performances inflects avant-garde production in different ways. But I choose to approach "early Carpentier" texts here and in my discussions of ¡Écue-Yamba-Ó! in Chapter 4 by questioning the effects of cultural translation, the discursive intervals separating the lived realities of "minor" and excluded communities from their aestheticization in texts by generally privileged male avant-gardists.

In this context, does Carpentier's performance experiment amount to the promise of a political future beyond nineteenth-century *costumbrismo*? While his engagement with the national myth of archaic insularity seeks to enable a new Afro-Cuban politics, to what extent would that political horizon expand beyond an aesthetics of cultural appropriation? To begin to answer these questions, I now turn to issues of set and place in *El milagro de Anaquillé*. The *mise-en-scène* is carefully built around the familiar cultural icons and rich visual archives of Cuban *costumbrismo*. It is largely inspired by the influential works of two well-known mid-nineteenth-century artists, Víctor Patricio de Landaluze's *paisajes criollos*, and Pierre Toussaint Frédéric Mialhe's scenic tropicalizations of sugar plantations in *Isla de Cuba pintoresca* and *Viage pintoresco al rededor de la Isla de Cuba*.[49] The central motif in the ballet is the feast of the Día de Reyes, the celebration of the Epiphany on January 6 in the Catholic calendar, when Black Cubans of different backgrounds receive a special license to parade in an atmosphere of Carnival, performing ritual dances, singing, and playing Afro-Caribbean musical instruments. Carpentier and Roldán found inspiration for *El milagro de Anaquillé* and another seriocomic ballet libretto, *La Rebambaramba* (1928), in "Día de Reyes," a lithograph from Mialhe's *Viage pintoresco* that features four dancing *diablitos* (little devils), musicians, dancers, and onlookers; and possibly also in an article by Ortiz, "La fiesta afrocubana del *Día de Reyes*."[50] Predictably, the backdrop of a Landaluzean *paisaje criollo* stands for rural Cuba:

> Behind, as a kind of vegetation barrier, the steady line of a cane field occupies the entire width of the stage. A few isolated palm trees, almost equidistant from each other. In the distant background, the geometric mass of a Sugar Mill, a building that can be superimposed and almost

hidden on a slope, but whose three chimneys, very exaggerated and covered in thick black letters, disappear into the stage ceiling. (271–2)

A grotesque caricature of a "Business Man" arrives in a Cuban village on a mission to transform the rural enclave into a profitable commercial hub. Carrying "over his shoulder, a folded movie camera tripod, like a rifle" (272), he turns poor peasant *bohíos* (huts) into shops and promptly overwrites local culture. Concealing an image of San Lázaro that hangs outside the Iyamba's hut, he insults the orisha Babalú Ayé, the Yoruba god in charge of healing and protecting the land. In the "Glosario" included at the end of *¡Écue-Yamba-Ó!*, Carpentier defines the word "Iyamba" as a prominent *ñáñigo* leader [*Uno de los jefes máximos en las agrupaciones ñáñigas*], while Babalú Ayé (or Babayú-Ayé) is an "Afro-Cuban medical deity represented in altars by the image of San Lázaro." The *diablito* that appears later in the ballet is "a male dancer dressed in picturesque costume in *ñáñigo* ceremonies. His ritual role resembles that of a sacristan," and the *Jimaguas* who kill the Businessman in the final scene are "twin deities of Afro-Cuban witchcraft [*Divinidades mellizas de la brujería afrocubana*] represented in altars by two identical wooden dolls, their necks linked by a piece of rope or twine."[51] Maguire explains that, "while the term *ñáñigo* was often used in the nineteenth and early twentieth centuries to refer to any kind of Afro-Cuban initiate, particularly one engaged in casting spells, the term refers more specifically to members of the Abakuá order, an all-male religious society composed primarily of Africans from Efik peoples and their descendants."[52] The stage directions mention two *bohíos* on the foreground, the *guajiro's* and the Iyamba's. In these notes, a stereotypical image of rural Cuba is cut out and projected through an avant-garde choreography that includes *guajiro* and Black characters. While the Iyamba's *bohío* has a "real" door, the *guajiro* hut is a flat *trompe l'œil*.[53]

Aiming to "cast" the group of *guajiros* in a film, the Businessman treats them with an arrogant crudeness that denotes a slave auction: "The BUSINESSMAN inspects the premises. He takes a close look at the *guajiros* as if they were purebred horses. He feels their muscles" (273). A "*Yankee* sailor" and a "Flapper" that accompany the Businessman perform the first dance to the sound of a "*black bottom*" tune. The Businessman builds a skyscraper and films the "Marinero" and "Flapper" disguised as Spaniards, wearing "a *peineta*, a *mantilla* and a Manila shawl"; and "a *muleta*, a cape and a bullfighter's hat" (274). Against this backdrop, a group

of "folkloric" *guajiros* are handed tambourines and play along, "completely frightened" (274). These consecutive displays of *black bottom* and *andalucismo* merge what Luisa Campuzano calls the "Mérimée syndrome" or "Spanish fashion" with jazz-age dance styles.[54] Led by the Iyamba, a group of Black laborers enters "as if they were the only ones on stage" (274) and spoils the Businessman's shoot. The Iyamba strips his hut of the Businessman's posters and unveils the image of Babalú Ayé / San Lázaro.

In a parallel action, while the *diablito* dances frantically in and out of the Iyamba's *bohío*, assisting him with preparations for a ceremony, the Businessman improvises a new scene: "He dresses the SAILOR with a tiger skin and several necklaces. He disguises the FLAPPER as a Hawaiian dancer, places flowers on her hair and raffia grass skirt. He asks them to join the group of the faithful. He gets ready to print a new movie" (276). This parody of a *mise-en-scène* foregrounds the scandal of colonial pastiche, cultural appropriation, and ethnographic intrusion. The scene complicates the story by introducing the conceit of the play within the play, a *mise-en-abyme* that encapsulates the constructed character of colonial representations of "otherness" and ethnographic accounts of "authentic" others. By contrast, as the Black dancers perform the Afro-Caribbean island choreographically, they embody a potentially insurgent Cubanness. By inserting the cinematographer on stage, Carpentier suggests how US colonial interference produces cultural differences in Cuba and, by extension, other Caribbean contexts.

The use of the camera tripod as a weapon stages a further critique of colonialism. When "the Sailor" and "the Flapper" attempt to enter the social space of an Afro-Cuban ritual, the Black laborers resist their advance "with angry gestures." When the Businessman wields the tripod "like a spear, approaching the group with signs of threatening authority" and uses the object to destroy the ritual altar, the Iyamba and *diablito* confront the violent intruder with magic. Thus, the voyeuristic curiosity that pervades *El milagro de Anaquillé* excites our desire to enter the secret depths of Afro-Cuban ritual through the only open door. The ballet's eight scenes build up to a performative space of insurrection, culminating on a symbolic defeat of the capitalist colonizers when the supernatural *Jimaguas* strangle the Businessman with the rope that ties them together.

As Carpentier designs the cultural atmosphere of these Caribbean scenes, he intends to intervene in a Parisian context that is accented with simultaneous attitudes of modernist transgression, primitivist

simplification, and racist ideology. While Paris sets aesthetic norms, Carpentier's performance sets out to tropicalize Parisian audiences and chroniclers. But there is no irony in this game of projections, despite the complex intersection of burlesque and *costumbrista* detail, cosmopolitan pastiche, and references to cinema and ethnography. Instead, the colonialist intruder's death satisfies a voyeuristic fantasy of cosmopolitan self-justification: *he* is being punished while *we* watch. While potential metropolitan audiences (and twentieth-century readers) may enjoy a spectacle of parody and primitive magic that resists US imperialism, they might equally appreciate the broad necessity of colonial self-interest and intervention. As Jean Franco comments, "'Magic' and lore detached from religious roots were deterritorialized by the avant-garde." Indeed, as she explains further: "The storyteller, the shaman, and popular mythology became ports of entry to a sacred world as well as being identified with American originality, even as destruction of traditional societies seemed imminent."[55]

Mary Louise Pratt argues that "Carpentier realizes himself as a transcultural Euro-American subject, a creole crossroads who mirrors images back and forth across the Atlantic with dizzying spontaneity."[56] What we "see" in the mirrored images of *El milagro de Anaquillé* is perhaps only a constellation of gestures and signs arranged on the geometric planes of a stage. Implicitly, however, we are the absent enablers of an act of modernizing aggression and de-signifying violence that contradicts a spirit of anticolonial resistance and national emancipation among avant-gardists like Carpentier. His audacious acts of cultural translation, historical memory, and aesthetico-political reinvention interpellate metropolitan expectations of Afro-Caribbean exoticism and expand the limits of modernist internationalism. Like many other examples of "minor" and "marginal" avant-gardism, *El milagro de Anaquillé* was never staged in the time and place for which it was designed.[57]

According to Carpentier, the legendary Russian impresario Sergei Diaghilev had expressed an interest in two Latin American composers, Villa-Lobos and Roldán, for a new ballet season featuring "works with a Latin American flavor" [*obras de carácter latinoamericano*]. Although Roldán completed the musical score in 1929 and hoped for an imminent premiere in Paris, Diaghilev's death in the summer of that year interrupted the project.[58] The planned performance in Paris in 1929 or 1930 would have complicated the location of Afro-Cuban experience by dislocating historical and ethnographic clichés in unpredictable ways. As Said observes in a

reflection that combines "the global enterprises of European and American empire" with its modernist ironies:

> Cultural texts imported the foreign into Europe in ways that very clearly bear the mark of the imperial enterprise, of explorers and ethnographers, geologists and geographers, merchants and soldiers. At first they stimulated the interest of European audiences; by the beginning of the twentieth century, they were used to convey an ironic sense of how vulnerable Europe was, and how – in Conrad's great phrase – "this also has been one of the dark places on the earth."[59]

Bearing "the mark of the imperial enterprise," *El milagro de Anaquillé* mobilizes the postcard *guajiros* and Black laborers who populate the rural island interior as they are being captured by a US camera. Douglas Sirk performs an analogous maneuver a decade later in his Nazi-era melodrama *La Habanera* (1937); but unlike Sirk's politically infectious production, Carpentier's *"paisaje criollo"* is a powerful anticolonial statement, however lost or diluted it becomes in the trans-Atlantic freight and failure to stage the ballet. Unlike Espinosa's inscriptions of "universal literature" and selective *regionalismo*, Carpentier's Afro-Cuban libretto displays topographies and iconographies of nineteenth-century Spanish imperialism, US neocolonialism in the aftermath of 1898, and Cuban nationalism during the *Machadato*. The rural and proletarian version of Afro-Cuban culture that Carpentier allegorizes appears to question the epistemic privilege of the white, European-descended, and *mestizo* peasants (*guajiros*). But are these elements of *"bufo"* and *costumbrista* traditions intended solely as light-hearted irony for the Parisian stage, or do they constitute an effective subversion of conventional cultural and racial stereotypes? Enabled by his position as a member of the Cuban intelligentsia, Carpentier invests the performative strategies of "black magic" with the symbolic power to repel invasion and conjure domains of cultural and political resistance.

El milagro de Anaquillé echoes tensely and provocatively Guillén's characterizations of the metropolitan subculture of Parisian *variétés* and frivolous "negritos." Carpentier's intention to inscribe Afro-Cuba on the Parisian stage contrasts with Guillén's defensive and paternalistic reviews. Supporting Black Cuban performances in Paris avant-garde circles, Carpentier demonstrates a clear investment in the project of national emancipation, even if his implication in Afro-Cuban struggles for cultural and political self-representation tells an ambivalent story of attraction and

appropriation, commodification, and misrepresentation. The next section approaches the problem of limits in Caribbean colonialism and resistance from a different insular viewpoint and historical context, in *Insularismo*, a text that reacts to the crisis of the Great Depression by locating the problem of Puerto Rican struggle for cultural definition at its core.

Tropical Compass: *Insularismo*

What, then, of sugar and race relations in the construction of a resistant Puerto Rican insularity? *Insularismo* (Madrid, 1934) begins with the image of the compass – a humanist compass for a disoriented author.[60] By the time he published the book, Pedreira had matured as a journalist, teacher, and cultural critic. He had been an active intellectual figure on the island and studied in Puerto Rico, New York, and Madrid. A leading member of the "generation of 1930," he was a contemporary of the Puerto Rican *ismos* and a fervent supporter of the nationalist cause.[61] He lived in New York at the height of the "Harlem Renaissance," and in Madrid at the start of the Spanish Republic, during the crucial years of avant-garde activity among the "generation of 1927" group and at the Residencia de Estudiantes. Yet these triangular experiences of Atlantic avant-gardism are conspicuously muted in *Insularismo*. Pedreira's discourse is cosmopolitan only in a restricted sense, striving to project pragmatic rigor rather than formal or semantic playfulness. At the end of a decisive chapter, "Pretension and Artistic Expression" ("Alarde y expresión"), he cautions: "The fitting expression of our character can only be made by one who can count on a broad cultural range worthy of such undertaking" (44). In another memorable sentence, he declares: "Our vital statistics [*Nuestra aguja vital*] fluctuate between two extraterritorial points: Madrid and Washington" (98). The historicist character of *Insularismo* reflects Pedreira's search for intellectual and spiritual solace in the cultural politics of Spanish regeneracionismo. In Spain, Sebastian Balfour observes: "The Disaster stimulated anguished enquiries into the history and the soul of the nation ... This widespread movement of opinion came to be known as Regenerationism."[62] While ideologically conservative and aesthetically reactionary, *Insularismo* remains one of the most influential Puerto Rican essays written after 1898.[63]

A decade before the publication of *Insularismo*, the December 1924 issue of *National Geographic* featured an article by John Oliver La Gorce, "With Illustrations from Photographs by Charles Martin, Staff Photographer." Relating the discovery of Puerto Rico by Christopher Columbus in 1493, La Gorce observed: "The story of the island's rise to prosperity and well-being under American direction of its affairs constitutes one of the greatest romances of government in modern times." In La Gorce's piece, triumphant colonial administration and unprecedented development are compounded by nationalist ideology, racist cultural geography, and ethnographic curiosity: "The rural laboring native is known as 'jíbaro,' which literally means 'escape from civilization.' Good-natured, reconciled to a hard lot and a precarious existence, a mixture of Indian and Spaniard, he combines the care-free ideals of the Redskin and the impetuous temperament of the Spaniard."[64]

John Perivolaris reviewed eleven *National Geographic* articles on Puerto Rico during the period 1899–1924, noting that, "in the ideological war between the US and Spain, the press and photography served as important instruments of international and national legitimation." The December 1924 issue:

> signals the growing economic importance of Puerto Rico for the United States. There are timeless exotic tourist views of the major landmarks and colourful locals, especially "racially pure" Puerto Rican "belles" of "Castilian descent" ... But most striking ... is the series of photographs that represent the modernization of the sugar industry. Photographs of state-of-the-art, mechanized sugar production offset one of the manual harvesting of cane by Puerto Rican labourers ... The sugar industry itself is presented as being in the process of development, poised between a rural past and a mechanized future, hence still dependent on American technology and know-how.[65]

Insularismo, by contrast, wrestles with the existential dilemmas of orphanhood, forced minority, and obstructed maturity. Its meandering prose affirms a purposeful straying or wandering in the unique sense that Édouard Glissant ascribes to the French word *errance*, often posing this notion as a conceptual riddle: "Roots make the commonality of errantry and exile, for in both instances roots are lacking. We must begin with that."[66] Pedreira wanders and "errs" across the melancholy waters of island history, folk culture, sociology, politics, and "psychology." His point of view pivots on the viewing point of the agonist present circa 1934, when Madrid is no longer the seat of kings and emperors, but the

capital of a European republic, and the economy of the occupying United States flounders in thrall to the Great Depression. But it is the repeated, eloquent, desperate, and often convincing truth of *insularismo* – a word that means insularity, islandness, islandedness – that structures the book's chapters. Pedreira's attitudes to Puerto Rican society almost three decades after 1898 oscillate between moral condemnation and severe criticism, on the one hand, and bitter resignation and pessimism, on the other. By contrast, Martin's *National Geographic* illustrations resonate with *Insularismo*, the captioning offering a fascinating intertext that appears suspended between colonial propaganda and representational calculation.

Martin's photography renditions of the Puerto Rican picturesque in the December 1924 issue include image captions such as this: "COCONUTS AT MAYAGÜEZ": "Numerous lagoons are found in the lowlands along the coast of Porto Rico, many of them fringed with feathery palms. Ten species of palms grow in the island, but the variety shown above, the coconut, is the most familiar in the developed regions" (644). Another caption reads: "SORTING TOBACCO IN CAGUAS": "There is an opportunity for the development of more industries in Porto Rico. Only Belgium, Holland, and Great Britain of the Occident are more densely populated. Jobs are not always to be had, and a good position is an heirloom to be handed down from generation to generation when possible" (620); and yet another: 'A "BANANA SPECIAL" EN ROUTE FOR BARRANQUITAS': "Among the jíbaros shoes are a seldom-seen mark of distinction. The police are said informally to divide Porto Ricans into Shod and Unshod groups" (624). Mapping a colonial imaginary of growth across the plantation areas and "developed regions" of the island, this photographic discourse embraces the superior and calculating attitudes of capitalist expansion, paternalistic humor, and vulgar stereotyping.

The contrast between Martin's photographic discourse and Pedreira's outlook is striking. As *Insularismo* unfolds in multiple and sometimes spiraling directions, there is a recurrence of the intertwined motifs of *brújula* (compass) and *tema* (topic or thesis). The central *tema* of *Insularismo* is indeed an incapacitating condition that the book explores through considerable lexical and semantic proliferation: "The seeds of our nationalism [*El ovario de nuestra civilidad*] have not flourished [*aún no ha cristalizado en tema*]" (44). In Pedreira's speculative reflections, the island of Puerto Rico appears as if afflicted by a "Puerto Rico fever," the leitmotif in Katie Trumpener's piercing discussion of *La Habanera* (see Chapter

1).[67] *Insularismo* often portrays a suffering and restricted social body. There are references to hands and feet; metonymies of labor that the text summons, represses, or forecloses; but also touching passages about the dancing and singing body. Pedreira speaks of "our etiology" (89) and the social "pathological medium" (134). He celebrates the ardent abolitionist and pan-Caribbean spirit of nineteenth-century Puerto Rican patriots, but he largely ignores a wider contemporary Caribbean of mass unemployment and social precarity among migrant sugar workers.[68]

Besieged by the ghosts of a long colonialism, the disappointment of a truncated arrangement with the Spanish state, the promise of modernization under US tutelage, and the collapse of the local and federal economy during the Great Depression, the Puerto Rican body politic despairs:

> We speak in terms of our country, yet we have sold her. We call ourselves Rico, that is to say rich, but we are poor. Sugar cane consumes us and is life giving. Coffee continues to be threatened by storms while tobacco is threatened by buyers. We can produce everything yet we even import meat and tomatoes. Corporations exploit us while they give food to the worker. (80)

The list of grievances mounts, ending in crisis, the word of the times. Furthermore, the island of Puerto Rico suffers from a constitutional gender deficiency, an excessively feminine tropical landscape: "The danza, like our landscape, is feminine, mild and romantic [*de condición femenina, blanda y romántica*]" (121).

Pedreira finds a therapeutic alternative to the disorders of the Great Depression in the *jíbaros* living and laboring in the rural islandscape. Seeking to gauge a crisis of masculine self-confidence, this identificatory strategy protects an overwhelmingly male and European-descended *intelligentsia* from the dangers of cultural and ethnic debilitation. Thus, he projects the book's tropology onto a primarily white, Hispanic, and rural *type*, the Puerto Rican *jíbaro* or campesino. Díaz Quiñones observes that Pedreira, "whose pedagogical and historical works were so defining, in the racist proposals of *Insularismo* attributes all Puerto Rican heroism to European blood, and all docility to African blood."[69] Indeed, Pedreira grounds his Hispano-centric overview of the island in an erudite discourse of its physical, historical, and moral interior. In the penultimate chapter, "Roots," he lays out a meaningful insight about the project of *Insularismo*: "We've been on a long distance

flight providing a bird's-eye view [*panorámicamente*] of parts of the historical landscape [*algunos trozos del paisaje histórico*] upon which Puerto Rican affirmation is grounded. In this section we intend to penetrate the secret dominions of totalitarian life [*la vida totalitaria*]" (116). He observes that, "in due course, the man that was shaped here gradually began differentiating himself from the original predecessors. The Creoles, products of the land, slowly but surely manifested preferences and tastes, attaining ways the Spaniards branded as displays of autonomous leanings." To illustrate the cultural autonomy of the European-descended *criollos*, Pedreira notes the interrelation of ethnic and cultural contributions to the Puerto Rican nation: "A native orchestra in which the three racial elements of our core come into play. The indigenous people ... Africans ... Spaniards ... With these instruments (Creole products with the exception of the guitar), we created our high-spirited *música brava*" (116).

The sum of these cultural exchanges coincides in *jibarismo*, the romantic admiration for the peasant cultures of rural Puerto Rico: "The jíbaro, central figure in our culture, seems to be a man sewn to his horse, a witness forever mute about his physical toil, diversions and passions" (117).[70] The *jíbaro* of the island interior would nourish a repository of masculine energy and patriarchal vitality, despite an excess of *costumbrista* embellishments and deviations. Applying a horticultural image, the last paragraph insists: "Let us pull out dried lifeless roots and nourish only those that contain hearty plant lineages" (127). When Pedreira describes the island as *nuestra*, as the collective soil in the national imagination, he evokes the inner landscapes where the *jíbaro* exists in a timeless past. Here, the crisis of national vigor and reproductive strength emerges with singular intensity. A passage about the island's geology projects Pedreira's gender anxieties onto the environmental dynamics of the island:

> Little by little, native woods [*las ricas maderas autóctonas*] have also disappeared and our current shortage of mahogany, *ausubo* and *ortegón* is deplorable [*nuestra indigencia actual es lamentable*]. Our stateliest and sturdiest trees [*los árboles más vigorosos y machos de nuestro suelo*] have given way to prettier more decorative ones [*otros más femeninos y ornamentales*] such as the pine and cypress. Deforestation is responsible for spindling rivers [*raquitismo fluvial*] and a declining bird population. (23)

The deterioration of autochthonous nature is *indigencia*, a kind of destitution, and a warning that the exotic soil has been deprived of its originary strength. This feminization of islandscapes tells an oblique tale of the colonial taming and ordering of the island's species, a process that substitutes them with prettier, weaker invading ones. The effects of deforestation and resource extraction that Pedreira denounces are evidence of colonialist emasculation – both practices have been a characteristic of Caribbean colonialism since the sixteenth century and accelerated subsequently.[71] Pedreira reads this reality as a debilitating illness traversed by colonial docility and impotence, a stunting of the island's resources and natural habitats that is felt in the "spindling rivers" and "declining bird population"; a feminized and manicured islandscape and, by association, the decline of romantic fictions of precolonial manliness and purity. But Pedreira's concerns are more directly demographic, responding to the hemispheric climate of the Great Depression, and tempering the aggressive universalism of Spengler's speculations about decline and regeneration. In Paulo Drinot's analysis:

> If both the impact of and the responses to the Great Depression were gendered, they also were racialized. As in the United States, where Depression-era unemployment rates among African Americans were much higher than among whites and where racism often broke down labor solidarity, in much of Latin America too race shaped how the slump was experienced. In the circum-Caribbean black labor migrants from Jamaica, Trinidad, Haiti, and other islands were among the first to be laid off in the sugar and banana industries.[72]

Alarmed by the threats of an endemic weakness and a potentially constitutive effeminacy, Pedreira calls for an urgent transformation of Puerto Rican youth: "this unproductive and sterile situation (139); "today's youth ... appear to be a generation of invalids unable to weigh this reality with any precision" (130). Pedreira's demarcation between a north centered on Washington and a south centered on Madrid is calculated to locate his authoritative point of view at a benevolent distance from the young intellectuals destined to bear the fruits of nationhood. He sees himself "*a la retaguardia*," on the rearguard of the new generation's struggle for Puerto Rican independence, and he imagined this *juventud letrada*, a conservative *intelligentsia* of Hispanists and patriots, at work in the service of the cultural politics of the new state, while the reader persists "on his pilgrimage toward the homeland" (128). The Puerto Rican

condition is therefore tautologically desperate, if not tragic. Unable to fulfill their historical purpose as a Latin American people, Puerto Ricans live or half-live as the shadows of an unaccomplished self-ideal. What, then, does *Insularismo* say about Puerto Rico as an island among islands and continents? At the start of the chapter "The Dutchman Will Catch Us" ("Nos coge el holandés"), Pedreira discusses the island as a space of multiple historical, geographic, and cultural dilemmas:

> An almost uniform parallelogram surrounded by a ripped necklace of tiny isletes, Puerto Rico lies between the Caribbean Sea and the Atlantic Ocean, an inhospitable place for soirées, to be sure. It is the smallest of the Greater Antilles, and continuing guardianships and executors have maintained it in an inviolable state of adolescence [*inviolable niñez*] for centuries. This extended childhood [*vieja niñez*] prolonged to the present day, and overseen by mandatory governesses has forced us to obey rules that restrict our friendships with the other Antilles, and consequently from confraternity with Latin America and the rest of the globe. We have not yet come of age and this separates us from the world. (92)

As this passage shows, *Insularismo* measures a dramatic divide between nineteenth-century Caribbean struggles for independence and the Puerto Rican predicament circa 1934. For Pedreira, neither orphanhood nor neocolonialism constitutes a desirable position. Instead, Puerto Ricans must find a third way, yet Cuba's racial politics and Black revolutionary impetus post-1898 represent uncomfortable referents. "We have been so attentive to the Spanish and American dimension, we have forgotten to seek the third dimension, our own. The Puerto Rican dimension is the only one that compels us to select and order those things from today and the past that it suits us to keep for the future" (130). The temporal perspective of *Insularismo*, the *not yet* of an indeterminate and long-deferred coming-of-age, is the very condition that separates and constitutes Puerto Rico as an island, preventing it from joining "the world."

Although Pedreira stops short of rejecting the *ismos*, he refuses to capture the deep aesthetico-political processes that motivate Puerto Rican and Caribbean avant-gardism. Caught up in his critical malaise, he circumvents those practices and discourses, focusing instead on the double movement of mourning and denial that orients the representation of Puerto Rico as not only small and defenseless, but also fragmented and distorted by its marginal status

as a Caribbean border zone. Ramón E. Soto-Crespo outlines this agonistic discourse as "the Puerto-Rican condition," arguing that "[Pedreira] considered Puerto Rico an ever-increasing borderland that was in direct conflict with escalating Puerto Rican nationalism and with U.S. colonialism ... Pedreira wished for an expansive notion of Puerto Ricanness, one that was locally seasoned while pan-Hispanist or cosmopolitan in scope."[73] But Díaz Quiñones underlines 1898 as *the* historical border for Pedreira and his generation of Puerto Rican intellectuals.[74] Indeed, the border trope repeats itself on multiple levels in this and other insular texts discussed in this book, where the material and imagined island appears to be traversed by a multiplicity of historical, geopolitical, and epistemic demarcations that spell out local and archipelagic perspectives on "the world."

Pedreira's passion for outlining the moral dilemmas of creole national identity distinguishes him from the leading voices of Hispanic avant-gardism. His reactionary discourse resonates with the ideas of the Spanish "generation of 1898" and with liberal and conservative thinkers of the previous century.[75] However, the experimental attitude and cosmopolitan intent of *ultraísmo* provides Pedreira and other Latin American authors who frequent the Madrid group with a relatively open-ended attitude to cultural differences. In *Insularismo*, images of aimless or negative cosmopolitanism like "a ship adrift [*la nave al garete*]" (57) bear the mark of 1920s inventiveness, even if Pedreira's commitment to metaphorical play is more ideological than exploratory. However, Díaz Quiñones discerns a possible connection between navigational metaphors in *Insularismo* and the Cuban *Revista de Avance*, observing that the Minoristas' journal "estuvo en diálogo" (was in dialogue) with *Índice*, in which Pedreira participated in Puerto Rico; and noting the use of another Caribbean archetype in *Insularismo*, the *topos* of the shipwreck.[76] By the early 1920s, a dynamic sequence of Puerto Rican *ismos* had echoed the historical structure of international avant-gardism, from Expressionism and Cubism to Futurism and Dada. Pedreira witnessed the emergence of *pancalismo* and *panedismo*, initiated by Lloréns; *diepalismo*, *euforismo*, *noísmo*, and *atalayismo*; and *integralismo* and *trascendentalismo*.[77] Yet, the *–ismo* in the title of Pedreira's book resonates more directly with prefixes that denote negative and pathological conditions linked to colonialism, such as *paludismo*, *raquitismo*, *caciquismo*, *oscurantismo*, *clientelismo*, *pesimismo*, and *derrotismo*.

Four poets, Graciany Miranda Archilla, Clemente Soto Vélez,

Alfredo Margenat, and Fernando González Alberty, founded the "Grupo Atalaya" in 1929, and the *atalayistas* adopted Futurist and Dadaist gestures initially, before embracing Puerto Rican nationalism.[78] In a passage of "Pretension and Artistic Expression," we read this benevolent judgement:

> I respect any attempt at innovation for the new possibilities it may contain. That thing that around town is referred to as *atalayismo*, in my opinion, has a profound experimental feel [*un profundo sentido experimental*] only frightened souls find irritating. If instead of jeering, we adopted an inquisitive attitude [*gesto inquisidor*], *atalayismo* could be seen as a yearning for novelty of expression [*un anhelo de novedad expresional*], or at least a rebellious gesture [*gesto rebelde*] of a few young men [*unos jóvenes*] who cannot content themselves with the literary insolence of our grandfathers ... Before anything else, we need to respect ourselves intellectually. (41)

This wide-ranging invocation of "respect" for "any attempt at innovation" reads like ambivalent approval. Pedreira appears to value the *atalayistas*' experimental dimension, finding in them a sense or meaning that merits intellectual or aesthetic scrutiny. But their *desire* for "novelty of expression" amounts to a worldly interest in new trends. This "movement" has no transformative value; its relevance is symbolic and resides in its gestures. As a "movement," *atalayismo* is the work of an unpopular minority, "a few young men" whose part in Pedreira's vision for a more resolute Puerto Rican masculinity seems unclear. What he admires in contemporary authors like Evaristo Ribera Chevremont, Lloréns, and Palés is a collective patriotism, a virtuous rebelliousness where avant-gardism is subjected to the nationalist imperative. Pedreira then turns to the Spanish-speaking Antilles in a geographical displacement that complicates his comments on Palés's *poesía negra*. He evokes vague abstractions that range from "an Antillean expression" and "the spiritual movements of the Larger Antilles" to "the individual tone of each island" and the "expressive balance of the Antillean triangle" (42).

Pedreira splits the field of possibility into a defining opposition of Schmittean resonances: "In the debate to which I now allude, two antagonistic ideas stand face to face as enemies: universality and criolloism [*la universalidad y el criollismo*]" (42). What, then, would be the *positive* cultivation of what Pedreira calls *el criollismo*? The circuitous answer returns to the matrix of Hispanism. Henceforth, the text deploys a collection of quotes

by literary authors where "expression" is generally reducible to *literary* expression in Pedro Henríquez Ureña, Guerra Junqueiro, Unamuno, Manuel Alonso, Félix Matos Bernier, Muñoz Rivera, Virgilio Dávila, and Ortega: "And within the wide parameters of what is considered Hispanic, Spanish literature and its offshoot Hispanic American literature fall into distinct categories" (42). Pedreira lists the national literatures of Mexico, Chile, Argentina, and Uruguay, and Spanish regional literatures from Catalonia, Galicia, and Andalusia, before asking: "Why shouldn't Puerto Rican literature stand on its own as well? Perhaps we have no reasons to coin our own expressions knowing as we do those from Spain, Argentina and Cuba? Or do we lack the cultural funds to do so?" (42). At this point, when regional and national expressions of literary Hispanism appear to form a field of mercantile relations and solvencies, Pedreira turns to a wider terrain of cosmopolitan exchanges. Referring to a quotation by Keyserling, "'The shortest path to finding yourself circles the world'" (35), he comments: "The world is not found by heading outward [*caminando hacia afuera*], but inward to the heart. Yet we must also remember the quote I cited previously, the shortest route to finding one's very self circles the globe. The universal, that abstraction which by being so common does not dwell in any one place, cannot be inconsistent with the national" (42).

The political thrust of Pedreira's discursive negotiation is ultimately agonistic; he must consider the autochthonous soil of Puerto Rico in tension with antagonistic forces just as he struggles to imagine "the third dimension, our own. The Puerto Rican dimension" (130) – an agonistic third space of potentially liberating transformation. But Pedreira's perception of the agonistic present gravitates toward Castile, the symbolic and territorial center of Hispanist ideology. As Chantal Mouffe maintains: "For the agonistic perspective, the central category of democratic politics is the category of the 'adversary', the opponent with whom one shares a common allegiance to the democratic principles of 'liberty and equality for all', while disagreeing about their interpretation."[79] Barring the anachronistic projection of Mouffe's political thought on the Puerto Rican context of *Insularismo*, her notion of agonism in politics interrogates Pedreira's reflections on "the world" as a shorthand for broader debates around Hispanism and universalism that traverse the historical moment between 1898 and the early 1930s. Celebrating the centrality of Unamuno in contemporary Spain, Pedreira observes: "There are probably few who understand

Hispanic American literature better than he ... His knowledge of botany and economics has guided his aesthetic eagerness to make Castile known. In his work, Unamuno offers the world the exact measure of what is Castilian" (43).

Pedreira does not dwell on the diverse meanings accrued from the signifiers Castile and Castilian since the late nineteenth century in relation to essentializing and centrifugal ideas of Spain and its post-imperial sphere of influence. Among the leading intellectuals of the "generation of 1898," these ideas had centered in part on discussions and "meditations" around the decline of the empire, varieties of Eurocentrism, and a paternalistic literary Hispanism. Yet, the analogy between Unamuno's Castile and the colonial island of Puerto Rico inspires a rhetorical crescendo that culminates in some of the most memorable passages of *Insularismo*. To make the island known, Puerto Rican expression *must* locate itself firmly within the paradox of a nonparochial *criollismo*: "We must desist from the voluntary abandonment of what is ours in order to end the disdain and indifference with which the world regards us. Creolism needs ideas far removed from the hamlet [*ideas antialdeanas*] originating on the open road which no mayor of municipal poetry can travel" (43–4). In this passage Pedreira evokes a central idea of Martí's essay, "Our America" ("Nuestra América") (1891), a text that is often cited for its extraordinary statement on race: "There is no racial hatred, because there are no races." This sentence resonates with Pedreira's notion of a constitutive demarcation between two ideological poles of Caribbean settler colonialism and nationalist struggle – the creole *aldea* or village, and the narrow path to hard-earned sovereignty. But Martí warns that "the prideful villager thinks his hometown contains the whole world ... Whatever is left of that sleepy hometown in America must awaken."[80] In Martí's generation, as in Pedreira's, negotiations with universalist and emancipatory ideals among the creole elites are inescapably tied to wide-eyed anti-imperialist struggles.

In this paradoxical construction, Hispanism serves elitist and reactionary purposes, incorporating the region but sublimating it to gain international recognition and attain a sense of global belonging. Thus, Pedreira's vacillations, his anxiety around what he sees as the conditions of Puerto Rican isolation and insularity that set the island apart from other Spanish-speaking countries. He cautions against the pathological figure of tropical contagion, which might interfere with the projected "open passage" to what he calls "the universe": "The contagion of our isolation [*el contagio del aislamiento*] must

be avoided and make its ties to our solitariness [*nuestra soledad*] plain. We too form part of what is called 'the universe' [*eso que llaman 'universo'*], and it is necessary to cultivate our letters from the inside out so that they may have open passage" (44). The feared contagion of Puerto Rican isolation registers common anxieties of the hemispheric *fin-de-siècle*, so preoccupied with modernizing and universalist aspirations, phobic concerns around "the problem of the Indian," and the inevitable advance of miscegenation. But these anxieties run deeper, affecting the foundations of Pedreira's ideology of the nation. As Priscilla Wald reminds us:

> The word *contagion* means literally "to touch together," and one of its earliest usages in the fourteenth century referred to the circulation of ideas and attitudes. It frequently connoted danger and corruption. Revolutionary ideas were contagious, as were heretical beliefs and practices ... The circulation of disease and the circulation of ideas were material and experiential, even if not visible. Both displayed the power and danger of bodies in context and demonstrated the simultaneous fragility of social bonds.[81]

Pedreira's vision for an emancipated social body requires communities of tactile propriety that are defensively articulated around homosocial empowerment and homophobic panic, institutional and capillary misogyny, and a generalized obsession with national masculinity. Therefore, what does it mean to "cultivate our letters" between the existential extremes of "our isolation" and "the universe"? In these terrifying conditions, who will inhabit the new island as a citizen, and who will build the new nation? Conversely, who will be excluded and suppressed? Finally, how would such a cultivation "from the inside out" help end the "contagion" of provincial isolation and solitariness? In Pedreira's diagnosis, *insularismo* can be cured by men of letters and educators like Unamuno and Ortega in Spain, and Pedreira himself in Puerto Rico; men capable of expanding the potential of *criollismo* thematically, pedagogically, and spiritually as *brújula* and *tema*.

Ortega writes in *El tema de nuestro tiempo* in characteristically universalist and vitalist strokes:

> The modern theme [*El tema de nuestro tiempo*] comprises the subjection of reason to vitality, its localisation within the biological scheme, and its surrender to spontaneity ... The mission of the new age [*la misión del tiempo nuevo*] is, precisely ... the demonstration that it is culture, reason, art and ethics that must enter the service of life.[82]

But Pedreira's attitude deviates substantially from the relative optimism and vitalist attitude of Ortega's essay. Identifying the absence of several themes in Puerto Rican literature, he prescribes a catalog of historical subjects, such as "our interesting indigenous life, the defining attitudes of our conquistadors, the essence [*la savia*] of our formation, the bitter roots [*la raíz amarga*] of our beginnings..."; and he concludes with an afterthought: "... or even the disquieting instability of these days" (44). Although he does not fully reject the possibility of a critical avant-garde attitude that might express (although not overcome) the turbulent present, the spirit of his thoughts about racial and gender hierarchies is decidedly anti-avant-gardist.

Marked by an obsessive return to the nineteenth century, the final chapters of *Insularismo* turn to a hygienist discourse of gender policing and sexual control. In a thinly veiled reference to female prostitution, and the potential threat of women's self-fashioning and emancipation, Pedreira writes: "We qualify the woman who smokes, drinks and is always on the go [*que camina y que corre*] 'modern'" (89–90). As Díaz Quiñones states, for Pedreira, "women are out of their 'proper' place, therefore they also represent 'the enemy'"; and Eileen J. Suárez Findlay reflects:

> Creating a sexual threat – and thus a common enemy around which the community can bond in self-defense – is a particularly powerful way of constructing consensus of great social stress and change. In Puerto Rico during the late nineteenth and early twentieth centuries, the focus of such sexual panics was the prostitute – the dangerous, disreputable, and implicitly darkened workingwoman who had to be ripped out of the heart of the community ... By 1918, working-class women posed a different kind of threat: they were at the forefront of the labor mobilization sweeping the island.[83]

Insularismo sketches a pathetic caricature of the docile working women of Fordist capitalism. Their cultural and political kinship with metropolitan images of modern femininity is difficult to discern, as the text demonizes the very possibility of identifications and alliances between these contrasting experiences of womankind. I read Pedreira's cautious contemplation of working women decades before the migratory explosion of the post-World War II period against Pedreira's idealistic views of a fundamentally patriarchal and reactionary society. Yet many Puerto Rican women supported labor movements and contributed to the emergence of Left partisan

politics at least following the founding of the Socialist Party in 1915, and many joined an international precariat of racialized labor migrants in the United States. They fought for social and political rights, including women's suffrage, reproductive rights, and the abolition or legalization of prostitution. By the early 1930s, when Pedreira published *Insularismo*, these struggles involved cross-class, cross-racial, and cross-gender solidarity networks, alliances, and confrontations. For example, according to Suárez Findlay: "By 1918, women were in the forefront of the labor militancy. They jammed Socialist study circles and meetings in Ponce by the hundreds, far outnumbering the men. Workingwomen demanded higher wages, better working conditions, and a minimum wage for women workers and protested managerial physical and sexual abuse."[84]

The concluding chapter, "Our Most Precious Treasure: The Young," regresses to the spirit of the *modernista* period, discussing the transcendental topic of Puerto Rican youth in overtly paternalistic terms. A reference to Rubén Darío, "Juventud, divino tesoro" (1905), resonates with José Enrique Rodó's *Ariel* (1900), an influential essay in which the author addresses "the youth of America." Pedreira acknowledges that "in the last eight to ten years an awakening has occurred in our young people that although sporadic is responsible for attitudes auguring a new budding consciousness [*una nueva floración de la conciencia*] ... Already this germinating, future flower is a revelation that men of my generation ought to encourage" (128–9). But he establishes a demarcation between his own generation (the *men* of 1898 who turn to Unamuno and Ortega in Spain, and Hostos and Lloréns in Puerto Rico, for inspiration and guidance) and the uprooted Puerto Ricans who straddle the contending cultural poles of Madrid and Washington. He then returns to the trope of conflicted tutelage: "As the twentieth century began, we were already abandoned by our historical mother [*huérfanos ya de la madre histórica*], and remained in the care of a rich and enterprising step-father" (129). *Insularismo* repeatedly connects Spain's historical role to "feminine" notions such as nostalgia (albeit for a past of poverty and abandonment), feeling, and a sense of cultural belonging that cast Puerto Rico as *daughter*, while maintaining an oblique relationship with Europe. The United States, by contrast, is a technically advanced, enterprising, and *wealthy* "father" that will take Puerto Rico into the modern future.

In a section on the suitability or women for teaching, Pedreira informs us that he does not think women are inferior and clarifies:

"There are also useless men [*hombres inservibles que debemos arrinconar*]. These posts must be retained for forceful males only" (78). After a lengthy discussion of the role of women in Puerto Rican society, he laments the chaotic state of the island's economy under US control: "This is why I believe our most serious problem is that of the people themselves [*es el del hombre*], our most serious need the formation of a new Puerto Rican [*un nuevo tipo puertorriqueño*] who knows how to frame and gauge our reality with fresh determination [*con nuevos bríos*], without sugarcoating or confusion [*sin azucaramientos ni confusiones*], but with a fitting, high-minded vision" (81). Pedreira's sense of a national subjectivity erases political and cultural antagonisms and makes him perceive partisan opponents as insufficient or inoperative. This attitude prompts the question of a space of difference between the opposite extremes of the noble *jíbaro* and the institutional elites Pedreira represents and defends.

Pedreira coincides with the Atalayistas and other Puerto Rican avant-gardists in rejecting the affected cultural elitism of the previous generations. But his desire to overcome old weaknesses with masculine vigor exceeds the casual homophobic register: "Who isn't familiar with the impotent, affected vocabulary of our social pages?" (89). His defensiveness becomes frontal when he speaks of "These tamed youngsters [*esta juventud domesticada*]" (132), calling for a "a new means of appraising men and women [*una nueva tasación de hombres*]," and denouncing the empty patriotism "that is passed around like a hired call girl": "It is imperative that we make enemies of these shameless men that deprave the passions and pimp our youth by their example" (132). Offhand or aggressively pejorative, homophobic observations center around feelings of inadequacy that translate as a collective defect: "The new generation is intellectually lazy, furthering the defeatism of a pernicious inferiority complex [*nuestro complejo de inferioridad*]" (133). The text culminates in a homophobic explosion:

> The crushing impact of today's inferiority complex [*El complejo de inferioridad que hoy nos agobia*] can be traced to geographical, historical and political limitations, favorable in any case for fusing self-contempt [*vituperio*] with a sense of insignificance [*apocamiento*]. Needless to say, contempt [*menosprecio*] is responsible for the circulation of that lot of stuffy, insufferably vulgar milquetoast [*esa tupida cantidad de afeminados, insufribles hasta la vulgaridad*], pinheads with small hearts who think and feel on a small scale. (133–4)

Insularismo expresses an eminently reactionary dream of Hispanic universalism. Pedreira roots for a *criollo*, white-identified, and heterosexual fraternity of professional Hispanists, but he suggests that this elite can only aspire to a limited version of Puerto Rican affirmation. While the conservative or proto fascist *new man* lingers in fantasies of this exclusive class, the suppression of working-class women and the exclusion of *modern woman* are implicit and eloquent gestures; and the repudiation of the effeminate Puerto Rican is overtly paranoid. The perfected masses of workers and laborers appear to *include* or *contain* minorities of Black or "colored" Puerto Ricans, but Pedreira does not comment on how US demographic politics affect Puerto Rico after decades of subjection to a colonial logic of US racism and plantation capitalism.[85] Yet, according to Sidney Mintz, "[W. E. B.] Du Bois grasped the implications of an American hemisphere that extended thousands of miles beyond the United States, populated in large measure by peoples of color."[86] Thus, the protagonism of Pedreira's *lettered* elite precludes the ascent of those other Puerto Ricans who will largely build and expand the recovered nation not despite, but in complicity with, the colonial reverberations of the color line. The consistency of this fantasy hinges in part on a defensive reaction to the threat of the modern, the new, and the morally insurgent. And that reaction includes engaged forms of avant-gardism whose defiant aesthetics, progressive racial politics, and deviant gender practices will undoubtedly threaten the balance of Pedreira's nationalist-conservative outlook. In *Insularismo*, the imperative of a potentially authoritarian Hispanism forecloses the possibility of an agonistic and necessarily unpredictable "third dimension" – a potentially polymorphous (and polymorphously perverse) investigation into nationalist desires beyond the Madrid/Washington axis, and against the multiple facets of enforced minority and dependency.

Affirmation / Deracination

Insularismo exudes a painful sentiment of colonial uprootedness; an experience of *deracination*, in Claudia Milian's formulation, shared in part by Spanish intellectuals of Pedreira's generation, Hispanists and exiles of the Spanish Civil War who carried ideas and institutional experiences into the Caribbean and the Americas.[87] Pedreira's insular vision, however, resists critical confrontation with the vast reach of the color line, and forecloses consideration of a politics of

solidarity beyond ambivalent recognition and phobic defensiveness. This refusal to spell out the demarcation separating "colored" and Black Puerto Ricans from the ideal of "a new Puerto Rican" recalls Espinosa's discomfort with the *lanzaroteños* and contrasts with the Afro-Cuban enthusiasm of Carpentier's early works. But what do these authors *affirm* jointly beyond their irreducible particularities? *Affirmation*, a word Pedreira uses to characterize the critical project of *Insularismo*, is grounded in historical and cultural recognition, even as the exclusiveness of his political vision stops short of advancing a generous program of social and political solidarity. If affirmation is the action of making firm, strengthening, and empowering, then the grounds of Espinosa's, Carpentier's, and Pedreira's non-European projects are clearly circumscribed to particular understandings of moments of crisis within discourses of Hispanism and universalism. While affirmation, in Pedreira's discourse, represents a search for new beginnings, it also constitutes a reaffirmation of regressive values that fails to articulate Puerto Rican solidarity in social life, political projects, and anticolonial action.

The binding of European mythologies with geography and biology in *Lancelot 28°–7°* revives a powerful, "integral" sense of island consciousness in the present. But by repressing the "Desastre de Annual," Espinosa forecloses the scenario of contemporary Spanish and French colonial enterprises in North Africa as extrinsic. In *El milagro de Anaquillé*, Carpentier engages superficially with Black cultural performance as an expression and affirmation of Cuban nationhood. The text displays the frontier "space" of anticolonial insurgence while failing to allegorize other internal borders, such as the implication of white and other elites in the political and economic processes of the Cuban Republic under US control. In *Insularismo*, direct or implicit evocations of "the people," the masses of the Puerto Rican proletariat, suggest the proximity of Pedreira's ideas to Unamuno's notion of *intrahistoria*, the silent and dynamic life of a people that can be harnessed to form a collective sense of national belonging. Yet Pedreira's adoption of Hispanism circumvents the realities of Puerto Rican and Caribbean deracination among Afro-descended laborers and other groups.

Perhaps the conspicuous absence of the *lanzaroteños* in Espinosa's text represents the impossibility of transcending the cultural borders that had established the Canary Islands historically as a *deracinated* exclave during the long process of Spain's own constitution as a nation state, imperial power, and global colonizing actor. If the non-European and non-African Canary Islanders fail to rejoin the

creacionista textuality of *Lancelot 28°–7°*, what shall we make of the planned performance of Afro-Cuba for European audiences in *El milagro de Anaquillé*? What do we learn about the ideological limits of insularity and avant-gardism in *Insularismo*'s difficult orientation within Hispanic avant-gardism? Immersed in difficult negotiations around affirmation and deracination, Espinosa, Carpentier, and Pedreira appear disoriented (though not lost) in the pan-Hispanic archipelago, striving from their specific locations and viewing points to navigate a perplexing mixture of colonial stagnation and relentless change. The next chapter turns to works by Luis Palés Matos, Nicolás Guillén, and Julia de Burgos to further interrogate how insular avant-gardism confronts not only cultural and political change in the Atlantic 1930s, but also the notion of a shared Hispanism.

Part II
Caribbean, Colonial, Avant-Garde: From *Poesía Negra* to Carceral Romances

3
Islands of Desire: A Poetics of Antillean Fragmentation

Poesía Negra

In the 1930s, three avant-garde poets from Puerto Rico and Cuba shaped the Caribbean imagination in unprecedented new ways. This chapter explores their poetics through close analyses of texts that stand as central referents of the poetry of the Hispanic Caribbean. In the following sections, I discuss poems from Luis Palés Matos's *Tuntún de pasa y grifería* (1937); Nicolás Guillén's early Afro-Cuban books, *Motivos de son* (1930), *Sóngoro Cosongo: Poemas mulatos* (1931), and *West Indies Ltd.* (1934); and *Poema en veinte surcos* (1938) by Julia de Burgos. This constellation of poetic works forms a composite image of non-European Hispanisms in the 1930s. Reading these texts through the critical lens of an Antillean poetics of fragmentation, I argue that they constitute a field of confrontations with political and cultural change where gendered, racial, and ethnocultural images of the Antilles emerge as a contested aesthetico-political space. While these works participate in a shared practice of pan-Hispanic prosody, formal conventions, and emerging discourses, individual voices express contrasting ideological positions that stretch the boundaries of a presumed common Hispanism.[1]

Some critics of *poesía negra* position Palés and Guillén alongside the Negritude movement and Aimé Césaire's poetry, reading these major Caribbean figures against the emergence of a Black Caribbean

poetics and internationalism.[2] In recent decades, African American and other critics based in the US have posited poetry as a distinctive dimension of Latin American and hemispheric avant-gardism, representing the Black experience across the Spanish-speaking world in dialogue with Francophone and US contexts.[3] Yet another view of *poesía negra* emphasizes the nationalist element and its adjacent sociocultural contexts, either as the central focus, or in connection with other critical angles. This other view underlines historical and sociopolitical processes that differentiate individual poetic invention across a background of political resistance and creative innovation.[4] Building on these diverse critical perspectives, this chapter places Guillén's and Palés's works in relation to ideological debates bearing on the place of *poesía negra* within nationalist and anticolonial contexts. I discuss these texts in conjunction with Burgos, a Puerto Rican poet who extends *poesía negra* beyond (and despite) the huge success of her male contemporaries. Burgos's poems open suggestive lines of flight that foreground a politics of feminine (and sometimes feminist) writing, connecting and intersecting with other insular authors and contexts on both shores of the Atlantic.

The examples I have in mind are Josefina de la Torre, and the circles of the Residencia de Estudiantes in Madrid and the "generation of 1927" more broadly; Suzanne Césaire and the Martinican journal *Tropiques*; and Lydia Cabrera and the artistic and intellectual life of Havana in the early 1940s, after Cabrera and the artist Wifredo Lam returned to the Caribbean from France. Throughout this chapter, I consider Guillén's, Palés's, and Burgos's nationalist and Antilleanist poetics. I highlight their relations with Hispanic and other referents, including Lorca and Langston Hughes, Futurist and Dadaist practices, and local and transnational proletarian struggles before and during the Spanish Civil War. Given the reorientation of Hispanism in *poesía negra*, how do these poets negotiate hegemonic discourses of institutional Hispanism?

In the 1990s and early 2000s, Caribbeanists and avant-garde critics wrote extensively on the figurations of racialized female bodies in Afro-Caribbean poetry specifically, and international avant-gardism more generally.[5] Robin Moore, for example, explains that "the *mulata* as cultural construct has a long history in Cuba. In novels, popular song, and in the theatre, discourse about *mulatas* is perhaps more common than that of any other subject."[6] Clearly, women's agency is not a central concern in insular avant-gardist texts, most of which were written by heterosexual men who repeatedly inscribed this tired construct to the point of tediousness.

Furthermore, as Vera Kutzinski has shown, specific passages in Guillén and others "situate slavery and sugar production at the root of the mulata's imputed sexual pathology."[7] Building in part on the Spenglerian inspiration of discourses of insularity I discussed in Chapter 2, I argue that fantasies of the Black female body are often incorporated into Afro-Caribbean texts in tension with an avant-garde rhetoric of masculinist defensiveness and homosocial bonding, making Burgos's poetry particularly interesting to study alongside that of Palés and Guillén.

The connection between these two fantasy realms should be considered against a panorama of socioeconomic crisis and anticolonial revolt. Indeed, in these texts women are not always passive receptacles of a male libidinal gaze, but embody social and political forces that cannot be limited to libidinal repression and erotic expression. Conversely, poetic representations of laboring, idle, and oppressed Black men often suggest homoerotic curiosity and a latent or explicit recognition of their insurrectionary potential. Directly or indirectly, these representations fixate on the sexual and reproductive energy of ethnoracial others. They construct them as symptoms of an excessive physicality that interpellate the degenerate colonial state, US colonial capitalism, and the revolutionary demands harking back to the slave uprisings that predate the Haitian Revolution. But how do these biopolitical entanglements and discursive strategies *relate* to the material conditions (the conditions of political and economic colonialism) of archipelagic insularity? While this question informs my reflections in the following pages, I start from the related insight that Puerto Rican and Cuban *poesía negra* and avant-gardism are bound by an asymmetrical familiarity with US popular culture, Afro-American intellectual communities, and international Hispanism.

Antilleanist discourses in the 1930s form a changing panorama of entanglements between nationalist, cosmopolitan, and progressive aesthetico-political performances. My readings of poems by Palés, Guillén, and Burgos in this chapter examine a series of tensions between avant-garde poetics and *poesía negra* that exceed national and ethnocultural boundaries. For this reason, I suggest that these tensions affect nationalist, Afro-centric, and Germanophile Hispanisms, revealing numerous contrasts between cosmopolitan avant-gardism on the one hand, and racist and phobic ethnonationalism on the other. Palés, for example, finds refuge in fantasies of an archaic and regressive Puerto Rican autochthony, while Guillén and Burgos project different libidinal and subjective horizons that

reach beyond the national soil. The three poets compile, adapt, and inscribe vocabularies of cultural difference that advance competing visions of Afro-Caribbean experience. The first edition of *Sóngoro Cosongo* by Guillén has a short "Vocabulario," while Palés includes a longer annotated "Vocabulario" in the second edition of *Tuntún* (1950). Burgos, by contrast, selects a minimal Afro-Puerto Rican lexicon in "Ay ay ay de la grifa negra," one of the poems in *Poema en veinte surcos*. Thus, while their combined attitudes demonstrate a common Caribbean consciousness, their individual projects amount to a poetics of Antillean fragmentation.

Uprooted Hispanisms

Josaphat B. Kubayanda underlines the importance of *hispanismo*, a discourse of post-imperial consciousness developed by a handful of influential Spanish intellectuals around the turn of the twentieth century. Commenting on the conservative author Ramiro de Maeztu, Kubayanda writes: "According to the *Revista de Avance* of April 15, 1927, Maeztu had designed a Hispanic universal aesthetic or a cultural-spiritualist *hispanismo* that would unite all Spaniards and Hispanophones in one Hispanic *raza* under an indivisible Iberian-Spanish sovereignty." However, the aspiration to consolidate a common trans-Atlantic consciousness around these ideals separates Maeztu's project from Caribbean realities. Kubayanda summarizes the piece further in *Revista de Avance*: "In addition this Iberian outreach into former and actual colonies would, it was hoped, guarantee preservation of the purity of the Spanish blood, religion, and language, and offset the influences of non-Hispanic origin, especially those of U.S. derivation." Maeztu's response to postcolonial conditions across the former Spanish colonies denounces a panorama of impurity, degeneration, and interference by non-Hispanic political and economic forces. He expresses a firm conviction that, "insofar as its African interest could be maintained, Spain advocated an approach along the lines of the Reconquest: belligerent spiritualism against Muslim and pagan tribal Africa, and elevation of the indigenous African peoples to higher forms of civilization."[8]

Kubayanda glosses over Oswald Spengler's *The Decline of the West* as "an influencing factor in this Negritude democratization of history."[9] However, Spengler's text represents a prestigious version of historical dialectics that greatly influenced island intellectuals

of avant-garde and other persuasions. Among Hispanic Caribbean intellectuals, Spengler's text becomes a "master discourse" onto which they graft other discourses of idealist inspiration, such as Menéndez Pidal's philological historicism, Unamuno's *intrahistoria*, and the Marxism of Mexican or European ascendancy embraced by the Minoristas and by Guillén.[10] Published by *Revista de Occidente*, the Spanish translation of *The Decline of the West* enables the gravitation of European Hispanism and, by extension, Spanish and Latin American readers, toward Germanic historicism and universalist categories. Theodor W. Adorno, in a relentless critical demolition of German existentialism, calls this ideological seduction "the jargon of authenticity." As Adorno observes, "Spengler's plantlike cultural soul, the vital 'being-in-form', the unconscious archaic world of symbols whose expressive force intoxicates him – all these signs of a self-glorifying life are actually harbingers of doom whenever they appear in reality."[11]

In his "Prologue" to *Sóngoro Cosongo*, Guillén writes that "these initial pages must be fresh and green like young branches," and "Blacks [*El negro*], in my view, contribute very firm essences to our *cocktail*."[12] As Kubayanda and other authors have argued, reading *Sóngoro Cosongo* and Guillén's subsequent books of the 1930s through the "external model text" of Afro-centric, pan-Caribbean, and anti-imperialist contexts is both politically and hermeneutically astute. But locating all Guillén's Afro-Caribbean production, as Kubayanda does, within the critical perspective of Negritude results in a retrospective strategy that, in my view, elides important aspects of the finely grained aesthetic and ideological contexts of Atlantic Hispanism and avant-garde practice where Guillén's first books appear historically.

In the aftermath of the Cuban Republic (or *pseudorepublic*) inaugurated under US occupation, the Minoristas read the Spanish avant-garde writers through a lens that is broadly determined by their nationalist aspirations. In this political context, Lorca's *Romancero Gitano* (1928) impacts on Guillén's *Motivos de son* (1930). Both books feature popular characters and voices, oral and aural traditions, attentiveness to performative and musicological elements, and a combination of traditional and avant-garde poetic forms.[13] In 1923, Lorca planned to write a book of poems inspired by Andalusian Roma culture and musical performances. By 1926, versions of these poems had appeared in the *Litoral*, an important journal among the young authors of the "generation of 1927" – some of them, anecdotally, next to poems by Josefina de la Torre. Lorca

also published some of these poems in other avant-garde journals, surrounding the promised book with an aura of anticipation, and making its publication an international literary sensation. One of these poems, "La casada infiel" ("The unfaithful wife"), appeared in the January 1928 issue of *Revista de Occidente* with a dedication: "*A Lydia Cabrera y a su negrita*" ("To Lydia Cabrera and her little black girl"). This dedication to the then unpublished Cuban anthropologist and writer evokes Lorca's connections with Cuban culture prior to visiting the country in 1930. He had befriended the Cuban diplomat and writer José María Chacón y Calvo in Seville in 1922, and met Cabrera in Madrid in 1927, while she was a student at the École du Louvre in Paris. As Cabrera related years later:

> I met Federico at José María Chacón y Calvo's home ... we immediately took to each other ... Federico carried the manuscript of *Romancero* in his pocket ... we went to the Café de Pombo and spent the day there ... he asked me: What is your favorite poem? ... when the book came out, I saw that he had dedicated the poem to us.

According to Cabrera, Lorca based his reference to a *negrita* on a passing observation that one of her Afro-Cuban domestic workers also wrote poems. "Federico met her when he traveled to Cuba in 1930 ... she was famous ... she was very talented and witty ... Her name? – Carmela Bejarano."[14] We cannot ascertain what led Cabrera to choose the poem in question, but there are thematic resonances between "La casada infiel" and two of her works, *Cuentos negros de Cuba* (1936) and *El Monte* (1954). Like many passages in those works, "La casada infiel" features riverine motifs that intermingle with sexual desire, gender asymmetry, cultural memory, and cultural exclusion. Thus, a subtle thread connects two places of the Hispanic Atlantic, Lorca's Romani Andalusia and Cabrera's Afro-Cuba. The scene of reading and recognition takes place in a subterranean space, the crypt of the legendary Café de Pombo in Madrid. Some two years later, in June 1929, Lorca travels to New York, then leaves the US for Cuba in March 1930, and returns to Spain in July 1930.

During this period Lorca writes the poems that will be collected posthumously in *Poeta en Nueva York* (Mexico, 1940), four years after his assassination at the start of the Spanish Civil War. By the time three of these poems appear in *Revista de Avance* in April 1930, Lorca is well known, if not famous, having inspired the formation of Afro-Caribbean literary avant-gardism in Spanish.[15]

The last section in *Poeta en Nueva York*, "El poeta llega a La Habana" ("The poet arrives in Havana"), contains "Son de negros en Cuba," a poetic homage to Lorca's hosts and friends in Havana. Lorca dedicates this poem to the person who officially invites him to Cuba, the renowned anthropologist Fernando Ortiz, director of the Institución Hispanocubana de Cultura, and Cabrera's mentor and brother-in-law. In Havana, where Lorca's poems had been appearing in the magazine *Social*, he meets Nicolás Guillén, José Antonio Fernández de Castro, Jorge Mañach, Juan Marinello, and other Minoristas, and sees his old friend José María Chacón y Calvo. Lorca and Carpentier meet in Madrid in 1933, where the latter publishes his Afro-Cuban novel, *¡Écue-Yamba-Ó!*[16]

These shared experiences of an uprooted Hispanism in Madrid, Paris, Havana, and New York open a different critical perspective on our investigation into insular avant-garde entanglements. But the perspective is markedly different from the unique neocolonial location of the Puerto Rican avant-garde. Palés's interest in Afro-Antillean themes rejoins this project through aesthetic and political affiliations with Caribbean and Latin American *poesía negra*, on the one hand, and with nationalist and anti-imperialist resistance, on the other. In Puerto Rico, as elsewhere in trans-Atlantic contexts, symbols and myths of the idyllic tropical island had developed since the nineteenth century through the creole elites' acquaintance with metropolitan discourses of exoticism and primitivism. Yet a tense relationship between the archetypal *jíbaro* and the exotic *mulata* of *poesía criollista* permeates traditions of *costumbrismo* and *andalucismo* and, in the influential Cuban case, *siboneyismo* and *nativismo*.[17] In these visual, textual, and oral genealogies, ethnic symbols stand in relation to a pan-Caribbean poetics that distinguishes them from other Black avant-garde expressions, such as Cuban *poesía negra*.

While Cuban authors like Emilio Ballagas, José Zacarías Tallet, Guillén, and the early Carpentier are more concerned with Black Cuban subjects than with a pan-Caribbean poetics, Puerto Rican avant-gardists navigate social and political crises by juxtaposing figures of a decomposing social body with onomatopoeia and *jitanjáfora*.[18] Some of Palés's *diepalista* experiments from 1921 persist in the Afro-Caribbean poems he starts publishing in 1925. Dada had affected the formation of the Puerto Rican *ismos*, leaving clear marks in *diepalista* poems like "Orquestación diepálica" (1921): "Glu-glu-glu, ta-ta-ti-ta-to, ta-ta-ti-ta-to ... / Flowing black water: ta-ta-ti-ta-to ... sssuuuss, / above pit-pit-pit, the stars, pit,

/ incomprehensibly / bite the moon. Behold: pit-pit-pit, on / trees; / the wind, witch-broom, sweeps: fluffffff ..."[19] In his essay "El Dadaísmo" (1922), Palés expresses a nostalgia for action when he writes about "a group of young revolutionaries that just formed a school under the name 'DADA,' in whose avant-garde figure the poets Tristán Tzara y Francis Picabía [sic]."[20]

But Palés does not endorse revolutionary attitudes, practicing instead a nativist aesthetics that sits comfortably with the liberal politics of the Puerto Rican "generation of 1930." In the 1922 essay, he captures primitivist and Dionysian elements: "The Dadaists extend this attitude to an extreme of revolutionary action: they don't sing but shout; the don't think but act – with a barbaric and primitive expressive apparatus they are consumed by an overwhelming enthusiasm to reach the mass more directly."[21] This description resonates with the poetic form of "Orquestación diepálica," a text that predates Palés's first "Black" poems, although the attempt to "reach the mass more directly" echoes a more elaborate formulation of an Afro-Antillean poetics in *Tuntún*. The "sour virility" and "truly pathetic pain" he perceives in Dada suggest an identification with European youth, and a desire to participate in the great "drama" of Western decline.[22]

Referring to Italian Futurist and other European contexts, Cinzia Sartini Blum sees in the interbellum period "a shifting defense strategy against the decaying structure of gender domination – a complex reaction to the myriad changes in gender roles and power relations that threatened male identity in modern society."[23] Among the young *diepalistas*, an elaborate rhetorical display replaces the perceived softness of their literary progenitors, the *modernistas* and *postmodernistas*. The *diepalistas* fetishize images of working men, militaristic gestures, and misogynist intimidation that verge on Whitmanesque homoeroticism. They appropriate the virile hands of builders, carpenters, and stevedores to pulsate the "great resounding instrument" and break the "old Pan's flutes." In "Abajo" (1921), a poem-manifesto that adopts Futurist and Dadaist gestures, Palés and José I. de Diego Padró mock *modernista* decadence: "All that tinplate music: / trinkets, cameos, reliquaries, / carved boudoir jewels, / black Congolese beads [*cuentas de negra congolesa*], / all that improbable fraternity / ... / let's leave them in Venice or Rome." Echoing Marinetti's misogynistic poetics, they renounce the "effeminate" *fraternity* of old, but while Marinetti envisions a novel poetic expression of velocity, the *diepalistas* forge a contrarian poetic idiom and evoke a vague universalism to come. Another stanza in "Abajo"

combines phallic images with traces of Dada and *creacionismo* – examples of what Marjorie Perloff identifies as "a collage aesthetic" and "collage works of a new kind" in Marinetti's manifestos of the 1910s: "The hour of the airship that lights his cigar with lightning, / ... / and the *jazzband* and the cowboy, / and drags and leprosy, / and empty stomachs."[24] Thus, Italian Futurism inscribes itself in *diepalista* poetics through a tropology of working men and literary effeminacy, present-day producers of the future-bound, and attacks on pastoral softness. *Postmodernista* "black Congolese beads" will be displaced by "hanging breasts," "dances," and "rhythms" in *Tuntún*, reinforcing a sexist and racist defensiveness that responds to an obsolete pan-Hispanic discourse and registers the effects of a changing Black internationalism.

Tuntún de pasa y grifería

Appearing in 1925 and 1926, some of the poems in *Tuntún de pasa y grifería* ("Black and mulatto drums," or "Drumming by Blacks and mulattos") count among the earliest examples of *poesía negra*. Relying on *costumbrista* and exoticist discourses of race and gender stereotyping, the images form emblematic icons of an idealized island, allowing Palés to thematize Puerto Rico as a space of autochthonous Caribbeanness.[25] Such gestures express a desire to articulate a pan-Caribbean construction of insularity that departs from cosmopolitan and international styles, yet exhibits what Sartini Blum calls "an attempt to deal with loss and adapt to historical developments that are beyond men's control."[26] The recourse to a stereotypical Caribbeanness is counterbalanced by an awareness of the political effectiveness of language, and by the necessity of formulating a "Black" poetics. In 1933, in a short essay on Palés's poetry, the Spanish critic Ángel Valbuena Prat writes: "Palés appears in the history of Puerto Rican poetry as the first national and at the same time (by the very intensity of this) cosmopolitan acquisition."[27] Valbuena does not elaborate on the precise nature of Palés's cosmopolitanism, but he refers to the intensity of his Black themes in contrast to the provincial *costumbrismo* and Antilleanism of Palés's mentor and national poet of Puerto Rico, Luis Lloréns Torres. Crafting images of an idealized Afro-Caribbean insularity, Palés intends to intervene in Puerto Rican and pan-Caribbean consciousness. But the struggle to establish a new poetic foundation for the truncated national project requires novel strategies for

imagining social cohesion and political inclusiveness. Palés's variety of *poesía negra* offers instead a cosmopolitan "aestheticization of politics" that circumvents cultural, ethnoracial, and gender realities, reinscribing a field of regressive tropes where "politics" disappears into escapism or a latent insinuation of political reaction.[28]

Following the "Prelude in Boricua" ("Preludio en boricua") (1937), the three parts of *Tuntún*, "Trunk" ("Tronco"), "Branch" ("Rama"), and "Bloom" ("Flor"), assert a Spenglerian poetics of ethnocultural development. Palés organizes this tripartite cycle as an ascending progression, with the final stage, "Bloom," signaling a sense of organic ripening. Beyond the tree metaphor, this arrangement evokes a project of genetic and cultural affirmation. What is striking about these poems is not simply the celebration of essentialist and nativist values – of what Stuart Hall calls "the question of roots."[29] The weight of these poems lies in their detached aerial views, the rhetorical distance they establish with Afro-Caribbean life. The vertical thrust of the tree metaphor is counterpointed by layers of cultural signifiers, indexes of the exotic island that deploy an intricate network of Afro-Caribbean clichés. But the insular ground remains impenetrable, the locus of unpredictable forces whose allegorical effectiveness relies on imaginaries of colonialist paternalism and racist stereotyping. In a chapter dedicated to "Tropes and Tropicality," Michael Dash lays out the coordinates to understand these imaginaries, or this discourse, as it applies specifically to Caribbean literary cultures. He traces the "early attempts to write the New World into existence"; the period when "The Caribbean became a fantasy theater for the imaginations of travelers, adventurers, and missionaries"; and a Western "impulse toward mythmaking that is directed at other, non-Western societies [that] tells us more about the West than it does about the societies written about." As Dash observes further: "The structuring of this discourse, its grammar of images and metaphors and especially its application to the Caribbean, must be seen as the starting point for any critical treatment of the emergence of the Caribbean in imaginative literature."[30] This starting point is sustained by fantasies of an archaic "place" of premodern and precolonial innocence onto which not only "Western" and colonial, but also Caribbean and anticolonial authors have often regressed, displacing images of a tame and timeless "Africa" onto the living cultures of Afro-Caribbeans.

Anne McClintock's discussion of "panoptical time" includes the emergence of a new trope in the late nineteenth century marked by

the cultural ascendancy of attendant discourses on European colonialism in Africa, "the invention of anachronistic space." "Within this trope, the agency of women, the colonized and the industrial working class are disavowed and projected onto anachronistic space: prehistoric, atavistic and irrational, inherently out of place in the historical time of modernity."[31] If McClintock's observation applies *globally* to a late Victorian colonialist ethos, it resounds only partially with the Puerto Rican context. There are echoes in *Tuntún* of the pastiche iconographies and pseudoethnographies of H. Rider Haggard's colonialist romance *King Solomon's Mines* (1885), and Joseph Conrad's novel *An Outcast of the Islands* (1896) and famous novella *Heart of Darkness* (1899). There are rich ethnographic accents in these works and in *Tuntún* that are enhanced by photographic captures of exotic and primitivist detail that "dialogues" with such mainstream films as W. S. Van Dyke's *Tarzan the Ape Man* (1932). In *Tuntún*, fetishistic annotations can be so convoluted and exact that they evoke the position of an informal ethnographer. While its poetic representations of island life are both "out of place" and out of joint with US colonial policies, they also incorporate an internalized colonial gaze, projecting a fantasy of homosocial appreciation for the pleasures of historical regression, biological immaturity, and cultural abjection.

Throughout these poems, the poetic voice wields reason through the distance imposed by the intensely voyeuristic structures of address. But discursive distance is another device, which probably never intended to reveal its own objectifying intent. The rigor of photocentric reason is intensified by the adjacent use of ethnographic material throughout the poems. The poetic project is intensely referential, producing visions of blackness that are constantly mediated by ethnographic authority. The island it seeks to reveal is an effect of efforts to identify with, and ventriloquize, "Black" sounds, bodies, and material culture. But at the core of *Tuntún* the photographic stillness and passivity of Afro-Caribbean voices and the absence of their returned, interpellating gaze render this discourse of insularity voyeuristic and phobic. We are left with a dialogue between poet, reader, and ethnographic palimpsest, where the referential matter is provided by static bodies who are trapped in ritualized performances of an ahistorical Afro-Puerto Rico.

I return to my discussion of representations of idealized Black bodies, and of the female body in particular. As I outlined above, cultural vitality and sexual excess invest performances of Black female bodies in *Tuntún*, suggesting vague political intensities, but failing

to articulate this potential beyond exotic dance. The performers are the subjects of elaborate representation, but not the agents of social emancipation or political action. They remain ornamentally in the referential third person, purveying local knowledge and voyeuristic reassurance for the male-identified, heteronormative reader. As Lydia Platón Lázaro notes:

> The central signifier of dance is located in the dancing body within altered conceptions of time and space. A parallel can be drawn with the native informant, a key figure in anthropological fieldwork … A dancer becomes a "native informant" in the language of movement, dancing knowledge, and expressing cultural experience through the body.[32]

In *Tuntún*, the activity of these elements that Platón Lázaro locates in "the dancing body" suggest the kinds of epistemic distancing that were characteristic of ethnographic and anthropological fieldwork in the 1920s and '30s. In many of these poems, there is a clear ethnographic thrust, but also a calculated pose and a will to seduce the reader-spectator in the self-exotic attitudes of the Black "subjects" under sensory scrutiny. In "Black Town" ("Pueblo negro") (1925), the earliest poem included in *Tuntún*, the stanzas advance like a camera, zooming into the deepening, intimate folds of an unknown scenario. The descriptive gaze takes in a pastiche of the African environment, including hippos, elephants, baobabs, and palm trees, before reaching the village where a singing Black woman reveals the residue of her inner folds. The poem frames the generic subject in the social space that constitutes her domestic abode and her social difference: "It is the black woman singing [*Es la negra que canta*] / her simple life as a domestic animal; / the black woman from sunbaked zones, / who smells of earth, of game, of sex" (49). Collapsing place, task, and character, these stereotypes reverberate through other poems in the book that inscribe repulsive clichés of the laboring classes. While the homosocial port scenes of late *modernista* texts and avant-garde literature, photography, and film are often coded as scenarios of productive labor and revolutionary potential, *Tuntún* casts laboring and dancing Afro-Caribbeans in domesticated acts of apolitical generosity and servility.

As the poetic voice approaches the Black town, a single stanza contains this vision of a tree: "The raging light layers / hard ochre over the vast land. / Red-hot, the stones sweat steam, / and the moisture of huge trees / mists to plant coolness / in the acrid crucible of arid air" (47). The corpulent tree in the middle of the "extensive

field" opens a rich array of indexical connotations, as the uniquely local and insular space where solace may be found the midst of a hostile expanse; or as the vessel that is also made of wood and *brea* (pitch), a metonym for Black bodies, and provides refuge and coolness like a home. This most sensitive of bodies, the tree, is made up of diverse parts, some reaching high, and others deeply rooted into the ground. *Tuntún*'s organicist aspirations are reflected in its many dismembered parts. They represent the chimeric struggle for a unified sense of national belonging across social, sexual, and ethnocultural differences. They inscribe Palés's project of an Afro-Antilleanist poetics in an endlessly articulated domain of avant-garde fragmentation and repetition extending far beyond Puerto Rico, the Caribbean, and the insular Atlantic. Palés transforms the melancholy lament over rootlessness into an affirmation of visionary poetic idealization.

In "Candombe" (1927), images of excessive physicality intermix with a stereotypical atmosphere of the tropical night in a dance scene: "Under coconuts, before ocean waves, / ferocious, lascivious teeth, / bodies coated with mud and molasses, / armpit smells, dangling breasts, / and coal-glazed eyes / the deep *gongo* ignites" (51). Finally, "Black Majesty" ("Majestad negra") (1934) compares a Black woman to a *trapiche* (sugar mill). Her bodily fluids, "sweating, bleeding" [*suda que sangra*], signals the hard labor and suffering of slaves and indentured workers, but it also aestheticizes the scene, and dilutes historical and critical polysemy. The female body performs a sort of collage where social realities are projected alongside voyeuristic sexual desire. This inscription of social differences onto the Black female body is further intensified by the conflation of the sugar-cane harvest (*zafra*) and the grinding of coffee: "Black sugar mill for a sensual harvest" [*Prieto trapiche de sensual zafra*]; "so the grinding culminates in dance" [*y la molienda culmina en danza*] (59).

A disjointed geocultural consciousness of the insular Caribbean finds a poetic replica in *Tuntún*. Within the book, symbols of African origins and onomatopoeic invocations, pan-Caribbean topographies and myths, musical and ethnographic terminology, and ironic tourist stereotypes similarly effect a poetics of fragmentation and mythical, historical, and contemporary mobility.[33] Antonio Benítez-Rojo's Deleuzian observations on "the Caribbean text" apply accurately in Palés's case. As he reflects: "The most perceptible movement that the Caribbean text carries out is, paradoxically, the one that tends to project it outside its generic ambit: a metonymic

displacement toward scenic, ritual, and mythological forms, that is, toward machines that specialize in producing bifurcation and paradoxes."[34] Indeed, *Tuntún* reinscribes numerous *topoi* of trans-Atlantic navigation and relocation. The aerial image of the tree that structurally holds this poetic dispersion together encapsulates a poetics of colonial and diasporic *uprootedness* and *errance*, and materializes into a poetic performance of *enracinement* in keeping with Spenglerian, pan-Caribbean, and nationalist Antilleanism.[35]

In *Tuntún*, places are haunted by nostalgia for the far away and the exotic. Visual and lexical longing are projected onto object-signs, bodies, and places mediated by ethnographic data, decontextualized and recontextualized materials, recodifications of autochthonous and exogenous cultural codes that result in poetic collages or pastiches assembled and reassembled to construct idyllic scenarios. Each poem is an act of fantasy, a sort of remedy against social dystopia. In no other Caribbean poetic corpus, perhaps, are the disillusionments, anxieties, and desires of the *modernista*, *postmodernista*, and avant-garde continuum better registered than here. Yet, the poet-ethnographer is not only a fantasist who dreams of accessing a sublimated African space. Palés writes for educated Puerto Rican and wider Spanish-speaking readers, and in a desired dialogue with these readers, he contributes to the permanence of a cultural object, the mythopoetic "trunk," "branch," and "bloom" of Black Africa in *mestizo* Puerto Rico and in the wider Antilles. What, then, is the function of the "native informant" or performer for the nationalist project to which Palés is committed? What does *Tuntún* suggest about the libidinal economy of this vision of national emancipation?

In "Mulata-antilla," the last poem in *Tuntún*, the poetic voice traverses the Caribbean or Antillean sea in a small boat at night, "sugar port, warm harbor" (*puerto de azúcar, cálida bahía*), repeating the verse "In you, mulata, now" (*En ti ahora, mulata*), or a variant. At the start of the fourth stanza, the poem's addressee, the generic "mulata" has become one with the sea: "Mulata, now you are / the entire sea and land of my islands" (*Eres, ahora, mulata, / todo el mar y la tierra de mis islas*).[36] The penultimate stanza contains an enumeration of Caribbean islands and cultural differences that recalls Guillén's *West Indies Ltd.*, and the final stanza recalls a couplet from the third: "Mulata, you are now / a glorious dawn in my Antilles" (*Ahora eres, mulata, / glorioso despertar en mis Antillas*). The mulata's assimilation to the islands seems complete, as signaled in the elision of A in "-antilla" in the

title of the poem, yet not without ambivalence. Palés will alter this graphic and phonic peculiarity in subsequent editions of *Tuntún* in 1950 and 1957. The "mulata" in "Mulata-antilla" or "Mulata-Antilla" is metamorphosed as object of desire, sexual partner, and sensory image of the islands, those tropes that the poem allegorizes as cornucopia of fruits, atmospheric sounds, and sexual innuendo. Sublimated and conflated with a battery of gender stereotypes, *what is the mulata* of Palés's imagination? *Who* lives and acts potentially in this fantasy of a passive, available, and speechless ethnocultural image?

Tuntún explores a play of identifications, desiring and exposing abject primitive subjects in photographic terms. Palés's project of a *poesía antillana* exoticizes the supposedly young and invigorating Afro-diasporic "roots" of the Antilles. As gendered carrier of timeless African difference, the native performer mirrors the project of Puerto Rican postcoloniality as its abject negative in space and time. She embodies a vision of the Caribbean island that the creole classes seek to understand and transcend. But the "poetic gaze" does not identify with the scientific, modernizing regimes of US colonialism; instead, Palés's limited repertoire of Afro-Caribbean clichés satisfies the Spenglerian and ethnocentric attachments of Atlantic Hispanism. The homosocial and racist fantasy of an Atlantic Hispanism informs Palés's poetry of anticolonial resistance and forecloses the articulation of a different poetics of race in Puerto Rico. In these complicated libidinal scenarios, it is difficult to imagine how Palés's *poesía antillana* might incite political resistance to US imperialism and support the inclusion of Puerto Rico among the diverse peoples and nations of the Americas. *Tuntún* caters instead to the racist demands of Eurocentric exoticism and "photographs" the Antilles as alluvial shores of Spenglerian universal history.

Voices / Places: *Motivos de son*

The poems in *Motivos de son* and *Sóngoro Cosongo* feature oral and aural renditions of Cuban types who seem to pose for the poet's recording equipment and camera, demonstrating Carpentier's apt observation on his experiences of this period in Cuba, when "Eyes and ears became aware of the living and the near" ("Los ojos y los oídos se abrieron sobre lo viviente y próximo").[37] The *son*, a musical and dance genre that, as Moore notes, "in its urban form has become the most influential Cuban music of the twentieth

century," permeates Guillén's early books as a structuring cultural metaphor, engaging Black performance practices as a means to intervene in the historical juncture. Guillén's unique audacity comes precisely from his elevation of the son to the subject matter and the political focus of his poetic work. Moore explains further that "*son* first developed as a marginal genre, composed and performed exclusively by blacks and mulattos in the poorest districts of Havana ... Together with *música guajira* (the music of Hispanic *campesinos*), it was among the first working-class genres to be disseminated on recordings and in radio broadcasts."[38] But the *son* is also an exclusively male performance tradition that adopts a gendered libidinal perspective to chronicle the immediate past and gerund-inflected present. The popular pedigree and formal freedom of the late 1920s *son* form that in turn inflect Guillén's poems of the early 1930s are markers of a patriarchal understanding of public performance, political resistance, and revolutionary action.

Guillén is not only interested in constructing portraits of specific Black subjects or types. His project, and his unique achievement, consists in the performance of suggestive, fragmentary, and non-idealized evocations of Black Cubans – *motivos*, representative musical and thematic fragments. Embodiments of blackness are here more fluid and transient than those framed by Parisian or local ethnographic scenarios in that voices are projected as transcending longstanding distinctions such as inside/outside, private/public, local/universal, civilized/primitive. But these very distinctions are reframed in syncopated *cuadros*, fragments of conversation, interlocutions and encounters that clump like a discontinuous verbal collage in the series of poems published by Guillén between 1930 and 1934. The relative stasis of many of these poems is perhaps a form of containment, a formatting of embryonic concerns that become spectacularly amplified in *West Indies Ltd*. What made Guillén change this intimate framing of an emerging social and poetic subject – Afro-Cuban experiences, voices, and struggles, with their performative and political potential – for an expanded, panoramic, and kinetic strategy?

Guillén's first "Black" poems appeared in "Ideales de una raza," the Sunday pages of *Diario de la Marina* in Havana famously initiated in 1928 by the Black architect and editor Gustavo E. Urrutia. In his 1982 memoir, Guillén relates an anecdote that propels the writing of the first poem in *Motivos de son*, "Thick-Lipped Cullud Boy" ("Negro Bembón"), and the other seven poems in the series.[39] "One night – it was April, 1930 – I was already in bed and navigating

that blurred line between dream and wakefulness, that in-between state [*la duermevela*] prone to goblins and apparitions, when a voice from who knows where formed these two words very clearly next to my ear: *negro bembón.*"[40] In Guillén's account, the *duermevela* precedes the writing of a Cuban "classic" of Spanish-language literature. In the polemic that follows publication, some critics read an attitude of excessive *choteo* (a Cuban form of mockery and sarcasm), paternalism, and even racism directed at Blacks by a young *mulato* or mixed-race poet. Others, in Cuba and beyond, understand Guillén's extraordinary poems differently. He reports in his memoirs that, in June 1932, Unamuno, then one of Spain's most influential writers and critics, writes from Madrid in a warm and celebratory tone. He explains that Lorca had mentioned Guillén and declares his interest in the poetry written by North-American Blacks and sung in Curaçao: "I have been following the blacks and mulattos' sense [*sentido*] of rhythm, of verbal music ... It's the spirit of the flesh, the feeling [*sentimiento*] of immediate, unmediated, earthly life."[41] But while Guillén's Black poems attract international attention, early readings of the poetic corpus fail to articulate cogent interpretations of the poet's desire beyond Unamuno's clichés.

Unamuno's assimilation of Guillén's poetry to the prescribed place of Black culture on the side of body and performance, rather than critical intelligence and innovation, expresses a common paternalistic attitude among European intellectuals or *hispanistas*. But what is the non-European poet's vision for the place of Afro-Caribbean experience, intelligence, and critique, within the wider arena of international Hispanism? The answer to this question is buried deep in the fabric of Guillén's writings, but the reasons for the precise articulation of Guillén's critical location of an Afro-Cuban variety of Hispanism are no less intricate. When Langston Hughes visited Cuba in 1930, Guillén interviewed him despite the seemingly insurmountable linguistic barriers – Hughes spoke some Spanish, but the two poets did not master each other's language. In his memoir, Guillén states that he had not read Hughes, although their names would become associated in the literature on *poesía negra* because of Hughes's coauthored translations of Guillén's poems in 1948 and a supposed influence of Harlem Renaissance aesthetics on Guillén. The publication of three of Hughes's poems in "Ideales de una raza" coincides with Lorca's visit in the spring of 1930.[42] While Lorca's untimely death in 1936 and the posthumous publication of *Poeta en Nueva York* shaped the Havana encounter, Hughes and Guillén remained friends and interlocutors for decades. As Shane Graham

points out, they met again "in Paris, Spain, and presumably New York during some of Guillén's trips to the city in the late 1940s and early 1950s ... Like Hughes, it seems, Guillén was receptive to signs of kinship and similarity with another mixed-race artist – and indeed, it is often noted that Guillén did not begin to write about racial themes in his poetry until he met Langston Hughes."[43]

In "Negro Bembón" Guillén appropriates a racist slur, turning it into a portrait of the poor and illiterate men who are commonly the targets of racism in popular culture, the printed press, and everyday speech and *choteo*. Moore observes that "Criticisms of the *afrocubanista* vanguard raised by the middle-class black community must be viewed in light of their overriding concern for integration into Cuban society."[44] Guillén's poems are mocked and imitated with malice in the press, while others see the poet as a trespasser, as he explains in his memoirs:

> Cuban Blacks protested against my *Motivos*, especially the two leading societies representing the Black population in Cuba, the Club Atenas, commanded by what one might call the "aristocratic" sectors, and the Unión Fraternal, which included in its midst people "of color" without the immediate means to climb up the higher floors of the great Cuban national edifice.

Encouraged by several literary friends, Guillén lectured on "Literary motifs" at the Club Atenas, where he "tried to explain the avant-garde literary movements not only in Cuban poetry but also in universal poetry and, of course, in Spanish poetry."[45] The scandalous edge in Guillén's poems hinges more on his relative opacity as a young *mulato* intellectual from the provinces than on the truly innovative and political character of his work. He was seen as a polarizing figure, and his first two books provoked uneasiness among the politically active Afro-Cuban societies.[46] In *Sóngoro Cosongo* and *West Indies Ltd.*, what might have been an ambivalent or compassionate identification by a relatively privileged mixed-race intellectual became a declaration of solidarity in support of anticolonial and antiracist insurgency. The new direction of what ostensibly began in the twilight of a balmy Havana night carries a series of erasures and absences, a condescending appropriation of class, linguistic difference, and gender register. The interrogation addressed to a *negro bembón*, "How come you jumps salty / when they calls you thick-lipped boy / if yo' mouf's so sweet, thick-lipped cullud boy?" (82), suggests anger in response to racist interpellation.

The paternalistic "good advice" offered by the ventriloquizing poetic voice asserts a poetic mode of complicity and vigilant support that permeates Guillén's early poetry, with its attentiveness to the miseries of the Great Depression and the Machado dictatorship, marked by political repression and violence, unemployment and squalor.

Kutzinski's interpretations "trace these masculinist poetics back to the quite overtly homosocial structures in a number of Guillén's early Afro-Cuban poems."[47] There are humorous, theatrical types, inserted in comical domestic scenes: the betrayed Black man and the unfaithful Black woman in *Sóngoro Cosongo*: "You'll treat her like you treated me, / as soon as I had no money / you went and had a good time / and forgot all about me."[48] To what extent are Black women represented as protesting and resisting political subjects and actors, and as people who are capable of effecting change and altering their own material conditions? Unlike Palés, Guillén does not foreground the voluptuous bodies of stereotyped Cuban *mulatas*, yet neither does he reflect the insurrectionary potential of their speech acts. Commenting on Masao Maruyama's ideas on invention as a cultural resource, Judith Butler observes: "For Maruyama, the subject who can take responsibility for building a future must become capable of both translation and invention, what I am proposing we might understand as a kind of performative agency."[49] In Guillén's Afro-Cuban poems, "performative agency" can be seen as *potentially* emancipatory for the writing subject. Its practice of cultural representation – or translation – is predicated on the *mulata*'s undeniable visibility beyond cosmopolitan references to modern womankind as central drivers of what Emilio Bejel posits as "new spaces and new subjectivities."[50] To the extent that Guillén does not fully *translate* communal subjectivity, but limits it overwhelmingly to a male-centered perspective, performative agency remains partial and problematic, fragmenting rather than enabling political transformation. Guillén's racialized female characters perform, but their agency remains uncertain.

Guillén's astute uses of vernacular linguistic and musical referents resonate with Bill Ashcroft's notion of *interpolation* – as "the entry into the 'scene' of colonization to reveal frictions of cultural difference ... so as to generate transformative cultural production. In this way the colonized subject 'interpolates' the dominant discourse."[51] Guillén's *interpolation* effected the dominant discourses of Cuban nationalism, trans-Atlantic Hispanism, and Black avant-garde cosmopolitanism. But it did not fundamentally undermine naive

renditions of the sensual and musical *mulata*, often confined to the space of the voyeuristic and male-centered *son*. Instead, Black women and queer subjects remained invisible and inaudible, located in abject peripheries and carceral non-spaces like those I examined in the previous chapter. Their whispers did not enter Guillén's half-awaken state, as if their interpellation (a type of primary and restricted preamble to *interpolation*) could not transcend the prescribed orders of the performative and the abject, pre-empting the poet from translating them into poetic language. Yet, the half-conscious insinuation of *negro bembón* carries with it a potential participation of abject subjectivities in poetic language: the women and queers who remain anecdotal as proto-political figures, haunting the domestic and carceral margins of island life like an unwanted noise. These Afro-Cuban poems deploy the signs of a new and powerful sociocultural imaginary. Through calculated ellipsis and exclusion, and creative invocations of a distinctly Caribbean consciousness, they conjure up a transitioning Cuba.

Tempestuous Tense: *West Indies Ltd.*

"Words in the Tropics" ("Palabras en el Trópico"), the opening poem of *West Indies Ltd.*, explores scenes of popular speech and creates an atmosphere of elegiac, solemn, or intimate in-betweenness. As a preamble to a formal gathering, *palabras* also indicate a tone of relationality, structuring the prosopopoeia at work in this and other early poems. The location of these *palabras* in a dialogic scenario between a geophysical space, el trópico, and a point of elocution, the Caribbean Sea, is abstract and lucid. Indeed, the tropical dimension of the title offers a stage or background to the panoramic vistas and detailed folds of the book's structure. The poet's words center a subject position only to fragment and dissolve its national self-awareness. In subsequent poems, Guillén's voice projects a tropicalized version of what Kaja Silverman calls the "dominant fiction" of prescriptive gender identities that can be contested, and where it is possible to discern a "male subjectivity at the margins."[52] I will argue that *West Indies Ltd.* is a reflection on margins and marginalities that questions the male-ethnic-national subject of Guillén's previous books. While this reflection is the result of Guillén's explorations of Black Cuban sonorities and subjectivities within the nation, *West Indies Ltd.* does not constitute a final detour. Instead, it demonstrates an active questioning of

the national project's sociocultural margins. In this detour – the beginnings of a cosmopolitan errancy, in Glissant's terms – Cuba appears to be refigured as an island among islands, immersed in the common tropics, and bound, beyond nationalism and Hispanism, by an emerging consciousness of marginality under a hemispheric imperialist dispensation. In this poem, the poetic voice addresses Trópico, a gendered addressee. The phallic impulse of the poem is both transparent and elusive: "Your bright light," "You dry ... You grease ... You pierce" (110).

In the opening stanza, the poetic voice addresses a character, Trópico, whose actions and attributes are god-like. But from the second stanza, there is a shift to the lyrical subject: "I see you come by ... I see you with rough hands." Walking the scorching pathways, Trópico carries a basket on his head containing mangoes, "begging sugar cane," and caimitos, "dark as a black woman's sex [*morados como el sexo de las negras*]." Expanding beyond the island garden, revealing perspective unfolds in the vouyeuristic third stanza: "Here, in the midst of the sea, / frisking [*retozando*] in the water with my naked Antilles, / my salute to you, O tropics! / A sportive, / vernal salute / soars from my salty lungs / over the heads of these scandalous Islands / who are also your daughters." Mediated by Guillén's intensely sensory identification with the Caribbean Sea, the sea of islands, Trópico is a simultaneous personification of the Caribbean environment. The location of Guillén's salute is vague, but the interpellation is certain, from virile heterosexual man to man. The poetic voice represents itself in a playfully erotic and domineering position, *retozando* with *his* naked Antilles, yet the islands are also *your* daughters. This place is thus constructed as a space of dynamic errancy and displacement: "Here, in the midst of the sea, / ... in the water ... / over the heads of these ... Islands" (110). Like some of the paintings Gauguin made during his Martinican convalescence in the late 1880s, Trópico "translates" numerous sexist clichés, yet the function of this exoticist fantasy soon splinters into a fragmented field of Caribbean crossings.

"Nocturne in the Docks" ("Nocturno en los muelles") is a solemn poem about cultural memory and historical consciousness, and about a multitude.[53] In the Italian and Spanish tradition of *terza rima*, the eight tercets (*tercetos encadenados*) and a final *sirventès* detail a night scene on the docks: "The dock, under the tropical night." The main symbolic elements are metaphors of marginality; a poetic space of remembrance that is steeped in slavery, sugar cane, and other raw materials; and a review of lived

realities that are constitutive of Caribbean exploitation, resistance, and consciousness. A dormant resentment seethes the crepuscular atmosphere: "But a tempestuous nightmare floats / above the lonely docks." The drama unfolds between two extremes, *under* the tropical night and *above* the docks. The third tercet speaks of a *shared* sorrow ("A sorrow of cemeteries and ossuaries") that is *fragmented* across as many anguished tombstones. Torn between the fourth and fifth tercets, the docks become a space of violent repression. The specter of slavery takes on the form of physical and psychic suffering: "... the dreadful / hours of many muscular / and weak men held by the reins / like horses. Wills come to a stop, / and pale unbandaged wounds." In the *sirventès*, a tone of defiance comes into focus through the introduction of a new symbol that resonates with the docks, lighthouse, cemeteries, and barracks. The fist is an addressee: "Oh, strong, elemental and hard fist!" We are reminded of the rough hands and other action-laden images of "Palabras en el Trópico," but "Nocturno en los muelles" culminates in an existential note whose political ramifications are at the center of the book's visionary project. "Who holds back your open gesture?" A questioning and ambivalent space opens between the question and the immediate answer, contained in the laconic final verses: "No one replies on the grief-laden port. / The lighthouse screams across the pitch-dark sea." The poetic voice seems immersed as a witness in this desolate space of death, emptiness, and loss.

The poem "West Indies Ltd." concludes with a couplet ironically titled "Lápida" (tombstone): "This was written by Nicolás Guillén, Antillean, / in the year nineteen thirty-four."[54] The author of "esto" is an "antillano" writing in the present. Like an early 1930s newsreel, the poem's genre is elusive, forming a collage of diverse images and musical references; and a compilation of perceptive local, regional, and hemispheric *faits divers* that amount to a crossing that chronicles visits to a few ports of call. The register is ironic, mocking, and bitter. Sections 3, 5, and 7 start with an apostrophe in italics: "*Five-minute break. / Juan el Barbero's charanga / plays a son.*" Timing and rhythm, and the introjection of musical patterns inscribe the radio broadcasting culture of the period, that formidable vehicle for vernacular cultures and aural literacies, when, from the early 1920s the *son* becomes a popular music genre that seduces affective communities from the Cuban Oriente to Havana.[55] The *son* dimension of "West Indies Ltd." highlights the overall construction of the poem as a chronicle and *recording* of public performances, reproducing the lively street-level

agitation in fragmentary and syncopated scenes of the fast-changing political climate. Adopting the tourist-colonizer's perspective, the poetic voice observes that the Caribbean landscape is miniaturized: "Ah, insular land! / Ah, narrow land! / Doesn't it seem just made / to plant a palm grove?" The Caribbean is not only an archipelago of passages and routes; it is, more fundamentally, a fragmented *land* of *ports*, a "field of islands": "Land on the 'Orinoco' route, / or another excursion boat route, / packed with people, not an artist / or a madman; / ... Ports where English is spoken / that starts in *yes* and ends in *yes*." By contrast with this enforced cosmopolitanism, the hungry, dejected, and unemployed men in "Walking" and in the seventh section of "West Indies Ltd." live on the edge of insanity and crime.

In "Guadeloupe, W. I.," the panoramic sweeps, fragmented recordings, and edited materials document seafaring passages and crossings that reach beyond the antagonistic limits of "West Indies Ltd." This last poem turns to the French island of Guadeloupe. The note "*Pointe-à-Pitre*" adds a reading clue that extends the mappings of Guillén's previous books. Guadeloupe and Pointe-à-Pitre belong to the Lesser Antilles, at the opposite extreme from Cuba and Havana. In this port, men of different ethnic and cultural origins are constantly at work, while the colonizers enjoy themselves. Under the burning sun, as the steamboat departs, a proliferation of gerunds expresses the hustle and bustle of the melancholy port city. The dramatic farewell to the island takes on an existentialist accent: "... I shout: Guadeloupe! / There's no reply." Despite the dynamism of the scene, there is no voice – the island cannot respond to the interpellation. Atmospheric conditions, ever present in *West Indies Ltd.*, turn opaque in the final verse. Is the scorching sun a metaphor for the hardships of the tropical climate, or a symbol of revolutionary solidarity and Black internationalism? Adopting the perspective of a receding steamboat, the poem concludes: "Back there, the blacks still work [*trabajando*], / the Arabs sell [*vendiendo*], / the French play, rest [*descansando*] / and the sun burns [*ardiendo*]" (89). This and other boats are not the harbingers of League of Nations cosmopolitanism, and Guillén responds to the spectacle by evoking the spirit of the Haitian Revolution. What else could these fires, planted across the meta-archipelagic Caribbean, express?

West Indies Ltd. denounces the ravages of imperialism on the fragile social and economic territories of the Caribbean archipelagos. In these poems, Guillén's cosmopolitan experiments reach a point of overexposure, an excessive torchlight effect that threatens the race

and gender politics of his own poetics. His fragmented dialogues with Hughes and Lorca are *palabras en el trópico* that destabilize his experimental desire. Tensely wrought between the metropolitan extremes of Hughes's Afro-American cosmopolitanism and Lorca's cosmopolitan Hispanism, Guillén's performances interpellate and co-constitute a pan-Caribbean poetics. But to what extent do these poems articulate a pan-Antillean poetics? *West Indies Ltd.* exceeds earlier poems, wrestling with a more generous view of Caribbean experience, and resulting in a vision of the Antillean archipelago reshaped by Black and *mulato* subjects and by other Caribbeans. But the gendered limitations of Guillén's repertoire are evident. While his visionary renditions of a novel West Indies imaginary are often homosocial and occasionally homoerotic, they exhibit a characteristic exclusion of female agency. In Burgos, by contrast with Palés's and Guillén's poetics, we see an uncompromising affirmation of gender difference.

Conscious Island: *Poema en veinte surcos*

In her first book, *Poema en veinte surcos* ("Poem in Twenty Furrows"), published in Puerto Rico before she moved to Cuba and the United States, Burgos does not imagine the island as a nostalgic scenario, as she will in her poems written in exile.[56] She explores a poetics of the ruptured earth in which images of the island soil, planting, irrigation, and suffering express an insurgent desire to transform previous imaginaries of the island as plantation, and of Afro-Caribbean and *criollo* islanders as the subjects of a tropicalized and picturesque vision of colonized island spaces. There is an awareness in this book that for generations, on the island of Puerto Rico and across the hemisphere, as Michel-Rolph Trouillot writes, "sugarcane was the slaves' most sadistic tormentor."[57] Sadistically inflicted torments leave traces of wounds and wounded subjectivities, an anxious desire to understand what fails to find articulation in language, and what figures in poetry. Published during the third year of the Spanish Civil War, *Poema en veinte surcos* earned Burgos the early critical acclaim that only a handful of avant-garde women poets, such as Josefina de la Torre in the Canary Islands, enjoyed in the insular Atlantic. The immediate recognition of her talent and promise has had long-lasting consequences for her inclusion in the canons of Puerto Rican and Latin American literature.[58] When, in a 1938 article, Lloréns declared Burgos "the most modern

[*ultramoderna*] and avant-garde among these five genial troubadours [*trovadoras*] from América", he inscribed her in the Latin American literary canon in ways that were both unequivocal and limiting, as a *poetisa*, and as a young promise.[59] Lloréns highlighted Burgos's "otherness," but not her difference, by noting her avant-gardism or "modernism." While Burgos stands formally in Hispanic and Latin American literary canons halfway between late *modernista* or *postmodernista* poets and avant-garde experimentalism, the content and implications of her work are unquestionably "*ultramoderna*" and avant-garde.

Locating Burgos in a transnational, rather than an exclusively insular, map, Lloréns measures her early work both inside and outside the local canon, freeing her from uncomfortable comparisons with other, not-so-modern figures, including himself. While the work of many *postmodernistas* carried cultural weight, Burgos was political and avant-garde in a more radical fashion. She introduced the bold contours of new political subjectivities and nuanced their voices in innovative ways.[60] One of the most intriguing poets in the Spanish-speaking world from her generation, Burgos is largely recognized today as Puerto Rico's "national poet." For the popular and critical imaginaries, she clearly belongs in a different category from Palés and Lloréns. The distance between Llorén's "Canción de las Antillas" (1913) and *Poema en veinte surcos* is colossal, making it impossible to reconcile the objectifying and racist tone of Lloréns's epic *criollista* Hispanism with Burgos's voice: "We are Indians! [*Somos indias!*] We are fierce, free, rough / and bare [*rudas, / y desnudas*] Indians, / darkened [*trigueñas*] by the Equatorial sun"; "... we shall be the Antilles, / summit and center of the language and the race!"[61] While Palés and Lloréns represent a national literature in tune with other examples across Latin America, Burgos stood soon after her death in 1953 as a national symbol of a different kind. She can be said to be the most popular Puerto Rican poet in the second half of the twentieth century and to date.

Burgos departs from the ethnic Puerto Ricanness of Lloréns's and Palés's nativist scenes and tropical habitats. "I don't want handouts from a worn out inheritance," she writes in "Cutting Distances" ("Cortando distancias") (21), as she sets out to transform received lyrical traditions.[62] Perhaps because Burgos is more often a poet of spaces than places, the abstract renderings of spatiality in her poetry have led critics to conclude that her poems suggest or describe landscapes, or that, in a telling critical metaphor, her "poetic landscape" contains the elements of a certain insular exoticism.[63]

Yet, instead of landscape, what we "see" in Burgos's first book is a desire to erase the normative stability of Antillean landscape constructions. In "My Symbol of Roses" ("Mi símbolo de rosas"), she gathers elements of the local environment as metaphors of *her* "symbol." In the fourth stanza, "The sea also wants to climb the palm tree of sounds / encrusted in my route ascending to the symbol" (43). A calculated substitution of tropical imagery for the construction of the island as a vantage point turns landscape into an interiorized experience of locality, rather than an exterior performance of place – a chorography and choreography – for the pleasure of travelers and tourists. In "Dawnings" ("Amaneceres"), in passages like "a million proletarian hymns" (23), Burgos thinks in overtly socialist terms; and in "Eighty Thousand" ("Ochenta mil"), a homage to the defeated of the Spanish Civil War, the battlefield is a landscape, and a political sense of rage and frustration takes precedence over chorography: "To lick the river, the blood / stretches in tongues of flames" (53).

"From the Martín Peña Bridge" ("Desde el Puente Martín Peña") is one of the rare poems containing a recognizable local referent in Burgos's poetry. Like the Río Grande de Loíza, which appears in a poem I discuss below, the indexical gesture inscribed in the specific bridge is loaded with historical and political meanings. This dramatic poem reminds us of the pessimistic political denunciations of César Vallejo's poetry, and of some of the anguished poetry written after the Spanish Civil War, yet its somber tone rises in two climactic couplets: "Break a million fists / against so unjust a morality! // Raise, raise your arms / like they were raised in Russia!" (41). This poem departs from the sugar-cane genre in its revolutionary call to violence against colonial injustice. This is a poem about the land, as the beginning indicates: "Broken land. The day becomes / the frame of the lagoon" (39). These powerful first words are firmly grounded on the same autochthonous mystique we find in "Ochenta mil," the poem Burgos writes to lament the deaths of anti-fascist fighters fallen during the Spanish Civil War. In the second and third stanzas, the image of "An army of houses" reinforces the atmosphere of violent insurrection. These verses are a declaration of the violent clash between the tropical construction of nature as the site of the projected dreamworld, and the imminence of political revolt. Words such as "hunger," "march," and "bones" evoke the atmosphere of other revolutionary struggles, such as the Mexican and Russian revolutions, and the Spanish Civil War, yet consciousness of a local genealogy is no less poignant.

In "The ax of time cutting / flesh of centuries of fasting" (41), one hears a clear reference to the exploitation of sugar cane and other crops on the island. In "Broken land. Strength broken / from excavating anguish so much [*de tanto cavar angustia*]" (39), the image of broken land hinges on a related image of digging, the strength now broken, too, from excavating or digging. An apostrophe addresses the worker in one of the last stanzas: "Workers! / Slash the fear [*picad el miedo*]. / Yours is the naked earth. / ... / and join the peasants / and those knotted to the cane" (41). Burgos enunciates a political map where references to peasants, urban workers, and sugar-cane laborers amplify experiences of island and archipelagic dependence, thus foregrounding different dimensions of capitalist exploitation in Antillean environments.[64] In their efforts to underscore Burgos's difference, critics have persuasively emphasized how her work strategically departs from hegemonic discourses on insularity and territory like those laid out in Antonio S. Pedreira's *Insularismo* (1934), one of the most influential books on Puerto Rican national character since the 1898 war (see the discussion in Chapter 2).

The twenty poems in *veinte surcos* represent efforts to *plow* the soil of an insular territory that, in spite of Burgos's attention to literary and Left universalism, names the island of Puerto Rico from a personal, intimate, and gendered viewpoint. In her preference for metaphors of insular soil, she contributes sophisticated ethnic, gender, and social layers to the traditions of *poesía criollista* and *jíbarismo*, fostering a new imagination of the island as ethnosymbolic landscape.[65] She turns away from stereotypical uses of landscape, expressing dissatisfaction with the visual and sensory regimes that had informed *poesía criollista*. Considering Ivette López Jiménez's discussion of Burgos's poems alongside Francisco Matos Paoli's *Cardo labriego* (1937) is enlightening in that it desingularizes Burgos as a hackneyed figure of the rebellious woman poet. While I agree with other critics that Burgos re-images pre-existing and surrounding genealogies, her flight away from authorized reflections on the land, including *Cardo labriego* and *Insularismo*, further supports my claim that she elects to suspend any direct engagement with the saturated field of idyllic tropicality. The word "landscape" appears often in readings of Burgos's poetry as shorthand for social and political referents. Yet the referent here is not landscape, but a poetics of rupture and insurgency – a rhetorical construction representing the material immediacy of a colonized people and their insular space.

"Río Grande de Loíza"

In "The Negro Speaks of Rivers" (1921), Langston Hughes writes: "I've known rivers"; "My soul has grown deep like the rivers." He adopts the lived memories and diasporic experiences of a political *figure*, the speaking and and remembering "Negro" of US racist discourse and African-American resistance.[66] Hughes's river is not a figure, but an intermittent and changing toponymic constant; it is the young and self-conscious "I" that awakens to the centuries-long diasporic experience. Two decades later, in *Cahier d'un retour au pays natal* (1939), Césaire muses: "Who and what are we? Excellent question." He replies with a series of *enforced* physical and mental metamorphoses: "By dint of gazing upon trees I have become a tree." He *thinks* of the river Congo in a collage of sensory evocations of Martinique and the distant memories of the island's African origins: "By dint of meditating on the Congo [*à force de penser au Congo*] / I have become a Congo rustling with jungles and rivers."[67] Césaire's evocation of the distant Congo is more symmetrical than Hughes's. His identification with the vast region and immense riverscapes is complete: *I have become*, by force or habit of looking and thinking from his displaced standing point on the island of Martinique. Hughes's perception of historical development, the revelation of intermittent displacement and repetition, fixes him in an awakening position, while Césaire's expansive reflections on African nature help him articulate a poetic transformation on Martinique, binding the Caribbean island of colonial experience with the sensory, aesthetic, and historical memories of African lives, colonialism, and imperial belonging.

In "Río Grande de Loíza" (9, 11), Burgos *embodies* the island she feels and sings as a liberated woman. In her transfigurations of Puerto Rican experiences and affects, she lends it a female body and a bold political voice. Her identification with various places is an example of this epic attitude of identification with a male-gendered space whose production of landscapes has been altered by feminine desire. Through games of address and indexical gestures, Puerto Rico is not seen, exposed, or exhibited as a body of land attractive to tourists and other outsiders. The island appears instead as the living body of a voice whose traces, outliving the material life of the poet, are the *furrows* or paths of a particular Caribbean geography. The island is the lived experience of the people and its "daughter," and its presence in time is far more decisive than its

inscription through the means of capitalist circulation and aesthetic proliferation. Burgos undeniably realizes the project of narcissistically rendering her life and work as a poetic mirror of the political struggles of the island's wretched and dispossessed, and as a participant in international efforts to denounce social oppression. Her poetry intervenes in the interlocked landscapes of contemporary avant-gardism, literary institutions, and radical politics.

The heightened sense of subjectivity and the fragmented self appear here in a bodily interaction with the river, and in various metapoetic gestures, in verses such as "Coil yourself upon my lips and let me drink you," and "To hear astonished voices in the mouth of the wind." In the third stanza, the poetic voice insists on a kind of symbolic and metaphoric embrace with the river, addressed as a lover and, in any case, as an anthropomorphic being; in the tenth and eleventh stanzas, the river arises as the idealized lover, a man as pure as the river. In the fourth stanza, the first person constructs the river as a "memory scape," a place of remembrance where childhood is idealized: "Río Grande de Loíza! ... My wellspring, my river / ... / "and my childhood was all a poem in the river, / and a river in the poem of my first dreams." The river is a space of intimate projections, but its material referentiality enhances its semantic strength as a symbol of the island of Puerto Rico. The fluidity of this "place" agrees with the general poetics of liquid fluidity that positions Burgos in contrast to the poetics of enclosure and isolation in Pedreira's *Insularismo*. Furthermore, she uses the temporal qualities of the river to reflect on her island childhood and youth. "Life," "my soul," and "my body" interlace in the fifth stanza, composing a composite sensory image of the island as the space of embodied time: "Where did you take the waters that bathed / my body in a sun blossom recently opened?" The nostalgic memory contains only a vague displacement of sexual desire and exotic longing: "Who knows on what remote Mediterranean shore / some faun shall be possessing me!"

The "rainfall" [*aguacero*] of the eighth stanza suggests a boundless Atlantic Caribbean, while "I shall be freezing in icicles [*me estaré congelando en cristales de hielo*]" denotes an existential premonition of death and suffering. In these images, two visions of the island, its history, and the desire to transcend it and to transgress its cultural stagnation, are outlined. The ninth stanza imagines the Río Grande de Loíza not as a distilled symbol, but as an aspect of an organic world of nature on the island. In the last stanza, images of pouring would converge in the image of crying: "Great river. Great

flood of rivers [*Río grande. Llanto grande*]." The river rhymes with the powerful embodiment of the poetic voice. These oft-cited verses are an Antillean and Puerto Rican anticolonial declaration, and the poet's body, now identical with the body of the island, is the evidence of its rhetorical and political consciousness. In "Río Grande de Loíza," Burgos's identification with the river articulates a complex metaphorical field linking body, soul, life (time, memory), and further allowing for an identification between the suffering poetic voice and her enslaved people through the liquid, embodied image of crying. As Iris M. Zavala suggests, these regional images are suggestively tied to specific social realities: "She establishes a firm Caribbean and Afro-Puerto Rican presence by choosing as the cartography of desire the flow of the river that borders the grounds of the most famous Black settlement on the island."[68]

The sensory emphasis of "Río Grande de Loíza" offers an interpretive key to the fragmented totality of *Poema en veinte surcos*. "Woe Woe Woe to You, Black Hair" ("Ay ay ay de la grifa negra") (33), for example, is a first-person *planctum* or lament. A female voice tells her story of racism and exclusion (she refers to herself as "a black statue"), and playfully remembers the history of slavery in Puerto Rico: "Ay, ay, ay, wash the sins of the white King [*del rey blanco*] / in forgiveness black Queen [*la reina negra*]."[69] The "kinky-haired and pure black [*pura negra*]" character, the deployment of a Black–White power dynamic, and the evocation of *mestizaje* in the final stanzas connect the poem with Guillén's dialogic strategies, while distancing it from *Tuntún* an other examples of *poesía negra*.[70] "I cry" [*lloro*] evokes the "great flood of tears" [*llanto grande*] and "our island's tears" [*nuestros llantos isleños*] in the last stanza of "Río Grande de Loíza." The two poems enrich one another and point to common preoccupations with slavery, blackness, and Caribbean diasporas. In both cases, there is a resistance to construct Black subjects as embedded in insular landscapes. If "Río Grande de Loíza" figures the river as addressee and object of desire, "Ay ay ay" constructs a self-grounding persona: "Black chunk of black in which I sculpt myself, / ay, ay, ay, my statue is all black." The image of a black statue converses with representations of the "primitive" in avant-garde objects. As López Jiménez argues, there is a meaningful "distance" between the dancing *mulata* and this static image of a Black woman's statue.[71]

"Río Grande de Loíza" is a genealogical poem that mocks and reinscribes myths of interracial rape, power, cultural shame, and, ultimately, a discourse of *mestizaje* that projects a pan-American

future in the final stanza. Like the flow in one of Mayakovsky's poems, "150.000.000" (1924), Burgos's river stages a poetics of bodily confluence and transcendental embrace: "Our soul / will be the confluence / of Volgas of love," shouts Mayakovsky, and "Down every / fine artery / we'll let sail / the fantastic ships of poetic inventions." He also exclaims: "Beat, drum! / Drum, drum! / There once were slaves! / No slaves anymore!"[72] While the poem evokes more directly Hughes's and Césaire's American and Caribbean sonorities, there is an undeniable revolutionary desire in her identification with the political pulse of Puerto Rico. In his 1938 essay, Lloréns universalizes Burgos as a great "American" poet. The last stanza evokes an ideology of *mestizaje* that echoes other poetic voices from Latin America and the Caribbean, from Martí to Guillén.

"Ay ay ay" ends on an ambitious utopian gesture that includes "América" and de-localizes the insular experience of race. The poem indicates how Burgos's textuality remains grounded in a dialectical engagement with the aesthetic, social, and historical conditions of 1930s Puerto Rico. Deviating from pessimistic constructions of the island, such as Pedreira's "ship adrift" in *Insularismo*, Burgos's poems enact an avant-garde "politicization" of poetic affects that most Caribbean poets of her generation only dare to outline or project.[73] This enactment does not theorize pan-Hispanist ideology; instead, it insularizes trans-Atlantic debates, tropicalizing institutional discourses through a poetics of solidarity, transnational awareness, and political universalism that is rooted in Puerto Rican and pan-Caribbean struggles.

In these poems, race does not flee to a utopia of cosmic integration of races and cultures; it reaches the water and suggests a fluid Caribbeanness that transcends insularity without effacing the impact that traces of slavery and racism have on island lives.[74] As Burgos travels to New York and Havana in 1940, she distances Puerto Rico from itself and narrates the island from the many locations she will inhabit. Lena Burgos-Lafuente reminds us that, in Cuba, Burgos sees Juan Bosch and joins the spaces "of the Marxist intellectuals Raúl Roa and Juan Marinello, Nicolás Guillén and Pablo Neruda, and of political links with Mexico ... Cuba was also the world of loneliness, amorous passion, and economic precarity ... Indeed, her Cuban sojourn was, above all, a time for writing."[75]

Disidentification: After "Mulata-antilla"

Burgos's distancing strategies should be measured against the composite image of an Antillean poetics of fragmentation in the Caribbean 1930s. If the figure of the "Mulata-antilla" reinscribes longer genealogies of misogynistic exoticism, avant-garde re-readings of the colonial Antilles separate geopolitical projections and progressive identifications. In the 1930s, Germanophile Hispanism and Spanish avant-garde culture enabled a new poetic Antilleanism. But in different ways, these textual crossings evoked the exotic pastiches of world's fairs or *expositions universelles*, grotesque reconstructions of ethnographic fieldwork that reproduced colonial and commercial scenarios enhanced by the objectified sensuousness and real-life "presence" of cultural others. In her extensive critical argument around the 1931 Paris Colonial Exposition, Patricia Morton observes that "The 1930s saw the eruption of nationalist struggles and anticolonial, anti-Western movements, of which the protests around the Colonial Exposition were a sample."[76] As carefully constructed performances of remote colonial cultures, world's fairs and exhibitions paraded the trappings of Western civilization, colonial supremacy, and technological superiority; they deployed a "taxonomy of marginality" where "colonized natives could participate in the Exposition only as servile accessories to its pavilions."[77] Confronted with this performative regime, Palés, Guillén, and Burgos imagined how the colonized nation might resist and survive despite the fragmentary pictures, motifs, and scenes of racialized essentialism that conditioned and to a large extent constituted *poesía negra*.

The decentering of the Eurocentric compass has complex aesthetico-political ramifications and yields different responses in the texts I have discussed. For these poets, confronting the logic of Germanophile rationality, navigating institutional Hispanism, and participating in national literary circles might all have required a reorientation of deep-seated identifications; a radical and experimental renegotiation, for example, of an uprooted transnational Hispanism wrought halfway between the intellectual modernism of Unamuno and Ortega, and the progressive avant-gardism of Lorca and Valbuena Prat. I have tried to show the importance of addressing a not altogether "new" or "avant-garde" consciousness of the exploited island to better understand the process of *poesía negra*, and to illustrate what the title of this chapter names "a poetics of

Antillean fragmentation." Clearly, the texts I have discussed form a composite image that interpellates cultural and political reality. But can we speak of a common reorientation in the trans-Atlantic traffic of avant-garde poetic exchanges? An aesthetico-political reorientation of Antillean poetics would perhaps require a more radical rupture away from the institutional and ideological varieties of Hispanism; and the avant-garde poetics of fragmentation constitute a kind of disidentification *within* Hispanism only in a limited sense.

Writing a century after the publication of Marinetti's *Manifesto del Futurismo* in 1909, José Esteban Muñoz reflects on "disidentification" as a notion that "focuses on the way in which dominant signs and symbols, often ones that are toxic to minoritarian subjects, can be reimagined through an engaged and animated mode of performance or spectatorship. Disidentification can be a world-making project in which the limits of the here and now are traversed and transgressed."[78] Muñoz's engagements with contemporary avant-garde practices and detailed critical work around the *spaces* of performance, spectatorship, and daily life survival among Antillean, queer, diasporic, and other "minoritarian subjects" constitute an instance of deviation from early twentieth-century Hispanisms. To the extent that "dominant signs and symbols" remain hegemonic through the Antillean 1930s, Muñoz's ambitions for a "world-making project" where "the limits of the here and now are traversed and transgressed" resonate with what might and might not be transformed in the avant-garde poetics of Palés, Guillén, and Burgos. A century after the explosion of Black avant-garde poetry, important questions remain around the precise relationships between prescribed identities, broken identifications, and experimental modes of representation.

4
Carceral, Island, Nation: Cuban Romances in Photography and Fiction

The Male Witness

This chapter centers on Cuba and extends the story that starts in Havana with the Minorista group, its activities after the political gesture of the "Protesta de los Trece" (Protest of the Thirteen) in 1923, and the foundation of one of Latin America's foremost avant-garde journals, *Revista de Avance*. I focus on Cuban cultural politics during the 1930s, highlighting how three authors narrate and conceptualize avant-gardist politics, including issues of race, gender, and masculinity. The first section examines an intriguing event in the history of twentieth-century photography, the Cuban photographs that Walker Evans includes in *The Crime of Cuba* (1933), a political essay by the leftist journalist and Latin American expert Carleton Beals.[1] The second section considers Alejo Carpentier's first novel, *¡Écue-Yamba-Ó! Novela afrocubana* (Madrid, 1933), and the third and last section discusses another novel, *Hombres sin mujer* (Mexico, 1938) by Carlos Montenegro. None of these men is a native of the Caribbean, yet they share intimate relationships with the trans-American dimensions of Afro-Atlantic culture. Montenegro's birthplace is a small town in Galicia in the Spanish northeast. Born in 1900, he emigrated to Cuba with his family in 1907. Although born in 1903 in St. Louis, Missouri, Evans had become a New Yorker by the time he traveled to Havana on commission to do a photo essay on the political situation there.

Carpentier was born in 1904 in Havana to a French father and a Russian mother.[2]

Coming of age around World War I, the three men were children of the intellectual and political radicalism of the period. Montenegro and Carpentier were Communist sympathizers and had a direct experience of political violence under President Machado. They participated in avant-garde circles and reflected on the sociocultural dilemmas of their time. Unfolding uneasily across contrasting repertoires of inter-American, Atlantic-Caribbean, and "minor" cosmopolitanisms, their works share a passionate investment in Afro-Cuban entanglements and intercultural dialogues, prompting a set of critical questions. But do these written and visual works (photographs, essays, ballets, novels, short stories, and poems) intersect, dialogue, or contrast with each other in discernible patterns? Given these authors' backgrounds, can their works be considered as variations of a Black Caribbean and trans-American avant-garde? I will argue that the materiality of the visual/textual island informs a dilated zone of critical intersections in their individual renditions of Cuba.

If tropes of social, racial, and cultural degeneration abound in 1930s US prison narratives, a range of simplified conventions shape "tropical," colonial, and island-prison literary production. A chapter in Viktor Folke Nelson's popular prison autobiography, *Prison Days and Nights* (1933), is unambiguously titled "Men Without Women." But further tropes of gender segregation and sexual and emotional privation among male inmates are not Folke's invention – Ernest Hemingway's second short story collection has the same title.[3] According to Regina Kunzel: "Following the success of Nelson's book, discussions of sex would become nearly obligatory in prison autobiographies and in much of the inmate-authored fiction that gained popularity beginning in the late 1920s and 1930s."[4] As the period literature on male imprisonment confirms, carceral spaces were often reconstructed as sites of social interaction, cultural friction, and gender-bending affect and deviance. Like some versions of the merchant or military vessel, secluded farming and mining communities, and military garrisons, carceral spaces functioned as sociopolitical islands or "miniature continents." In literature and cinema, tropical island prisons were spaces of containment and contagion bent on limiting, reducing, and breaking its dwellers. While seeking to insulate the polity from malignant contagion, these spaces represented society's undesirable margins and unspeakable practices. No less central in the following

discussion is the perspective of the male witness who documents, remembers, and narrates. While there are autobiographical and documentary aspects in all three "narratives," I claim that they present us with fragmentary facets of an island-centered avant-garde cosmopolitanism.

"A photographic editing of society": The Cuba Portfolio

Evans is a cosmopolitan witness, a distant participant and aesthetic enabler intruding in the final days of President Gerardo Machado's regime (1925–33), a period known in Cuban historiography as the *Machadato*.[5] In a bold review essay published in the American journal *Hound and Horn* a year before he traveled to Tahiti and Cuba, he discusses a series of recent European photography books, downplaying pictorial, Dada and Bauhaus developments. He notes, somewhat hermetically: "Actual experiments in time, actual experiments in space exactly suit a post-war state of mind"; and "Eugene Atget worked right through a period of utter decadence in photography. He was simply isolated, and his story is a little difficult to understand."[6] If Atget's "state of mind" captures Evans's imagination, in the last paragraph he mentions *Antlitz der Zeit* ("Face of our time"), the phenomenally influential book by August Sander containing an essay by Alfred Döblin:

> *Antlitz der Zeit* is more than a book of "type studies"; a case of the camera looking in the right direction among people. This is one of the futures of photography foretold by Atget. It is a photographic editing of society, a clinical process; even enough of a cultural necessity to make one wonder why other so-called advanced countries of the world have not also been examined and recorded.[7]

Early in 1932 Evans travels to Tahiti on commission as the main photographer for a group of wealthy vacationers. Gilles Mora and John T. Hill claim convincingly that "some of Evans' surviving still photographs strike us today in their almost ethnographic style, particularly the portraits." But their interpretation of Evans's cultural genealogy is less persuasive: "It is as if Evans had begun to see through the eyes of Lewis Hine. He also experimented with a few botanical compositions. In them, confronted with the lushness of the tropical landscape, Evans took pains to avoid cliché and the

picturesque."[8] In their efforts to distance Evans from the visual climates of the tropical "South Seas," Mora and Hill refer somewhat anxiously to Lewis Hine's signature images of New York industrial modernity and its workers. But the "almost ethnographic style" and content of these images cannot be easily circumvented. The cultural and aesthetic frames are indeed ethnographic from this point on in Evans's career and, decisively, in the Cuban photographs.

As Evans filmed and photographed yachts, travelers, sailors, islanders, and tropical landscapes, we can discern in the Tahiti photographs the distinctive texture of "documentary" and fiction films such as *Tabu*, *Moana*, and *White Shadows in the South Seas*. Writing to his former New York roommate and close friend Hanns Skolle, Evans commented on the "South Sea" footage in these terms: "Movies are more difficult than I realized. I seem to be able to get striking individual pictures but have difficulty in composing any significant sequence. Hard to dramatize my subjects."[9] Standing in relation to filmic time, some of these images are dynamic and narrative, but they generally resist freezing their subjects in anecdotal or ethnographic poses. While I concur with the opinion that "Evans took pains to avoid cliché and the picturesque," I would suggest that he alternates between the requirements of ethnographic and picturesque conventions, counterpointing them with his own inquisitive "hungry eye" for modernist composition, subject matter, and wit. However, Evans's work is no mere tributary of Atget, Sander, or Hine. The Cuban portfolio is occasionally reminiscent of Hine's "work portraits": *Child Labor in the Carolinas* and *Day Laborers Before Their Time* (1909), and *Men at Work* (1932). But other photographers of Evans's generation, including Ralph Steiner, Martín Chambi, Dorothea Lange, Tina Modotti, Martin Munkácsi, Manuel Álvarez Bravo, and Henri Cartier-Bresson, started out and often continued photographing "ethnic" subjects.[10] Like Evans's early images, their works are neither exclusively ethnographic nor consistently picturesque.

Beals's editor at J. B. Lippincott in Philadelphia had looked for a photographer with some urgency and, as *The Crime of Cuba* shows, a panoramic approach of the ongoing revolution had to be captured, framed, and exposed for a North American readership. Years later, Evans relates: "But I did land in Havana in the midst of the revolution".[11] Machado had been forced out of power by August 12, 1933, one month before publication of *The Crime of Cuba*; in the second edition, published in 1934, Beals added an "Aftermath" subtitled "Revolution." Evans's images and Beals's

pledge to end colonialist meddling on the island must have had a powerful impact at the time. The images navigate a tense political border separating social reality and cultural stereotyping, a dividing "color line" in the changing senses that Frederick Douglass and W. E. B. Du Bois ascribed to this expression.

Evans arrived in Havana in May 1933 on a mission to provide illustrations for Beals's book on Cuban politics. A few anecdotes define the quick visit, including how the agreed two weeks were extended to three upon Hemingway's invitation. He wanted to find his way as a commercial photographer and artist and needed to make sense of the urbanscapes he had experienced since his trip to Paris in 1926. As he confided to Skolle in 1932: "I am beginning to understand what sort of a period we are living in."[12] In Havana, Evans gravitated toward Hemingway, a cosmopolitan American of his generation, a situation that seemed worth recounting in an interview almost four decades later: "It was a job. It was commissioned. You must remember that this was a time when anyone would do anything for work ... which turned out to be lucky because it brought me to Hemingway. Drinking every night. He was at loose ends ... and he needed a drinking companion, and I filled that role."[13]

Evans chose not to read Beals's manuscript before or during the trip. He retained the freedom to select his subjects, establish the photographic sequence and include his work at the end of the book so as not to illustrate it, as he explained decades later: "I did make some conditions. I said I wanted to be left alone. I wanted nothing to do with the book. I'm not illustrating a book. I'd like to just go down there and make some pictures but don't tell me what to do. So I never read the book."[14] J. B. Lippincott obliges, and the images figure in a separate section at the end of the book under the heading: "Cuba: A Portfolio of Photographs by Walker Evans."[15] But what is the sequential or narrative logic of the Cuba series? Svetlana Alpers foregrounds "the calculated relation of theme, shape, and intermittent rhythms ... But there are losses: loss of the many fine photographs that did not fit in, and loss because those that fit in are subjected to the sequence."[16]

The sequence of thirty-one images transmits the illusion of a photographic montage, a sequence of the sociopolitical situation that could be rearranged in multiple ways. The series is both a paratext and an autonomous visual composite, reflecting Evans's wish that his work not be presented as merely illustrative of Beals's essay. As Mora and Hill note: "Even though this order

bears some of Evans' later style in sequencing, it is uncertain that Lippincott followed his suggested 'arrangement'." In any case, the visual work became "Cuba: A Portfolio of Photographs by Walker Evans."[17] The photographic sequence that Alan Trachtenberg calls "the sequential method" is not only a narrative device, but also a visual arrangement, a specific environment through which we can establish distance and proximity with Cuba. Trachtenberg explains:

> Except for numbered titles on the blank page facing each image, no text intervenes to inform the pictures or explain the sequence, whose most evident order seems to be a series of social contrasts – elegance and shabbiness, pleasure and labor, wealth and poverty, begging mothers and fashionable prostitutes – leading to a closing section in which the bloody police images are intercut with Evans's own pictures of tough stevedores, patrolling soldiers, and the rebellion portended in the wall slogans. The effect is cinematic, a political montage.[18]

There is an air of excited expectation in many of these images. Evans is preoccupied with capturing the changing atmosphere, the transforming time of impending revolution or, to use Susan Buck-Morss's expression, "the politics of conflicting temporalities."[19] Throughout the sequence, and in images that do not appear in the portfolio, such as *Citizen in Downtown Havana* (see Figure 4.1), Evans reflects on symptoms and indices – gestural, contextual and photographic evidence of the social and political present affecting all Cubans. He identifies with "the man in the street" and holds any analysis of Machado's supporters or his various antagonists and critics until the end of the sequence. The photographs articulate an appropriation of "others" for metropolitan eyes by historicizing and illustrating coevalness between Great-Depression America and neighboring Cuba, an insular space that Beals insists on calling "our protectorate." As David Luis-Brown observes, quoting from the first edition of *The Crime of Cuba*: "The text presents an unrelentingly grim picture of Cuba that contests, as did Guillén's poetry, the romanticized view of 'Old Havana' then used to lure tourists. Beals's Cuba is ruled by absentee landowners from the United States who make life 'an elementary, savage struggle for survival'."[20] And Hugh Thomas comments on Machado's leading role in this state of things: "His origins were rough and crooked. He began life in a butcher's shop in Camajuaní, and bore thereafter the macabre marks of that trade: his left hand had only three fingers."[21]

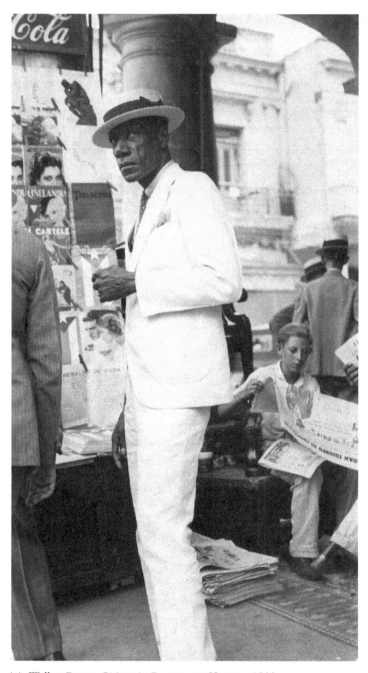

Figure 4.1: Walker Evans, *Citizen in Downtown Havana*, 1933

The Butcher

The fifth part of *The Crime of Cuba*, unironically titled "American Penetration," summarizes a process of neoimperialist practices spanning the three previous decades. Although Beals does not mention the "Platt Amendment" (1901) and the "Cuban-American Treaty of Relations" (1903), he questions the moral grounds of US activity on the island: "Profits, not justice," as he concludes. He lists the means the US had used to serve its own interests during the long "banana wars" period:

> Despite American dollars poured into Cuba to buy out the island, despite all the technical knowledge we have bestowed, despite the good advisers and experts paid for by the American and Cuban treasuries, all this sanctimonious effort has merely helped precipitate our protectorate into its present tragic economic and political condition. Why?
> Our major purpose in Cuba has been profits, not justice.[22]

At the time of Evans's visit, Havana boasted dynamic cultural institutions and, at the forefront of avant-garde activities, a composite of journals, political attitudes and individuals that orbited around Minorismo. On his return to New York, he wrote to Beals, on June 25, 1933:

> The old butcher seems firmly in, still, for some time to come. Your friends were invaluably helpful to me as well as immense entertainment ... It was a perplexing job, so many different courses to follow. I wonder if the illustrations will seem Cuba to you, as you know it. I do think that if they are reproduced precisely my way, as indicated, they will be something noticeable, and that ought to help the book.[23]

Evans told Beals he wanted to mention in the acknowledgements those who had helped him: "Fernández de Castro and his brother; Rivero, Farres and Phillips and the U.P. man, Haas; lots of others. What do you think? ... P.S. ... Had no trouble with the authorities."[24] Following Beals's lead, he met with members of the Minorista group, like José Antonio Fernández de Castro, who had participated in the "Protesta de los Trece," with members of the Communist Party, and with intellectuals outside Hemingway's circle. It is not surprising that there is a striking synchronicity between Evans's work and the central tenets of the Minoristas and

their *Revista de Avance*. Like other art photographers working in the 1920s and '30s, Evans styled himself an avant-gardist and pushed the formal conventions of the medium in a series of images from the late 1920s. Like Modotti, Steiner, Munkácsi, Álvarez Bravo, and Cartier-Bresson, he was interested in the human figure in social and spatial contexts. The range, depth, and distinctive languages of these photographers make them protagonists of twentieth-century photography, while Evans's commission to append his photographs to Beals's book was a defining moment in his career and, arguably, in the history of pan-American documentary photography. In the portfolio, Havana is a politically overexposed carceral space threatening to overwhelm the hackneyed purity of its photographic subjects. Indeed, one fears that this space is too close to the "cliché" and "picturesque" that frame life and colonial activity in Tahiti. However, as Ana Dopico observes incisively, other framing mechanisms obtain: "Echoing nineteenth-century heterotopic visions of Havana as a place of darkness."

> As the United States transformed the Cuban Revolution of 1895 into the global imperial project of the Spanish-American War, U.S. citizens read newspapers, magazines, and books whose images and descriptions confirmed the sensuous promise, commercial opportunities, missionary agendas, and geopolitical necessities of their country's expansionist and annexationist aspirations. The island at war became a "no place," a screen onto which the United States could project these designs.[25]

Evans sees Havana through yet another lens, one that Mora and Hill seem to elide as they locate the Cuban images in the double frame of the US photographic canon, with appropriate cosmopolitan references to French and German models, and within the narrative that establishes Evans as a key representative of Depression-era photography. That other lens is Harlem in New York, a cultural and political space whose modes of expression and visuality cannot have escaped the young modernist photographer about to experience a different cultural environment, and a distinct configuration of the color line, in an Afro-Caribbean city. Unlike Beals, a respected commentator of Latin American affairs, Evans was not well acquainted with Cuban politics and cultural differences. He found himself documenting a uniquely Caribbean version of what Marlon B. Ross calls "*racial trespassing*, the contrary of the more frequently studied phenomenon of racial passing."[26]

Most of the Cuban photographs, including the estimated 400

negatives that illustrate various catalogs, would be seen rarely in future publications, and only a few are among Evans's signature creations.[27] These images are portraits of the vibrant contemporary city and the besieged island-nation, reflecting only indirectly on the events that Beals seeks to diagnose and expose through his film noir formula of tropical crime. Evans transposes onto Havana a certain way of "reading" street life that he had acquired in explorations of New York neighborhoods. We recognize similarities with his photographic ramblings through Brooklyn from 1929 to 1932, retraced in part by Cartier-Bresson in the 1940s with a different "ethnographer's eye". Evans approaches the island as a first-time visitor, but his photographic approach reverberates suggestively with the narrative "gaze" of the two novels I discuss below. Indeed, some of the images allegorize the kinds of contained insularity that the novels explore. Yet these differing interpretive takes are not only allegorical; they are concerned with conveying images of uncertainty and ambiguity where gesture, community, and language are woven into prevailing notions of Black Cuba. As Robin Moore shows, the "expressive culture" that Fernando Ortiz identifies as *potential* cultural matter, or "materia prima," for Black music and performance is also a dividing line, a Cuban version of the color line known to Evans.[28]

Most of the photographs are not garish illustrations of police repression and political brutality like those that characterized US mainstream discourses of tropical state corruption in tabloids and respectable publications following the Spanish-American war. Superficially, Evans appears to gaze over Havana and its citizens from the paternalistic standpoint of Franklin D. Roosevelt's "Good Neighbor policy," laid out in his "First Inaugural Address" of March 3, 1933.[29] Crime appears to have been banished to the background, while the foreground details a kind of social and individual despair that translates as the political incarceration of Havana and the island of Cuba. As Alpers crucially asks: "But where and how does a photographer want his work to be seen? Evans thought of his photographs presented in a book and grouped around, or is it constructing, a theme … The ordering serves the images. An image is the thing."[30] At the end of the portfolio, Evans offers a panoramic sequence of the effects of state crime and hemispheric colonialism that had turned Cuba into a de facto US "protectorate." These images portray a people incarcerated in their own country, yet coeval, in terms of technological and cultural practices of space, aesthetic modernity, and political demands, with metropolitan

urbanscapes across the Americas. There are few notes of tropical bliss in Evans's approach, and no "ethnographic" musings around the myth of a Caribbean "magic island."[31] Through his somewhat epidermal portrayals of daily life, Evans crafts a nonlinear narrative of rare emotional eloquence and insight. The tropical sensuousness of the "banana republic" vanishes to its proper place in the vagueness of the exoticist imagination, to be substituted by images of an island immersed in the mixed temporalities of social agony, political exhaustion, and revolutionary momentum.

Imaging Havana

Evans's subjects interpellate us with singular intensity. His photographs document a visual journey that resonates questioningly with the novels. Trachtenberg's evocation of a "psychology of form," an expression he borrows from Kenneth Burke and applies to Evans's *American Photographs* (1939), obtains here, yet less decidedly psychologically than in later work.[32] The photographs extend from inner city life to the island's interior; from *Havana Street* to *Bohío* in the first part of the sequence through *Sugar Plantation. Off-Season* and *Stevedore* to *A Document of the Terror* toward the end. Three images labeled "anonymous photographs" tally not only with gangster crime scenes but also with the sordid aesthetics of lynching photographs from the previous decade of racist violence across the US South.[33] The words "document" and "terror" signal Beals's political denunciation and rejoin a photographic attitude that predates Evans's portfolio.

Evans's photographs are more immersive and evocative than one might suspect. In *Woman Behind Barred Window*, a portrait composition of a crossed-armed woman behind bars, the subject smiles relaxedly, as if ignoring the barriers that separate her from the viewer (Figure 4.2). The image's verticality is accented by the long bars, electrical cord and vines that frame the window and double-frame the woman. Appearing to wait, is she daydreaming or contemplating what might be unfolding in the streets of Havana? This portrait resembles the pensive young woman in Álvarez Bravo's *The Daydream* (*El ensueño*) (1931).[34] The iconicity of Catholic statuary saturates an interior space in another image by Evans, lending the photograph an air of religious keepsake or votive card. Evans might have been unaware that the saint he portrays is San Roque, a representation of the *orisha* Inle, Erinlé, the healer and epidemiologist of

Yoruba cosmogony – an analogous image appears in Carpentier's Afro-Cuban ballet, *El milagro de Anaquillé* (see Chapter 2). Cuba's social and political illness is only a contemporary example in the history of Caribbean catastrophes – hurricanes, invasions,

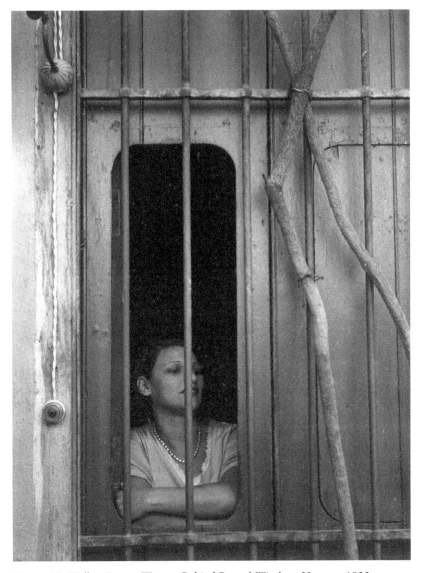

Figure 4.2: Walker Evans, *Woman Behind Barred Window*, Havana, 1933

annexations, and racist violence that another observer, the Spanish socialist writer Luis Araquistáin, calls "the Antillean agony" in a phobic and racist travelogue, *La agonía antillana* (1928).[35]

Other images document Cubans surviving as beggars, men sleeping on benches in public spaces, indigent individuals and families, street vendors, bystanders, large groups gathered for political demonstrations, public spaces that exude sociability and danger, the daily activities of a large city, cinemas and tramways, a *Butcher's Shop* and *Breadline*. With the collapse of the sugar industry and the economic collapse of 1929 still looming, Evans's images seem to measure the hemispheric amplitude of what he has witnessed in the streets of New York. There are echoes in the sequence of the experimental attitude of Claude McKay's novel *Banjo: A Story without a Plot* (1929), a text that documents and narrates the fragmented lives of dock workers and stevedores of various ethnic origins in the port city of Marseille. Dialoguing with *Banjo* and other Harlem Renaissance texts, the Cuba portfolio translates the complex scenario of Havana, the largest Caribbean port city, in terms of racial and labor anxieties. As Jules Benjamin writes: "By 1933, Cuban labor was more highly organized and more radically led than almost any proletariat in Latin America. This fact, coupled with a dictatorial and anti-labor government and severe economic hardship, made for an explosive situation."[36] Seen from the street, the city brims with casual interactions, but Evans's high-angle and frontal views of crowds suggest the sociopolitical explosiveness that the book analyzes at length. On a more intimate level, some of the photographs capture scenes of social fracture, abjection, and despair. In *Beggar with Outstretched Arm on Street*, a Black man sits awkwardly on a sidewalk holding his hat between his knees, and extending a hand (Figure 4.3). The man's outstretched legs appear on the foreground, showing one bare foot and a ragged shoe hanging from the other. His half-turned head and begging hand "speak" to the figure of a passing woman, her firm step and heeled shoes intersecting with, but not meeting, the half-recumbent man.

In another street-level image, *Mother and Children in Doorway*, a woman sits on a step leaning against a large wooden door (Figure 4.4). She holds a sleeping baby in her arms and gazes distractedly to the right. Her dejected attitude contrasts with her dark hair, neatly done despite the obvious squalor she lives in. Two barefoot and scantily dressed children lie to her right and left, also appearing to sleep. This scene is reminiscent of a subseries of recumbent and dozing subjects, most poignantly *Beggar*, but *Mother and Children*

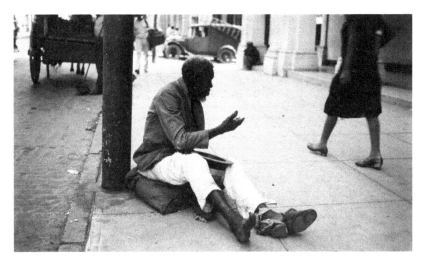

Figure 4.3: Walker Evans, *Beggar with Outstretched Arm on Street*, Havana, 1933

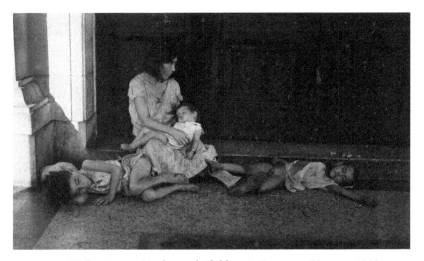

Figure 4.4: Walker Evans, *Mother and Children in Doorway*, Havana, 1933

in Doorway resonates differently with a group portrait that is located at the center of the sequence, *Havana: Country Family* (Figure 4.5) and also, perhaps more strikingly, with a later subseries in which one feels the social tension mount: from *Stevedore*, a portrait of a cigar-smoking young man, to the political slogans in the final image, *Wallwriting*. In *Mother and Children in Doorway*, an

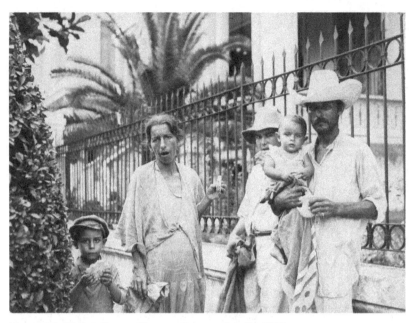

Figure 4.5: Walker Evans, *Havana: Country Family*, 1933

intuitive photographic aesthetics of the Great Depression surprises the viewer via the contrast between the group's shabbiness and dejection, and the dynamic compositional balance. Evans allegorizes "the crime of Cuba" through a language of proximity and identification that summons countless period images of social neglect, squalor, and despair.

Havana: Country Family evokes the island beyond Havana, introducing a question about city/country relations that Evans explores in disturbing detail in the second half of the sequence. A group of three simply dressed adults, a small child, and a baby, appear to pose against a receding backdrop of cast iron bars and tropical vegetation. The man carrying a baby on one arm dons a rural *guajiro* hat. Holding pineapple slices, the adults and the small child stand looking unceremoniously at the camera. In contrast to the dramatic scene of *Mother and Children in Doorway*, the group appears dignified, facing the camera despite their tired and vacant expressions. Both photographs suggest a practice of measured portraiture. The following image, *Public Spectacle*, captures a large group of people on the street, and smaller groups on the vast staircase and surrounding areas in front of the Capitol building,

a colossal civic structure built in 1926–9 at the height of the *Machadato* and in the last years of Cuba's economic bonanza. The subjects are well-dressed, with many of the men wearing suits, jackets, ties, and the ubiquitous white boaters and Panama hats. The political nature of the "spectacle" is signaled by the attire and official-looking surroundings. But in the broader spectacle of the Cuba portfolio, Evans narrates "the crime of Cuba" in less obviously political images. Instead, these photographs denounce an insidiousness of class and color lines, and the scenes and portraits speak of abandonment, segregation, and incarceration.

The two novels I discuss in what follows document periods of political stagnation, communal and individual hardship, and revolutionary energy during the last years of Machado's dictatorship. These texts present us with alternative sequences, environments, and perspectives on "the crime of Cuba" as the authors experienced it during the *Machadato*. Importantly, they frame their investigations of Cuban reality in the late 1920s and early 1930s through tropes of insular space that are delivered via varying avant-garde textures. Like Evans's photographs, the novels portray Cuban subjects, figures of racist violence, and widespread social injustice. They deploy critiques of US imperialism and comment on the masses of unemployed and restless Afro-Cubans who languished in prisons, struggled to survive in the country's interior, and occupied the streets of Havana. In both novels, the biographical traces of carceral experience are woven into social and political denunciation as reflections on masculine and racial self-fashioning.

"Isla de corcho": *¡Écue-Yamba-Ó!*

Like *El milagro de Anaquillé*, *¡Écue-Yamba-Ó!* takes an ethnographic and anticolonial approach to rural Afro-Cuba. In his earlier Afro-Cuban texts, Carpentier investigates an archaic social world of ritual, social injustice, and political oppression to formulate new images of national identity. This project is embedded in the avant-garde poetics of national consciousness and cosmopolitan internationalism that defines *Revista de Avance* and the Minorista group. Reflecting Carpentier's preoccupations of the late 1920s, *¡Écue-Yamba-Ó!* includes avant-garde parody, "ethnographic" fiction, and sociopolitical chronicle, and contains the most daring avant-garde prose written by a member of the group. In the first edition of the novel, the words *¡Écue-Yamba-Ó!* figure on the

front cover (without accent marks), in the unnumbered third page, and in the interior title page, while the subtitles vary: *novela afrocubana* on the front cover, and *historia afrocubana* on page five.[37]

Carpentier wrote a first draft of the novel when he was a political prisoner in Havana in 1927, and produced a final version in Paris, publishing it in Madrid in 1933 after escaping from prison and leaving Cuba for France.[38] Arriving in Paris in 1928, he met André Breton through Robert Desnos, and became a kind of Caribbean "native" informant among the Paris surrealists.[39] *¡Écue-Yamba-Ó!* is a transitional work that does not entirely represent Carpentier's aesthetic and political commitments at the time. Instead, as Anke Birkenmaier observes, Carpentier's use of ethnography in the novel, as well as in earlier works, "functions as a lens allowing him to focus his perspective on Afro-Cuban culture."[40] Precisely because of his relative disavowal of this early novel in later years, we must read it as an evolving response to the changing personal and aesthetic situation. Furthermore, Melanie Nicholson writes about Carpentier's "ambivalent surrealist gaze" and calls "for readers not to disavow Carpentier's surrealist underpinnings."[41] Carpentier distanced himself from Surrealism in 1929 when his friend Desnos was expelled from the Paris group. He became critical of the movement and attacked it openly in the Prologue to *The Kingdom of This World* (1949). Yet *¡Écue-Yamba-Ó!* owes more to Surrealism than to the reception of Futurism in *Revista de Avance*.[42]

¡Écue-Yamba-Ó! begins with a portrait of the old sugar-cane laborer Usebio Cué, immersed in a *mise-en-scène* that amplifies the stereotyped atmosphere of *El milagro de Anaquillé* that I discussed in Chapter 2. As this individual portrait recedes, the background expands into a group portrait, as the narrator tells the full-blown fable of Menegildo Cué, Usebio's son and the novel's protagonist. The novel relates a journey from the rural interior to Havana that allegorizes the experiences of thousands of Cuban, Caribbean, and Central American laborers in the first three decades of the twentieth century. Like *La vorágine* (1924), by the Colombian José Eustasio Rivera, *¡Écue-Yamba-Ó!* "translates" international dynamics into national preoccupations. Margarita Serje and Erna von der Walde argue:

> [Rivera] locates the periphery as a center in the reflection it proposes about capitalism's accumulation processes. In this sense, the novel establishes a dialogue with a series of contemporary works in Latin America that can be called "commodity novels" [*novelas de la mercancía*] ...

Like *La vorágine*, these novels address social and spatial transformations in the production of commodities for international commerce.[43]

In a passage from the section "Adolescencia," the narrator comments: "Eaten away by the chancre of the sugar estate, mortgaged in the prime of adolescence, the *cork island* [*isla de corcho*] had turned into a large sugar mill that could no longer float." Imagined as a vast sugar factory, the island sinks under the weight of "the Yankee sugar mill" (114). Beals uses the "sugar mill" trope abundantly in *The Crime of Cuba*: "During the War and post-War booms, Cuba rode on the crest of extravagance; in off years it has hit the nadir of misery. The popular saying is, 'Cuba is a cork' – meaning it will always bob up again."[44] Images of cancerous corruption and political frustration with the US run to the core of the young Republic. "Already the creole countryside yielded images of foreign fruits that ripened in soda ads! *Orange-crush* was turning into an instrument of North-American imperialism, just the same as the memory of Roosevelt or Lindbergh's aircraft!" Only one hope remains – neither the corrupt politicians and "rotten banks" of the Republic, nor the submissive *guajiros*, nor the intellectuals: "Only the blacks, Menegildo, Longina, Salomé, and their offspring lovingly retained an Antillean character and tradition. The *bongo* drum as an antidote to Wall Street!" (115).

Passages like these respond to the neocolonial restructuring of the Cuban landscape and society with ambivalent touches of avant-garde humor, resentment, and horror. Carpentier recognizes a genealogy of nationalist resistance inspired by José M. Heredia and José Martí, by the Black and *mulato* heroes of Cuban independence, and by the insurgent *mambises*.[45] The reorientation of the Cuban economy under US control required a complete restructuring. As Frantz Fanon argued years later:

> You do not disorganize a society, however primitive it may be, with such an agenda ["to have the last move up to the front"] if you are not determined from the very start to smash every article encountered. The colonized, who have made up their mind to make such an agenda into a driving force, have been prepared for violence from time immemorial. As soon as they are born it is obvious to them that their cramped world, riddled with taboos, can only be challenged by out and out violence.[46]

Menegildo embodies a Spenglerian desire for strong and primitive humanity, but in the context of the *Machadato* he becomes

uprooted and ultimately dies violently after a period of dissipation. Carpentier's identification with three Black characters from different social, cultural, and ethnic backgrounds is telling, as it hints at the complex left-nationalist politics among the Minoristas. Cuba's disorganized *morphology*, to evoke a Spenglerian term that was popular among Hispanic thinkers and avant-gardists in the 1920s and '30s, is capitalist and colonial; its underlying Lombrosian *physiognomy*, that of a Black man. As Pedro Barreda notes: "Carpentier means to capture the essence of blackness and the black environment, beginning with its roots, by placing himself in the magical-mystical world of this black man."[47] Indeed, Carpentier explores ethnic "roots," but in attempting to "capture" blackness he projects a novel authorial voice. This voice identifies with a rural version of Afro-Cuban masculinity that enables the production of the avant-garde author as cosmopolitan interpreter or "ethnographer." The portrait of an adolescent Menegildo reinscribes a range of objectifying traits: "He often covered his wide pectoral muscles with a purple-striped T-shirt … The hat he wore was woven with the same stuff as the family hut's roofing" (65). This young body, so profoundly attached to the land, to blood ties and place, and this Afro-Caribbean "spiritual life" (65) somehow demonstrate the dynamic presence of another Cuba within national consciousness. Carpentier suggests a *cultural* distinction between traditional Black Cubans and cosmopolitan white intellectuals:

> Just as white folks have filled the atmosphere with coded messages, symphony movements, and English courses, colored men who are able to perpetuate the great tradition of a science bestowed down the centuries by fathers on sons, kings on princes, initiators on the initiated, know that air is a fabric of seamless threads transmitting the forces invoked in ceremonies. (66–7)

Hallucinations / Cubans and Haitians

¡Écue-Yamba-Ó! narrates the story of Menegildo in three parts: "Childhood," "Adolescence," and "The City." The novel contains forty-three sections, each introduced by a heading: "Landscape," "Initiation," "Festival," "Bars," and so on. The son of Usebio and Salomé Cué, Menegildo is born into a family of poor sugar-cane laborers that has become uprooted as a result of US involvement in the Cuban sugar industry. In Vicky Unruh's reading, Menegildo

"does not enjoy the same geographic proximity to his roots as the inhabitants of indigenous worlds do. But possessed of an 'unpolished humanity' ... he is cast as an originary being, and the community to which he belongs is portrayed as an early world."[48] Unruh's observations echo Robert Redfield's discussion of "the folk society," a term that aptly captures the fragility of sugar labor communities in 1920s and '30s Cuba who are neither folk, in the generic or typical sense, nor urban, but rather insular and disjointed.[49]

Menegildo falls in love with Longina, a *guantanamera* who had spent time in Haiti as a child. Having lost her father to a mysterious "man-god," she returns to Cuba with a Haitian laborer who sells her "for twenty pesos" to another Haitian called Napolión, who abuses and terrorizes her (96–7). One night, Menegildo attacks Napolión with a knife. At the end of the second part, he is arrested by the "rural police" and imprisoned (116). In the third part, Menegildo is in jail in Havana – the same jail where Carpentier wrote the first draft of the novel. Through influential friends of his cousin's, Menegildo is released and reunited with Longina. He engages in a life of dissolution and abjection, but joins a *ñáñigo* group, while Longina expects their child. At the end of the last part, Menegildo is killed during a violent confrontation between rival *ñáñigos*.[50] The voyeuristic view of Afro-Cuban life in the 1927 ballet, *El Milagro de Anaquillé*, is magnified in *¡Écue-Yamba-Ó!* as layers of secret ritual and allegorical meaning populate the novel. While US imperialism is a protagonist in the ballet, Haitian immigrants occupy a central position in the novel as threatening and abject intruders. Haiti, therefore, appears to function as an internal enemy of the nation and the Afro-Cuban culture that Menegildo Cué allegorizes tragically.

In an abandoned barracks of the old *ingenio*, Menegildo finds a group of Haitians who had stayed on after the latest sugar-cane harvest. "Overtaken by terror, by a panic descended from the origin of the world, the father fled the barracks thinking no longer about the storm. The dead, the dead from the cemetery! [*¡Lo' muelto! ¡Lo' muelto del sementerio!*] And Paula Macho, the witch, the evil one, worshiping with the Haitians!" (62). It is symptomatic that Usebio is here referred to as "the father" (*el padre*) just as in other contexts "the nigger" (*el negro*) or "the female" (*la hembra*) refer to generic characters throughout the text. This family of authentic Afro-Cubans finds a precarious shelter under the sacred *ceiba* tree, literally reduced to the soil, half-buried in its ancestral roots. Meanwhile, the evil woman, outcast and traitor to the community,

is spared through her perverse alliance with the secretive and dangerous Haitians. "Foreign trees fall one after the other, while *ceibas* and bullet trees stand strong" (56). And against the *ceiba* tree, an index of the Black Cubans' resilience and faithfulness to their African ancestors – their roots – the father beholds the "prodigy" of an uncanny rearrangement of the world that fills him with such primeval horror:

> A kind of altar stood at the bottom of the barracks, lit up with candles, holding a skull in whose mouth three gold teeth shone. Several ox antlers and poultry spurs lied around the skulls. Necklaces made up of rusty keys, a femur, and a few small bones. A rosary of teeth. Two black wooden arms and hands. In the middle, a statuette with nails for hair held a long metal stick. Drums and bottles ... And a group of Haitians who stared at him disapprovingly. In a corner, Usebio recognized Paula Macho donning a crown of paper flowers, her expressionless face paralyzed. (61–2)

This assemblage of parts, residues, dismembered indexes of dead and desecrated bodies, stages the unspeakable experience of the tortured and disappeared, the mutilated and brutally murdered under Machado's regime. Usebio's encounter with the Haitians establishes an unresolved dichotomy at the core of Carpentier's hallucinatory poetics of an essentialized Afro-Cubanness between two faces of blackness: the primitive, superstitious, and ultimately defeated Cués; and those threatening, violent, and powerful foreigners, the usurping Haitians. The novel displaces a vision of violent and corrupted Cubanness onto "Haiti," an invading cultural other that stands perversely for incomparably more privileged others within Cuban society and US colonialism.

Carceral Desires

¡Écue-Yamba-Ó! projects an overarching desire to mobilize Cubans for the pressing cause of restoring the Republic from the claws of corrupt institutions and foreign capitalists. In the third part, "The City," Menegildo's innocence dissolves abruptly when he enters the urban world of the "*hampa afrocubana*" (Afro-Cuban lumpen) and ends up in jail.[51] Far from the countryside where he grew up, the prison in Havana symbolizes the perverting forces of urban life. In a schematic, avant-gardist passage, we are told: "Any sense of roundness must be abandoned when the lock of a prison strikes."

There follows a pictorial description of the prison that labors to evoke Cubist and constructivist compositions:

> The sailor's circular firmament, gnawed at by the city's teeth, falls apart in pockets of light within the penitentiary, projecting itself in ever narrower rectangles. The larger rectangle of the patio, where the sun delivers lessons in descriptive Geometry before and after noon. The rectangle of the patio seen through rectangular windows. Cell bars divide windows into square boxes. (125)

The island is occluded in the carceral *mise-en-abyme* at the heart of the novel. Paradoxically, this occlusion takes place in the port city of Havana. The cell is within the old colonial fortress-prison, and the cosmopolitan city is on the edge of the canefield island. In this place of exasperation, Carpentier locates an intense voyeuristic scene, framed by prison walls, and observed from a distance by a group of prisoners charged with an excess of communal desire. From the barred windows, the prisoners spy one night on a hotel room only a few meters away, as "a blonde woman, an American no doubt, shed her lace brassiere slowly." They watch her undress inside the hotel room, as she tries to arouse the interest of a man reading a newspaper in bed. The prisoners yell: "Seize it, you hog, what 'ya waitin' for!" The prison guards break into the galley and Menegildo goes back to bed: "Menegildo sank his face in the pillow to prolong the inner vision of that blonde female flesh – the first pink nudity he had ever seen." That the object of voyeuristic desire is a white *yanqui* woman complicates the rhetoric of protectionism, xenophobic remarks, and nationalist resistance in an important maneuver. Absorbed in his newspaper, the man shows no interest in her: "Conference on Disarmament? Cooperative movement? ... The woman's fingers drew cuddles that yielded no results. They then turned to a bowl of candy rested on the bedside table" (137). In the narrative's dramatization of nationalist outrage, fifty Black men are forced to compromise their masculinity while their country is exploited by the imperialist neighbor. Their excessive libidinal impulses are wasted and perverted; the possibility of access to the American blonde is denied to them. Meanwhile, the American capitalist shows no interest in this willing woman. She resorts to dissolving candy in her mouth. Thus sugar, the distilled hard labor of Cubans and other Caribbean laborers, perpetuates the cycles of excess, exploitation, and waste. But it also quenches her desire and the text's desire for voyeuristic enjoyment, interracial transgression, and symbolic revenge.

Menegildo's assassination at the hands of a corpulent, machete-waving Black man (*negrazo*) is a scene of expressionist and Noir overtones that culminates in an ominous symbol: "The silence filled with crickets" (180). The text explores Menegildo's dead body in sordid detail. The description becomes graphic and gory under an oil lamp: "Menegildo looked gray, emptied of blood, his jugular slashed by a stab. His wound had filled with ants" (181). This surrealist image is loaded with dramatic detail and intertextual excess. A lynching image like the hundreds that appeared in the Cuban and US press of the period, it shows a vision of arrested, tortured, and depleted Black manhood. But Menegildo's extraordinarily quick decay carries a further anxious reflection on his symbolic emasculation as the Black protagonist. Resonating with some of the images contained in Evans's sequence, and in Beals's chronicle of political crime under Machado, there is a double movement of tumultuous violence and depletion (silence/crickets; wound/ants) that appears to bring sensory and poetic closure to Menegildo's tragic fate.

The prison in *¡Écue-Yamba-Ó!* is a space where male desire diverts under ethnic and political pressures from masculine and heteronormative boundaries. Menegildo's masculinity, a central locus of white avant-gardist constructions of national purity and authenticity, is preserved from all contact with perversion in a way that could be seen as Carpentier's phobic response to what he *saw* and *heard* during his own imprisonment. The voyeuristic excursion into the hotel room I discussed in the previous section condenses the contained energies of intense longing and vicarious fruition into a single scene, effectively translating as an allegorical performance of national frustration, degeneration, and anger. Framed by the separating windows, ethnic difference connects through visual orifices: passages that communicate and dislocate an excessive desire for sexual pleasure and political freedom. Against the group of "fifty exasperated men," Carpentier astutely frames Menegildo as an instinctively virtuous representative of male reproductive Antilleanity. The protagonist's character is accented by a new figure of abjection. The specter of homosexual contagion enters the novel at a point where US imperialism and social disintegration are allegorized through mutually reinforcing anxieties around masculinity and emasculation:

> What remained of the love letters that were sent to many inmates by the "Aphrodite men" of row 7? In the picture of Guititío's girlfriend? In the "girls" – handsome inmates forcibly traded by their comrades, and in

the *muscatel cigar box* and other erotic contraptions, before the living tableau that fifty exasperated men had to witness that night? (137–8)

This passage frames the difficult content under consideration through various distancing devices. Carpentier questions homosexual desires and acts in a phobic gesture; the question marks inscribe "love letters," a photograph, and improvised erotic objects, and activities and practices that outline a subclass of sexual deviants within the carceral space. This detailed enumeration contrasts with the voyeuristic scene, a living representation that remains less accessible than the scattered and displaced functions of homosexual deviance. The novel finds provisional closure in the family portrait on the last page: "Three months later, Menegildo was a one-month-old black baby with bulging eyes and an aggressive belly button. He writhed crying in his humble cradle under the approving eyes of Salomé, Longina, and wise Beruá" (183). Emily Maguire argues that "by condemning Menegildo's wife and child to return to the country, Carpentier denies his black characters (and, by implication, their culture) the possibility of positive change."[52] The literary close-up of the infant at the end suggests anxieties around frustrated modernization in the Machado context, and potentially also with a mounting rebelliousness of Black masculinities. In *El Milagro de Anaquillé* and *¡Écue-Yamba-Ó!* Carpentier attempts to denounce and subvert a discourse of utilitarian superficiality and political violence during the *Machadato*. Both texts exhibit a Minorista denunciation of social injustice among the largely poor and uneducated Afro-Cuban communities of the rural interior. They invite us to reexamine avant-garde discourses of race, gender, and anticolonial resistance in Caribbean and Atlantic insular contexts. Like the Caribbean and Central American *novelas de la caña* (sugarcane novels), the text is a "document of the terror." Menegildo and his family absorb the displaced anxieties of Carpentier's intellectual generation around nationhood, race relations, labor migration, and US colonialism during the *Machadato*.[53]

Indoor Climates: *Hombres sin mujer*

Carlos Montenegro's *Hombres sin mujer* is a confessional exploration of male sexuality in a Cuban prison where degeneration and social chaos wreak havoc among a group of inmates.[54] Like Carpentier, Montenegro wrote his novel in just over three weeks.

And while Carpentier started work on his manuscript in a prison cell in Havana, Montenegro's novel takes place in the island's interior, yet reflects cathartically on the author's personal experiences as a young inmate of the Castillo del Príncipe, an eighteenth-century fortress in Havana. Like Carpentier's characters, Montenegro's men are deprived of social and sexual intercourse with the exterior world. Their sexual drives degenerate into pathological and, ultimately, tragic homosexuality.[55] The text describes a range of hierarchies that increasingly convey the literary illusion of a secluded island universe. The chronotope of the prison appears successively as a humiliating and dehumanizing space and as a space of sadistic torture and unspeakable vice.

The protagonist, a Black man called Pascasio Speek, is subjected to a moral trial of existential proportions in the form of a passionate homosexual relationship with Andrés Pinel, a younger white inmate, barely eighteen when he enters the prison. In the first chapter, Pascasio is described as a lonely and introspective figure in a series of passages that characterize him indirectly as a strong and wholesome cane laborer. He is a vaguely stereotypical Black Cuban with whom readers are expected to identify. In the description of Pascasio that opens the novel, his body appears fragmented and translates as a gesture and an arrested position: "He opened his eyes, violently stretching his arms and legs to a cramp, then returned to an immobile sitting position, leaning back against the wall" (21). He yawns and lights up a cigarette. He has been in prison for eight years. In Pascasio Speek's name, if not in his attitudes, one can read not only a sign of linguistic difference, but also a reference to a Caribbean context that extends beyond the island of Cuba and gestures toward an archipelagic and cosmopolitan dimension of the carceral space. This accented nominal note invokes the diverse linguistic archipelagos that assert pan-Caribbean and pan-American cultural consciousness, informing the Afro-Caribbean and hemispheric aspects of this narrative by a white immigrant from Spain.

By contrast, several secondary characters project a distinct atmosphere of deviance and insanity in the prison context. They, too, are grotesquely stereotypical, prefiguring the intricate web of secondary and minor characters who interact in the boisterous and degrading universe of the tropical prison. Valentín, "the deranged mulatto" (*el mulato loco*) (23), insults Black Cubans viciously. His prison slang is only an aspect of the consistently diverse linguistic registers we encounter in the novel, packed with Afro-Cuban,

creole, and popular words and expressions. The inmates receive new names, often alluding to individual traits, racial categories, or gender and sexual preferences. The prison universe is insular also in this regard: there is a compulsion to rename and reduce to a suffocatingly intimate scale the wider stakes of the outside world. Candela and "la Morita" are feminized nicknames for effeminate or gay-acting inmates who pursue Pascasio flirtatiously. La Morita openly expresses a lustful interest in Pascasio, prompting several stream of consciousness passages here and in ensuing chapters.

The new inmate, a naive teenager called Andrés, provides fresh insights into the thick degenerate world of inmate life. But as soon as he arrives, he perceives the devious interests in his presumed protector, Manuel Chiquito. Noting the latter's ambiguity, he is soon besieged by a mental state that mirrors Pascasio's: "His thoughts tormented him but gave no clear conclusions, leaving him in a state of equivocation, as if his mind were, like Manuel Chiquito's, damaged by something ambiguous that prevented him from tearing the veils" (78–9). This construction of Andrés as a confused and debilitated *mind* soon extends into a corporeal state of unrest, again rhyming with Pascasio's secret struggle. There is an erotic differential that is prescribed by an underlying atmosphere of sexual perversion. Pascasio dreams of recovering his wasted manhood, while Andrés feels overwhelmed by the viscosity of the carceral environment: "As night fell, youth and insomnia penetrated his adolescent muscles, the martyrdom of the senses taking him by the hand towards truth ... Could that be *it*?" (79).

As tensions develop relentlessly among the characters, Pascasio and Andrés experience the claustrophobic lack of a material outside. This is overall a text without landscapes in which the only sense of Cuban natural space resides in narrative or emotional climate. Instead of tropical, picturesque, or other landscapes, a carceral atmosphere expands, saturates, and ultimately explodes in the series of violent events at the end of the story. The interwoven threads of a "womanless" universe fuels a sense of maddening forgetfulness, rather than nostalgia, of women, thus driving this carceral world to an incendiary atmosphere of illicit desires, lustful appetites, and, ultimately, insanity. There is nothing out of the ordinary in the novel's inscription of carceral literary traditions, with its tendency to produce discourses on the moral and anthropological aspects of prison life. However, the specific dimensions of this Cuban story reside in the complex intertwining of masculine, racial, and political facets of the allegorical parable. What is displaced and

impossibly sublimated here is not easily allegorized, for it is an autobiographical reflection on mental decline, but, more deeply, on the political decline of the nation's mind. In *Emerson and the Climates of History*, Eduardo Cadava defines climate in the literary or romantic and old metaphysical senses:

> Like the movement of Emerson's writing, the tendency of nature to incline or drift away from understanding can be read in the word *climate*. Derived from the ancient Greek word *klima*, it refers not only to a latitudinal zone of the earth but also to an inclination or slope. Climate therefore refers to both what falls from the sky and what falls away from understanding. Referring to whatever is incalculable and uncontrollable, it is at times another word for chance and time.[56]

The carceral environment tropicalizes the island-nation and its broader environments through a strategy of erasure. *Hombres sin mujer* narrates the decadence and downfall of Cuban social coherence – or of its hygiene and sanity – through the sympathetic exploration of its men's incarceration. The critical edge of this investigation connects with prestigious and popular modes of social reportage and photomontage available in the 1930s, recalling through its sense of immediacy the attitudes of the Minoristas and their *Revista de Avance*, and complicating them beyond the limits of nationalist ideology. The world of the cane fields appears as an absurdly idealized landscape in Pascasio's ruminations: "The same thing over and over! ... Can't they think of anything else? Why didn't they talk about freedom, the countryside, the time when they were in the cane field [*en el cañaveral*]?"

There are two dimensions to this stereotypical evocation of the cane field. In the first, Pascasio is the seasonal laborer who struggles and resists state repression. The potential "paradise" of the sugar-cane environment is subject to police violence: "Oh, he could fell tons of cane! ... If it hadn't been for the rural police figuring that the workers' backs were a good stone to sharpen the edge of their machetes, the cane field would've been a paradise." Pascasio belongs to a specific class of the Cuban cane labor force and engages in political resistance, if not action. "Distance made him forget the bad things: the wages of hunger, the overwhelming task, the pest-infested barracks, the jobless months, the persecution against those who tried to organize, the subterranean or brutal horror forcing them to take to the paths en masse [*en masa*], as if fleeing an earthquake or the plague" (26). In the second dimension,

Pascasio remembers his immersion in a slightly more elaborate version of the Cuban landscape as a straight man. This more organic recollection of the Cuban countryside certainly reinscribes versions of the insular Caribbean picturesque as a fixed image of powerful Black masculinity, yet also expands Pascasio's desires and fantasies beyond (and before) the domains of carceral temporality and climate, as a free man: "Freedom was on sight, he would soon leave all that rot surrounding him now ... Free in the sunny countryside! ... Immersed in the cane plantations that obsessed him like a wonderful dream" (29). Montenegro indulges the reader with such obsessive images of the paradisiacal cane field – a sensuously homoerotic vision of the Cuban pastoral that betrays the writers' projections of a free and healthy masculinity.

> Being able to scream at the top of his lungs in the burning afternoon, grabbing an ox by the horns and lowering its head, rubbing its wet snout in the red earth, then unleashing it to see it run and jump, while he, mad with joy, drunk, threw himself on the ground and rolled down a slope scaring the wild deer with his laughter ... and roll, roll, not alone but with her, with his woman, and disappear in the high river grass or in the mangroves. (29)

This fantasy of a dreaming Pascasio displaces the Black Caribbean character not only away from the prison space, but also beyond the limits of the sugar-cane environment, and onto a precolonial and pre-plantation place of luscious overgrowths. The senses of political disenfranchisement, social alienation, and gender-sexual deprivation coincide at the end of this sequence of ruminations in the expression *womanless men*: "Deprived of a woman year after year a man discovers what he misses – in another man" (29). Later in the novel, Pascasio tells Andrés: "There are no degenerates here, there are only womanless men" (83). Unable or unwilling to declare their individual desire, the protagonists oscillate between the two extremes of a *climate* of obsessive sexuality, and libidinal and relational loss. Like the sounds and voices that permeate the novel from beginning to end, sex stands for the lack of social reality, inhabiting spaces and objects like a ghostly atmospheric presence: "Sex is in everything, even if the flesh isn't immediately visible ... It's everywhere: in corners, behind columns, anywhere a little shade or sunshine falls. It is, above all, in bedroll sheets, in the rules that forbid the use of soap bars and scented talcum powders ... It's in the climate!" (29–30).

From Skull Island to Severance Machine

The melodramatic last chapter features Gothic carnage and surrealist sadism. Andrés is a weeping teenager doting on his beloved, while the masculine Pascasio becomes insane. In the atavistic finale, carceral affects and inconclusive homosexualities congeal in a tableau of expressionistic gore. Aphasia and savagery impregnate the atmosphere as the joiner turns to a strangely metaphorical space of wood and insanity. In a preamble to Andrés's assassination, the narrator portrays Pascasio in a place of primitive regression that inscribes multiple Afro-phobic clichés:

> But he heard nothing and felt nothing but the high leap in his muscles and the brief irritated-beast grunt locked in his throat. Had they released him naked in the jungle, he might have walked beating his chest with clenched fists like a gorilla. Then he would have let out the roar suffocating him, challenging all the powers. (294–5)

"Like a gorilla," an image of unbridled animality wildly confronting an overwhelming enemy, Pascasio becomes a pastiche figuration of King Kong at the end of Merian Cooper and Ernest Schoedsack's 1933 film, letting out a parallel roar *"como un desafío a todos los poderes"* (295).[57] In *King Kong*, the giant gorilla Kong falls in love with Ann, a Depression-era young woman in need (an average white American girl). As Susan Buck-Morss writes: "*King Kong* was mass movie entertainment about a captured beast, 'a king and a god in his own world,' who fought against urban-industrial civilisation and lost."[58] The beast hails from a "mystery island" with enough racist and geopolitical innuendo to capture the popular imagination by commenting on invisible yet sufficiently familiar color lines. Buck-Morss observes further: "*King Kong* is a movie about making a movie. A New York director has a map of an uncharted island and wants to sail there to film its mystery, which turns out to be the monster, Kong."[59] Like *La Habanera*, produced five years later in Nazi Germany, *King Kong* naturalizes colonial invasiveness as rational and healthy curiosity. The film's unprecedented success built on both US and international audiences' appetite for monstruous allegories of illicit and unbridled sexuality, and was fueled by anxious justifications for social scapegoating.

In Buck-Morss's reading, Kong's identification with "the masses" is versatile, "the racism takes on a political tone of

anti-immigrationism."[60] Citing a passage from Ortega's Germanophilic essay, *La rebelión de las masas* (*The Revolt of the Masses*) (1930) ("the primitive in revolt, that is, barbarism"), she notes perceptively that "Descriptions of the masses as a giant animal, an instinctual, primitive force, were common at the time ... But the film's depiction of the 'barbaric' and 'primitive' have an antidemocratic association as well."[61] Pascasio's ambivalent desire retains the literary trope of Beauty and the Beast, but alters it by exposing a cultural montage of superficially healthy and ultimately corrupted masculinities. In the specular configuration of the carceral environment, Cuba appears as an inverted and exploited political project – a racialized island colony and a besieged island-state. Unlike Kong, Pascasio is not an exiled tyrant, but his excessive masculinity still threatens the national project from within. At the end of the novel, he buries a steel key in Andrés's cranium "with the full strength of his arm and his brutality":

> Andrés ran towards Pascasio, his jacket unbuttoned, and was going to tell him something, but there was no time. He stopped abruptly, the words broken in his throat and his eyes watering as he stared at Pascasio who with the full strength of his arm and his savagery had planted the sharp edge of the key on Andrés's skull. (296)

Pascasio severs his own hand while operating the frightful table saw, the *sinfín*, literally "endless," due to the machine's unstoppable rotation. The scene is detailed and gory and accented with racist and masculinist clichés. The self-inflicted amputation – the severed hand holds a sharp key that Pascasio has just sunk in Andrés's head – is the result of a process of self-conscious retribution, human endurance, and self-maiming insanity. This phobic finale also provides a sort of dystopic narrative closure for other issues, for which carceral homosexual desires, bondage, and rape are conveniently figured as allegorical subplots. Instead of an individual and family story like Menegildo Cué's, *Hombres sin mujer* narrates a passionate homosexual romance that deploys racial and interinsular hierarchies against a background noise of carceral voices. The psychopathological construction of Pascasio and Andrés as figures of a tensely or impossibly mixed-race nation is carefully staged throughout the novel to highlight a tension at the heart of what Ortiz calls a "welding" between people of European and African descent: "The welding (*soldadura*) was total both psychologically

and physiologically. The contributing causes were identical: the coincidence of an extensive, intimate, and permanent contact."[62]

In *Cuban Counterpoint: Tobacco and Sugar* (1940), Ortiz refines his ideas on the sociohistorical, ethnic, and psychological character of Cubans, and coins the concept of transculturation. Fernando Coronil writes in his introduction to the 1995 English translation: "*Cuban Counterpoint* constantly displaces and re-places home and exile, the national and the international, centers and peripheries, and shows how they are formed historically through constant interplay".[63] An apt description of Ortiz's study of Cuban national character, the same wording could be applied to the carceral narratives of the Cuban 1930s. *¡Écue-Yamba-Ó!* and *Hombres sin mujer* feature analogue displacements and re-placements, only they combine avant-garde and documentary interrogations not of historical processes, but of the construction of the present and the interplay of its figures of confinement. Both novels frame this welded construction by exploring the dystopic universe of the interior jail, projecting prestigious discourses of cultural decadence and scientific racism on Black masculinity, abject homosexual practices, and creole effeminacy. These inscriptions of monstruous subjectivities among social outcasts resonate with contemporary politics in another way. The same normalizing and scientific interpretations that contribute to shaping hierarchies of race and cultural difference in Cuban nationalist discourse account for the reception of Spengler's ideas on organicism and racial decadence. As Emilio Bejel explains:

> In effect, Pascasio – who as a rural black is thought to be closer to nature – imagines himself loving and caressing a beautiful woman in a cane field. His dream represents freedom and the solution for the "womanless men" ... It is precisely the "outside" Cuban society of the day (the 1930s) that creates the "inside" world, the prison that Montenegro criticizes so sharply.[64]

The calculated absence of reproductive bodies reinforces the illusion of a naturally degenerating space, of nature taking an inverted route and foreclosing the possibility of national growth. Pascasio and Andrés mimic and denaturalize Spengler's vision of an emerging Atlantic hybridity – a mixing of "old civilization" and "young blood." Their emasculated subjectivities perform the symptom of national decadence from beginning to end. Cut off from women and the sugar-cane fields, the men in *Hombres sin mujer* are stateless,

nationless, insane men. As homosocial desire, homosexual lust, and racial and sexual degeneration become gradually entwined in the text, the prescriptive narrative voice struggles to justify the actions it condemns. Yet, Andrés and Pascasio's romance is hardly concealed, exciting and inciting the reader's curiosity beyond the requirements of ethnographic and criminological detail. Ultimately, Montenegro's authorial involvement in his characters' passions and moral dilemmas contrasts perversely with the sweltering cacophony of carceral banter and mounting exasperation.

Citizen in Downtown Havana

A disorderly labor economy and a disorder of biopolitical arrangements in Caribbean plantation cultures mark the tumultuous 1930s documented in Evans's Cuba portfolio and reflected upon in Carpentier's and Montenegro's novels. Evans's imaging of Havana as a restless, hungry, and labor-less city expresses the temporality of carceral insularity. Through different strategies and perspectives, ¡Écue-Yamba-Ó! and Hombres sin mujer envision islands as material and allegorical prisons – a trope that I explored in my discussion of *La Habanera* in Chapter 1. But while the portfolio foregrounds an unraveling of the social and political climate in Havana, the novels cast tropical and carceral spaces as backdrops to processes of social disintegration and political chaos. Both novels attempt disturbing mappings of the Depression-ridden island and exploitative, racialized, and gendered sugar economy. I conclude this chapter with a brief analysis of an image that does not figure in the portfolio, but perhaps constitutes the most questioning among Evans's Havana photographs. In *Citizen in Downtown Havana* (shown above in Figure 4.1), avant-garde cosmopolitanism intersects with the political scenarios of racially conflicted masculinities in the two novels I have discussed, and in other examples of Cuban avant-gardism. This is one of the rare Cuban photographs that has become vintage Evans, alongside the stevedore series and the *Mother and Children in Doorway* group portrait – an anachronistic reminiscence of Dorothea Lange's *Migrant Mother* (1936), a photographic icon that, "to many ... came to symbolize the despair and uncertainty of the Great Depression."[65]

Claudia Milian examines the difficulties Langston Hughes encountered as he attempted to enter Cuba two years before Evans's visit. Evans's access to Havana was relatively easy and straightforward:

"Had no trouble with the authorities," he reports plainly to Beals.[66] But as a Black American, Hughes endured "a rigmarole of bureaucracy," a bitter reminder of the persistent inscription of hemispheric color lines beyond US contexts.[67] As I have suggested, there are multiple interplays of shadows (I paraphrase Vicky Lebeau) in the series of Black–White, male–male, and male–female confrontations in which color, class, and political and aesthetic lines are crossed, transgressed, and distorted at different junctures of Caribbean avant-garde cosmopolitanisms.[68] The variously cropped versions of *Citizen in Downtown Havana* (sometimes labeled more descriptively as *Man in White Suit*, or a similar title) contain some of Evans's most personal stylistic traits: a richly textured Caribbean *downtown* in which posters, newspapers and magazines, and signs of public entertainment blend with anonymous subjects, the citizens of an urban center going about their daily business. Donning an elegant white suit and hat, the Black Cuban citizen seems lost in thought. There is an air of self-evident sophistication to this man and the scene that surrounds him that seems uncannily removed from the wider story told in the portfolio, in Milian's analysis of Hughes's experiences of the Cuban color line, and of the novels I have discussed in this chapter.

Citizen in Downtown Havana fulfills a fantasy of modern Havana, the crime-ridden US playground that often features in noir renditions of the alluring metropolis as a tropical variation of what Edward Dimendberg calls "naked cities."[69] Abstracted from sociopolitical and historical spacetime, this photograph narrates a future that could be imaged in multiple locations: the Paris or Marseille of postwar cosmopolitan exile; Fort-de-France, New Orleans, or Veracruz before and after World War II; or Cali, Port-au-Prince, or Kingston, where the sight of a Black man elegantly dressed, thinking, in a busy commercial downtown would have been coded and made sense of differently. By contrast with Depression-era figurations of Caribbean masculinities, where fantasies of animality, primitive culture, and excessive physiques override experiences of transnational labor and enforced precarity, Evans experiments with a different Caribbean visuality. His Cuban images dialogue uneasily with familiar tropes of plantation-bound experience and incarcerated Black protagonists like Menegildo Cué and Pascasio Speek. He gazes questioningly at a pan-American archipelago of competing masculinities, gender transactions, and sexual entanglements that spell out peripheral and unequal forms of Black cosmopolitanism. From this perspectival openness, an image like

Woman Behind Barred Window (Figure 4.2) interrogates gendered tropes of the "mulata-Antilla" that I discussed in Chapter 3 as a man-less, freedom-less figure that does not complement, but further fractures, the class, gender, and interracial sex dynamics of the carceral island-nation.

My readings in this chapter, of works by Evans, Carpentier, and Montenegro, have considered some of the complexities of a white (Anglo and Hispanic) avant-garde gaze at work during the *Machadato*. I have highlighted cultural locations and intellectual investments by engaging these authors' views of Black masculinity, political corruption, and social injustice. Yet the masculine identifications, racial sympathies, and forms of progressive cosmopolitanism that their works project constitute only a partial angle on a broader Cuban and Caribbean story of evolving race and gender relations. These combined trajectories delineate a diverse map of continental enclaves, ocean-bound routes, and cultural crossings; and a characteristic cocktail of accented imperial languages. Would it be too speculative to understand the sequence of Evans's portfolio as a fictional reconstruction of the lives of the dead and jailed Cubans evoked in the three newspaper images that he included at the end of *The Crime of Cuba*? Might we not also speculate that *¡Écue-Yamba-Ó!* and *Hombres sin mujer* transgress linear temporality in analogous fashion by attempting to reanimate the lives of those jobless and womanless men whom the authors met in jail, and the parts of themselves that remained immersed in the carceral experience?

Part III
Surrealism after France: Crime and Desire from the Canary Islands to the Americas

5
Surrealism and the Islands: The Practice of Dislocation

Paris / Madrid / Tenerife

The previous chapters chart several central aspects of insular avant-garde activity in the 1920s and 1930s. Exploring a period when avant-garde groups flourish across the Hispanic Atlantic, they narrate encounters, connections, and ruptures. This chapter considers the attraction of islands as alluring and enigmatic spaces through situated readings of surrealist cultural production from the Canary Islands. I discuss the early surrealist paintings of Óscar Domínguez and, centrally, one of the quintessentially surrealist texts produced in Spain and in the insular Atlantic, Agustín Espinosa's *Crimen* (1934). While critics have praised Crimen as "the most intense and best among Spanish surrealist books" and "the masterpiece of surrealist narrative in Spain, and a summit of oneiric literature," what does this text say about its insular location?[1] The fragmented history of Atlantic Surrealisms configures the Paris-based movement as a phenomenon that follows several different trajectories before it becomes irreversibly uprooted and diverted to the Caribbean and the Americas. As I explain in what follows, the story of the Tenerife surrealist group can be told in three stages or movements. Each of these moments helps us understand how Surrealism takes hold and becomes a flashpoint of insular, Hispanic, and transnational avant-gardism. The first and second are Domínguez's trip to Paris in 1925, and Eduardo Westerdahl's

journey through Central Europe in 1931. In the third, André Breton travels to the Canary Islands in 1935.

On April 18, 1925, at the Residencia de Estudiantes in Madrid, Louis Aragon delivered an explosive talk in the grand surrealist style, with incendiary echoes of Dada performance and a wild hallucinatory narcissism in the mode of his recently published *Une Vague de rêves* (*A Wave of Dreams*). Philippe Forest highlights Aragon's visionary discourse and sense of urgency: "He does not presume to speak as politician or poet ... he adopts instead the tone of a prophet announcing an emergent movement that will usher in a 'Great Terror' destined to ravage the world, allowing it to be reborn from its ashes."[2] In the excerpted text of the conference that appeared in *La Révolution surréaliste* three months later, Aragon accused everyone of being effeminate, and, disavowing France and his own identity as a Frenchman, he declared: "Stop this comedy, I urge you only once to consider that I am the messenger of a great drama ... I am a carrier of germs, a public poisoner ... Ah, bankers, students, workers, civil and other servants, you are the fellators of the useful, the wankers of necessity!"[3] A declaration published in the Communist newspaper *L'Humanité* on July 2 denounced the French intervention in the Moroccan War in support of the Spanish army. The text sent the clear message that Surrealism was aligned with the French Communist Party and embraced a politics of anticolonialism. In Robert Short's lucid opinion, "the outbreak of hostilities between the French army under Pétain and the Riffs in Morocco precipitated the Surrealists into politics."[4]

As Surrealism expanded in Spain, Luis Buñuel, Salvador Dalí, and Lorca, then members of the Residencia de Estudiantes, all contributed to the Paris-centered movement.[5] Buñuel moved to Paris in 1925 and later joined Breton's circle, while Rafael Alberti, Vicente Aleixandre, Manuel Altolaguirre, Domínguez, Juan Ismael, Maruja Mallo, Joan Miró, Pablo Picasso, Emilio Prados, and Remedios Varo participated at various points in the activities of the Paris group, or embraced the movement as members of different avant-garde groups in Spain. In the Canary Islands, Surrealism flourished mainly within one of these avant-garde formations, the group that produced the journal *Gaceta de Arte*. Its main representatives, Westerdahl, Pedro García Cabrera, Espinosa, Domingo López Torres, and Emeterio Gutiérrez Albelo, investigated notions of insularity in prose and poetic works, but their interests were generally cosmopolitan and cosmopolitical.[6] Engaging Central European discourses on architecture, social hygiene, and revolutionary politics, *Gaceta*

de Arte benefited from the editorial adventures of 1920s avant-gardism, and its project reflected centrally on the revolutionary spirit of the Spanish Republic. According to José-Carlos Mainer, "*Gaceta de Arte* entirely embraced those three new possibilities for action – social realism, the expressionist-surrealist denunciation, and rationalism, all mixed in a remarkable synthesis."[7] Jordana Mendelson and Estrella de Diego comment further:

> Among the leftist journals, *Gaceta de arte* ... was the only magazine to have international status both in its understanding of progressive art and in its distribution. (It was circulated more widely abroad than in continental Spain.) It was the only Spanish publication that understood Surrealism both as an avant-garde movement and as a politically relevant art form.[8]

In its support of the Republican project, *Gaceta de Arte* constitutes a typical example of avant-garde internationalism and, despite differences of opinion among its members, revolutionary politics. As Nilo Palenzuela explains, the journal projects upon the Republic "its utopian hopes for a new order ... This determination in *Gaceta de Arte* connects with Spanish attempts to participate fully in avant-garde cosmopolitanism."[9] The group's involvement in regional cultural politics resembles other Atlantic circles – the Minorista project and *Revista de Avance* in Cuba, *Tropiques* in Martinique, and, to a lesser extent, *La poesía sorprendida* in the Dominican Republic. For a brief period, members and sympathizers of these avant-garde formations coincided in Marseille and the Caribbean (a labyrinthine story that I revisit in Chapter 6). Reflecting on *Gaceta de Arte*, the journal he had directed five decades earlier, Westerdahl relates: "In those years we worked within architectural rationalism, searching for evasion, light, the contact with Nature, searching for freedom." This quest for aesthetico-political "evasion" and "freedom" expanded on an older generation of avant-garde criticism (among the well-known Spanish figures Westerdahl mentions are Ortega, Ramón, and Guillermo de Torre). But he highlights the regional dimension of Republican cosmopolitanism that orients the journal:

> There was also in the Canaries a great current of international tourism, of customs and freedoms, that normalized the traffic of foreign goods, and among those, books and journals that kept us up to date of distant activities in art and letters. As a more circumstantial cause, a trip to Europe I made in 1931 had some effect too.[10]

During his 1931 trip, Westerdahl spent time in the Netherlands, Germany, Czechoslovakia, and France. He went to the Bauhaus at Dessau and visited a range of museums, galleries, and architect studios. Back in Tenerife, he shared the atmosphere of experimentalism and creative freedom that he had experienced during the European tour with his avant-garde friends. This foundational experience infuses *Gaceta de Arte* with an expansive intellectual curiosity and at times a contradictory fascination with the varieties of Eurocentric cosmopolitanism. The journal's Germanophilic orientation follows the example of Ortega's *Revista de Occidente*, but its international openness developed, at least in part, against the aesthetic universalism of the journal *La Rosa de los Vientos* ("The wind rose") (1927–8).[11] Above all, the self-conscious location of the Canary Islands within *Gaceta de Arte* grounds the journal's orientation in a diverse exploration of regional imaginaries, collaborative critical practices, and politically progressive interventions. For Westerdahl and his group, the Canaries are now a central referent in a fragmented avant-garde geopolitics where Dada, Cubism, Bauhaus, socialism, communism, and syndicalism must be taken equally seriously.

In May 1935, three members of the Paris surrealist group, Breton, Jacqueline Lamba, and Benjamin Péret, traveled to Tenerife to participate in the Second International Surrealist Exhibition at the recently inaugurated Ateneo de Santa Cruz. In a photograph that is probably the work of Westerdahl, Péret, Breton, Lamba, and the literary critic and member of *Gaceta de Arte*, Domingo Pérez Minik, pose against a luminous backdrop of lattices (Figure 5.1). Breton had recently visited Prague with Lamba, the artist Josef Šíma, and Paul Éluard. The Prague surrealist group had formed in March 1934, and Breton and his entourage spent two weeks in the Bohemian capital at the behest of the poet Vítězslav Nezval and the artist and critic Karel Teige. Three years earlier, a group of Czech enthusiasts had organized *Poesie 1932*, the First International Surrealist Exhibition at the Mánes Gallery in Prague, featuring the work of local and international avant-gardists and surrealists, "not to mention a group of anonymous 'Negro sculptures' – in what was probably the largest display of surrealist art yet seen anywhere in the world."[12] Breton and Éluard felt encouraged as new international inroads opened up for the movement, at a time when Surrealism dreamt of securing a presence in Russia. In a letter addressed to his wife Gala from Prague on April 1935, Éluard speculates: "I think that Prague is our door to Moscow."[13] Expanding Surrealism

beyond the continent, the Tenerife exhibition would be the first of its kind in Southern Europe. The movement's international projection had increased considerably since the May–June 1934 *Minotaure* exhibition in Brussels, and a Cubist-Surrealist show in Copenhagen in January 1935; a fourth would follow in London in 1936. Indeed, as Henri Béhar writes: "By a communicating vessels effect, Surrealism gains on the international terrain what it loses in its own care".[14] The Paris and Prague groups co-signed a bilingual (Czech and French) *Bulletin international du surréalisme*, dated April 9, 1935, and a second bulletin in Spanish and French appeared in Santa Cruz de Tenerife in October, "Published by the Paris surrealist group and 'Gaceta de Arte' in Tenerife (Canary Islands)." The text includes Breton's opinions on surrealist approaches to contemporary psychology, dialectical materialism, currents in art history, and Aragon's flight from the movement, all proffered during an interview with López Torres for his short-lived radical journal, *Índice: Revista de cultura* (1935).[15]

The Paris group's visit to the Canary Islands is an important landmark in the history of Spanish Surrealism. Breton dedicates the fifth chapter of *Mad Love* (*L'Amour fou*) (1937) to this adventure,

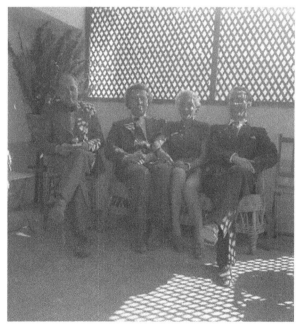

Figure 5.1: The Paris surrealists pose with Domingo Pérez Minik, Tenerife, 1935

a text that contains numerous traces of the long island excursions on which the local avant-gardists took the Paris visitors. In another photograph, presumably by Westerdahl, López Torres (Figure 5.2; second from the left) squats next to Péret, Lamba, Breton, and Pérez Minik during one of these outings. In a memoir published in 1975, Pérez Minik, then a surviving member of the *Gaceta de Arte* group, describes the events of May 1935 in great detail.[16] He refers to the surrealist members of the journal as "the Tenerife Spanish surrealist group" ("*facción española surrealista de Tenerife*"). In an earlier essay, "De André Breton a Óscar Domínguez," Pérez Minik combined a piece he had published after Domínguez committed suicide in Paris in 1957 with a new obituary note remembering Breton after his death in 1966: "But Tinerfeños cannot speak of André Breton without foregrounding Óscar Domínguez and the position he acquired in the surrealist movement." With irony and

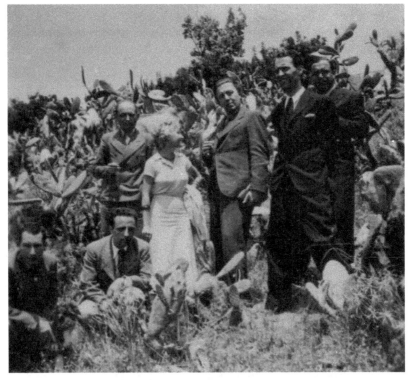

Figure 5.2: Domingo López Torres and Domingo Pérez Minik pose with the Paris surrealists, Tenerife, 1935

humor, Pérez Minik recalls that Breton had "'officially' declared Tenerife a surrealist island" during his visit, "and unveiled for our generation a world of things, figures, and values that we couldn't have imagined."

> When he reached the Cañadas del Teide and saw the lava and the lunar landscape, pointing at them with his finger he said with the certainty of a non-Classical Olympian god: "This is pure Surrealism." On the second day, Breton said the same thing of the black sands on our beaches, and on the third day he reiterated his unimpeachable opinion before the thousand-year-old dragon tree. He was pleased with his discovery, and we were satisfied with that ignored treasure. We now had a new interpretation of the Island at our disposal that was neither Humboldt's nor Miguel de Unamuno's.[17]

An anecdote about the projection of Buñuel's scandalous film, *L'Âge d'or* (1930), encapsulates the fast-degrading political climate. In Hugh Thomas's concise words: "The history of Spain during the two and a half years after the general elections of November 1933 was marked by disintegration."[18] Breton brings one of the rare copies of the film from Paris, courtesy of Buñuel, but the announcement of a planned projection precipitates a wave of attacks by Catholic and fascist groups. The "Juventud Católica Femenina" orchestrates a campaign in the press, and the local Catholic journal *Gaceta de Tenerife* boycotts the projection with the support of the local bishop, a man whom Pérez Minik does not hesitate to call "*fascista*": "This battle went on for several months, all the press stepping in, from right to left, with very violent articles."[19] On June 14, *Gaceta de Tenerife* published an article describing *L'Âge d'or* as a "criminal heresy," a film that "tends to spread degeneration, the most disgusting corruption of the day." "*La Edad de Oro* is the latest poison for the use of Judaism and Freemasonry, and of angry and revolutionary sectarianism that corrupts the people."[20] The scandal repeated another famous anecdote surrounding the public screening of the film in Paris. As Short explains, on December 3, 1930 the "Ligue des Patriotes" and the "Ligue antijuive" had attacked the projection space, Studio 28 at rue Tholozé in Montmartre, destroying the surrealist paintings in the exhibition in the foyer and shouting, among other slogans, "Death to the Jews!"[21] The film was finally shown in a private session after the triumph of the Frente Popular in the national elections of February 1936, "in Santa Cruz de Tenerife's Numancia theater and with a great deal of police surveillance."[22]

Homo Meridionalis

The events of May 1935 would not have happened without the mediation of Óscar Domínguez, the Paris correspondent of the *Gaceta de Arte* group. In 1925, Antonio Andrés Domínguez, a businessman and amateur archaeologist from Tacoronte on the north coast of Tenerife, sent his son Óscar to Paris, where he was to support the family's banana export business. Óscar joined bohemian circles in Montmartre and made a name for himself as a self-taught surrealist artist and the inventor of the gouache *décalcomanie*, a pictorial technique that other surrealists adopt in the 1920s and '30s. Although he had been making surrealist paintings since 1927, the year when he moved to Paris permanently, he only came into direct contact with Breton and his group in 1934. *Gaceta de Arte* offered Domínguez a foothold on the Islands, and in turn the local avant-gardists secured a sympathetic ambassador in Paris.[23]

Several members of *Gaceta de Arte* produced surrealist texts, commentaries, and artworks, and by the spring of 1935 the relationship between the Paris surrealists and the Tenerife group was openly friendly. Domínguez's first surrealist show took place in Tenerife in 1933, two years before his paintings figured in the Second International Surrealist Exhibition that he helped organize with *Gaceta de Arte* and Breton. According to Federico Castro Morales, *Composición surrealista II* (1933) prefigures the more obviously surrealist works of the following year, some of which were shown in the Copenhagen and Tenerife exhibitions of 1935.[24] In the spring of that year, Domínguez organized one of the first international surrealist exhibitions and convinced Breton to travel to the Canary Islands, accompanied by Lamba and Péret, for the occasion of the opening at the Ateneo in Santa Cruz de Tenerife. He painted *Cueva de guanches* (*Guanche Cave*) and exhibited it in Tenerife in 1936, just before the outbreak of the Spanish Civil War.[25]

Domínguez is often tropicalized in surrealist lore as a man of the South, an example of the playful distinction Roberto Dainotto makes between "*homo meridionalis*" and "*homo europaeus*."[26] In Domínguez's case, discourses of meridional backwardness, self-exotic irony, and stereotypical cultural performance are taken for cultural authenticity. He figures variously in surrealist anecdotes as Picasso's protégé and as a self-destructive brute, thus embodying an image of monstrous difference that recalls the Latin brutes of Buñuel's films. Both artists inhabit cultural fantasies of "primitive" Spain

and the "bestial" South that correspond to Buñuel's documentary film, *Tierra sin pan* (*Land without Bread*) (1933). Domínguez's last lover was an eccentric socialite and surrealist patron, Marie Laure Henriette, née Bischoffsheim, Vicomtesse de Noailles. De Noailles prided herself on being a descendant of the Marquis de Sade, and Charles de Noailles, her husband in the 1920s, famously financed the production of *L'Âge d'or*. The Vicomtesse met Domínguez in 1952 and lived with him until his death on New Year's Eve, 1957. A Noailles biographer construes the couple as a grotesque version of *La Belle et la bête*, quoting the famous journal of French critic Matthieu Galey: "They looked like Louis XIV walking with the Cro-Magnon man." She describes Domínguez as "A monster worthy of a children's tale," having "something beastly about him," and "a sort of prehistorical Buñuel."[27]

The construction of Domínguez as *homo meridionalis* (shorthand for "primitive" islander and exotic foreigner) satisfies bourgeois fantasies of European civilization – a combination of cultural hegemony and moral self-righteousness that the surrealists professed to undermine. Yet, Domínguez's early surrealist works are enigmatic and subtle experiments in self-exploration and oneiric "discoveries" of insular spaces, objects, and discourses. His themes are sexual desire, dreams, metamorphoses, specular images; and a series of objects, spaces, animals, and severed body parts that form his signature fetishes: pianos, sewing machines, boxes, sardine cans and openers, mirrors, islandscapes, dragon trees, bulls, and horses. Writing in the *Dictionnaire abrégé du surréalisme* in 1938, Breton calls the results of Domínguez's experiments with diluted gouache "*décalcomanies du désir*," while the Argentinian writer Ernesto Sabato names the technique *litocronismo*.[28]

Like Dalí and other surrealist artists (the Fuerteventura-born Juan Ismael, for example), Domínguez adopted some of the clinical tropes that circulated in international intellectual circles after Freud's groundbreaking publications of the early twentieth century: displacement, projection, condensation, compensation, and the uncanny or *unheimlich*. What distinguishes Domínguez is an intense concentration on islands as spaces of psychic revelation and metaphysical awareness. Clearly Giorgio De Chirico's allegorical architectures and "metaphysical" compositions from the 1910s, and Atget's and Brassaï's photographs, infuse Breton's circle with a repertoire of, in Hal Foster's words, "subversively nonfoundational scenes."[29] But a different experience of the earthly sensorium permeated the pictorial grammars of Dalí, Domínguez, Juan Ismael,

and Max Ernst, signaling their commitment to an aesthetic of tectonic and elemental perception. Cadaqués (Girona) in Dalí's case, and Tacoronte in Domínguez's, are not only places in a vague geography of the European South, but metaphysical enclaves that haunt the visual field.

In *Cueva de guanches*, unconscious associations morph into enigmatic shapes under a surface of volcanic sands. The referential force of the painting can be partly interpreted, as I am about to suggest, from a biographical anecdote. As an amateur archaeologist, Domínguez's father would explore the local caves along the coast of Tacoronte searching for the mummified remnants of the Guanches, the "native" Canary Islanders who were colonized and, in some cases, enslaved and transported to the Caribbean in the early phase of Spanish Atlantic imperialism.[30] But the painting also suggests the atmosphere of a tourist poster, postcard, or visual souvenir. Thus, Yoke-Sum Wong's perceptive reflections on the colonial postcard apply to my discussion: "Imagine the visual currency of souvenirs – how a lion becomes an empire, or the other way around; how a foreign land one has never been to embodies a memory; how a tea towel typifies an experience, however momentary, however fleeting."[31] For Domínguez, the *return* to the island exceeds the register of nostalgia. These paintings express an exploration of the souvenir in a double sense. They subvert the "exotic postcard" visual regimes that were prevalent in the Canary Islands of Domínguez's childhood and youth, and that had been growing exponentially since the period known as the Scramble for Africa. *Cueva de guanches* and other paintings by Domínguez fulfilled the double purpose of capturing exotic island "souvenirs" that circulated in Parisian and other metropolitan circles and sending them back to the Islands as an ironic gesture with each new local exhibition. As Wong points out, "the visual currency of souvenirs" inscribes fleeting processes of becoming and embodiment – remembering the island and dissolving the islander's origins.

Amanda Boetzkes makes an observation that resonates provocatively with the aesthetics of *Cueva de guanches* and other paintings by Domínguez from the same period: "While the artworks are designed to reveal natural activity, this process does not facilitate unencumbered visual or tactile access, as one might expect. Instead, sensation occurs at the threshold to the elemental, beyond which the viewer cannot grasp."[32] In some of these memory paintings by Domínguez, an insular visual grammar integrates references to autochthonous flora, volcanic landscapes, dramatic shorelines, and symbolic images

from the repertoires of the artist's erotic and libidinal worlds: lovers, musical instruments, bulls and horses, and other totemic animals index an imaginary of the South that coincides at times with those of Picasso and Dalí. An obsessive reckoning with the past-present of psychic and metaphysical experience reveals the artist's subjectivity as a displaced islander and as an island surrealist. These traits, uniquely imprinted in Domínguez's imaginary and increasingly recognized in recent years, express varieties of colonial ambivalence that are common more broadly to the cultural production of the Tenerife surrealist group. Even though its depiction of a liquefied organic mass resembles the interior of a body, *Cueva de guanches* is a calm fishing scene. The edge of a hill, cliff, shoreline, or skin flows sinuously like an open book. The visual revelation of depth does not only contain the colors of internal body organs – there are also uncannily bright blue-greens like those in Picasso's *Demoiselles d'Avignon* (1907) and Wifredo Lam's *The Jungle* (1943). The fluid zoomorphic and anthropomorphic figures appear to be dead, asleep, or lost in the dream we are witnessing. The subterranean space is divided into "stories" that resemble shelves – like those holding the skulls in the artist's father's amateur collection in Tacoronte. The abyss where the objects of desire or horror flow and transform summons the notion of the unconscious – a concept that is neither entirely individual nor human in its surrealist versions.

Domínguez's use of vaguely picturesque landscapes, defamiliarized bodies, and indexes of the unconscious in *Cueva de guanches* and other paintings indicates an impossible identification with the exoticist myth of island purity, evoking instead the sadistic and voyeuristic maneuvers of colonial history. The "scene" of primitive insularity that the title suggests cuts diagonally across colonial space, time, and relation, spelling out the violence that produces the island as a vanishing point of modern island utopias. The cave, a locus of repose in the afterlife and introspective reflection in the present, is a revolving door into the recesses of unconscious remembrance. Thus, Domínguez's oneiric homecomings write themselves in pictorial iterations of insular "space," but the severed ground, gendered body parts, and morphing organs signal a crisis of exoticist authenticity, a consciousness of aboriginal pasts, and a reflection on the unconscious reverberations of colonial violence.

What Is a Surrealist Text?

In *Crimen*, Espinosa adopted textual practices that had become established among the Paris surrealists.[33] Carrying an illustration by Domínguez on the cover, *Crimen* appeared in Gran Canaria in late 1934 in the publishing series "Ediciones de *gaceta de arte*." The text completes a process of partial revision and assemblage of a total of twelve fragments, most of which had been published in various journals in the Canary Islands and Madrid between July 1930 and October 1933.[34] Espinosa's hometown of Puerto de la Cruz in Tenerife, as well as Granada, Madrid, and Paris, inform the genesis of this text. *Crimen* opens with a tragic accident, the death of a friend, and closes in a scene of apocalyptic terror. Inscribing these two events like book holders, the text comprises an untitled preamble, four sections evoking the four seasons, and "Epílogo en la isla de las maldiciones" ("Epilogue on the island of curses"). As early as 1919, the year of the foundation of the journal *Littérature*, Breton and Philippe Soupault had published *Les Champs magnétiques* using the automatic writing technique. Breton had become aware of psychoanalysis in 1916 and visited Freud in Vienna in 1921, forcing him to engage in a conversation around the surrealist project, and eliciting a *dialogue de sourds* that frustrated both parties. Freud did not understand what Surrealism wanted and, as Jean Starobinski observes astutely, Surrealism never understood Freud and, indeed, misinterpreted psychoanalysis.[35]

In a scathing review of Soupault's book of poems, *Le Cœur d'or* (1927), Walter Benjamin reflected on the previous years of surrealist ferment: "It may be much harder for artists than for amateurs to follow the precepts of an art based on a relaxed psyche, a stock of ideas from the unconscious, and that the entire task of the 'artist' is to dredge them to the surface."[36] Following the second series of *Littérature*, in the *Surrealist Manifesto* (*Manifeste du surréalisme*) (1924) and in *Communicating Vessels* (*Les Vases communicants*) (1932), Breton laid out his own theories on the interrelated spheres of the real and the dreamed, and published accounts and analyses of his own dreams. The first section in *Clair de terre* (1923), for example, contains five short *rêves* dedicated to "Georges de Chirico." The same heterogeneous collection figures the mysterious vertical "ILE" (ISLAND) insert, probably drawn by Breton himself.[37] Buñuel and Dalí explored a similar surrealist route in *Un Chien andalou* and *L'Âge d'or*, and Domínguez and Dalí formalized

related strategies in their "paranoid" paintings. Aspiring to capture what Benjamin calls "the quality of dreams," *Crimen*'s recurrent nightmares constellate instead around the final scene, "on the island of curses."[38]

Not content with publishing records of his dreams, Espinosa produced oneiric variations around the motif of the *crime passionnel*, a tortured and delirious investigation into perverse and criminal passions. While his earlier text, *Lancelot 28°–7° [Guía integral de una Isla Atlántica]* (1929) is a kind of avant-garde journal of a stay in Lanzarote, the fragments in *Crimen* form a different type of *diario* or *guía*, the result of an introspective crossing into the spaces of unconscious activity.[39] A "landscape" of fantasies and interdictions enacts a poetics of displacement, projection, and condensation that corresponds to Domínguez's fetishized objects, dreamed souvenirs, and islandscapes. The book is dedicated "To you, Ernesto, that broken cloud shuddering over / your black suit, waiting for my soul" (52). This is a clear reference to the avant-garde critic Ernesto Pestana Nóbrega, who died tragically after Espinosa had started publishing the fragments of the as yet unassembled *Crimen*. Like Espinosa and Juan Manuel Trujillo, Pestana published locally in *La Rosa de los Vientos* and in *La Gaceta Literaria* in Madrid. As Palenzuela suggests in his introduction to *Polioramas*, Pestana's untimely death explains why his work would remain largely unknown until the late twentieth century, "beyond a small group of researchers." Yet Pestana was an influential figure in the development of avant-garde culture in the Canary Islands, notably through his contributions to *La Rosa de los Vientos*, and his role in the local reception of Ramón's ideas and *ultraísmo*.[40] His short critical pieces, the *polioramas*, show that his political positions were as progressive as those of López Torres and Pedro García Cabrera, the other partisan leftists (and surrealist supporters) in the *Gaceta de Arte* group.

At the start of *Crimen*, the murderous narrator finds himself in a love triangle. He performs multiple roles – as masochistic victim, sadistic agent, and voyeur in an ambiguous relationship with "a young man with a soft dark moustache." María Ana, the bride and dominatrix, is equally versatile. Like the Paris surrealists, who identify a *medium* in photography to access surreality, Espinosa uses María Ana as a *mediatress*. A homoerotic undercurrent emerges in the narrator's fetishistic fixation on a portrait: "She masturbated on him daily while kissing the portrait of a young man with a soft dark moustache." In the next paragraph, "She urinated

and defeated on him. She spat – and even vomited – upon that frail love-stricken man, thus satisfying an uncontrollable need and conquering, in passing, the discipline of a sexuality of which she was the only mistress and officer" (53). On the following page, the memory of the female lover and the fetishized portrait of the young man coincide in a composite image: "But the memory of her and the portrait of a young man with a soft dark moustache have never left me" (53, 54). Like the dreamer or analyst who struggles to comprehend a confused dream, *Crimen* "remembers" fragments of past experience that are immersed in historical and aesthetic time. Perhaps, in mourning a lost friend, as the dedication to Pestana suggests, *Crimen* revisits the visionary avant-gardism of *La Rosa de los Vientos* and *Lancelot* (see Chapter 2). But the central quandary for readers and interpreters of *Crimen* regards the assemblage of surrealist fragments or, more concretely, how to write Surrealism from the Canary Islands (and how to write the Canary Islands into Surrealism) through "a path back into a landscape of writing" and a "syntax of dream writing."[41] In the second fragment, titled "Luna de miel" ("Honeymoon"), the newlywed narrator commits a murder but declares it suicide. Obeying his dominatrix-wife's orders, he adopts a crucifixion pose while being humiliated by "the truncated head of a dark-skinned woman." After he has thrown her over a balcony, her body is run over by a passing train. Subsequently, "the autopsy wouldn't reveal anything useful about the formless mass of red flesh" (53). The victim returns to haunt him, and *Crimen* "narrates" or disfigures these events through an abundant use of surrealist tropes.

While there are clear differences between *Lancelot 28°–7°* and *Crimen*, Espinosa's surrealist writing stages a series of continuities around a self-fashioning attitude that traverses the insular avant-garde following the "Primer manifiesto de *La Rosa de los Vientos*." Despite these texts' structural similarities and correlations, Miguel Pérez Corrales speaks of a *"juego de contrastes"* ("game of contrasts"), explaining that "Lancelot *es un libro solar allí donde* Crimen *lo es nocturno*" ("*Lancelot* is a solar book, while *Crimen* is a nocturnal book"). These distinctions are perplexing, since Espinosa wrote and published the texts contiguously – *Lancelot 28°–7°* appeared in Madrid in 1929, and the first fragments from *Crimen* in 1930.[42] The journey from *Lancelot 28°–7°*'s avant-gardism to the exquisitely truculent Surrealism of *Crimen* measures the intensity with which some avant-gardists from the Canary Islands embraced the aesthetic and ethical tenets of the 1924 *Manifesto*. However,

contrary to Breton's rapturous reminiscing of childhood in *Mad Love* (*L'Amour fou*) (1937) and elsewhere, *Crimen* reverses the tropes of the island-paradise and idyllic childhood.

In *Crimen* the island is a provisional *location*, a temporary site where the paranoid narrator assembles textual fragments, producing *montages* of literary spaces, distorted, mobile visions of the island, and a kind of visualized self-analysis that never translates as personal narrative, therefore challenging the reader to consider what Henri Lefebvre calls "a logic of space" and, beyond this contentious domain, the specific dimension of "an *illusory space*."[43] As Lefebvre notes in his appraisal of surrealist poetics, "the leading surrealists sought to decode inner space and illuminate the nature of the transition from this subjective space to the material realm of the body and the outside world, and thence to social life."[44] As a transitional material space, Espinosa's island locates and dislocates memories, rearranging the *mise-en-scène*. There are numerous analogies between *Crimen* and Buñuel and Dalí's surrealist films. However, despite an uncanny resemblance between certain motifs of *L'Âge d'or* and the textual universe of *Crimen*, Espinosa's text is not a literary extrapolation on surrealist cinema, but an expression of a common absorption of French Surrealism.[45] Espinosa almost certainly had not seen *L'Âge d'or* before 1935, but he must have read reviews of the film that appeared in French and Spanish literary journals and in the press. Furthermore, various textual elements coincide, sometimes with perplexing exactitude, with Lorca's *Poeta en Nueva York*, written in 1929–30 and published posthumously in 1940. Yet there is little to prove any direct influence. Espinosa probably read Lorca's surrealist poems before the publication of *Crimen* in 1934, while Lorca may have read published fragments of *Crimen*. How, then, does *Crimen* produce the *illusory space* of a surrealist island?

In "The Author as Producer" (1934), Benjamin explores the social conditions (and conditions of production) of literary works in Soviet Russia, Germany, and France. Benjamin's homosocial perspective in this text is symptomatic of a male-centered construction of the proletariat and the socialist intellectual across the Moscow/Berlin/Paris axis. He extends his argument beyond "the attitude of a work to the relations of production of its time" to focus on "the literary *technique* of works" as "the concept that makes literary products accessible to an immediately social, and therefore materialist, analysis."[46] As Michael Löwy observes, "For a brief 'experimental' period between 1933 and 1935, during the years of the Second

Five-Year Plan, some of Benjamin's Marxist texts seem close to 'Soviet productivism' and an uncritical adherence to the promises of technological progress."[47]

Benjamin considers the work of Sergei Tretyakov to shift the discussion from the latter's distinction between "the operating writer" and "the informative writer" onto the realm of the capitalist press and "the author as producer" (770, 772). He concludes that "the place of the intellectual in the class struggle can be identified – or, better, chosen – only on the basis of his position in the process of production" (773). He summons Bertolt Brecht's notion of *Umfunktionierung* (functional transformation, or "refunctioning") and reminds us that "[Brecht] was the first to make of intellectuals the far-reaching demand not to supply the apparatus of production without, to the utmost extent possible, changing it in accordance with socialism." In the ensuing discussion of the New Objectivity (*Neue Sachlichkeit*) movement, Benjamin discusses yet another type, the "hack writer" – "... a writer who abstains in principle from alienating the productive apparatus from the ruling class by improving it in ways serving the interests of socialism." In a vertiginous gesture, he turns to photography as a form of reportage, arguing that "both [literary and photographic forms of reportage] owe the extraordinary increase in their popularity to the technology of publication: radio and the illustrated press." He relates that "the revolutionary strength of Dadaism consisted in testing art for its authenticity":

> A still life might have been put together from tickets, spools of cotton, and cigarette butts, all of which were combined with painted elements. The whole thing was put in a frame. And thereby the public was shown: Look, your picture frame ruptures time; the tiniest authentic fragment of daily life says more than painting. Just as the bloody fingerprint of a murderer on the page of a book says more than the text. Much of this revolutionary content has gone into photomontage. (774)

Benjamin mentions John Heartfield ("whose technique made the book cover into a political instrument"), but dismisses the increasing use of modern photography as an instrument of fashionable mass consumption. He reflects: "What we require of the photographer is the ability to give his picture a caption that wrenches it from modish commerce and gives it a revolutionary use value" (775). As an example of *Umfunktionierung*, he considers music and word in Bertolt Brecht and Hanns Eisler's cantata, *Die Maßnahme* (*The*

Measures Taken) (1930), and Brecht's Epic Theater: "It is, measured by the present state of development of film and radio, the contemporary form" (778). Underlining "the most primitive elements of the theater," he insists on the photographic principle of photomontage, Brecht's intention "to portray situations, rather than develop plots":

> ... by interrupting the plot ... Here – according to the principle of interruption – Epic Theater, as you see, takes up a procedure that has become familiar to you in recent years from film and radio, literature and photography. I am speaking of the procedure of montage: the superimposed element disrupts the context in which it is inserted ... Epic Theater, therefore, does not reproduce situations; rather, it discovers them ... Brecht's discovery and use of the *gestus* is nothing but the restoration of the method of montage decisive in radio and film, from an often merely modish procedure to a human event. (778)

Benjamin concludes his argument on the writer's position in the process of production by referring to the French journal *Commune* and endorses a statement by Aragon: "Aragon was thereby entirely correct when, in another connection, he declared, 'The revolutionary intellectual appears first and foremost as the betrayer of his class of origin'" (780). While Espinosa can hardly be seen today as a revolutionary intellectual, he complies with Benjamin's partisan guidance in a non-partisan way: "... the demand to think, to reflect on his position in the process of production" (779). Some six decades later, Foster observed in a well-known essay:

> [Today] there is the assumption that the site of artistic transformation is the site of political transformation, and, more, that this site is always located *elsewhere*, in the field of the other: in the productivist model, with the social other, the exploited proletariat; in the quasi-anthropological model, with the cultural other, the oppressed postcolonial, subaltern, or subcultural.[48]

The *Gaceta de Arte* group that largely mediated Espinosa's surrealist practice represents an interesting example of the unfolding dynamics of such negotiations. Foster highlights two further assumptions:

> That this other is always *outside*, and, more, that this alterity is the primary point of subversion of dominant culture ... that if the invoked artist is *not* perceived as socially and/or culturally other, he or she has but *limited* access to this transformative alterity, and, more, that if he or she *is* perceived as other, he or she has *automatic* access to it.[49]

As a member of *Gaceta de Arte*, Espinosa participated in an analogous topological understanding of alterity. His archipelagic provenance locates him as someone who thought from an "elsewhere," a "cultural other" some distance from continental constructions of the revolutionary avant-gardist. But he was only a relative "outsider," with neither "limited" nor "automatic" access to any kind of "transformative alterity" outside the production of textual assemblages. In Domínguez and Espinosa, the spatial and temporal subjectivity of *homo meridionalis* is a decisive driver of their engagements with Surrealism. Their anachronistic concerns resonate with what Maria Gough calls, brilliantly, "Benjamin's well-known investment in the potentially liberatory potential [*sic*] of anachronism, a word the etymology of which may be traced to a verb meaning 'to be late in time.'"[50] Their construction as men of the South implies a cosmopolitan sense of mobility, but not an allegiance to what Foster calls "the quasi-anthropological model" or paradigm. From the Atlantic viewpoint of *Gaceta de Arte*, this construction includes a reorientation of the production of insularity and a complex understanding of the unstable political field, the cultural possibilities of the Spanish Republic, and the commitment to intervene in the unfolding present.

The contexts of *Gaceta de Arte* and Surrealism resonate with Benjamin's concerns only in part, yet his analysis of technique and disturbances in production processes speak to the insular situation within the fractures of Republican Spain. The dislocation of the author's consciousness as producer of aesthetico-political shock and debate becomes apparent when fascism takes over less than two years after the publication of *Crimen*. In that unprecedented juncture, Surrealism challenged social order and political power, but its denunciations remained invested in an aesthetics of subversive performance whose effects on material life were at best vague. Yet, while the power of photomontage and textual montage might express a reaction to systemic capitalist and colonialist violence, in the Canary Islands and mainland Spain, it meant incalculably more in the fascist overturn of the Republic – a reorientation of the souvenir, and a new assemblage of the elements of previous imaginaries. Given that, at the end of his essay, Benjamin evoked "the *Umfunktionierung* of the novel, the drama, the poem" (780), does *Crimen* represent an *Umfunktionierung*, a functional transformation in the Brechtian and Benjaminian sense?

While *Crimen* is the result of a process of textual experimentation, its final shape suggests a long and sustained critical investigation

of the sensory, affective, and literary temporalities of insular provincialism. In this sense, Espinosa remains faithful to Pestana's invective against "the unnecessary putrefaction of *costumbrismo*."[51] He confronts traditions and allows images to appear displaced, condensed, and projected onto a textual space that is fixated on a specific geocultural ideology: the cultural construction of the Spanish South and its African insular appendix as simultaneously decadent and exotic. In Espinosa's text, the space of this theatrical reckoning with personal and geopolitical imaginaries remains subjected to a great deal of pressure. On the one hand, the structural sequence of the surrealist text stands in paradoxical tension with the optimistic avant-gardism of *Lancelot 28°–7°*. On the other, it responds to the insular situation or climate indirectly, reducing picturesque and tourist anecdotes to a minimum. Fragmentary and spectral, *Crimen* sketches darkly romantic and *costumbrista* spaces to meditate on outmoded temporality, not subtropical sensuousness. The spectral vision of island temporality "forgets" the present and avant-garde horizons of the tourist Canary Islands "*de velas latinas y de chimeneas trasatlánticas*" (93) ("of lateens and transatlantic chimneys"). These textual hallucinations never entirely coalesce into clearly defined souvenirs, but, rather, disjoint postcard images and ultimately configure *Crimen*'s ontological distortions of the idyllic island as surrealist production.

Commenting on Blaise Cendrars's *Prose du Transsibérien* (1913), Marjorie Perloff observes: "The journey itself is poised on the threshold between documentary realism and fantasy ... The train itself appears to be a microcosm of the international technology of the 1910s."[52] Cendrars's Transsibérien is a modern space-object that traverses and disconnects spaces, historical periods, and narrative domains. In *Crimen*, the surrealist rendering of the train as a symbol of modern mobilities and speedy transitions distorts both the object and its conventional meaning by inscribing them in a new and unstable grammar of island-centered affects. The sinister train (a disfiguring machine) that "murders" the heroine contrasts with the sailing boats and lateens that appear elsewhere in the text: "At the bottom of Calle del Muerto there was a seascape of sailboats on a sea of calm, seagulls, setting suns, and pink clouds" (78). The macabre contrast between "Calle del Muerto" ("Deadman's Road"), where Espinosa was born in 1897 in the port city of Puerto de la Cruz, and the idyllic description of the seashore with "pink clouds" suggests a different intersection – in both Espinosa and Domínguez the birthplace is a distorted islandscape, and *Crimen*

evokes it as the obverse of a tourist postcard, an ironic souvenir of the subtropical Belle Époque.

Crimen conveys a vertiginous sense of speed through its experimental use of montage and fragmentation. The scenes of playful and exotic tropicality that we associate with *La Rosa de los Vientos* and pre-surrealist avant-gardism are now presented in a dialogue across space and time. Espinosa mobilizes Surrealism's aesthetic ideology to collate and collapse not only different objects, but also various images and discourses of the islands. Combining the literary and metaphysical registers of Lautréamont and De Chirico, *Crimen* dismembers fragmentary scenes of insular childhood and youthful continental experience. In "Parade," the first fragment in "Invierno," the narrator revisits the crime scene, finding it intact, and transcribing his impressions in atmospheric detail. The moon shines on the train tracks as the sad shadow of the switchman comes and goes: "Two trains went by, haloed in black smoke and sorrowful sirens" (85). This lurid atmosphere is rendered more sinister by a reference to the "Valse Poudrée" by French composer Francis Popy, interpreted by clowns in a deserted neighborhood; a pathetic phantasmagoria of the Belle Époque of the narrator's childhood.

In "Retorno" (78–9), the narrator remembers a square by the sea, a place that captures old sensory memories and early glimpses of aesthetic experience. In its initial publication in *Heraldo de Madrid* (December 4, 1930), this fragment bears the title "La plaza de la soledad" ("Solitude Square") and contains the sentence: "You could hear the sea from the square, which turned into an island bordering on the sea" (105). In *Crimen*, the revised version of this fragment erases the word "island," substituting it with "beach" (79). Toward the end of the revised version, the sensory archive of this childhood memory sprouts as a surrealist montage of "fish market smells, old flowers, rotten water and human excrements" (79). The psychic flotsam of Espinosa's childhood evokes the contours of a less than idyllic island life and reduces the space of Tenerife to narrowly littoral remembrance.

Crimen "cites," via Surrealism's obsession with the photographic universes of Atget and Brassaï, and De Chirico's paintings, the melancholy qualities of outmoded spaces and hauntingly emotional scenes. The trains that appear in the distance in De Chirico's metaphysical paintings of the 1910s, *Melancholy of an Autumn Afternoon* (1910), *The Uncertainty of the Poet*, *The Melancholy of an Afternoon*, *Departure of a Friend* (1913), and *Anguish of Departure*

(1914), evoke Mediterranean versions of Belle Époque decadence that obsesses the narrator of *Crimen*. Of course, Espinosa's trains are nocturnal and sordid and their smoke is black, not cloud-white like De Chirico's, yet Serge Fauchereau's reading of *Melancholy of an Autumn Afternoon* could apply to *Crimen*: "This new painting ... no longer presents a wild or marine landscape to place some mythological scene, but a timeless urban view, a mixture of antique buildings and modern details."[53] The surrealists explore the enigmatic value of railways and locomotives as transitional objects that were once celebrated as romantically inflected, or as symbols of the modern city's latent inhumanity. Commenting on a well-known passage in *Mad Love* (*L'Amour fou*), Foster writes: "This violent arrest of the vital, this sudden suspension of the animate, speaks not only of the sadomasochistic basis of sexuality posed by the death drive theory, but also of the photographic principle that informs so much surrealist practice."[54] Foster observes further that the image of the train in *Mad Love* resurfaces in a text by Péret, "La nature dévore le progrès et le dépasse" ("Nature devours progress and surpasses it").[55] *Mad Love* frames and *contains* photographic moments in a relatively linear organization of the personal album narrative or register, the arrangement of autobiographical, sentimental, and hazardous elements in a chronology. But the apparent nonlogic of Espinosa's text responds to the capricious rearrangements (displacements, condensations, projections, and mutilations) of dreams in literary form. *Crimen* inscribes an aesthetic of visual and cinematic montage, substituting the mnemonic register of the album with a questioning reconstruction of portable souvenirs. We might speak of the double shock of assemblage and montage as a driving force that grounds the production of island souvenirs under Surrealism's conditions.

Crimen as Kino-Text

In "The Photographic Conditions of Surrealism," Rosalind Krauss observes: "Never could the object of violation have been depicted as more willing."[56] She discusses *Monument to de Sade*, a Ray photograph of 1933, and Florence Henri's photographic *Self-Portrait* of 1928, comparing these images in the context of "what could be called the character of the frame as sign or emblem." She notes the "sexual import" of the frame in both images, highlighting how, in Ray's photograph, "the act of rotation, which transmutes the sign

of the cross into the figure of the phallus, juxtaposes an emblem of the Sadean act of sacrilege with an image of the object of its sexual pleasure."[57] Krauss's insights on the frame, transmutation, and juxtaposition can be extended to transgressive uses of formal and other conventions in surrealists' texts more broadly. In a lucid appraisal of the surrealist movement, Yvonne Duplessis renders the movement's relentless assault on conventional morality delicately as "the meta-moral aspect" of Surrealism.[58] Dada had placed anticlericalism at the core of its live and media performances, and Breton, in the 1924 *Manifesto*, naturally targets Catholic iconography as part of its vocation of "nonconformism." In notorious examples like *L'Âge d'or*, in irreverent or blasphemous imagery, and in carefully staged attacks against the religious establishment, the surrealists dive into the archaic, repressive, and authoritarian universe of the bourgeois imagination. But while French Surrealism experienced such symbolic effluvia as intrinsically authoritarian, Espinosa and other Spanish surrealists, including Lorca, Buñuel, Dalí, Picasso, and Domínguez, were variously entangled in an anticlerical front whose enemy was at once a persistent image of Catholic Spain and the reactionary forces that resisted and sabotaged the revolutionary impetus of a progressive Spanish Republic. As María T. Pao concludes: "*Crimen*'s most original contribution resides in the overdetermined way in which it depicts the avant-garde narrator as a literal – and *literary* – transgressor, as the author of a crime against the textual body of conventional narrative."[59]

In *Crimen* and other French and Spanish surrealist texts, Catholic images embody an ideology of unfreedom that separates transcendence from unconscious desire and physical pleasure. But in surrealist culture more broadly, references to religious cultural icons inscribe genealogies of Southern European anticlericalism, popular religion, and unorthodox metaphysical quests. Anticlericalism is sometimes mixed with irreverence and humor, in works like Ernst's *The Virgin Spanking the Christ Child before Three Witnesses: André Breton, Paul Éluard, and the Painter* (1926). In the Spanish case, the varieties of surrealist anticlericalism range from Dalí's overt blasphemy to Buñuel's humorous irreverence and Lorca's respectful ambivalence. These Spanish surrealists valued Catholic iconography even as they devalued it, dramatizing theological symbols and popular renditions of religious myth.

Crimen exhibits a baroque excess, a fixation with Catholic icons and motifs, not only to seek liberation from moral and religious norms, but also to expose and torture the agents of repression in

ways that connect Espinosa's textual tactics with changing notions of *the surrealist text* in the mainstream of French and Spanish Surrealism. In "Luna de miel," the opening fragment in "Primavera" (Spring), the narrator proffers a subtle insult against the influential French Catholic writer Paul Claudel. Elsewhere in *Crimen*, there are Sadean and libertine traces, and an offensive response, in the context of the Spanish Republic, to the mounting cultures of conservative, reactionary, and fascist alliances between the Catholic Church, the monarchy, and state politics.[60] Espinosa demonstrates a detailed familiarity with the "precursors" and contemporary allies of the movement that Breton mentions in the *Manifesto* of 1924 and in other texts, evoking works by Sade, Baudelaire, Rimbaud, and Lautréamont; and traces of the erotic, decadent, and morbid literature that informs French and international Surrealism. But *Crimen* expands and provincializes the surrealist canon through culturally conscious displacements.

In *Mon corps et moi* (1925), for example, René Crevel explores the interlocked realms of deviant sexuality, religious profanity, sadism, and suicide. Aragon, Péret, and Man Ray collaborated in *1929*, a clandestine pornographic "calendar" published in Brussels that features four explicitly sexual photographs by Ray labeled after the four seasons, and poems by Aragon and Péret divided in two "*sémestres*" and twelve months.[61] While we ignore the name of the male poser (or posers), the female model is Alice Ernestine Prin, known as Kiki de Montparnasse, and Ray's lover in the 1920s. Kiki had famously posed with an African mask for *Black and White* (*Noire et blanche*) (1929) and for other photographic nudes.[62] In 1933, the Paris and Belgian surrealists gathered for a celebration of parricide with a *plaquette* titled *Violette Nozière*. Published in Brussels by "Éditions Nicolas Flamel," the document features eight poems, nine illustrations, and a cover image by Ray. Nozière, a free-spirited eighteen-year-old woman, had been accused of poisoning her parents and declared that her father had tried to abuse her. When she was condemned to life imprisonment, the surrealists send her a bouquet of red roses in recognition of her defiance of bourgeois hypocrisy and the corrupt institution of the family. Nozière embodies the virtues of convulsive beauty and the kinds of scopophilic exposure that fueled surrealist views on male heteronormative desire.

In Spain, Valle-Inclán and Ramón had long played on the edge of Catholic censorship, but *Crimen*'s attacks on moral conventions are more radical. While the tropes of class transgression, unrequited

love, and *crime passionnel* do not necessarily shock bourgeois sensibilities, explicit representations of perverse sexuality and religious iconoclasm single *Crimen* out as a politically incendiary instrument against the established social order. Disturbing images of childhood, adolescence, and youth surround the construction of María Ana's character as *mediatress* and underlie fragmented memories from the narrator's past; they are inseparable from the narrator's narcissistic obsessions and orient the critique of Catholic and conservative morality as a perverse assault on childhood innocence. In the 1924 *Manifesto* we read: "The mind which plunges into Surrealism relives with glowing excitement the best part of its childhood"; and in chapter IV of *Mad Love*, Breton evokes "the path lost with the loss of childhood" and alludes to the disillusioned avant-gardism that succeeds the politically naive experiments of the Belle Époque.[63] In *Crimen*, childhood memories are nightmarish apparitions, unsettling images of a remote spacetime that persists in the surrealist field of vision. The end of "Hazaña de un sombrero" ("A hat's doing") describes the corpse of a six-year-old girl in forensic detail: "She wore a man's hat held with a thick pin that perforated both parietal bones and pierced her encephalic mass" (62). And in "Retorno" ("Return"), the murder of a young woman anticipates the apparition of "a grotesque funeral, a burnt boy, a frightful parade" (78). This gruesome enumeration culminates in a first-person perspectival focus: "near my abnormal child's eyes, since my desperate tragic childhood" (78). Lorca's "Niña ahogada en el pozo" ("Girl drowned in the well") and other poems from *Poeta en Nueva York* resonate with these images.[64] The libidinal pressure of the Catholic imaginary inflects repressive social apparatuses, institutions such as the family, church, school, army, and the colonial war machine. This multifaceted *revenant* draws from romantic notions of a quintessentially archaic Spain and affects the *andalucismo* of Buñuel, Domínguez, Lorca, and Espinosa.

In *Crimen*, religious icons surface repeatedly as the agents of a pernicious temporality, reverberating in the narrator's delectation in perverse sexual practices, scenes of moral abjection, and cultural and institutional decadence. Figures of aging, decay, and decomposition affect male bodies, while figures of mutilation and violation distort and deform female bodies. The narrator suffers grotesque disfigurations after he murders his lover. In the fourth fragment of "Primavera," he imagines himself as a statue and a horse, called Agustín, and tells a second-person addressee: "You palpated a sick horse's genitals – you were so pretty still in your veterinary gown,

just out of Training College [*la Escuela*]" (65). The displacement of the author's name onto a horse is a humorous symptom of Espinosa's obsessive masculinity. Like the horses and other farm animals that populate the works of Buñuel, Domínguez, Dalí, and Picasso, *Crimen*'s animals are specifically cathected to fetishistic anxieties.[65] But while explorations of sadistic debauchery and ritualized eroticism are common in surrealist textuality, Espinosa is as interested in confronting the objects of desire and remembrance as in exploring authorial/textual decomposition. Surrealist "island time" flows uncannily through the textual labyrinth, propelling the oneiric displacements of the narrative voice across the past of childhood and the present of narrative elocution.[66] Similarly, Surrealism's experimental frames shape Espinosa's confrontations with the religious icons of recent pasts, the changing political present, and archaic childhood scenes. This relentless iconic motion renders the text kinetic, transitional, and potentially explosive.

Misogynist Fantasies

María Ana, the heroine of *Crimen*, has the sort of larger-than-life presence that we find in female protagonists of decadent tales, horror flicks, and melodramas. She indulges in adulterous desires and pleasures, and her murder defiles Catholic notions of the sanctity of matrimony and family echoing works by Sade, Crevel, and Bataille. But Espinosa could have modeled her after expressionist and surrealist films like Germaine Dulac's *La Souriante Madame Beudet* (1923) or *La Coquille et le Clergyman* (1928). In any case, she focalizes the changes in visuality that Malcolm Turvey defines broadly in a discussion of Benjamin and Kracauer as "the modern, distracted mode of perception" that is "perpetuated by the visual art and culture of modernity, especially the cinema."[67] María Ana is not only diluted and viciously fragmented, but also paradoxically intermediary – an erotic distraction in a text that transcribes and distorts the narrator's narcissistic turbulences. Acting as a recurrent figment, she is entangled in a web of unstable memories. She is a muted prism, a suppressed catalyzer for vectors of sadistic desire. Subjected to processes of grotesque transformation and mineralization, she becomes sedimented, but her accidental murder focalizes a chronicle of the decomposing present. In his "Surrealism" essay (1929), Benjamin calls those kinds of accidental events "profane illuminations":

> It is a cardinal error to believe that, of "Surrealist experiences," we know only the religious ecstasies or the ecstasies of drugs ... But the true, creative overcoming of religious illumination certainly does not lie in narcotics. It resides in a *profane illumination*, a materialistic, anthropological inspiration, to which hashish, opium, or whatever else can give an introductory lesson.[68]

Such experiences typically involve a chance encounter, an amorous "lucky find," and the mysterious or magical occurrence of objects and enigmatic connections with places that are construed as mythical or sacred. Margaret Cohen lists these environments as "uncanny landscapes, ghosts and sorcerers, strange stones and constructions, *illuminati*," adding a succinct conceptual enumeration: "Objective chance, intersubjective desire, the lucky find, the encounter, the dream, bohemian resistance, the social unconscious, and the capillary tissue connecting the communicating vessels of psychic and material life."[69] Benjamin's analysis proceeds:

> To say nothing of Aragon's *Passage de l'Opéra*, Breton and Nadja are the lovers who convert everything that we have experienced on mournful railway journeys (railways are beginning to age), on godforsaken Sunday afternoons in the proletarian neighborhoods of great cities, in the first glance through the rain-blurred window of a new apartment, into revolutionary experience, if not action. They bring the immense forces of "atmosphere" concealed in these things to the point of explosion. What form do you suppose a life would take that was determined at a decisive moment precisely by the street song last on everyone's lips?[70]

As if answering Benjamin's question, Espinosa's narrator inserts himself in the text as protagonist, casualty, and witness of his own *profane illumination*. A crucial biographical anecdote at the heart of the story is a lover from Espinosa's years as a university student in the Andalusian city of Granada. The narrator introduces her as María Ana in the opening fragment: "In an hour of passing mindlessness and forgetfulness, I penned the elegy to María Ana that I offer in this book ... A María Ana from those remote years as a student of Filosofía y Letras" (54). However, this "elegy" is not originally given in *Crimen*, but in three fragments published between 1929 and 1931.[71] The surrealist pose of absent-minded forgetfulness is clear, but the text deviates from nostalgic remembrance to focus obsessively on different versions of the heroine's death, the somber psychic landscapes of the narrator, and his tragic

location on an accursed island at the end of the book. Like Lorca, one of his classmates, Espinosa studied Filosofía y Letras at the University of Granada in 1917–18, the period when he supposedly courted a local prostitute called María Ana, the woman who inspired the surrealist heroine of *Crimen*.[72]

The seemingly casual references to the elegy, book, and remote student years orient the biographical parody toward a particular sociocultural and intellectual formation. These fragmentary adventures refer indirectly to a literary device that explores gender and class dynamics in nineteenth- and early twentieth-century Spanish novels – the debauched or existentially tormented male student who seduces a working-class woman. Like other Spanish and Latin American avant-gardists of his generation, Espinosa was an academically trained *scholar*, a cultivated and cosmopolitan interpreter of international avant-gardism.[73] He was a member of an overwhelmingly male elite of avant-garde intellectuals, well known in publishing circles in Madrid (*Revista de Occidente*, *La Gaceta Literaria*) and at home (*La Rosa de los Vientos*, *La Tarde*, *Gaceta de Arte*). He completed his studies in Granada and the Universidad Central in Madrid, and in the early 1920s conducted research at the prestigious Centro de Estudios Históricos alongside members of the "generation of 1927." In 1935 he became director of the newly created Instituto Nacional de Segunda Enseñanza de Tenerife, and president of the Ateneo de Santa Cruz.[74]

Granada and María Ana are minimal signs of the minutely codified discourse of romantic and avant-garde *andalucismo*, the construction of a cultural imaginary of the Andalusian south that includes aspects of Orientalism, *Arabism*, and *costrumbrismo*, such as the fiery Moorish character and Roma culture, exotic architecture, bullfighting, music and dance, exacerbated religious affect, and extreme gender roles, sexual passions, homoeroticism, and homosexual perversions.[75] This is in part the universe of Lorca's play *Mariana Pineda* (1925), his collections of poems, *Romancero gitano* (1928) and *Poema del cante jondo* (1921–31), and Alberti's *Marinero en tierra* (1925). But while *andalucismo* relies on cultural detail and stereotyping, *Crimen* erases most of these signs, reducing them to vague parodies of the discourse (the symbolism and atmospheric detail of Lorca's *Mariana Pineda* is inspired by Mariana de Pineda y Muñoz (1804–31), a heroine of romantic liberalism from Granada). Instead, the Granada of *Crimen* is both nebulous and contemporary. Lorca names sections of his play *estampas*, and Espinosa's scenes chime with the domestic and urban spaces of

avant-garde and surrealist cinema. There are intertextual references, brief *découpages* from disparate space-times that evoke the aesthetic practices and poetics of photomontage. An underlying cultural logic of female types steeped in atmospheric locations justifies the Lorquian and broader surrealist intertexts. But if María Ana represents an Andalusian gesture (her name splits and reinscribes that of Lorca's heroine, the historical Mariana), Espinosa gives only vague ethnic clues. Unlike the *mulatas* and *gitanas* of nineteenth- and twentieth-century Hispanic literatures, María Ana remains barely recognizable as an ethnic type; she represents instead a surrealist ideal of cultural and erotic transgression.

The text introduces María Ana at one point as a young prostitute working in the ports of the Mediterranean. Although she is often described as an adolescent girl, her age is unclear. Her virginal body is defiled, raped, and murdered repeatedly. The surrealists explore variations on fetishes of youth and purity, innocence, and virginity, evoking Sadean violation and the forbidden realm of adolescent and childhood sexuality. Breton's poem "Sans connaissance," included in *Le Revolver à cheveux blancs* (1932), fantasizes over the rape and murder of a "fourteen-year-old girl" called Euphorbe.[76] In *Mad Love* he idealizes Lamba's beauty and youth, "and I can certainly say that here, on the twenty-ninth of May 1934, this woman was *scandalously* beautiful."[77] And Espinosa writes: "He had married a woman so arbitrarily beautiful that despite her insulting youth, her youth was surpassed by her beauty" (53).

The narrator murders María Ana with the help of a few "good anonymous friends," a sinister assemblage of surrealist objects. They are named in the opening fragment as "an electric cord, a jasmine tree, a Gillette blade, a cradle, a 63-year-old penis, etc." (54). In "Parade," the narrator is a prematurely aged man: "Thus I fulfilled the arrogant dreams of a man in his fifties. My curved back, my insecure step and my excessive baldness took the measure of the days to come" (85). Remembering the "tragic balcony," he relates his friends' other exploits (murdering a girl, a newborn baby, a young man, and twin children). One of these accomplices, "a corpulent jasmine tree," commits a crime of sordid Orientalist overtones: "The victim was a seventeen-year-old girl who slept unsuspectingly through the final sleep of dark-skinned virgins" (86). Like Violette Nozière, Jacqueline Lamba, and other sexualized heroines, María Ana is a figure of convulsive beauty who absorbs numerous misogynist tropes. In "Luna de miel," speaking as "a dark-skinned woman's truncated head [*una cabeza*

truncada de mujer morena]" (59), María Ana tells her crucified husband:

> I can tell you now that I hate you, my poor fooled old man, my great gaunt cuckold. You will never again touch my breasts, that angels' hands caress today. My sexual organ haunts the prostitution houses of the Mediterranean ports that are visited by bold sailors, and my feet run after unnailed arms and virgin lips. (60)

In this scene, María Ana's blood spills on the balcony at dawn, and drips on the street "over the little white dresses of the first schoolgirls" (60). These analogies (woman/girls, head/dresses, horror/innocence) are part of the "system" of *Crimen*, the purposeful dislocation and relocation of assembled textual fragments and images. The defiled "little white dresses" in the twilight of dawn resound with atmospheric notes like "this sunset [*este ocaso*]," and sordid images like the "lonely benches where the corpses of recently murdered girls lie" (93). Immersed in an atmosphere of Gothic resonances, the murder points to a Sadean fixation with the defilement and violation of selves and objects of desire. Like Espinosa's memories of Granada, María Ana acts as a projection screen where masculinist anxieties around sexual prowess, aging, and domination dissolve in fragmentary succession. Adding dramatic shape to the repressed contents of *Crimen*, she unlocks authorial deliriousness, only to intensify the confessional pleasure of the text.

The narrator gives us his elegy to María Ana "in this book" (54), but *Crimen* is not a book in a conventional sense. The "book" in question holds an album of disfigured *estampas*, a compendium of textual genres and sources, dramatic annotations, and glosses like those included in *Mariana Pineda*; a notebook of performance annotations where the "actors" rehearse the narrator's memories and dreams. Like *Mariana Pineda*, *Crimen* features souvenirs of the Spanish South, fragments of lived experience, and oblique references to the cultural present. But the aesthetics of *Crimen*, with its orbiting, gyrating, and recurrent variations on a handful of scenarios, is not exclusively performative. *Crimen* stages a textual montage, a metaphorical photomontage, a narrated silent film script, and the materials of an autobiographical convolute.

Shipwrecked Masculinity

Crimen concludes its textual montage of personal, avant-garde, and aesthetico-political parts on a dramatic appraisal of authorial location. Among the motifs that wash up on the discursive shores of the text, childhood returns to maroon itself at the point where the self is about to vanish or be reborn: "A high gold of absence lingers in the air, like the wake of a restless soul, or an agonizing child's dream, in a silent struggle with the landscape and its memories" (93). Espinosa publishes the final section of *Crimen*, "Epílogo en la isla de las maldiciones" ("Epilogue on the island of curses"; henceforth "Epílogo"), initially in *La Gaceta Literaria* as a poetic obituary, "Elegía a Ernesto Pestana." Thus, this closing fragment returns to the apostrophe, "To you, Ernesto ..." (52), and to the elegiac impulse of what brings together two disappearances, the possibly biographical María Ana and Espinosa's deceased friend, the literary critic Ernesto Pestana Nóbrega. "Epílogo" amplifies the confessional tone that dominates the previous fragments: "This distant island where I now live is the island of curses" (93).

"Epílogo" seems strangely detached from the previous sections, but it provides an intriguing counterpoint, inviting the reader to reconsider the reiterated accounts of the murder scenes under a different frame. For if in *Crimen* the island of Tenerife is only vaguely suggested in a few autobiographical traces, that other frame is grounded on the literal point of elocution, the material Islands where Espinosa writes the fragments of his surrealist montage. "Epílogo" is a dense surrealist prose poem, a lament around two reiterated sentences: "I, the island's stepson. The isolated one [*Yo, el hijastro de la isla. El aislado*]" and "I attend the inauguration of history's longest shipwreck [*Asisto a la apertura del naufragio más largo de los siglos*]" (93, 94). This lyrical exploration of an island at the end of the world, a vanishing point of civilization, represents a poetic excursion beyond surrealist games and atmospheric distortions. It evokes Breton's declaration that "The eye exists in a savage state" (*L'œil existe à l'état sauvage*) at the start of *Le Surréalisme et la peinture* (1928), a conceptual perspective that orients Surrealism's investigations into the visionary dimensions of sensory and libidinal experience.[78]

Pedro García Cabrera, a surrealist member of *Gaceta de Arte*, reflects further on the surreal (and political) urgency of vision: "Men pass like trajectories, zodiacs, discarnate constellations across those

planetary plains and flying slopes where a single ray of rebelliousness shines: the little Davies lamp of protest, struggling to escape prison to spread the light to the dead mass that holds it."[79] The collapse of spatiality in "Epílogo" is perhaps not so much an inversion of the myth of blissful insularity on the subtropical Fortunate Islands as an immersive trajectory across the insular-repressed, into what constitutes the possibility of an island consciousness in avant-garde cosmopolitanism and Surrealism. "Epílogo" short-circuits conventional picturesque landscapes by juxtaposing urban visions of Granada or Madrid with displaced references to the sea, and Andalusian or Canarian shorescapes. Instead, the text favors Gothic scenes of death and perverse sexuality in the fictional cityscapes of Spanish romanticism over the idyllic insular environments preferred by Breton and other surrealists (see Chapter 6).

"Epílogo" synthesizes insular experience but bears an indexical connection with Espinosa's memories of the northern coast of Tenerife in the early twentieth century. The sun presides over this vision of the island at the end of *Crimen*. Vaguely romantic environments contrast with the landscapes of Lanzarote, volcanic ruins ravaged by natural and historical time. These are the visionary spaces of the remote and outmoded. Reverberating with the architectural archetypes of De Chirico's paintings, and surrealist texts such as Aragon's *Le Paysan de Paris* (1926), Breton's *Nadja* (1928), and Soupault's *Les Dernières Nuits de Paris* (1928), Espinosa's text distorts his sparse memories of the island port city – these textual images resemble faded old photographs, defamiliarized souvenirs of an idealized childhood. *Crimen* recuperates the coded syntax of Aragon's and Breton's urban atmospheres, and Soupault's morbid and apocalyptic renditions of nocturnal Paris: "I know, we know, that in Paris death alone has power to quench that pointless thirst, to bring to a close an aimless walk. A corpse confronts us with eternity."[80] But just as these narrative texts about the city inflect *Crimen* with the intensity of surrealist revolt, so the lyrical display of an inner dispute directs us back to the sensory shorescapes of late *modernista* and Belle Époque avant-gardism.

The shipwreck motif indicates a journey into another dimension, the visionary space of archaic regressions and temporal collapse of exoticist adventure narratives, from *Robinson Crusoe* to *Treasure Island*. Instead of the "sublimation of the sea" that Margaret Cohen studies as "a process that occurred in the visual arts as well as in literature" from the early eighteenth century, *Crimen* inscribes the shipwreck trope at the center of a littoral hallucination, locating

it in a vague island shore.[81] The collapse of narrative temporality carries within it another meaning, the phantasmagoric dissolution of the tropical imaginary and the inauguration of a time of liberation and enlightenment. Like its literary and visual antecedents, this apocalyptic vision is remarkably androcentric. Throughout *Crimen*, María Ana, the perverse heroine, is repeatedly "thrown out" and reduced to amorphousness. The author is a sex slave and a horse, a newlywed and a prematurely decrepit middle-aged man, or the corpse of "a man aged around fifty" dressed in "a lady's coat … a tailor shop window mannequin coat, so long that it only freed the dead man's feet" (63). Caught in an eternal return of past-present images that recede into the displaced pasts of the previous sections, the island at the end of *Crimen* is a place of narrative distortion that regresses to the scene of writing, or, to use Derrida's expression, "a path back into a landscape of writing."[82]

Filtered through the fluid temporality of dreams, fragmentary memories summoned from an island space revive the voice of the sadistic dominatrix at the end of the ironic "Luna de miel" fragment. In that time-image, María Ana's blood, dripping from the edge of a balcony overlooking a street at dawn, stages an hourglass-like movement: "And this great puddle of my own blood, dripping over a sidewalk at daybreak … The clock of your crucifixion. Your bloody hourglass. Your dream, too, will end at the last drop of my blood" (60). Domínguez's *Máquina de coser electro-sexual* (1934) echoes this image, and the transitional position of this body, in garish detail.[83] José Pierre describes the painting's "lyrical scaffolding" as "dizzying," "sadistic," and "prodigiously extraordinary." More synthetically, Emmanuel Guigon observes that, like other period paintings, *Máquina de coser electrosexual* "celebrates the marriage of metal and flesh."[84] Yet there is no "marriage" in Domínguez's painting or Espinosa's text, but elaborate exhibitions of sadistic desire and scopophilic transgression. Their staged visions complicate easy passage to a coherent experience of the souvenir, evoking instead perverse fantasies of the island enclave, scenes of gendered violence, sadistic disfigurations of form, and the convulsive destruction of exoticist frames. In *Cueva de guanches*, *Máquina de coser electrosexual*, and other island paintings by Domínguez, atmospheric islandscapes express an introspective and critical Surrealism that senses the latent cultural dystopia of the interwar period, and an uncanny foretelling of the unfolding catastrophes of the Spanish Civil War and World War II.

Souvenirs of the Spanish Civil War

The apocalyptic scenario of "Epílogo" is laced with biblical and iconographic references: "I witness the opening of history's longest shipwreck. The one tenderly announced by the Apocalypse. The one where the sun suddenly stalls, or where its course is so shy that the gaze can't follow or barely notices it" (93). The cataclysmic event causes sensory alterations and an occlusion of visionary experience. What, then, is this temporality that *Crimen* narrates in the present tense of this *locus solus*? The apocalyptic scene turns into anti-scene, the empty atmospheric scenario. This end of time appears reduced to a frightful premonition: "I suspect [*presiento*] that this sunset will never end, as if measured by a great clock whose pendulum would slowly cover thousands of kilometers in each oscillation. The birth of an adventure, an egg in bloom, and a jammed pistol hang from it" (93). The premonitory vision evokes the atmosphere of *Lancelot 28°–7°*: "For Lancelot, the African island was South and Orient at once. This suited his adventurous appetite. The historical and geographic supplement to his West and North. His hall of senectitude as well ... It was also, perhaps, his island of penance" (11). Conscious of the events that transformed Spain and its colonial imagination through the 1920s, Espinosa might have had an anecdote in mind when he wrote this passage. In 1924, Unamuno denounced the military regime of Primo de Rivera and the dictatorship's Military Directorate banished him to the island of Fuerteventura, adjacent to Lanzarote, from where he fled to Paris before returning to Spain in 1930. We cannot know whether Espinosa identified with Unamuno's story, casting a composite image of Lanzarote and Fuerteventura to ground his literary viewpoint. For Unamuno and Espinosa, the extreme insular location is a geohistorical border beyond the European mainland, and a distorted souvenir of the Moroccan War. The African island is a remote outpost of the Odyssean narrative in the subtropical Atlantic – a geographic extension of Occidental "world literature."

What is the political horizon of these spatiotemporal distortions of the surrealist island? What is their *Umfunktionierung* beyond the functional transformation invested in surrealist techniques? I have posited the montage analogy as a tentative way to make critical sense of *Crimen* and its contexts – Espinosa's relationship with Spanish avant-gardism, the *Gaceta de Arte* group, and Domínguez's paintings and objects. While the trope of the return to the island

remains a supreme subject of representation among Atlantic avant-gardists and surrealists, in *Crimen*, and in Domínguez's early surrealist paintings, there is an eschatology of the present – an aesthetic transfiguration of idyllic islandscapes into nightmares of mutilation and death. These works are "souvenirs" of a morphing aesthetico-political location.

In *Crimen*, a montage of different origins and transitions assembles the fragments of a diverse cultural archive and projects them onto the present-future of a surrealist hallucination. The text inflects these fragments with a kind of archival disorder and a disorder of the *souvenir* where women are remembered, distorted, and dismembered at a safe distance from the Moroccan conflict. *Crimen*, then, represents a practical experiment in aesthetic and cultural dislocation.[85] Indeed, the progressive women of the Spanish Republic are at the forefront of tensions between conventional and unconventional roles, participating decisively in institutional battles between traditionalists and regionalists, *falangistas* and moderate conservatives, and partisan revolutionaries and left-leaning avant-gardists. In a scene describing a funeral, six top-hatted gentlemen wearing "wreaths of lilies on their heads" and a seventh carries "a Spanish flag, the thick pole [*grueso mástil*] crowned by a discarded slipper" (65). At the end of the fragment, flowers adorn "a wastebasket garnished with white lilies" (66). These impromptu still lifes summon Domínguez's objects and pictorial hallucinations. But while Domínguez's object-symbols and islandscapes reflect a mythology of Canarian and Spanish remoteness, *Crimen*'s fixation with bodily decay and the grotesque intersects with a conscious fascination with the decomposition of state politics and the charade of Catholic sentimentality. The *grueso mástil* – a maritime as well as a militaristic fetish – evokes the scene of the dead six-year-old girl in "Hazaña de un sombrero": "She wore a man's hat held with a thick pin that perforated both parietal bones and pierced her brain matter" (62). In *L'Âge d'Or* and later films by Buñuel, similarly displaced commentaries on aesthetic composition and social decomposition are distinctive traits of surrealist irreverence. In Ernst, Dalí, Domínguez, and other surrealist artists, this irreverence can be obsessive or playful repetition. But the image of the Spanish flag and the thick shaft was to have tragic consequences for Espinosa.

It all happens vertiginously between 1934 and 1936. In 1934, Domínguez joined the Paris surrealist group and Espinosa published *Crimen*. A year later, Breton, Lamba, and Péret participated in the Second International Surrealist Exhibition in Tenerife and co-signed

the second *International Bulletin of Surrealism*. As president of the Ateneo de Santa Cruz, Espinosa addressed the attendees at the opening of the exhibition and celebrated the imminent screening of *L'Âge d'or* in the local press. The second and final issue of *Índice* included a poem by Alberti, "Down with Imperialist War!" ("¡Abajo la Guerra imperialista!"): "War, war is coming / war is about to commence [*la guerra que se prepara*]." On the last page, an announcement read: "Great surrealist art exhibition, lectures by the French poets André Breton and Benjamin Péret, and screening of the film *The Golden Age* [*La Edad de Oro*]."[86] Right-wing Catholics and other conservatives published articles attacking the film, Espinosa, and the Paris surrealists.[87]

In July 1936, a group of insurgent army generals, General Francisco Franco among them, launched a coup d'état that triggered the Spanish Civil War. On July 18, Franco declared a state of war in the city of Las Palmas on the island of Gran Canaria. Like "a great clock," "the birth of an adventure, an egg in bloom, and a jammed pistol," Franco flew to Spanish Morocco, where the military uprising started in earnest, in a Dragon Rapide – the aircraft that symbolizes the Spanish preamble to World War II.[88] After joining the fascist Falange organization in Las Palmas, Espinosa was publicly denounced for authoring *Crimen* and for being implicated in subversive avant-garde activities. Copies of *Crimen* were burnt publicly, and on September 16, 1936, Espinosa was dismissed as Chair of the Instituto de Las Palmas.[89] Other members of *Gaceta de arte* were punished for their political activism during the Republic – Brian Morris relates that López Torres was executed "not by gunfire, but thrown into the sea."[90] Pérez Corrales writes that the fact that Espinosa lacked a political record saved him from certain death at the hands of the fascists. He died in Tenerife of complications from an ulcer surgery on January 28, 1939, three months before the end of the war. Domínguez was vacationing in Tenerife when the fascists took control of the island in the first few days of the military uprising of July 1936. He went into hiding for several months before reaching Paris, moving to Marseille with other members of the Paris surrealist group in 1940.[91]

6
Difficult Dialogues: Surrealism in the Francophone and Hispanic Caribbean

Marseille / Fort-de-France

In the opening of his silent short film, *Impressionen vom alten Marseiller Hafen (Vieux Port)* (1929), László Moholy-Nagy cuts out an area of a paper map around the Vieux Port, the insular void creating a window through which we enter a cinematic *montage* of the old port's hustle and bustle.[1] Resonating with other urban epics of the silent period, the city in Moholy-Nagy's short film signals changes and challenges on a less ambitious scale, yet the images form a radiograph of the extraordinary decade separating the end of World War I from the receding 1920s. For Moholy-Nagy, that had been the decade when he participated in the Bauhaus, another radiating "island" of intense collaborations, visionary discussions, and material co-productions that would alter twentieth-century aesthetic ideology and have incalculable repercussions for cultural politics. Unlike Walter Ruttman's Weimar capital in *Berlin: Symphony of a Metropolis (Berlin: Die Sinfonie der Großstadt)* (1927) and Dziga Vertov's Moscow, Kiev, and Odessa in *Man with a Movie Camera* (1929), Marseille is an ancient Mediterranean port city that looks outwards onto the cosmopolitan Interior Sea, and inwards to the French Hexagon. Gauguin had sailed out from Marseille in March 1887, and in *Romance in Marseille* (a novel that was initially titled "The Jungle and the Bottoms," then "Savage Loving"), Claude McKay, the Jamaican-born exile of the Harlem Renaissance, describes the

city in an eloquent metaphor: "Wide open in the shape of an enormous fan splashed with violent colors, Marseille lay bare to the glory of the meridian sun, like a fever consuming the senses, alluring and repelling, full of the unending pageantry of ships and of men."[2]

In late October 1940, André Breton, Jacqueline Lamba, and their daughter Aube moved to the Villa Air-Bel in the La Pomme neighborhood of Marseille, where a group of Paris surrealists and other cultural refugees were assembling. Demobilized from the army after 1 August, Breton had accepted Pierre Mabille's invitation to join him in Salon-de-Provence as both men worked to obtain invitations and visas to leave France. Mabille received a visa to work as a medical doctor in Guadaloupe and Martinique, and Breton hoped to travel to New York.[3] Driven on by the American journalist Varian Fry and supported by Eleanor Roosevelt, from the summer of 1940 the Emergency Rescue Committee organized accommodation at the villa for refugees fleeing Nazi Germany and occupied France. With support from institutions like MoMA and the New School for Social Research in New York, the Committee provided material assistance and helped hundreds of refugees to secure papers to leave France for the United States and other countries via Spain and Portugal, or by boat from Marseille. A longtime supporter and friend of avant-garde and surrealist artists in France, the American art collector and gallerist Peggy Guggenheim financed the Bretons and other refugees' passage to New York, where they were sponsored by institutions and individuals, including Alfred H. Barr Jr., the director of MoMA.[4] Among the exiles-in-transit were those fleeing political persecution, conscription, or internment, and generally hoping to find sanctuary in destinations beyond Europe. There were Jews, members of progressive political organizations, and various types of intellectual pariahs. In a photograph taken outside the villa in 1941, the Cuban artist Wifredo Lam and his lover Helena Holzer pose in the foreground, and Lamba sits to the left of Lam, their heads touching in the image. Holzer, a German scientific researcher, had met Lam in Barcelona in 1938 and the couple lived together in Paris in 1938–40.[5] To the left of the image, the Tenerife-born surrealist artist Óscar Domínguez stands looking sideways, perhaps listening to Breton, who sits in the background and is also captured from the side. The Romanian-born artist Jacques Hérold stands above Breton, and the entire group appears to have gathered, beehive-like, around the trunk and fallen

branches of an old tree on the snow-covered grounds of the Villa Air-Bel (Figure 6.1).

In a different image from Aube Breton Elléouët's collection, a five-year-old Aube sits on Breton's knee alongside Domínguez, Hérold, the French actor, playwright, and labor activist Sylvain Itkine, and Lam and Holzer. Lam, Domínguez, and Hérold hold segments of branches that have been pruned from the tree.[6] The surrealists and other refugees spent their time attending to administrative and domestic tasks. They also worked on many creative projects, as if energized by the anguishing circumstances in a "free France" where the Nazis might at any moment occupy the entirety of the Hexagon, and upend uncertain individual futures. They met at the villa and at a bohemian café on the Vieux Port, Au Brûler des Loups, a legendary space where the idea for a reimagined deck of playing cards germinated into *Le Jeu de Marseille*. Suggested by Breton and coordinated by the psychiatrist Frédéric Delanglade, the *Jeu* is a typical surrealist experiment in playful co-creation. Victor Brauner, Breton,

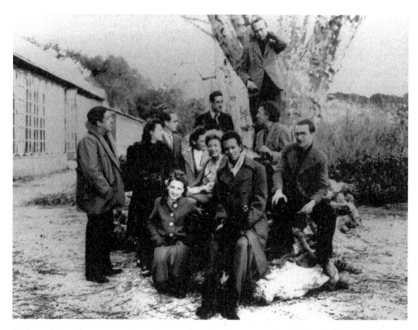

Figure 6.1: "A group of artists posing in the grounds of the Villa Air-Bel near Marseilles." The refugees-in-transit, Óscar Domínguez, Jacqueline Lamba, Helena Holzer, Wifredo Lam, André Breton, and Jacques Hérold, gathered for an impromptu photographic session with André Gómez in 1941

Domínguez, Max Ernst, Hérold, Lam, Lamba, and André Masson all contributed to the transformed deck, which by then featured esoteric symbols and images of surrealist precursors – including, among others, Alice (for *Alice in Wonderland*), Baudelaire, Freud, Hegel, Lautréamont, Novalis, Pancho Villa, and Sade.[7] Few spaces will have seen a parallel assembly of avant-gardists at the limit, in a historical situation that coincided with systems of detainment, labor, and concentration camps extending across vast swathes of the European continent since 1933. The apparent frivolity often thrown at avant-gardism after 1916 seemed irrelevant a quarter of a century after the Dadaist experiment in the landlocked "island" of the Cabaret Voltaire by Lake Zurich, and the diasporic archipelago of Dada across other European cities, reaching as far as New York. The catastrophe that underpinned the assembly at Villa Air-Bel represents an extreme crossroads of uncertainty and fear.

In December 1940, Breton wrote a long poem, *Fata Morgana*, that encapsulates the impulses driving him and, by extension, European Surrealism at the start of the wartime exile. Breton's relationship with Lamba had deteriorated, and they were contemplating an uncertain transatlantic journey with Aube. In *L'Amour fou* Breton had chronicled their love story, a theory of surrealist desire, the delirious Tenerife trip, and the outbreak of the Spanish Civil War. Sediments of those and other experiences re-emerge in *Fata Morgana*, a transitional project that Breton envisioned as a collaborative *plaquette* with Lam. The publication was denied a censorship visa in Marseille and, like other wartime surrealist texts, launched on a delayed life of exile that bears witness to the kinds of editorial cosmopolitanism forced by the political events. *Fata Morgana* appeared in English translation in the New York journal *New Directions in Prose and Poetry* in 1941. The French text was published in Éditions des lettres françaises in Buenos Aires in January 1942, and in the Parisian journal *Les Quatre Vents* in 1946.[8]

Assembled around the motif of the Italian legend of the *fata* (or fairy) *Morgana*, who creates mirages and haunts Mount Etna, the poem explores the registers of archaic navigation, oneiric curiosities, and marvelous visions. The Ondine of *L'Amour fou* has morphed into "the mountain girl [*la fille de la montagne*]," the *fata Morgana*.[9] Perhaps anticipating an uncanny return to the events of 1935 and the years of the Spanish Civil War, Breton evokes the island volcano and the libidinal projection of an idealized woman as memory-objects. But there are also references that conjure nostalgia,

expectation, and wonderment. In a possible reference to the transAtlantic trip to Mexico in 1938, Breton writes: "One day, a new day, which makes me think of an object that my friend Wolfgang Paalen keeps [*Un jour un nouveau jour cela me fait penser à un objet que garde mon ami Wolfgang Paalen*]."[10] In his Atlantic and trans-Atlantic excursions, Breton carries, displaces, and actualizes a moveable series of *objects* – objects of desire, space-objects, object-souvenirs, and objects-in-transit of past encounters and conflicts. These composite figures of monstrosity and promise evoke exhibitions of surrealist objects, signal a renewed "crisis of the object," and repudiate a reality where objects make utilitarian sense.[11]

The *Capitaine Paul-Lemerle* was one of the last boats to leave the port of Marseille on a wartime transatlantic journey. Carrying the surrealists and other exiles, it sailed on March 24, 1941, stopped in Oran and Casablanca, and arrived at Fort-de-France on April 14. The Bretons proceeded to their final destination in New York on May 16 after brief stopovers in Pointe-à-Pitre in Guadeloupe and Ciudad Trujillo (Santo Domingo) in the Dominican Republic.[12] Traveling to New York on the same boat to take up a teaching position at the New School for Social Research, the anthropologist Claude Lévi-Strauss remembers his impressions of Breton and the passage through Martinique in the opening chapters of *Tristes Tropiques* (1955).[13] He describes the chaotic scenes of boarding the *Capitaine Paul-Lemerle* on the docks of Marseille: "Far from being a solitary adventure, it was more like the deportation of convicts."[14] At the end of the successful passage from occupied France to Vichy-controlled Martinique, a chance encounter with a small group of Martinican avant-gardists awaited the surrealists, complicating a panorama of non-European protagonists of insular avant-gardism. What do we learn, *circa* 1941, about Paris and the Caribbean island colony of Martinique? What does Aimé Césaire's return to the island teach us about exilic and cosmopolitan avant-gardism? What do we learn from Breton's exilic journey?

Martinique charmeuse de serpents

The seven texts that Breton gathered in *Martinique charmeuse de serpents* (1948) evoke or relate the events of April and May 1941 in a tortured manner.[15] In a short preface ("Avant-dire") written in 1948, Breton presents the book as the result of a division, a reflection where the figure of the cut between opposite parts

predominates as an organizing principle. The succinct opening sentence cites a memorable sequence from *Un Chien andalou*: "In Martinique, in the spring of 1941, our vision splits in two [*notre œil se divise*]" (39). So does the text, which makes room for "lyrical language" and "language of simple information ... Hence, our use in deliberate opposition of these two forms, which our unified voice shelters from dissonance, but which furthermore are bound by a conversation between us ... even as our spirits yielded unreservedly to the magnetic force of this ideal and real place [*l'aimantation d'un lieu idéal et réel*]" (40). The sequence of parts orbits around two nuclei, "Le Dialogue créole" ("The Creole dialogue") and "Eaux troubles" ("Troubled waters"), each flanked by poems. The multifaceted text concludes in a cumulative process of cultural displacement and aesthetic condensation. Barring the "Avant-dire," which Breton wrote specifically for the book, the other texts were published in part or in full between 1941 and 1944: "Antille, par André Masson," "Le Dialogue créole entre André Breton et André Masson," "Des épingles tremblantes," "Eaux troubles," "Un grand poète noir," and "Anciennement rue de la Liberté." They had all appeared in a variety of journals in New York, Paris, Buenos Aires, Fort-de-France, and Algiers.[16]

Masson sailed from Marseille with his family in late March 1941 and met the Bretons in Martinique.[17] As a veteran member of the surrealist movement (he joined the Paris group in the early 1920s), Masson understood Martinique's function for Surrealism and could enhance it through his drawings. Two years earlier, in the May 1939 issue of *Minotaure*, an exultant Breton had published a short text, "Prestige d'André Masson," that celebrated his loyal friend in Nietzschean terms: "[Masson] is the most confident and lucid guide there is on the way to dawn and to the fabulous regions [*vers l'aurore et les pays fabuleux*]. With him ... we caress the myth of this epoch, effectively under construction."[18] Plans for a coauthored book about the Martinican sojourn were underway in the summer and fall of 1941, which Masson described in letters to friends and connections as a short volume containing "texts, drawings, and 'collages'," or "drawings and collages."[19] The book retains the miscellaneous character of a shared wartime album in which the collages would have highlighted the fragmented and irreconcilable facets of its parts. In its published form, where no collages figure, the book retains the documentary and creative strangeness of a wartime aesthetico-political *object* that conveys a kind of cultural baggage, allowing us to perceive continuities and

fractures in the trans-Atlantic drift of international Surrealism. The collage, as a limitless mnemonic and associative form, would have referred to Surrealism's avant-garde memory of prewar Europe in a moment of maximum uncertainty. Cubist and other protagonists of early twentieth-century Parisian avant-gardism who practiced collage *glued* the disparate textualities of the popular, mercantile, poetic, revolutionary, bizarre, or mundane, creating, in Serge Fauchereau's terms, a dynamic cultural moment of "plastic and literary interferences."[20] They would occasionally use indexical traces in the form of objects or remnants attached to the canvas to reinforce, not dissolve, the discontinuous boundaries between reality and representation. But could collage express the surrealist project in *Martinique charmeuse de serpents*?

As a characteristically unprepossessing Breton entered Martinique, he identified with "all Europeans passing through [*tous les Européens de passage*] whose impressions I gathered" (76). He expressed a desire to understand external reality and engaged critically with the material conditions on the island. Indeed, the subsidiary and longer text of "Eaux troubles" chronicles the present conditions of this *passage*. Since the early 1920s, Breton had integrated or edited the realities of place by highlighting symbolic, allegorical, and esoteric dimensions of urban and natural spaces in *Nadja*, *Communicating Vessels* (*Les Vases communicants*), *Mad Love* (*L'Amour fou*) and, more recently, "Souvenir du Mexique" and *Fata Morgana*. In *L'Amour fou*, which contains a chronicle of the Tenerife trip, one misses even a general interest in the history, literature, and culture of the Canary Islands. By contrast, in Martinique Breton borrowed "the two volumes, of which I was to hear more later: the *Economic History of Martinique* and a children's atlas" (73). He visited the island interior, observed local customs, and exchanged views with Martinicans of different social backgrounds. He perused the local press and listened to "Radio-Martinique," which confirmed widespread resistance to Maréchal Pétain's regime, and concluded that most members of the island's workforce ("*la population laborieuse de l'île*") hoped for British victory and supported General de Gaulle.[21]

Breton entered Fort-de-France and Martinique as if he were falling into an anxious dream. But when he accidentally came across the first issue of *Tropiques* in a notions store, the mood shifted dramatically: "All those grimacing shadows [*ombres grimaçantes*] were shredded and dispersed ... The human voice [*la voix de l'homme*] was not stifled and broken after all; it rose here like the

very staff of light [*comme l'épi même de la lumière*]. Aimé Césaire was the name of the one who spoke" (86). As the uncanniness of the first encounter with Fort-de-France dispelled, Breton celebrated his feelings of recognition and admiration for Césaire and the other *Tropiques* authors, especially René Ménil and Suzanne Césaire. The experience of meeting the small group of island resisters was so dramatic that it made Breton regain hope for France and for the world: "This land that [Césaire] showed me and that his friends also helped me get to know, yes, it is my land, too, it is *our* land that I had wrongly feared had been over-shadowed ... The world would not be allowed to remain in limbo: it would regain consciousness" (87).

In Césaire's *Cahier d'un retour au pays natal*, Breton highlighted "the power of transmutation that it engenders. This transmutation consists in beginning with the most base materials, among which are ugliness and servitude, and producing what we now know is the true goal of the philosopher's stone: —not gold, but freedom itself" (91). Breton was undeniably besotted with Césaire, the man, poet, and intellectual, and imagined him extravagantly as "a human cauldron heated to the boiling point. In that state, his knowledge, raised to the higher level, combines with his magic powers [*les dons magiques*]" (87). The celebration verged on delirium when Breton confessed "the exaltation of being in such close communion with one of the great poets ... and fundamentally, I was unable to distinguish his will from my own" (89). Breton read his own predicament, and the predicament of French Surrealism, into the momentous encounter with the Césairean universe:

> For me his appearance in his own element – and I do not mean only on that day – takes on the significance of a *sign of the times*. Césaire single-handedly defies a period in which we appear to be watching the general abdication of the human spirit, in which nothing seems to be created now except to perfect the triumph of death, in which art, too, threatens to become petrified in old notions. That first fresh, revitalizing breath of air capable of giving back our confidence is the contribution of a black man [*un noir*]. (87–8)

Mireille Rosello alerts us to the perspective stakes in critical engagements with the events of 1941: "To what extent did [Breton and Masson] succeed in seeing something different from what these artistic conventions dictated to them, which at the time invented the tropics as much as the Orient? What do they show us of a

Martinique that we continue to apprehend through the mediation of discursive or pictorial representations?"[22] My own take on the French surrealists' performances differs from Rosello's, to which I add two related questions: What do the surrealists *find* during their time in Martinique? What is it on the island that stimulates their desires? I suggest that exploring these questions alongside those put by Rosello and other scholars could help us measure some of the difficulties we are bound to encounter as we approach *Martinique charmeuse de serpents* as an island text that is steeped in the historical moment.

"Le Dialogue créole" evokes *The Snake Charmer* (*La Charmeuse de serpents*) (1907), an oil painting by Henri Rousseau, an aesthetic precursor of Surrealism commonly known as *le Douanier Rousseau* or *Rousseau le Douanier*. The imaginary of the jungle provides an apt analogy for the cultural dreamworlds that the Paris surrealists project onto Martinique and for an expanding panorama of Caribbean encounters and entanglements. The metropolitan surrealists are not concerned with traducing and occluding Martinique, but with producing a poetic account of *surrealist* Martinique. Their literary fantasy of island sensuousness is symptomatic of a will to recognize rather than encounter tropical nature, as Breton observes: "In the end, one realizes that surrealist landscapes are less arbitrary [*les moins arbitraires*]" (43). Masson brings up "the *Paradises* of Fra Angelico" and "Cook's *Voyages*," and Breton mentions *Ombres blanches*, a recurring item in the repertoire of films deemed meaningful for the surrealist cause. He refers to the French-language version of the American silent film *White Shadows in the South Seas* (1928), directed by W. S. Van Dyke, and loosely based on a popular travelogue by the American adventurer and exotic fiction writer Frederick O'Brien.[23] The passages that center explicitly on the film spiral from an anecdote from Cook's *Voyages*, "apparently a classic in the history of discovery of distant islands," Masson observes. Breton recalls from his reading of the *Voyages* "the romance of a sailor and a beautiful island girl" who communicate "in an invented language made solely of caresses" (46–7).

This anecdote about uncomplicated heterosexual love between young natives prompts further comments on the "melancholy aura" of native birdsong that Breton associates with lianas ("the harp of the earth"), and with "An apple for an Eve who would be a serpent" (47). The exoticist perspective seems irrepressible. Breton observes: "Fruits like these are what our friends, the great and perverse ones at the end of the nineteenth century, would have wanted to bite

into while listening to the poems of Levet, stretched out on a couch of darkness [*sur un divan noir*]" (47–8). Masson, too, turns to film – "*Ombres blanches*, truly, both far and near [*à la fois loin et proche*]" – and mentions his reading of Herman Melville's *Typee* (1846), a work that "tells how one can get accustomed to a cannibal Eden through the intervention of women, all of them somehow bewitching [*toutes un peu sorcières*]" (48). The association between two works separated by eight decades summons an entire popular imagination of colonial networks, remote islands, and cultural others that, in the interbellum period, *returns* in numerous films and literary texts that reinscribe the physical existence of faraway archipelagos and the nebulous romantic rendition of these places as historically remote in an almost mythical sense.

In a memorable reflection of 1925, Breton had written: "No one can shut the door without hinges," yet "I have never felt the slightest anxiety about my inner equilibrium."[24] The last pages of "Le Dialogue créole" turn to the catastrophic volcanic eruption of Mount Pelée that destroyed the capital city of Saint-Pierre on May 8, 1902, killing most of the population of 26,000 citizens. Masson mentions the "disrupted, distorted objects [*objets perturbés*]" he finds in the "vulcanological museum" (48), and a new spiraling discussion ensues around the effects of volcanic, telluric, and mineral phenomena on aesthetic perception. The surrealists "return" to the long avenue that traverses the Bois de Boulogne in Paris. "We are far from the avenue du Bois," writes Breton, and Masson responds: "Here, we are very far from artificial perspective [*perspectives inventées*]. True nature does not like straight avenues and does not allow symmetry, which is the traditional privilege of mankind [*l'apanage traditionnel de l'homme*]" (51). It is hard not to imagine the French surrealists as *objets perturbés* entering a space of Caribbean transformation that they would never succeed in coopting culturally, aesthetically, or politically after the travel companions parted ways. In the present tense of Breton and Masson's surrealist assemblage, Martinique was not only occupied by the Vichy regime, but also haunted by the specters of slavery, colonial exploitation, and metropolitan neglect. *Martinique charmeuse de serpents* enables ambitious readings and new versions of a multiply occupied Martinique, like those embodied in the textualities of Aimé Césaire and Suzanne Césaire. The grim circumstances insularized the islanded intellectuals en route to continental locations. They struggled and failed to locate the island beyond the enmeshed grid of exoticist, colonial, and Eurocentric ideologies. But

at the same historical juncture, Martinicans and Martinique are the subjects of a Caribbean reckoning with the future in *Cahier* and in "Le Grand Camouflage."

Cahier

Cahier appeared in the Parisian journal *Volontés* in August 1939, just days before the Césaires embarked for Martinique with their son Jacques at the outbreak of World War II on 1 September.[25] Aimé Césaire had attended the Lycée Victor Schœlcher in Fort-de-France and went to Paris in 1931 on a scholarship to study at the Lycée Louis-le-Grand. Between 1935 and 1939, he prepared, and initially flunked, the *agrégation* at the École Normale Supérieure. The eight years that Césaire spent in Paris were the years of gestation of *Cahier*, one of the foundational texts of the modern Atlantic. *Cahier* is fundamentally a relational poem in a sense I aim to elucidate by examining the place of Martinique and the Caribbean archipelago in the text. As a bright eighteen-year-old Black Martinican living in the metropolis, Césaire started out on a career that would take him back to the island after eight years and a few crucial detours in 1939. As Gregson Davis observes: "It would be misleading and reductive to depict the adolescent Césaire in his Paris lycée years as an uncomplicated model student, intent on the passive absorption of the European intellectual tradition." Those years were marked by transformative encounters that formed the foundation of the Black Atlantic movement known as *négritude*/Negritude. Césaire met other Black students from Martinique and the French colonies at a point in their lives in the early 1930s when they were committed to their academic and intellectual development in Paris. Césaire and other Caribbean students follow the sisters Paulette and Jane Nardal's essentializing vision of Black culture and *belles-lettres* in *La Revue du monde noir* (1931). But this is the moment of a foundational encounter in Atlantic avant-garde politics between Césaire, the Senegalese Léopold Sédar Senghor, and the Guianese Léon-Gontran Damas. Alain Blérald sees the formation of the movement as the result of a "double causality": these students' questioning of "the colonial condition," and attitudes toward "critical currents in Western thought [*la pensée occidentale*]."[26] Blérald outlines two distinct periods in this process centered around the metropolitan and anticapitalist avant-gardism of the Antillean Légitime Défense group in 1932, and the anticolonialist and

decolonial vision of the group that launched the journal *L'Étudiant noir* in 1935. While Ménil, Étienne Léro, and other members of Légitime Défense published a "Manifeste de légitime défense" and a single issue of the homonym journal, Césaire, Senghor, Damas, and other Black Francophone students developed and amplified the anticolonial and anti-assimilation vision of Negritude.[27]

What brings Césaire and his friends together is a determination to understand "Africa" through the common ground of their colonial education and literary inclinations. V. Y. Mudimbe refers to the group somewhat anachronistically as "negritude," "a literary coterie despite its political implications. Besides, these young men ... mostly used poetry to explore and speak about their difference as blacks."[28] Their spiritual quest for Africa is not intellectually one-dimensional but intentionally political. European ethnography plays a crucial role in shaping Césaire's and Senghor's intellectual investigations. *Histoire de la civilisation africaine* (1936), by the German ethnographer Leo Frobenius, made a profound impact on them.[29] Just as another Caribbean poet, Nicolás Guillén, found inspiration in the Harlem Renaissance from Cuba, so too did Césaire read the poetry and fiction of Langston Hughes and Claude McKay.[30] Africa, or its idea, was being explored as a pluriversal diaspora, a discontinuous web where historical commonalities and unresolved burdens were discussed transnationally by Martinicans, Cubans, Guyanese, Senegalese, or Americans from the South and the Midwest who took part in the expanding cultural revolution of Harlem.

Césaire renders the island as *pays*. The *pays natal* is more than the place of birth, it is the space of life. It is also the scenario of a transformative social dynamic that must be altered through consciousness, action, and visionary experiments. *Tropiques* dives into the project on an experimental decolonial process whose legacy continues to be both influential and contested seven decades after the first issue of the journal came out. Breton hails the *Tropiques* collective's ideas for intellectual transformation. He sees in them a fulfillment of the surrealist project to rise above the catastrophe of bourgeois imperialism. Césaire's attacks on imperialist interests in *Discours sur le colonialisme* (*Discourse on Colonialism*) (1950, 1955) intersect with Surrealism's anticolonial ideas and repudiation of French chauvinism. Referring to *Cahier*, Gerard Aching argues that "Césaire's aesthetically and politically revolutionary poem is not merely a forceful indictment of colonialism; it is at the same time an act of psychosocial decolonization that is partially compromised

both by the ways in which the histories of the colonizers and the colonized are inextricably bound and by the conscious participation of the native poet in this cultural regime."[31] As Aching suggests, Césaire's peripheral and complicated participation in avant-garde strategies and engagement with Surrealism are central to an understanding of the interlocking realms of island and avant-garde cultural politics.

The critical literature on *Cahier* locates the genesis of the poem almost invariably in the summer of 1935. However, Kora Véron shows that the anecdote invoked for decades by Césaire and his interpreters refers to the summer of 1936.[32] That year Césaire spent a vacation in Šibenik, on the coast of Croatia, with the family of one of his closest Parisian friends, fellow Yugoslav student Petar Guberina. In Césaire's account, proffered some seven decades after the event: "The landscapes, the contours of the coast, exile, the sea, everything reminds me of Martinique." He notices a small island that Guberina tells him is named Martinska. "'Martinska! – But this is Martinique, Pierrot!' In other words, I'm penniless, I arrive in a country that isn't my own, and I'm told that it's called Martinique. 'Get me a piece of paper!' That's how I started *Cahier d'un retour au pays natal*."[33] Despite all the elements that traverse this elaborate story, with its careful accents on the long journey, near homonymy, and the uncanny encounter with *the other island*, it would be simplistic to reduce the anecdote to the pangs of exilic nostalgia.

Svetlana Boym observes that "*Algia* – longing – is what we share, yet *nostos* – the return home – is what divides us." If the circumstances of the young Césaire warrant our identification with his private longing, *Cahier* demands our investment in an open-ended journey "home" to nonexotic and often uncanny visions of Martinique, the Caribbean, and Africa, and our commitment to a labor of distancing, loss, mourning, and revolt. Boym's intimation of nostalgia as "not merely an individual sickness but a symptom of our age, a historical emotion" seems a more accurate beginning for *Cahier* than the canonical anecdote.[34] From a different viewpoint, Patricia Northover and Michaeline Crichlow argue provocatively:

> Césaire clearly maps his intention to engage in an immanent critique of the social text of French humanism in search of a "new language." This mode of Creole critique thus draws upon available cultural resources in order to fashion contextual hybrid strategies for refashioning self, times, and places in the entanglement of global and local processes."[35]

A. James Arnold states that the poem is "laid out in 109 strophes of mixed prose and verse."[36] The text of *Cahier* folds and unfolds around geographic and geopolitical enclaves. In stanza 88, Césaire writes: "And my special geography [*mon originale géographie*] too; the world map made for my own use, not tinted with the arbitrary colors of scholars, but with the geometry of my spilled blood" (45). This area of *Cahier* comments sarcastically on the regimentation of colonial and metropolitan citizens through formal education. Césaire goes beyond the trope of the cahier or school notebook and continues in stanza 89, critiquing pseudo-scientific racism: "And the determination of my biology not a prisoner to a facial angle, to a type of hair, to a well-flattened nose, to a clearly melanian coloring, and negritude, no longer a cephalic index, or plasma, or soma, but measured by the compass of suffering" (47). Both stanzas playfully object to established principles of racist discrimination, affirming instead a different *geography, geometry,* and *biology* of historical consciousness ("my spilled blood"), and a personal identification with the legacies of the slave trade and racist plantation culture under French colonialism that are "measured by the compass of suffering."

Césaire transforms his middle-class background into an inverted family romance of poverty and abjection to represent (and disidentify with) the structures of colonial rule. Like other thematic threads in *Cahier*, childhood is a fictional composite of sociocultural fact and personal observation. The confessional mode of large areas of the text informs an ethnographic, documentary, and ultimately creative assemblage of colonial history and stories. Yet the main thrust of the poem remains a nightmarish immersion in the sensory experience of the colonial present. In stanza 26, the mother, father, and grandmother stand as backdrop figures in one of these assemblages of abjection. The stanza reads like elaborate stage notes, foretelling Césaire's distinguished career as a playwright:

> At the end of first light, beyond my father, my mother, the shack chapped with blisters, like a peach tree afflicted with curl, and the thin roof patched with pieces of gasoline cans, which create swamps of rust in the stinking sordid gray straw pulp ... And the bed of boards from which my race arose, my whole entire race from this bed of boards, with its kerosene case paws, as if it had elephantiasis, that bed, and its kidskin, and its dry banana leaves, and its rags, yearning for a mattress, my grandmother's bed. (15)

Identifying with "the bed of boards from which my race arose," the child-narrator stands for the experiences of the majority of Martinicans – the slaves, laborers, and contemporary victims of colonial depravation on one of the shores of Black Atlantic modernity. The poet of *Cahier* wishes to subject readers to a spiraling mix of immersion and incursion, a declaration of despair, and a manifesto for insurgency or revolt. These opening stanzas are written in poetic prose and free verse that signal atmosphere, space, location. They coincide occasionally in tone and register with an attitude of documentary questioning and affective indignation that the Cuban poet Virgilio Piñera summarizes in "La isla en peso" (1943) as "The curse of being completely surrounded by water" ("*La maldita circunstancia del agua por todas partes*").[37] In *Cahier*, the Antilles appear as a third-person referent, a territory of communal inanity or emptiness.[38] When landscape appears as an archetypal "character," in stanza 21, it does so with dystopic force:

> At the end of first light, this most essential land [*ce plus essentiel pays*] restored to my gourmandize, not in diffuse tenderness, but the tormented sensual concentration of the fat tits of the mornes with an occasional palm tree as their hardened sprout, the jerky orgasm [*jouissance saccadée*] of torrents and from Trinité to Grand-Rivière the hysterical grandsuck [*grand'lèche hystérique*] of the sea. (11)

In stanza 22, "And time passed quickly, very quickly. / After August and mango trees decked out in all their lunules, September begetter of cyclones, October igniter of sugar cane, November purring in the distilleries, there came Christmas" (11). This world of seasonal progressions and natural cycles contrasts with Césaire's perception of Martinican society around the time he left the island to study in Paris. "It was at that time that I started to *hate* – and I'm not using the word lightly – the Martinican society I grew up in, which was made up of the black *petite bourgeoisie*."[39] In the first stanza, "At the end of first light burgeoning with frail coves the hungry Antilles, the Antilles pitted with smallpox, the Antilles dynamited by alcohol, stranded in the mud of this bay, in the dust of this town sinisterly stranded." In the second and third, "... an aged poverty rotting under the sun, silently; an aged silence bursting with tepid postules / the dreadful inanity of our raison d'être." Throughout the poem, the reader notices what Gregson Davis identifies as a "penchant for lexical innovation that is a veritable signature of Césairean poetics."[40] The Antilles appear in image after image as a panorama

of abject abandonment and hopelessness that *speaks* through a dense poetic lexicon of inversion, condensation, and distortion of islanders and islandscapes. An example of how "Metaphorically volcanoes and explosions set up a network of apocalyptic images that run through the poem," the fourth stanza imagines the volcanic island after a cataclysmal event:[41]

> At the end of first light, on this very fragile earth [*cette plus fragile épaisseur de terre*] thickness exceeded in a humiliating way by its grandiose future – the volcanoes will explode, the naked water will bear away the ripe sun stains and nothing will be left but a tepid bubbling pecked at by sea birds – the beach of dreams and the insane awakening. (3)

From this first stanza, the poetic voice sounds realist and visionary notes, evoking the transgressive attitudes of Baudelaire, Rimbaud, and Lautréamont. Césaire often mentions these powerful voices, all towering figures in a French literary tradition of prophetic revolt and social critique alongside other referents, precursors, and contemporaries, including Mallarmé and Breton.[42] As the poem progresses, images, cadences, and a heightened register resonate with the poetry of Breton and other surrealists who claim the same "canon" of French modern poetry. Césaire's poetic discourse is steeped in symbolism and *décadentisme* – a particular sub-canon that shaped poetic sensibility among the Paris surrealists, Espinosa in the Canary Islands, and Lorca and others in mainland Spain. The stanzas on the "rue de Paille" mark the end of the thematic introduction to the poem. The tone changes in stanza 29: "At the end of first light [*Au bout du petit matin*], the wind of long ago – of betrayed trusts, of uncertain evasive duty and that other dawn in Europe [*et cet autre petit matin d'Europe*] – arises ..." With this atmospheric change of the rising wind, the text turns to Europe, the perspectival point of enunciation. The next stanza opens with the word *partir* (to leave) (17).

The poem contains vivid descriptions of colonial cruelty, abandonment, and misery. The "rue Paille" ("Straw Street") of stanzas 27 and 28 stands out as an invented memory in asymmetrical tension with "Europe." The street is "an appendage repulsive as the private parts of the village that extends right and left, along the colonial road, the gray surge of its 'shingled' roofs" (15). Like other "scenes" in the poem, this section represents a particular angle on the colonial condition on Martinique where personal memory and sociocultural reality form a composite image of lived

experience, affective density, and moral outrage. Leading onto a beach, the street merges with the spectacle of an unsanitary shorescape, a microcosm of littoral decay that evokes the scandal of the colonial condition in Martinique in minute metaphorical detail.

> A blight this beach as well, with its piles of rotting muck, its furtive rumps relieving themselves, and the sand is black, funereal, you've never seen a sand so black, and the scum glides over it yelping, and the sea pummels it like a boxer, or rather the sea is a huge dog licking and biting the shins of the beach, biting them so persistently that it will end up devouring it, for sure, the beach and Straw Street along with it. (17)

Césaire casts this scene of abjection and torment as a cumulative enumeration. The image of the sea as an enraged dog threatens to devour the beach and the street, thus destroying the fragile border space that connects Martinican culture with a grim vision of the shorescape. Depicting a space of deadly decay, the scene dismantles colonialist notions of Black Martinicans living in blissful simplicity amid picturesque tropical islandscapes. During his stay on the island in 1887, Paul Gauguin made *Martinique Landscape* (*Végétation tropicale*), a painting that, Tamar Garb observes, has "the expected ingredients of a Caribbean paradise conceived in the French imagination: impressive foliage, opulent fruit, mountain slopes, sea and terracotta earth, all made visible in a sun-drenched landscape."[43] Stanza 34 gives a powerful example of what Césaire ironically refers to later in the poem as "my special geography ... [tinted] with the geometry of my spilled blood" (45). The poetic first person identifies with the small island and the archipelago of the Lesser Antilles. This identification expands across a metaphorical accentuation of descriptive detail that culminates in a magnified cartography of trans-American and trans-Atlantic connections:

> What is mine, these few thousand deathbearers [*mortiférés*] who mill in the calabash of an island and mine too, the archipelago arched with an anguished desire to negate itself, as if from maternal anxiety to protect this impossibly delicate tenuity [*la ténuité plus délicate*] separating one America from the other; and these loins [*et ses flancs*] which secrete for Europe the hearty liquor of a Gulf Stream, and one of the two slopes of incandescence between which the Equator tightrope-walks toward Africa. (19)

This second half of the stanza personifies the island's attribute of lucid audacity through the double trope of a *standing* sailor and a

sailing vessel. If the first half reduces the island to demographic and scalar perception, this passage inscribes the trope of the plantation island as carceral space only to reject it through images of interinsular movement, intellectual dynamism, and bodily uprightness. The wider navigational space is the French-colonized Black Caribbean that extends beyond Martinique, to the Francophone island of Guadeloupe, and the relatively distant Haiti on one of the Greater Antilles. The island stands at the rear of the Caribbean meta-archipelago or *polynésie*, in possible reference to Charles de Brosses's travels, who coined the word *polynésie* in *Histoire des navigations aux terres australes* (1758). If Guadeloupe resembles Martinique in volcanic singularity and social deprivation, Haiti is the historical space of the Haitian Revolution, where "negritude rose," as Martinique's "brave audacity" rises in the present tense of the poem. The geographical outline advances further north and east to suggest a conscious relation with two peninsulas of historical and contemporary imperialisms and historical peninsulas. Florida, a peninsula of the North American subcontinent, is a site of racist violence in the segregated US South. By comparison to the "little tail" of Florida peninsula, the African continent advances toward the Iberian Peninsula like a gigantic caterpillar (*chenille*), the larva of a flying lepidopteran, reaching "the Hispanic foot of Europe." The last sinuous sentence forms a trans-Atlantic montage of racist analogies, including "the strangulation of a nigger," and Africa "caterpillaring," naked – a possible reference to the advance of fascist troops from North Africa under the command of General Franco, following the military uprising that initiates the Spanish Civil War on July 17, 1936 and culminates in a fascist victory in April 1939.[44]

As the text spirals, its thematic wanderings encircle the island time and again in a prefiguration of what Kaiama L. Glover considers "a spiral-based aesthetic" in works by three Haitian authors of a later generation – Frankétienne, Jean-Claude Fignolé, and René Philoctète.[45] Speaking in a radio interview with the France Culture host Édouard Maunick, Césaire explained that beyond the sunny, warm, and joyous face of Martinique and the Antilles there was a dimension of confinement: "It's also the space of claustration [*l'univers de la claustration*] … There is something of the concentration camp atmosphere [*Il y a un petit peu l'asmosphère du camp de concentration*]."

> In any case, I have experienced that intensely … Then, dynamically, there is something else … In one of my verses, I have said: "Toute

île appelle, toute île est veuve" [*Every island calls out, every island is a widow*]. It's true, there is the sentiment, the need to overcome or transcend [*le sentiment, le besoin d'un dépassement*]. The island calls out to other islands. The island calls out to the archipelago. For me, the island calls out to the continent, and therefore, for me, naturally, the island, Martinique, the Antillean island, in the end calls out to the continent, to mother Africa.[46]

In late August 1939, the Césaires sailed back to Martinique, where Aimé Césaire started teaching at the Lycée Schœlcher in Fort-de-France. After France signed an Armistice with Nazi Germany in June 1940, from July that year until August 1944 Maréchal Pétain and his government ruled France as a fascist collaborationist state known as the Régime de Vichy. In this context, Césaire decided to confront "a lack ... a cultural void" in the Antilles. "Not that we don't take an interest in culture, but the Antilles are too exclusively a society of cultural consumption. Thus, I have always worked so that they can express themselves, speak, create. To that end, it is absolutely necessary to have a center of reflection, a thought laboratory [*un bureau de pensée*], therefore a journal."[47] The first issue of *Tropiques. Revue culturelle*, appeared in Fort-de-France in April 1941. While all islands called out to other islands in the archipelago, *Tropiques*'s mission was "to overcome or transcend" the claustrophobic conditions of Martinican intellectual life by dwelling on the long experience of the *sugar islands* and reaching out to the hemispheric and Atlantic allies' anti-fascist rebellion.

Tropiques

Walking around Fort-de-France, Breton found the first issue of *Tropiques* in a small store and enquired after the editors, Aimé Césaire, Suzanne Césaire, and René Ménil. Thus began the story of a truly epochal event in cultural and literary histories of Surrealism, modern Francophone literature, and Caribbean avant-gardism.[48] Although Suzanne Césaire did not write abundantly in *Tropiques*, she cut an eccentric and formidable figure in the journal. Like the other editors, she embraced Frobenius's ideas, and soon identified Surrealism as a means to orient a new poetics of Martinican emancipation, political freedom, and cultural growth. She studied at the École Normale Supérieure d'Institutrices in Toulouse between 1934 and 1936, and at the École Normale Supérieure de l'Enseignement

Technique in Paris until 1938. From late 1940, she taught at the École Pratique de Commerce et d'Industrie in Fort-de-France.[49] Her first two contributions to *Tropiques* were, in part, intellectual portraits of "great men" who could help elucidate the journal's intellectual project.[50]

"Leo Frobenius and the Problem of Civilizations" discusses *Histoire de la civilisation africaine*, including the controversial notions of *paideuma, the morphology of cultures*, and civilizational *forms* and *substances*; and cultural and biological organicism, and the contrasting examples of Ethiopian and Hamitic civilization.[51] Césaire's synthesis of Frobenius's theory highlights what she sees as "A grandiose conceptualization that embraces human evolution in its entirety; an admirable particularity that wants human beings to learn from the study of all other human beings from all other times." Opposing the colonial view of French *civilisation*, Frobenius's ethnographic vision posits an Afro-centric theory of *civilisations* – "the search for intimate knowledge, of a secret reality revealed in the life-force itself" (4). Césaire concludes by emphasizing the *now* and *here* of *Tropiques*'s differential project: "It is now vital to dare to know oneself, to dare to confess to oneself what one is, to dare to ask oneself what one wants to be. Here, also, people are born, live, and die. Here, also, the entire drama is played out" (9–10). In Christina Kullberg's analysis:

> Via Frobenius, Suzanne Césaire pictures African civilization as the cradle of human identity, and for Martinicans, a vector of self-knowledge. However, it is precolonial Africa that *Tropiques* idealizes: Frobenius asserts that the arts of Africa are as valuable as European novels—arts that bear proof of an ancient grand civilization. What Suzanne Césaire develops is thus a vision of Africa as a mythical space rather than contemporary reality. This is an expression of what Glissant calls a "mystic relation" to land, privileging indigeneity, purity, and rootedness ... Yet paradoxically these roots to the land are transplanted from somewhere else.[52]

In "Alain and Esthetics," extending her reflections in the previous article, Césaire discusses an aspect of civilization through an analytical review of Alain (Émile-Auguste Chartier), an influential French philosopher, teacher, and pacifist. Discussing *System of the Fine Arts* (*Système des Beaux-Arts*) (1920), she outlines Alain's conventional critique of the art disciplines (drawing, painting, architecture, sculpture, music, and poetry), engaging his romantic and

phenomenological views on poetry with particular intensity. Poetry "elevates man to the highest degree possible of contemplation and majesty" and, "like music, it helps us to move beyond ourselves, and it goes yet further, it leads us into 'a new time,' into a new world" (14). But there are limits to Alain's categorization.

> For example, the greatest poet for him is Paul Valéry. And he does not feel that the classicism of Valéry can be surpassed, nor that it is outmoded ... he defines musical beauty admirably: "music threatened, lost, saved and once again threatened, is the essence itself of music," and he does not know whether his sentence even expresses the process of red-hot jazz. (16)

Césaire turns away from Alain's (and Valéry's) aesthetic values, again underlining the *now* of her critical viewpoint, and staging a discursive metamorphosis in the final passages of the essay: "Now it is a matter of seizing and admiring a new art, which while leaving man in his true place – fragile and dependent – opens up to the artist unsuspected possibilities however, in the very spectacle of things ignored and silenced." Questioning the validity of Valéry's universalism, and noting Alain's ambivalence about non-European music, she turns to the adventure of avant-garde aesthetics ("a new art"): "And here we are in the realm of the strange, of the marvelous, and the fantastic, which people of certain taste hold in contempt ... the liberated, dazzling, and pleasing image of a beauty that is precisely the most unexpected, the most upsetting" (17). These concluding passages commemorate a historical juncture in modern Caribbean culture that an abundant literature celebrates critically as the "chance encounter" in April and May 1941 between the Martinican intellectuals of *Tropiques* and the exiled Paris surrealists.[53] Césaire explicitly mentions *L'Amour fou*, which contains an account of Breton's experiences in Tenerife and references to the Spanish Civil War. But there is a "here finally" dimension to this covenant that locates Surrealism firmly within the interests of the *Tropiques* collective – an awareness of the colonial present and a consciousness of Martinican insularity that *recognizes* in Surrealism an allied aesthetico-political attitude: "Here finally is the world, nature, things entering into direct contact with the human who has recovered spontaneity, the natural, in the fullest sense of that term. Here finally are the veritable communion and the veritable knowledge, chance overcome, recognized, mystery friendly and helpful" (17). Césaire's five other essays return to the first two,

expanding and complicating these initial forays into the *now* and *here* of surrealist hallucination and Martinican self-affirmation.

"André Breton, Poet" appears in the third issue of *Tropiques*, six months after the Paris surrealists' sojourn in Martinique. Despite its overtly hagiographic attachments to Breton's charisma, the piece poses several critical questions. Imagining Breton as a visionary poet in the tradition of the surrealists' precursors Baudelaire and Rimbaud, Césaire casts him as a *seer* who transcends rational spatiotemporal categories: "The poet becomes a prophet" who travels down "infinite roads, along which the mind arrives at a more and more secure grasp of the world" (23). Césaire captures the process or metamorphosis that produces the surrealist poet as an Orphic seer and knower who travels in order to arrive at an authentic and final experience of the world. Very much at the center of *Tropiques*'s interests, the world Césaire has in mind is plural and different from Eurocentric universalism. As she endorses Surrealism's claims to a higher consciousness that can be achieved through the privileged medium of poetry, she charts a textual genealogy of Surrealism by engaging and actualizing a series of texts through direct or implied references: *L'Amour fou* (*Mad Love*), the *Surrealist Manifesto* ("le manifeste") of 1924, the "second manifesto of surrealism," a poem by Paul Éluard; and a clear familiarity with derived psychoanalytical notions of the unconscious, fantasies, day-dreaming, symbols, mysterious signs, childhood, and dreams (20–3).

In "Poetic Destitution," a meditation on the symbolist writer John-Antoine Nau, Césaire shows no deference to the exotic lyricism of canonical Francophone authors like the Réunionese Leconte de Lisle, the Cuban José-Maria de Heredia, or the French Basque Francis Jammes. She states: "Colonial professors continue to find that quite good. Poor ninnies!" and "Come on now, real poetry lies elsewhere. ... And to hell with hibiscus, frangipani, and bougainvillea." The final words depart from caricatures of Nau and the forms of literary exoticism and nativism he would have inaugurated: "Martinican poetry will be cannibal or it will not be" [*La poésie martiniquaise sera cannibale ou ne sera pas*] (27). This conclusion travels far across surrealist textuality. It echoes the last sentence of Breton's *Nadja*, "Beauty will be CONVULSIVE or it will not be" [*La beauté sera CONVULSIVE ou ne sera pas*], and the end of Chapter I in *L'Amour fou*: "Convulsive beauty will be veiled-erotic, fixed-explosive, magic-circumstantial, or it will not be" [*La beauté convulsive sera érotique-voilée, explosante-fixe, magique-circonstancielle ou ne sera pas*].[54] Thus, "Poetic

Destitution," a short text that discusses Nau and the "school" of colonial exoticism, articulates Surrealism with a declaration on a future Martinican poetry that evokes the trope of the cannibal as a "convulsive" image of the Caribbean. Césaire reflects further on various facets of this vision in her three best-known discussions: "The Malaise of a Civilization," "1943: Surrealism and Us," and "The Great Camouflage."

"The Malaise of a Civilization" and "1943: Surrealism and Us" are more historically inflected than Césaire's previous writings. These two complementary pieces reflect on the effects of Surrealism on Martinican and other, generally Black and colonial, Global South territories during World War II, the French Occupation, and Vichy France. "The Malaise of a Civilization" returns to Frobenius to posit that Martinicans are plant-like. Proposing to "question life in this island that is ours," she argues that the causes for a lack of creative responses to "our ancestral anxiety" (28) lie in successive historical experiences of "transplantation onto a foreign soil," "coerced submission" under colonialist regimes (29), and assimilationist and mimetic attitudes (31, 32). She glosses over historical, class, and psychoanalytical dimensions of the Martinicans' "failure in the world" (31) in an exploratory discourse that veers between cultural essentialism and a renewed new declaration of hope in Surrealism. The pathological understanding of Martinican society reminds us of Pedreira's essay on colonialism and culture in Puerto Rico, *Insularismo* (see Chapter 2). But unlike Pedreira, Césaire's discussion of the Martinicans' *malaise* is open to a novel interpretation of the island through anticolonial resistance, ethnographic and historical knowledges, and surrealist hermeneutics.

By July 14, 1943, Free France forces had retaken control of Martinique from the Vichy colonial administration, which had been under the relatively lenient command of Admiral Robert since the start of the war. For this strategically important island, the shift from the authority of Vichy France to that of General de Gaulle's Comité Français de Libération Nationale can be felt in the openly combative tone of Césaire's texts.[55] In a densely aphoristic transition in "1943: Surrealism and Us," she writes: "And now, a return to ourselves." Listing "our human task" and "our audacity" among the visionary points of convergence with Surrealism, she insists, modifying the pace of her declaration: "And then I think also to tomorrow. / Millions of Black hands, across the raging clouds of world war, will spread terror everywhere. Roused from a long

benumbing torpor, this most deprived of all people will rise up, upon plains of ashes" (37–8).

In 1944, the Haitian President, Élie Lescot, and the Haitian Foreign Minister invited Aimé Césaire to the International Congress of Philosophy organized by the Société Haïtienne d'Études Scientifiques.[56] Arriving in Haiti in May 1944, Suzanne Césaire gave lectures to female teachers until her return to Martinique in October, while Aimé Césaire continued to deliver public lectures and teach until December.[57] "The Great Camouflage," one of the most extraordinary works of modern Caribbean literature, responds in part to the Haitian experience. In this text Suzanne Césaire no longer engages explicitly with Breton and surrealist ideas. While her previous wartime essays advance her constant investigation of the relevance of metropolitan and Caribbean ideas for Martinique, she now refines a moveable perspectivism of the insular *now* and *here*. Like a documentary filmmaker, Césaire "films" her ideas about the postwar present of the Antilles by steeping a series of scenes on two different locations: Haiti, where the essays start, and Martinique, where the project of *Tropiques* culminates. The text is constructed around a sequence of six or seven *scenes* – moments of seeing and reflection that are dynamically interwoven with cultural and environmental reflections. This is a documentary and mural essay where the panoramic attitude must be seized by identifying with the requirements of Césaire's political voice. Adopting the viewpoint of the vacationing tourist, the colonial traveler, or the US military, the image of the window suggests a desire for freshly framed accounts of this Caribbean present:

> Now is the moment to look out the window of the aluminum clipper with its great banking turns.
> Once again the sea of clouds is no longer virginal since the Pan American Airways System planes have been flying through. If there is a harvest maturing, now is the time to try to glimpse it, but in the prohibited military zones, the windows are closed.
> On the planes they bring forth the disinfectants, or the ozone, whatever, you will see nothing. Nothing but the sea and the indistinct outline of lands ... Our islands seen from above, take on their true dimension as seashells. (40)

These instructive annotations evoke an insular Caribbean of picturesque vistas and secret enclosures where the view from above reveals *nothing* but "indistinct outlines" and those symbols of

tropical charm, hermetic seashells. Framing the text from the opening sentences as a deceptively exotic maneuver, Césaire rhapsodizes about the plural Caribbean: "There are, melded into the isles, beautiful green waves of water and of silence. There is the purity of the sea salt [*la pureté du sel*] all around the Caribbean [*autour des Caraïbes*]." She adopts an ambiguous standpoint or aerial perspective that wanders freely between gardens, landscapes, and shorescapes. Immersed in a surrealist vision, she continues: "There is before my eyes, the pretty square in Pétionvile [sic] [*la place de Pétionville*], planted with pines and hibiscus. There is my island, Martinique, and its fresh necklace of clouds buffered by Mount Pélé [sic] [*la Pelée*]. There are the highest plateaus of Haiti, where a horse dies, lightning-struck by the age-old killer storm at Hinche." The horse's "master" "does not yet know that he is participating in the islands' absence of equilibrium. But this sudden access to madness illuminates his heart: he begins to think about the other Caribbean islands, their volcanoes, their earthquakes, their hurricanes" (39). After this preamble, the narrator travels elsewhere, displacing the fragmented panorama to a simultaneous event and another surreal apparition, the cyclone as a sea-monster:

> At this moment off the coast of Puerto Rico a huge cyclone begins to spin its way between the seas of clouds [*les mers de nuages*], with its beautiful tails [*avec sa belle queue*] sweeping rhythmically the semi-circle of the Antilles. The Atlantic takes flight toward Europe with great oceanic waves. Our little tropical observatories begin to crackle with the news.

This two-paragraph opening ends in a laconic single-sentence paragraph: "After the rain, the sun" (39). Setting the stage for an atmospheric survey of the Caribbean present, Césaire adjusts lighting and focus, editing her takes to provoke an affective and intellectual response. Anny-Dominique Curtius argues that, in this text, "the entanglement between blindness, shadow, and lucidity is essential to her argument. Haiti inspires her in the articulation of a discourse that is not only oriented to Martinican reality ... She conceives this Haitian mission as fieldwork, which proves decisive for the writing of 'The Great Camouflage' and her contribution to Caribbean critical thought."[58] There are scenes about her arrival in Haiti, Black internationalism, and pan-Americanism. Other scenes critique racial and class prejudice among the mixed-race *petite bourgeoisie* of both islands and metropolitan functionaries in

Martinique, and three final paragraphs stage her Caribbean vision. The concluding passage, written in a single, spiraling sentence, reads:

> It is thus that the Caribbean conflagration [*l'incendie de la Caraïbe*] blows its silent fumes, blinding for the only eyes that know how to see, and suddenly the blues of the Haitian mountains, of the Martinican bays, turn dull, suddenly the most blazing reds go pale, and the sun is no longer a crystal play of light, and if the public squares have chosen the laceworks of Jerusalem thorn as luxury fans against the fieriness of the sky, if the flowers have known how to find just the right colors to leave one dumbstruck, if the tree-like ferns have secreted golden saps for their white crooks, rolled-up like a sex organ, if my Antilles are so beautiful, it is because the great game of hide-and-seek has succeeded, it is because, on that day, the weather is most certainly too blindingly bright and beautiful [*il fait certes trop beau*] to see clearly therein. (45–6)

The conflagration, a burning-together of Caribbean experiences, summons deep historical experiences of anticolonial rebellion – eruptive events that, like the Haitian Revolution, propitiate an atmospheric memory of burning outbreaks and destructive beginnings. In "The Great Camouflage," Césaire is a seer of the insular Caribbean. Those who can sense the Antilles silently going up in flames from Martinique to Haiti will perceive a dull and pale negative image of the exuberant tropics, or the reverse of "the great game of hide-and-seek." To see clearly beyond the bright surfaces of Caribbean nature and sensory pleasures would entail an immersion in that other Caribbean reality, enabled by personal returns and detours, by the visionary perspectivism of Surrealism, and by the desire to found new standing points of Caribbean insurgency and self-creation. The war and Vichy make the insular condition inescapable as an *object* of surrealist praxis. Césaire's participation in the Negritude vision, the poetic journey of *Cahier*, and the *Tropiques* group's dealings in Surrealism are traversed by undercurrents of Black Atlantic consciousness, ethnographic insight, and an existential awakening to the freeing potential of insular experience. In Suzanne Césaire, Surrealism and historical/ethnographic analysis become eloquent departures from metropolitan exoticism. Like Aimé Césaire, she seeks to combat the surrounding atmosphere of administrative torpor and cultural stasis with island-conscious critiques of colonialism, exotic reductionism, and scientific racism. Thus, in the wider Atlantic context, *Tropiques* practices a local-bound Black diasporic avant-gardism that helps us reorient the

cultural nationalism of *Revista de Avance*, and the Eurocentric cosmopolitanism of *Gaceta de Arte*.

Pointe-à-Pitre / Santo Domingo / Havana

The Bretons and the Massons sailed to New York on May 16, 1941, after brief stopovers in Pointe-à-Pitre in Guadeloupe and Ciudad Trujillo (Santo Domingo) in the Dominican Republic. Lam, traveling in the same boat, sailed on from Ciudad Trujillo to Havana.[59] They traveled on the *Presidente Trujillo*, a boat named after Rafael Trujillo, president and dictator of the Dominican Republic. When hurricane San Zanón devastated Santo Domingo on September 3, 1930, Trujillo had acted swiftly to mobilize the army, impose martial law, and reconstruct the city, and in 1936 he renamed it after himself. Having risen through police and military ranks leading up the US invasion of the Dominican Republic (1916–24), Trujillo ruled the country as a dictator until his death in 1961. He established a personality cult through a brutal single-party regime that was largely supported by the United States.[60] In 1937 he ordered the massacre of Haitians in the northwest of the country bordering on Haiti, killing approximately 15,000 Haitians. As Richard Lee Turits explains: "The extraordinary violence of this baneful episode provides a terrifying image not only of the brutality, ruthlessness, and Caligulesque features of the infamous Trujillo dictatorship but also of the potential depths of Dominican anti-Haitianism."[61] The surrealists' journey had started in Marseille and turned into a transcendental experience on Martinique. It then took on a newly symbolic tone with more encounters. Pierre Mabille, then working as a doctor in Guadeloupe, visited the Bretons on the boat at Pointe-à-Pitre, and in Ciudad Trujillo Breton and Lam meet the Spanish avant-garde exile Eugenio Fernández Granell. A refugee of the Spanish Civil War, Granell had had contacts with the surrealists in Paris in 1939 before moving to the Dominican Republic in early 1940, where he joined a large group of exiled Spanish Republican and other European intellectuals. He worked as a violinist at the Orquesta Sinfónica Dominicana and as a journalist, became a painter, and later helped found the avant-garde journal *La poesía sorprendida* (1943–7). When, in an interview with Breton during the Dominican stopover, he asked six questions, the former responded in French; the text then appeared in Spanish in the Dominican press.[62] This anecdote encapsulates the dialogic

climate of the period, an urgency to relate, translate, and reshape the mnemonic materials of previous decades.

In *Isla cofre mítico* (1951), Granell revisits the itinerary that Breton and other surrealist exiles had followed during the previous decade. All the texts in the book, including an untitled preamble and twelve titled sections, are preceded by Granell's drawings, inserted between each title and the start of the text proper.[63] Drawing on a large compendium of examples from the Atlantic and Caribbean islands, the book explores the island as myth. Breton's journey, too, takes on quasi-mythical dimensions through the "sea journey from continent to continent, island to island, that Breton and Surrealism undertook while war consumed the first half [*el primer tiempo*] of the unavoidable descent [*inmersión*] to which the old order of things seems doomed" (41). This is a text of remembrance at the start of a new decade that professes a renewal of faith in the visionary and prophetic powers of surrealist poetry. For Granell: "The island materializes dreams [*ensueños*], a life-giving spot on the known lost horizon [*horizonte muerto conocido*]"; and "The island [is the] living figure of the unexplored face of the world, of the original world that poetry anticipates and remembers" (46). The utopian impulse that structures these fragments projects sexual and erotic desire onto the island, "a woman-girl [*mujer niña*]" (59). In one of his painterly reveries, Granell writes: "The sky-blue island [*isla celeste*] projects its future memory against the earth. The shadow is an island. The island is a woman. A floating green woman" (54).

If *Isla cofre mítico* summons texts from the previous decades by Espinosa and Breton among others, it also responds to a historical need to reassess and confirm allegiance to interbellum Surrealism. Many passages in the book recall two works from the late 1940s, *Sens-plastique*, by the Mauritian writer Malcolm de Chazal, and (in the urgency to celebrate Breton's triumph) the first biography of Breton, Julien Gracq's generally hagiographic *André Breton*. Granell cites Rimbaud, quotes from *Martinique charmeuse de serpents* in Spanish, and mentions *Fata Morgana* and *L'Amour fou*. He remembers the other protagonists and companions of the Caribbean adventure: Masson, Lam, Victor Serge, Mabille, *Tropiques*, and Césaire's *Cahier*.[64] Just as Suzanne Césaire inscribes a passage on Mount Teide on the island of Tenerife from Breton's *Mad Love* in "André Breton, Poet" (21), so Granell, in a section titled "Triángulo Isleño" (Island Triangle), writes: "We should remember that one of the first surrealist groups appeared in the Canary Islands (the Fortunate Islands), and we should note that much of Miró's oeuvre,

whom Breton considers the most inspired among surrealist painters, was produced on the island of Mallorca." In the same paragraph, in a surrealist accumulation of disparate items, Granell assembles the names of historical figures and contemporary writers: "The names of distinguished islanders [*isleños singulares*] crowd into a large archipelago, [of] native and adopted islanders" (29). The list connects island-born and island-bound figures such as El Greco, Napoleon, Pissarro, Paul Lafargue, Joséphine de Beauharnais ("Josefina"), and Toussaint Louverture. He includes the pre-Socratic philosopher Xenophanes alongside Galdós, Lam, Hippolyte, Aimé Césaire, Robinson Crusoe, and José Martí; and Hegel alongside the Spanish liberal Rafael del Riego, Eugenio María de Hostos, the French art dealer Ambroise Vollard, and Óscar Domínguez.

The text exudes an awareness of Spanish and European imperialisms – a kind of *pharmakhon* that reinscribes and repels the previous half-century of Hispanism. Granell mobilizes a dense tropology of legendary Caribbean figures that "navigate," explore, and conquer freely between the islands and the European continent, including literary and historical figures who had anything to say about islands – Unamuno, Napoleon, Baltasar Gracián, and Antonio Albiol.[65] In several passages, Granell identifies Breton with Christopher Columbus. Like the latter, Breton "discovers" Césaire, Lam, and Hippolyte, who form an "island triangle" (30). For all the apparently uncritical evocations of Spanish imperial lore, Granell's tone is ironic and playful, evoking the *creacionista* assemblages and montage technique of Espinosa's *Lancelot 28°–7°* that I discussed in Chapter 2. In both texts, the imprint of Italian Futurism and its colonialist rhetoric can be heard, filtered perhaps by the recuperation of historical figures in Jiménez Caballero's *La Gaceta Literaria* and in other journals.[66] On the one hand, *Isla cofre mítico* evokes a conglomerate of historical, legendary, and mythical characters that populate the imagination of the colonial Atlantic. On the other, it dwells on the irreducible historical experience of his personal crossing as an exile of the Spanish Civil War.

In her memoir of her life with Lam during 1939–50, Helena Holzer, who married Lam in 1944, explains that Lam thought negatively of most Cuban painters at the time: "Their predominant use of stereotyped Creole themes, executed in convoluted styles, seemed academic and superficial to him." Those other painters, in turn, "considered Wifredo an outsider and a snob" (91).[67] The fact is that in June 1939 Lam had a solo exhibition at Pierre Loeb's gallery in Paris, Galerie Pierre, and his new Paris works were shown

at Klaus Perls's Perls Galleries in New York in November–December 1939: "Drawings by Picasso – Gouaches by Wifredo Lam" (41). Lam and Holzer left Santo Domingo for Havana in early July 1941 (58), where, having been away for eighteen years, Lam resettled and reconnected with family, old friends, and members of the Cuban intellectual scene, including some of the old members of the Minorista group with whom he had affinities. The couple soon befriended Lydia Cabrera, through whom they expanded their circle of friends and far-reaching cosmopolitan network (60–1).[68] In 1942, Carpentier and Lam, who had known each other since the 1920s, spent time together, but Lam did not feel entirely at home in Cuba. His "return to the native land" was ambivalent and complicated. He did not blend with other Cuban artists residing in Havana (81, 91). However, this return would represent an intense set of incursions into the universe of Afro-Cuban culture, ritual, and knowledge.

Through Cabrera, Lam and Holzer met the anthropologist Fernando Ortiz, who was married to Cabrera's sister. Ortiz had just published *Contrapunteo cubano del tabaco y el azúcar* (1940), a book that went on to become one of the most influential works of the Caribbean and Latin American twentieth century.[69] From those encounters with new and old friends, Lam must have gained a sense of reassurance and a community of knowledge and questioning. We can imagine Cabrera and Carpentier introducing Lam to the changing cultural formations that Ortiz discusses in his works and to two works of the previous decade, Carpentier's *¡Écue-Yamba-Ó!*, and Cabrera's *Cuentos negros de Cuba*. Guided by Cabrera, the four friends witnessed several Afro-Cuban ceremonies. Holzer concludes her description of a *ñáñigo* initiation ceremony with a candid appraisal: "... magic was in the air. We felt like we were in another dimension of time and place" (93, 96). From 1942 to 1947, Lam created the motifs of his idiosyncratic style. The nude portraits, self-portraits, still lifes, and interiors of the late Spanish years had morphed into the masked figures and Cubist compositions that he exhibited at Galerie Pierre and Perls Galleries. In his "Carnets de Marseille" and the illustrations for Breton's *Fata Morgana*, the zoomorphic characters exhibit some of the signal traits of later work: deformed noses, long feet, hooves, manes, and flying figures. This is the foundational period of his career as one of Latin America's most defining artists.

Like Breton, Holzer relates the experience of walking around Fort-de-France and visiting the island interior with the Bretons and Césaires. "Wifredo and Aimé felt great affection for each other and

soon became friends." In her recollection of an excursion to Morne Rouge "near the volcano Saint-Pierre," Holzer writes: "During this outing, Wifredo and I came to appreciate for the first time the structure and character of a virgin forest – the jungle" (55, 56). This passage evokes the intensity and wonder of an unexpected encounter that, on the island of Martinique, encapsulates a desire for purity, a nostalgia for uncivilized life, and a physical immersion in a space of utopian exception. These sensory experiences conjugate the sense of loss among the "returned" Caribbeans and "passing" Europeans in the spring of 1941. Less than a year later, Lam's aesthetic orientation underwent a dramatic transformation, and he painted a large work of art that remains a central aesthetic referent of the Caribbean twentieth century. Multiple traces of Lam's life until that point, and key contextual and historical "influences" can be read into *The Jungle* (1943), as Lam himself, and a long line of critics and commentators have done (Figure 6.2).

But what does *The Jungle* say about insularity? If we approach the painting through the textual and historiographic constellations assembled in this chapter, we can perceive an undeniable intensity of character and energy that resonates with *Cahier* and "The Great Camouflage", with texts by Cabrera, Carpentier, and Ortiz, and with *passing* texts like *Martinique charmeuse de serpents* and *Isla cofre mítico*. Ultimately, *The Jungle* suspends the conceptual boundaries that separate outdoor and indoor spaces, past and present, and conscious and unconscious. This feature of the work elicits the question: how does *The Jungle* image the island thus conceived? Carpentier called *The Jungle* "a veritable museum piece [*verdadera pieza de museo*]."[70] But the characters or apparitions seem to have escaped the museum or the ethnographic collection to reappear, transformed and transmogrified, in a space that refracts Western rationality, yet reflects the summum of the gazes, projections, and distortions that form *the island* of the exoticist avant-garde imagination. *The Jungle* conjures the transitional spaces of exile and displacement that, like *Cahier* and "The Great Camouflage," signal the experience of an existential and critical *return* to a Caribbean island in an open conversation with earthbound Surrealism and in a decisive *detour* toward Afro-Caribbean commitment. After this *historical* eclosion of natural depth, plant life morphs with anthropomorphic and zoomorphic apparitions, and backgrounds generally dissolve into flat monochromatic surfaces, the enigma of apparition displaced beyond the natural world of islands and jungles, the experimental

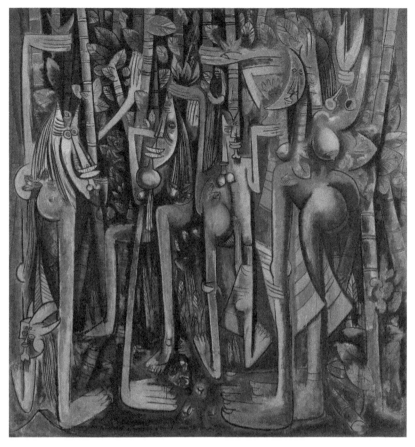

Figure 6.2: Wifredo Lam, *The Jungle*, 1943. Gouache on paper mounted on canvas. 239.4 x 229.9 cm (94¼ x 90½ ins). The Museum of Modern Art, New York

attitude dialoguing with the Abstract Expressionism of the New York School.[71]

A ripple effect of the passage from Marseille to Martinique is the first translation of *Cahier*. A year before Lam finished painting *The Jungle*, Cabrera undertook a Spanish version, *Retorno al país natal* (1943). The text includes a short preface by Benjamin Péret and three drawings by Lam: a colophon on the cover and title page, a large drawing before the start of the translation, and a second large drawing at the end.[72] Péret's preface, probably translated by Cabrera, salutes Césaire as "a great poet, the only great poet in

French to have emerged in the last twenty years. For the first time a tropical voice rings in our language"; and "the great Black poet who has broken loose and sails, without concern for any intellectual polar Star or Southern Cross, guided solely by his blind desire." After suggesting that Césaire represented the pinnacle of interwar poetry, where the bulk of surrealist poets appeared, Péret planted a perverse image that transported Césaire, *Cahier*, and Martinique back to the realm of surrealist hallucination. Césaire's poetry is "the primal cry [*grito salvaje*] of a domineering and sadistic nature that swallows men and their machines the way flowers [swallow] reckless insects." This passage evokes another text by Péret, "La nature dévore le progrès et le dépasse" ("Nature devours and overcomes progress") (1937). Indeed, Péret's preface "re-members" a field of images from his previous text that seem to offer a prophetic reading of *Cahier* and a more detailed set of coordinates for Césaire's "tropical voice." In Péret's 1937 text, thousands of plants suffocate the telegraphic wire that carries the human voice across a corridor in the forest in equatorial America, and tropical nature seduces and swallows an entire locomotive. These images of a vengeful and triumphant tropical nature migrate to the 1943 preface, where Césaire's text is presented as the tropical forest that seduces, arrests, and annihilates the machine.[73]

The translation and edition process reveals some of the rifts or contradictions that characterized the Caribbean avant-garde and surrealist moment. One can hardly think of a more apt definition of the meaning of return for Lam and Cabrera (and, by extension, Carpentier and the Césaires) than Emily Maguire's lucid observation: "They found themselves separated from the avant-garde artistic communities of the French capital and in many ways socially and creatively isolated in their home country."[74] Citing Brent Hayes Edwards's discussion of *décalage* and *disarticulation*, Maguire interprets "Cabrera's translation of Césaire's iconic text as a *disarticulation*: both a gesture of connection and understanding, and an expression of nonequivalency and fundamental difference."[75]

Retorno al país natal performs this *disarticulation* on several levels. As Katerina Gonzalez Seligmann observes: "The Havana printing thus consolidated the poem's presentation of Martinique as translatable, or comparable, into other parts of the Caribbean archipelago."[76] There is no doubt that Martinique and the rest of the Francophone and Creole-speaking Caribbean "translate" into and for the extended Caribbean archipelagos in the complex modes of creative and generative opacity, ambivalence, and distortion

(see the discussions of Luis Palés Matos, Nicolás Guillén, and Julia de Burgos in Chapter 3). Despite the translation and attendant problems that Maguire and Seligmann identify in the *passage* of *Cahier* into Spanish, the textual and material contexts of Cabrera's effort speak eloquently, although never conclusively, of the insular historical moment. As Seligmann concludes: "Even in its nodes of divergence, Cabrera's translation demonstrates that Césaire's critique of post-slavery racism in colonial Martinique translates into the persistent racist climate of neo-colonial Cuba, increasing by way of her crossing the readability of the Caribbean's existence as a location of shared pasts and horizons."[77] Of course, Cabrera's choices in translating certain words and passages, most notably the variations on "Au bout du petit matin," remain open to scrutiny and disagreement. So too are translations into English and other languages where the spirit of Césaire's text, his voice (or voices), and the particular appraisals of style and context continue to change and inform how we read the dialogic locations of poet and translator.

Translation, a form of *return* and hopeful new beginning, operates across Caribbean and metropolitan spaces formally and informally as a central practice of the time. Charles Forsdick proposes a nuanced and situated notion of "translation as resistance," an "understanding of translation as challenge, or as a form of resistant cultural translation" that would be "particularly apparent in anthropophagic rewritings, in a Caribbean context, of Western texts."[78] Indeed, in the particular junctures of 1940s Caribbean avant-gardism, translation and related intermedial practices constitute an archipelagic assemblage of cultural islandscapes that are interwoven with different kinds of resistance, uncertainty, and collaboration – the *difficult dialogues* I evoke in the title of this chapter. But not all these dialogues are difficult in the same ways. Holzer, for example, interprets fragments of *Cahier* at a reading by Césaire in Martinique to make the text intelligible for Lam (56). Breton invented, rather than translated, the French titles of Lam's works in preparation for the *Lam Paintings* exhibition at the Pierre Matisse Gallery in 1944, but Cabrera had been suggesting titles in connection with her own ethnographic research.[79]

There is a relational density to the chronology of encounters and friendships that shaped the stagnant weeks at Villa Air-Bel, a group performance that effected the archipelagic webs of Atlantic Surrealism. In 1941, Lam, Domínguez, and Masson collaborated in the mythical *Jeu de Marseille*, and Breton enlisted Lam to illustrate *Fata Morgana*. Despite her "mediocre" Spanish, Holzer "translated"

the poem for Lam, who only had a limited knowledge of French.[80] As a result of the events of Martinique, this poem was followed by Breton's collaboration with Masson in *Martinique charmeuse de serpents*, and by a further collaboration between Césaire, Cabrera, and Lam in *Retorno al país natal*. What *translates* in our readings of the insular historical moment is something slightly different. It relates to Julia P. Herzberg's observation on the process of *Retorno al país natal*: "The four collaborators [Césaire, Cabrera, Lam, and Péret], who were living in three different countries – Cuba, Mexico, and Martinique – were interconnected by their shared interest in *negritude* and Surrealism."[81] If in Surrealism we can intuit an obvious prewar connection with Paris, what of *"negritude"*? There is an undeniable Afro-Caribbean connection. But Péret's Latin American exile prompts us to complicate the notion of Negritude, opening it up to his insular experience in Tenerife, Breton's Mexican excursion, and Lam and Holzer's initial intention to reach Mexico, not Cuba, in their escape from France.[82] In a November 20, 1945 photograph, a group of friends pose relaxedly in the Matisse couple's apartment in the Fuller Building, an elegant address known for its art galleries in Midtown Manhattan (Figure 6.3). The select group had gathered to celebrate the presence of the Césaires, whom Breton had met in Martinique four years earlier. In May 1945, Aimé Césaire was appointed Mayor of Fort-de-France after running on a Communist list. On November 4, he was elected to the French National Assembly as Deputy for Martinique. The Césaires traveled to Paris via Haiti, Miami, Washington, New York, and Le Havre. Soon after the *grande soirée* at the Matisse's, the Bretons left for Port-au-Prince.[83]

White Shadows

In "White Shadows in a Black Land" (1932), Langston Hughes describes Haiti as "a country where the entire national population is colored … the first of the black republics, and that much discussed little land to the South of us," and a place where "the dark visitor from America will feel at home and unafraid." But Hughes launched a direct critique of the US Marines, the National City Bank of New York, Washington politicians, and the US Senate, decrying "how the white shadows have fallen on this land of color" and concluding that "the Haitian people live today under a sort of military dictatorship backed by American guns. They are not free."

Difficult Dialogues

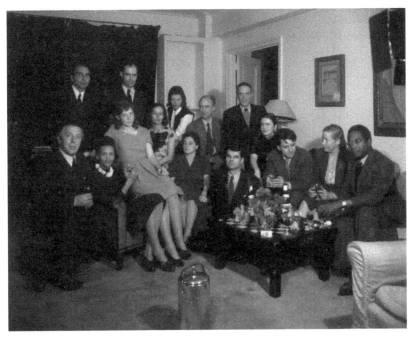

Figure 6.3: Surrealists and friends at Pierre Matisse Gallery, New York, November 20, 1945. From left to right: André Breton, Esteban Francés, Suzanne Césaire, Jacqueline Matisse-Monnier, Denis de Rougemont, Elisa Breton, Sonia Sekula, Madame Nicolas Calas, Yves Tanguy, Nicolas Calas, Marcel Duchamp, Patricia Kane Matta, Roberto Matta, Alexina Matisse, and Aimé Césaire

As Michael Dash explains, the white shadows of Hughes' discourse refer both to "the American Marines in Haiti" and "the bourgeoisie which had become blindly Eurocentric."[84] The American occupations of Haiti (1915–34) and the Dominican Republic (1916–24) had direct and dire consequences for the Haitian and Dominican peasantries and working classes that echo, however indirectly, the oppressive atmosphere in popular critiques of Caribbean and South Pacific colonialism in films like Van Dyke's *White Shadows in the South Seas* and Sirk's *La Habanera*. Hugues's first-hand appraisal of the Haitian situation contrasts in some ways with the scenario that visitors like the Césaires, then Breton and Lam, experienced more than a decade later in 1944 and 1945, respectively.

In 1945, Pierre Mabille, then French cultural attaché in Haiti, invited Lam and Breton (and their wives, Helena and Elisa) to visit the country. Like Eduardo Westerdahl in the Canary Islands, and

José Antonio Fernández de Castro in Cuba, Mabille was a talented facilitator of intellectual exchanges. He had been a member of the Paris surrealist group since 1934, a participant in the journal *Minotaure*, and author of *Le Miroir du merveilleux* (1940), a book Breton had read appreciatively.[85] In the January 1945 issue of *Tropiques*, he published "La Jungle" ("The Jungle"), a long essay on Lam signed in Havana in May 1944: "I remember Wifredo in Paris ... I saw him again in Marseille ... in Ciudad Trujillo ..."[86] Breton would deliver a series of lectures for mixed audiences of students, intellectuals, and the general public. Lam would exhibit his work in Port-au-Prince at the Centre d'Art. This institution had recently been founded by Dewitt C. Peters, an American artist who traveled to Haiti in 1943 to work as an English teacher at the Lycée in Port-au-Prince. The idea for creating a teaching and exhibition space emerged when Peters befriended "a number of young Haitian intellectuals." Through the cultural attaché of the US Embassy, Peters met with President Lescot and secured government support for the project. The Centre d'Art held the first exhibition of Haitian painting in May 1944, funded by the Haitian government and the United States Department of State. Among the earliest artists that the Center championed was Philomé Obin; Peters noted how, "now, emerging from the miserable starvation and obscurity of his middle years, came the greatest of Haitian primitive painters, Hector Hyppolite."[87]

Arriving in November, Lam and Holzer remained in Haiti until April 1946, and Breton and his new wife Elisa reached Port-au-Prince from New York in December. Breton traveled to Santo Domingo and Fort-de-France in mid-February and returned to New York in early March.[88] The events surrounding Breton's Haitian discourses and lectures soon entered the lore and history of Surrealism in exile. As Michael Richardson recalls:

> Breton's talks had a dramatic effect ... and were partially responsible for the fall of the government, with far-reaching consequences. The government's fall led to the election as president of Dumarsais Estimé, a popular, progressively inclined and relatively honest politician. Estimé was a black, the first non-mulatto president since the US occupation and also the first not to be a pawn of US interests (the United States retained control of the Haitian treasury until 1947).[89]

Referring to the lectures, Richardson explains that:

What Breton said was hardly incendiary. In our eyes at least. Or even in Breton's (one has the impression that he was somewhat bewildered by what happened, and not a little embarrassed, since he was a guest of the Haitian government and his trip was supported by a grant from the United States and sponsored by the Institut Français in Port-au-Prince).[90]

Undeniably, in Dash's account:

> The literary as well as political history of Haiti would not have been the same had [Breton] not unleashed a powerful revolutionary idealism among young Haitians by articulating the ideals of surrealism ... For the next few decades Haitian literature would be dominated by Alexis and Depestre, the ideals of the surrealist revolution of 1946, and increasing conflict between the radical writer and the repressive state.[91]

Lam's exhibition went on as planned at the Centre d'Art from January 24 to February 3. In Gérald Bloncourt's assessment, "Lam had a crucial influence on the development of Haitian art: his mere presence at the Art Center in 1944 swept away prejudices against popular painters, and he was highly instrumental in winning recognition for the magic of their creation."[92] On Christmas Eve 1945, Lam and Holzer accompanied Breton and Mabille on a visit to a vaudou ceremony. After the *hougan* (priest) had sacrificed a pig and shared its blood with participants, Holzer remembers: "As curious as I was to observe it all, I was disgusted and we left." After attending a different "Voodoo performance" with Mabille, Breton, and Lam, she reports: "Aroused by the beat of several drums, I felt eager to experience something completely unknown and mysterious." While Lam "continued to watch eagerly," "[t]he loud rhythmic sound of the drums made André very uncomfortable. As he walked away he confessed that each beat felt like a punch in the stomach" (133). The ambivalent and generally candid nature of Holzer's memoir suggests what is most difficult to grasp about the strange historical juncture. Like ñáñigo and Santería ceremonies in Cuba, vaudou "performances" attracted European and Caribbean visitors. We know that Mabille and Cabrera saw in these rituals the living expressions of cultural difference and historical experience, but that was the exception rather than the norm.

One exile of the Spanish Civil War in the Dominican Republic, the literary historian Vicente Llorens, evokes similar excursions outside Santo Domingo in the early 1940s. On rare occasions, "attracted by the exotic touch," the European exiles would attend "those ritual events [*fiestas rituales*] that, due to their Haitian or

Black provenance, were strictly forbidden in the country ... Our interest, excited by the vogue of Black art [*arte negro*] in Europe for some years, might have been too intellectual." Llorens describes the repetitive dancing and music as "overwhelming," and the drumming as "monotonous, persistent, obsessive, hour by hour ... It was morning when we left, exhausted, half-dizzy, and wishing nothing but seeing blonde women and hearing Viennese waltzes." He then mentions a short story by the Dominican writer Ramón Marrero Aristy in which a bailiff traveling at night between two villages kills the prisoners in his care so he can follow the drums and attend the dance.[93] Texts like this barely conceal cultural misunderstanding and racist overtones, revealing the limits of European cosmopolitanism among the intellectual exiles of the period. The expectation that Afro-Dominican culture should provide entertainment and titillation blends swiftly with humor and mockery.

In the gradual journey into the Afro-Caribbean "jungle," Lam's exchanges with Hyppolite and other Haitian artists at the Art Center would have reassured him in his artistic vision (137). Having found in Lam and the Césaires new echo-chambers for his surrealist alchemy, Breton enlisted Mabille and the Caribbean intellectuals into his New York-based projects, which were extended onto a dismantled Paris scene in the late 1940s. But what of the island? In Haiti, the idealized surrealist island appeared to dissolve like "shadows of the past" (139), splintering into the disjointed facets of a new and visionary materialism. Among the students and intellectuals who attended Breton's lectures, the Haitian poet and journalist Magloire-Saint-Aude stands out as an eccentric, although generally elusive, ally of the surrealist cause. He had been one of the founders of *Les Griots* (1938–40), a journal that extended the program of *La Revue Indigène* (1927–8).[94] In 1941 he published two intensely esoteric short books, *Dialogue de mes lampes*, and *Tabou*. From then on, he wrote frequently about Surrealism in the national press and met the Césaires when they visited Haiti in 1944.[95] It is tempting to read Surrealism into the deliberate opacity of Magloire-Saint-Aude's poems when he writes: "The oil of sleep / Eyebrows at my table" [*L'huile des sommeils / Des sourcils à ma table*] in "Écrit sur mon buvard," the eighth poem in *Dialogue de mes lampes*; or "At the intermediate lights, / Thoughts soft like cups of wind" [*Aux feux intermédiaires, / Pensées douces comme des tasses de vent*] in poem XIV, the last in *Tabou*.[96] He joined Breton, Lam, and Mabille as a companion of Surrealism, but the dialogue remains enigmatic, as if suspended or haunted by a middle passage.

The stagnation of the Villa Air-Bel foretells a detour in the perception of spatiotemporal reality and marks a new direction of Surrealism on Martinique and in the archipelagic relationships that commenced under the figures of embarkment, escape, and new beginnings across the Atlantic. But how do the chronicles of these *passings*, passages, and crossings figure in the cultural memory of the insular Atlantic? The texts I have discussed in this chapter deploy a panorama of mnemonic conflicts. The Césaires and *Tropiques* "remember" the depths of European colonialism and slavery, and the suffering and trauma of the plantation and post-plantation Caribbean. Breton and Masson, by contrast, regress to a Eurocentric imaginary of nostalgic and exoticist citations. Granell, writing almost a decade after the events of 1941, mobilizes the tropes of *Martinique charmeuse de serpents*. He reinscribes a parallel imaginary of decayed *hispanismo* with echoes of the Baroque imagination and an ironic celebration of imperial Spain. The historical events of Vichy, the Trujillo regime, and Francoist Spain resonate uncomfortably with the surrealists' quest for freedom, idealized (and reified) femininity, and escape from the debris of historical catastrophe. Today, after a century of surrealist splits and rejuvenations, the stories are reshaped by new critical narratives in feminism, postmodernism, transnationalism, and an attentiveness to new vectors of ethnic, race, colonial/decolonial, and environmental debate. But insular avant-gardism does not easily conform to metropolitan perspectives. It exceeds the short-sighted parochialism or facile universalism of academic and curatorial agendas "like a fever consuming the senses," for "the weather is most certainly too blindingly bright and beautiful to see clearly therein."[97]

Epilogue: Preface to the 1950s

Faithful to the spirit of the 1848 *Manifesto*, narratives of the revolutionary avant-garde rely on imaginaries of industrial modernity, aesthetic and political dissent, belligerent demands for emancipation, and a desire for destructive transformation.[1] What distinguishes insular avant-gardism is an awareness of the challenges that distance, enclosure, and institutional stagnation effectively pose in their determination to participate in broader cultural and political projects. Here, island and continental avant-gardists face similar challenges. But in insular contexts a consciousness of geocultural difference prompts the elaboration of the multiple discursive positions that I have identified as Atlantic avant-gardism in the previous chapters. This book ends at a critical juncture, when the European avant-garde and Surrealism appear exiled and marooned on the cultural shores of an uncertain new world.

Two dissimilar works measure the panorama of possibility and distinct challenges that traverse insular avant-gardism and Surrealism in the late 1940s and early 1950s. Alejo Carpentier's Prologue to *The Kingdom of this World* (1949), his first novel since *¡Écue-Yamba-Ó!* (1933), sets out to disavow the previous decades of surrealist activity. The Prologue evokes the dramatic forced exile of the Paris surrealists and the diasporic transformation of the movement as it participates in the permanent displacement of Paris, old capital of the art world, to the benefit of New York after World War II.[2] As T. J. Demos observes: "By 1940, the German occupation of France and the gradual emigration of surrealists to New York

and other destinations beyond the borders of central Europe only heightened the movement's sense of political disenfranchisement, loss of artistic relevance, and resulting anomie."[3] Demos recalls with sarcasm that, "[o]nce in New York, Breton regrouped and soon wrote a 'Prolegomena to a Third Surrealist Manifesto or Not,' published in 1942 in the movement's new journal *VVV*. In this new manifesto the leader of the surrealists in exile was determined to find new avenues of escape from reality, since there were no opportunities for meaningful action within it."[4]

The Prologue

The Prologue to *The Kingdom of This World* spirals around Carpentier's memories of a trip to Haiti "near the end of 1943," when he had been

> lucky enough to visit Henri Christophe's kingdom – such poetic ruins, Sans-Souci and the bulk of the Citadel of La Ferrière, imposingly intact in spite of lightning and earthquakes; and I saw the still-Norman Cape Town, the Cap Français of the former colony, where a house with great balconies leads to the palace of hewn stone inhabited years ago by Pauline Bonaparte. (84)[5]

Carpentier's account of his momentous encounter with "the marvelous real" (*lo real maravilloso*) is somewhat perplexing. It is difficult to discern what it is that the author finds marvelous in the romantic trope of island ruins – is it the nostalgic lore of the Haitian Revolution, or the patina of French imperial glory inscribed in "the palace of hewn stone"? It is possibly neither and both: "My encounter with Pauline Bonaparte there, so far from Corsica, was a revelation to me. I saw the possibility of establishing certain synchronisms, American, recurrent, timeless, relating this to that, yesterday to today. I saw the possibility of bringing to our own latitudes certain European truths …" Then comes an oft-quoted passage:

> After having felt the undeniable spell of the lands of Haiti, after having found magical warnings along the red roads of the Central Meseta, after having heard the drums of the Petro and the Rada, I was moved to set this recently experienced marvelous reality beside the tiresome pretension of creating the marvelous that has characterized certain European literatures over the past thirty years. (84)

Carpentier denounces the excesses of the surrealist movement, mounting a devastating attack on its principles, and conjuring up a mock-surrealist assemblage of "ghosts, immured priests, lycanthropes, hands nailed to a castle door" before declaring: "The result of willing the marvelous or any other trance is that the dream technicians become bureaucrats" (85).[6] Carpentier's reservations are an eloquent and detailed preamble to fresh recollections of Haiti in the final paragraphs: "This seemed particularly obvious to me during my stay in Haiti, where I found myself in daily contact with something that could be defined as the marvelous real" (86). He evokes the noble figures of the Haitian runaway slave Mackandal and the Jamaican Bouckman, then turns to Henri Christophe, "a monarch of incredible zeal, much more surprising than all of the cruel kings invented by the Surrealists, who were very much affected by imaginary tyrannies without ever having suffered one." He reveals further layers of meaning in the notion of the marvelous real: "I found the marvelous real at every turn. Furthermore, I thought, the presence and vitality of this marvelous real was not the unique privilege of Haiti but the heritage of all of America, where we have not yet begun to establish an inventory of our cosmogonies" (87); and concludes on a universalizing gesture: "After all, what is the entire history of America if not the chronicle of the marvelous real?" (88).

The ruins of the old French colony of Saint-Domingue that set the stage for the Prologue evoke three narrative and structural subjects of Carpentier's subsequent oeuvre: history, chronicles, and "the marvelous real." Thus, the 1949 Prologue expresses a conscious decision to turn away from Surrealism, that last ghost ship of the European avant-garde. However, as Jean Franco notes: "The genealogies of magical realism and 'lo real maravilloso' are usually traced to the German critic Franz Roh as well as to the surrealist 'marvelous' that flourished in Paris in the 1920s."

> The performances of the Revue Nègre, the protests against the Moroccan War, the first popular exhibition of pre-Columbian art in France, the "profane illumination" of surrealism, and the exodus of French writers and ethnographers – Leiris, Valéry Larbaud, Michaux, and Artaud – to Africa and Latin America were indications that the axis of culture was shifting from its Eurocentric base, encouraged by a widespread belief in the decadence of Europe and the originality and dynamism of the Americas.[7]

Franco sees in this process "an ambiguous terrain" where "*magical realism* and *lo real maravilloso* need to be situated as a form of reenchantment, a challenge to European cultural hegemony, as a cultural resolution of racial difference but always in the threatening shadow of the imminent dissolution of their base."[8] The ambiguity of this double genealogy haunts Carpentier's Prologue as much as a profound sense of spiritual and intellectual reenchantment. Thus, German and French residues of European avant-gardism are woven into the fabric of the text in expressions of encounter with lived reality, as he visits, witnesses, and experiences a kind of sensory revelation that awakes him to the miracle of Haitian originality. He "[feels] the undeniable spell of the lands of Haiti," acknowledges "magical warnings," and hears the ritual drumming addressed to the Petwo and Rada, the gods of Haitian vaudou (84). He mentions *Le Sacrifice du tambour–Assoto(r)* (1943), an ethnographic essay by the Haitian writer and political activist Jacques Roumain, and he is *moved* when he encounters "the marvelous real at every turn" (87).[9] He senses the historical transcendence of Haiti and the Haitian Revolution as grounds for a new thinking "of all of America" (87). Franco observes that Carpentier "attributes the marvelous both to the history of the discovery of the Americas and to nature."[10] She comments further on Carpentier's neo-baroque style in *The Kingdom of This World* and future novels:

> Nature, particularly Caribbean nature, seems to have inspired baroque ornamentation. The crossroads of empire and a natural wonderland of the Caribbean is where both mimesis and miscegenation display their creative potential, their productivity, hence the recurrent descriptions of islands, beaches, shells, fish, and plants. The symbiosis of nature and the human produces a burst of creative energy that defies habit and routine.[11]

In Haiti, Carpentier experiences the imbrication of history and nature on an Afro-Caribbean island as evidence that magic and reality could coexist in the post-World War II and largely post-avant-garde Latin American present. This insight enabled him to disavow the surrealist regime that helped shape the European direction of his writing beyond Cuban Minorismo and the intellectual circle of *Revista de Avance*. In a scathing reference to a text that had appeared a year earlier, *Martinique charmeuse de serpents*, he laughs that, "when André Masson tried to draw the jungle of Martinique, with its incredible intertwining of plants and

the obscene promiscuity of certain fruits, the marvelous truth of the matter devoured the painter, leaving him just short of impotent when faced with the blank paper." He compares the French surrealist's supposed impotence with a rising star of Caribbean art. "It had to be an American painter – the Cuban Wifredo Lam – who taught us the magic of tropical vegetation, the unbridled creativity of our natural forms with all their metamorphoses and symbioses on monumental canvases in an expressive mode that is unique in contemporary art" (85). Translating nature into monumental expression, Lam becomes a fellow traveler in Carpentier's project of grounding "the chronicle of the marvelous real" on Haitian, Caribbean, and American realities.

Divine Horsemen

Shot with a Bolex camera between 1947 and 1954, the footage that forms the basis of Maya Deren's documentary, *Divine Horsemen: The Living Gods of Haiti*, is not intentionally surrealist, but decidedly avant-gardist, which connects with discussions of ethnographic practices in the previous chapters of this book. Born in Kyiv, Ukrainian SSR, in 1917, Deren moved to the United States with her parents in 1922 to escape the antisemitic pogroms. Like Carpentier, she was a talented musician and received a European secondary education in French. Both authors shared a passion for Haiti, ethnography, music, and performance – Deren as a dancer and choreographer, and Carpentier as the author of Afro-Cuban ballet scenarios and an ethnomusicological study, *La Música en Cuba* (1946). Both grew up in adopted countries and languages, but their experiences of "the marvelous real" were markedly different. If Carpentier's Prologue is a manifesto for a nascent form of Latin American literature, Deren's entire film and theoretical oeuvre is a foundational compendium of experimental and avant-garde cinema. The avant-garde filmmaker and writer Jonas Mekas contextualizes what has long been a sensitive topic in discussions of Deren's aesthetic ideas:

> It was always a very sensitive subject with Maya: the surrealists, the twenties. Any reference, in the press, or in real life discussions, to her work as containing elements of surrealism made Maya mad ... When Maya began making her own films, they turned toward ritual and away from surrealism ... All the surrealists and Dadaists

had converged in New York, and she was looking for an escape into something else.[12]

Deren found and established an extraordinary legacy through that "escape into something else." In a 1989 essay on Deren, Annette Michelson writes:

> [I]t was she who located and defined many of the principal issues, options, and contradictions of filmmaking conceived as an artistic practice. Deren's formulation of aesthetic principles and social goals, as well as her career as filmmaker, writer, and organizer, epitomizes, in a clear and prescient manner, the central and unresolved tensions that continue to inform the relations between technology and artistic practice, between first and third world cultures, and that characterizes both the tasks and the predicaments of the woman artist.[13]

Deren relates her arrival on the island to conduct fieldwork after receiving an award from the Guggenheim Foundation.[14] "In September 1947 I disembarked in Haiti, for an eight-month stay, with eighteen motley pieces of luggage; seven of these consisted of 16-millimitre motion-picture equipment (three cameras, tripods, raw film stock, etc.), of which three were related to sound recording for the film, and three contained equipment for still photography." Thus began an existential adventure that would inform the direction of US experimental and avant-garde film and dance practices as investigations into ritual, form, and the sacred that centered on what Lydia Platón Lázaro calls "the somatic experience of bodies that dance."[15] The results of Deren's extensive work in Haiti took on a twofold form: her nonspecialist ethnography of Haitian vaudou, and "the footage." Students of Deren's films and photographic work use this expression to refer to the materials that became known posthumously as *Divine Horsemen: The Living Gods of Haiti* after they were edited by Teiji and Cherel Itō, Deren's second husband and his widow, and released as a documentary in 1977. As Deren explains:

> Today, in September 1951 (four years and three Haitian trips later) ... the filmed footage (containing more ceremonies than dances) lies in virtually its original condition in a fireproof box in the closet; the recordings are still on their original wire pool; the stack of still photographs is tucked away in a drawer labeled "TO BE PRINTED", and the elaborate design for the montaged film is somewhere in my files, I am not quite sure where.[16]

Deren's observation that the footage "lies virtually in its original condition" is particularly resonant with the avant-garde and surrealist works I discussed in the previous chapters. Like Carpentier, Deren connects islands, and islands and continents, with each other. Platón Lázaro writes that "Deren's approach to ritual is typically viewed as exemplifying an aesthetic collaboration that was a feature of a period of exchange between people from the United States and those from the Caribbean and Latin America."[17] Massimiliano Mollona reminds us further that Deren's Guggenheim fellowship application "included a cross-cultural comparison of Haitian and Balinese ritual and Western children's games linked through montage."[18]

By a remarkable coincidence, or simply because of a relative effervescence of Haitian-European relations in the postwar period, the Swiss anthropologist Alfred Métraux conducted fieldwork in Haiti in 1948–9, around the same time Deren was carrying out research for her Guggenheim project. Métraux's study, *Le Vaudou haïtien* (1958) contains a preface by the French (surrealist) ethnographer Michel Leiris, who describes Métraux as a "man in the field" or "man on the ground," and celebrates his choice of a subject of study "at the limits of Africanism and Americanism."[19] The English-language version of the book came out a year later, and Sidney Mintz, the pre-eminent anthropologist of sugar-cane labor culture in Puerto Rico, wrote a new preface for the second edition. Mintz relates a meaningful island anecdote: "In 1941, while Métraux was visiting the Ile a Tortue [sic] off Haiti's north coast in the company of Jacques Roumain, the idea of creating a Bureau of Ethnology for that country was born – an idea that Roumain was later able to convert into a proud reality."[20] In this way, the old Surrealism morphs and reverberates beyond the momentous crossings, encounters, and convolutions of the early and late 1940s that I discuss in Chapter 6.

In the conclusion to one of the most provocative essays ever written on the movement, James Clifford muses that "[p]erhaps an acquaintance with ethnographic surrealism can help us see the blue plastic Adidas bag as part of the same kind of inventive cultural process of the African-looking masks that in 1907 suddenly appeared attached to the pink bodies of the *Demoiselles d'Avignon*."[21] Like Clifford's "blue plastic Adidas bag," Carpentier's "magical warnings," and Deren's film fragments, the "inventive cultural processes" of the avant-garde and surrealist periods have expanded beyond the islands in unsuspected ways – in the cultural consciousness

of Ana Mendieta (1948–85) and Jean-Michel Basquiat (1960–88), for example, and in a plethora of less prominent witnesses of the insular avant-garde century. Through them, Atlantic avant-gardism persists as a disjointed body of non-European attachments, performing the radical separation and inexorable familiarity that islanders inhabit at home and away.

As Carpentier entered Haiti, his thinking departed from the politics of Cuban Minorismo and European cosmopolitanism. In Glissant's vocabulary, this cross-Caribbean displacement expresses an archipelagic *movement* or *detour* that reverberates with experiences of insular disorientation/reorientation, dislocation, and disidentification in works by Nicolás Guillén, Julia de Burgos, and the Césaires – and beyond, in Josefina de la Torre, Domingo López Torres, and Agustín Espinosa. For all these authors, to varying degrees, the expression *"Europe is indefensible"* confronts colonial ideology and practices of exploitation and subjection. These words, written by Aimé Césaire in *Discours sur le colonialisme* (*Discourse on Colonialism*) (1955) encapsulate a revolutionary vision that melds avant-garde rebelliousness with decolonial insurgence.[22] Tendaye Sithole's reflections on Césaire could apply to these authors: "The indictment of Europe by Césaire assumes the subjectivity of a slave to judge. To judge Europe as a civilization that is decadent, stricken, and dying suggests that there is nothing to gain from Europe." Furthermore, "Césaire postulates that there is no such thing as civilization in the colonial zone. There cannot be civilization while there is dehumanization. Colonial subjection does not compel any moral currency because it is justification in itself, and it goes without any limit because what it confronts is nothing but the non-human."[23] For Carpentier and Deren, Haiti represented a non-European exception to the dehumanizing foundation of Caribbean, Latin American, and trans-American difference; and Carpentier grounds *The Kingdom of this World* on that cultural and historical exception.[24]

For Deren, as Mollona suggests:

> The camera was not as powerful a medium in conveying the unmediated vision of the Haitian gods ... Deren's Haitian film lies in fragments: in the African-American songs and children's games in the streets of Harlem, in Broadway's vaudeville dances, in the desultory conversations of bourgeois dinner parties, and in the twenty thousand feet of 16mm film, one thousand stills, and fifty hours of audio recording that remain of her fieldwork.[25]

Arjun Appadurai's astute mappings of globalization-era modernities nearly three decades ago describe the fluctuating experiences of a "global cultural economy" that vindicates Deren's commitment to fragmentary experiences of cultural transmission and sensory alteration. Appadurai invokes "emergent" and "alternative" cosmopolitanisms that, to be sure, are no longer centered on the imperial hegemonies of the past two centuries. In his argument, biological and territorial notions of belonging, permanence, growth, and reproduction permeate the *genealogical* – a notion of generation that is intrinsically place-bound. Histories, however, might "lead outward" in divergent and extrinsic moves, in the direction of "transnational sources and structures."[26]

While those "sources and structures," and the inventions and distortions of colonial exclaves, no longer lie exclusively in the metropolitan and colonizing West, the stories they tell are necessarily genealogical because they are culturally place-bound and island-bound. In the sequence of constellated conversations I have presented in this book, interconnected notions of cultural lack, spatial gap, and temporal lapse spell out avant-garde strategies for constructive growth, political vision, and critical boldness. I have argued that metropolitan "centers" are not necessarily "sources." I have outlined instead a dynamic of insular and cosmopolitan interconnectedness where modes of non-European relation resonate across the archipelagic and littoral spaces of Atlantic avant-gardism – the *veinte surcos* and island fields that Julia de Burgos and Édouard Glissant invite us to imagine and cultivate into the uncertain future.

Notes

Introduction: On Tropical Grounds

1 Karl Marx and Friedrich Engels, *The Communist Manifesto*, trans. Samuel Moore (London: Penguin, 2002), 218.
2 Martin Puchner, *Poetry of the Revolution: Marx, Manifestos, and the Avant-Gardes* (Princeton, NJ: Princeton University Press, 2006), 3.
3 On the expression "history of the present" in Michel Foucault and Stuart Hall, see Charlotte Brunsdon, "Introduction," in Stuart Hall, *Writings on Media: History of the Present*, ed. Brunsdon (Durham, NC: Duke University Press, 2021), 11n.3.
4 I use the words "insular" and "insularity" to refer to islands and *islandness*. Insular is meant as "of or like an island," but not "ignorant of or indifferent to cultures, peoples, etc., outside one's own experience" (*OED*).
5 Michael Dash, *Edouard Glissant* (Cambridge: Cambridge University Press, 1995), 40.
6 Vicky Unruh, *Latin American Vanguards: The Art of Contentious Encounters* (Berkeley: University of California Press, 1994), 4.
7 For a discussion of the "evolutionary framing" often adopted in Latin American avant-gardes historiography, see Fernando J. Rosenberg, *The Avant-Garde and Geopolitics in Latin America* (Pittsburgh, PA: University of Pittsburgh Press, 2006), 13.
8 See the extensive discussion of French and European universalisms in Antoine Lilti, *L'Héritage des Lumières: Ambivalences de la modernité* (Paris: EHESS/Gallimard/Seuil, 2019), 35–158.
9 Chantal Mouffe, *On the Political* (London: Routledge, 2005), 20.

10 Mouffe, *On the Political*, 20.
11 Sebastian Balfour, *The End of the Spanish Empire, 1898–1923* (Oxford: Oxford University Press, 1997).
12 Fredric Jameson, *The Benjamin Files* (London: Verso, 2020), 4.
13 Gary Wilder, *Freedom Time: Negritude, Decolonization, and the Future of the World* (Durham, NC: Duke University Press, 2015), 13, 15; David Scott, *Conscripts of Modernity: The Tragedy of Colonial Enlightenment* (Durham, NC: Duke University Press, 2004).
14 Throughout the book, I often employ standard simplified versions of several authors' names: Ortega (José Ortega y Gasset); Juan Ramón (Juan Ramón Jiménez); Lorca (Federico García Lorca); Lloréns (Luis Lloréns Torres); Palés (Luis Palés Matos); Ramón (Ramón Gómez de la Serna); and Ureña (Pedro Henríquez Ureña).
15 Michael Löwy, *Fire Alarm: Reading Walter Benjamin's "On the Concept of History"*, trans. Chris Turner (London: Verso, 2016), 40.
16 Édouard Glissant, *Poetics of Relation*, trans. Betsy Wing (Ann Arbor: University of Michigan Press, 1997), 11, 211n.2.
17 Celia M. Britton, *Edouard Glissant and Postcolonial Theory: Strategies of Language and Resistance* (Charlottesville: University of Virginia Press, 1999), 13 (my emphasis).
18 Charles Forsdick, "Local, National, Regional, Global: Glissant and the Postcolonial Manifesto," in Eva Sansavior and Richard Scholar (eds.), *Caribbean Globalizations, 1492 to the Present Day* (Liverpool: Liverpool University Press, 2015), 227–45.
19 Michaeline A. Crichlow and Patricia Northover, *Globalization and the Post-Creole Imagination: Notes on Fleeing the Plantation* (Durham, NC: Duke University Press, 2009), 74.
20 See Michel Foucault, *Society Must Be Defended: Lectures at the Collège de France, 1975–76*, ed. Mauro Bertani and Alessandro Fontana, trans. David Macey (London: Penguin, 2004); *The Birth of Biopolitics: Lectures at the Collège de France, 1978–1979*, ed. Michel Senellart, trans. Graham Burchell (New York: Palgrave Macmillan, 2010). See in particular Ann Laura Stoler, *Race and the Education of Desire: Foucault's* History of Sexuality *and the Colonial Order of Things* (Durham, NC: Duke University Press, 1995). See also Paul Gilroy, *Against Race: Imagining Political Culture beyond the Color Line* (Cambridge, MA: Harvard University Press, 2000); Achille Mbembe, *Necropolitics*, trans. Steven Corcoran (Durham, NC: Duke University Press, 2019); and Giorgio Agamben, *Homo Sacer: Sovereign Power and Bare Life*, trans. Daniel Heller-Roazen (Stanford: Stanford University Press, 1998), and *Means without End: Notes on Politics*, trans. Vincenzo Binetti and Cesare Casarino (Minneapolis: University of Minnesota Press, 2000).
21 See Mario De Micheli, *Le Avanguardie artistiche del Novecento* (1966, 1988); Renato Poggioli, *The Theory of the Avant-Garde*

(1968); and Peter Bürger, *Theory of the Avant-Garde* (1984) and *The Decline of Modernism* (1992). In different ways, Matei Calinescu's *Five Faces of Modernity* (1987), and Richard Sheppard's *Modernism-Dada-Postmodernism* (2000), reinscribe a cultural logic of urban modernity and Eurocentric views of international avant-gardism.

22 Crichlow and Northover, *Globalization and the Post-Creole Imagination*; Kerry Bystrom and Joseph R. Slaughter, eds., *The Global South Atlantic* (New York: Fordham University Press, 2018); Christopher L. Miller, *The French Atlantic Triangle: Literature and Culture of the Slave Trade* (Durham, NC: Duke University Press, 2008); Robin Blackburn, *The Making of New World Slavery: From the Baroque to the Modern, 1492–1800* (London: Verso, 1997); Philip D. Curtin, *The Rise and Fall of the Plantation Complex: Essays in Atlantic History*, 2nd ed. (Cambridge: Cambridge University Press, 1998); Felipe Fernández-Armesto, *Before Columbus: Exploration and Colonisation from the Mediterranean to the Atlantic, 1229–1492* (Philadelphia: University of Pennsylvania Press, 1987), and *The Canary Islands after the Conquest: The Making of a Colonial Society in the Early Sixteenth Century* (Oxford: Clarendon, 1982).

23 Chris Bongie, *Islands and Exiles: The Creole Identities of Post/Colonial Literature* (Stanford: Stanford University Press, 1998), 18, 20. See also Frank Lestringant, *Le Livre des îles: Atlas et récits insulaires de la Genèse à Jules Verne* (Geneva: Droz, 2002), 372–8.

24 On "the archipelagic trope," see Markman Ellis, "'The Cane-land Isles': Commerce and Empire in Late Eighteenth-century Georgic and Pastoral Poetry," in Rod Edmond and Vanessa Smith (eds.), *Islands in History and Representation* (London: Routledge, 2003), 55. On figures of the Caribbean archipelago, see Michael Dash, *The Other America: Caribbean Literature in a New World Context* (Charlottesville: University Press of Virginia, 1998), 6.

25 Antonio Benítez Rojo, *The Repeating Island: The Caribbean and the Postmodern Perspective*, trans. James Maraniss (Durham, NC: Duke University Press, 1992), 151; Román de la Campa, *Latin Americanism* (Minneapolis: University of Minnesota Press, 1999), 99–103.

26 Jean-Marc Moura, *La Littérature des lointains: Histoire de l'exotisme européen au XXe siècle* (Paris: Honoré Champion, 1998), 172–3.

27 Glissant, *Treatise on the Whole-World*, trans. Celia Britton (Liverpool: Liverpool University Press, 2020), 18.

28 See Mariano Siskind's provocative discussions in "The Rise of Latin American World Literary Discourses (1882–1925)," in *Cosmopolitan Desires: Global Modernity and World Literature in Latin America* (Evanston, IL: Northwestern University Press, 2014), 103–83.

29 Guillermo de Torre, *Literaturas europeas de vanguardia* (Madrid: Caro Raggio, 1925); and Ramón Gómez de la Serna, *Ismos* (Madrid:

Biblioteca Nueva, 1931). See also Ramón Feria, *Signos de Arte y Literatura* (Madrid: El Discreto, 1936).
30 Pedro Henríquez Ureña, *Seis ensayos en busca de nuestra expresión*, ed. Miguel D. Mena (Santo Domingo: Cielonaranja, 2016), 50. See also Juan R. Valdez, *Tracing Dominican Identity: The Writings of Pedro Henríquez Ureña* (New York: Palgrave Macmillan 2011); and the critical appraisals included in Henríquez Ureña, *Ensayos*, ed. José Luis Abellán and Ana María Barrenechea (Madrid: ALLCA XX, 1998).
31 Henríquez Ureña, *Seis ensayos*, 17, 18. Sylvia Molloy, *La Diffusion de la littérature hispano-américaine en France au XXe siècle* (Paris: Presses Universitaires de France, 1972), 95–6.
32 Henríquez Ureña, *Literary Currents in Hispanic America* (Cambridge, MA: Harvard University Press, 1945), 203.
33 Gilles Deleuze, *Desert Islands and Other Texts, 1953–1974*, ed. David Lapoujade, trans. Michael Taormina (South Pasadena, CA: Semiotext(e), 2004), 9.
34 Michel-Rolph Trouillot, *Silencing the Past: Power and the Production of History* (Boston: Beacon, 1995), 52 (my emphases).
35 Agnes Lugo-Ortiz and Angela Rosenthal, "Introduction: Envisioning Slave Portraiture," in *Slave Portraiture in the Atlantic World* (Cambridge: Cambridge University Press, 2013), 11. See also Arlette Farge, *Des Lieux pour l'histoire* (Paris: Seuil, 1997), and *The Allure of the Archives*, trans. Thomas Scott-Railton (New Haven, CT: Yale University Press, 2013); and Agamben, "The Archive and Testimony," in *Remnants of Auschwitz: The Witness and the Archive* (New York: Zone Books, 2002), 137–71.

Chapter 1: Around the Atlantic Avant-Garde: Insular Dreamworlds / Archaic Islandscapes

1 For a different and longer version of the section on *La Habanera* in this chapter, see Francisco-J. Hernández Adrián, "Liquid Visuality: Douglas Sirk's *La Habanera* and Insular Atlantic Studies," *Journal of Romance Studies* 14/2 (Summer 2014): 62–77.
2 Katie Trumpener, "Puerto Rico Fever: Douglas Sirk, *La Habanera* (1937) and the Epistemology of Exoticism," in Sigrid Bauschinger and Susan Cocalis (eds.), *"Neue Welt" / "Dritte Welt": Interkulturelle Beziehungen Deutschlands zu Lateinamerika und der Karibik* (Tübingen: Francke, 1994), 129.
3 Mary-Elizabeth O'Brien, *Nazi Cinema as Enchantment: The Politics of Entertainment in the Third Reich* (Rochester, NY: Camden House, 2004), 1. Eric Rentschler, *The Ministry of Illusion: Nazi Cinema and Its Afterlife* (Cambridge, MA: Harvard University Press, 1996), 22.

4 Jacques Derrida, *Archive Fever: A Freudian Impression*, trans. Eric Prenowitz (Chicago, IL: University of Chicago Press, 1996), 2.
5 See Rentschler, *The Ministry*, 133; and David Welch and Roel Vande Winkel, "Europe's New Hollywood? The German Film Industry Under Nazi Rule, 1933–45," in Vande Winkel and Welch (eds.), *Cinema and the Swastika: The International Expansion of Third Reich Cinema* (New York: Palgrave Macmillan, 2007), 1–24.
6 Rentschler, *The Ministry*, 132.
7 Ramiro Rivas García, "La Guerra Civil en Tenerife," in Miguel Ángel Cabrera Acosta (ed.), *La Guerra Civil en Canarias* (La Laguna: Francisco Lemus, 2000), 66–72. On British and US economic support for the fascist cause, and on German and Italian military support, see Antony Beevor, *The Battle for Spain: The Spanish Civil War 1936–1939* (London: Phoenix, 2007), 154–5. See also Adrián Alemán, *Socius* (Santa Cruz de Tenerife: Gobierno de Canarias, 2010), 44–63.
8 Jon Halliday, *Sirk on Sirk: Conversations with Jon Halliday*, rev. ed. (London: Faber and Faber, 1997), 47.
9 O'Brien, *Nazi Cinema*, 161.
10 O'Brien, *Nazi Cinema*, 17. See also Johann Chapoutot, *The Law of Blood: Thinking and Acting like a Nazi*, trans. Miranda Richmond Mouillot (Cambridge, MA: Harvard University Press, 2018).
11 Lester Friedman, "The Combat Movie," in Friedman et al., *An Introduction to Film Genres* (New York: W. W. Norton, 2014), 278–323. Among films that exhibit variations of these traits, two are worth mentioning in particular: Merian C. Cooper and Ernest B. Schoedsack's *King Kong* (United States, 1933), and Jacques Tourneur's *I Walked with a Zombie* (United States, 1943).
12 Luis Hernández Aquino, *Nuestra aventura literaria: Los ismos en la poesía puertorriqueña, 1913–1948* (San Juan, PR: Editorial Universitaria, 1966), 7.
13 Malena Rodríguez Castro, "Silencios y estridencias: las vanguardias en Puerto Rico," in Amarilis Carrero Peña and Carmen M. Rivera Villegas (eds.), *Las vanguardias en Puerto Rico* (Madrid: La Discreta, 2009), 30–1.
14 Trumpener, "Puerto Rico Fever," 115–39; Chapoutot, *The Law of Blood*, 155–93.
15 Rentschler, *The Ministry*, 145.
16 The construction of cultural and racial difference is woven into the context of the film's production. Barbara Klinger discusses the development of this tradition in *Melodrama and Meaning: History, Culture, and the Films of Douglas Sirk* (Bloomington: Indiana University Press, 1994).
17 Derrida, *Archive Fever*, 81.
18 Ramón Chao, *Conversaciones con Alejo Carpentier* (Madrid: Alianza, 1998), 169–70. See also Samuel Llano, *Whose Spain? Negotiating*

"Spanish Music" in Paris, 1908–1929 (Oxford: Oxford University Press, 2013), 161–91; and Rentschler, "Astray in the New World: *La Habanera* (1937)," in *The Ministry*, 125–45.
19 Trumpener, "Puerto Rico Fever," 116.
20 On historical backgrounds to German and US imperialisms in the Caribbean and Latin America in the years leading to World War I, see Nancy Mitchell, *The Danger of Dreams: German and American Imperialism in Latin America* (Chapel Hill: University of North Carolina Press, 1999).
21 Carl Schmitt, *The* Nomos *of the Earth in the International Law of the* Jus Publicum Europaeum, trans. G. L. Ulmen (Candor, NY: Telos, 2006), 87, 100.
22 Jan-Werner Müller, *A Dangerous Mind: Carl Schmitt in Post-War European Thought* (New Haven, CT: Yale University Press, 2003), 88.
23 Stephen Legg, "Interwar Spatial Chaos? Imperialism, Internationalism and the League of Nations," in Legg (ed.), *Spatiality, Sovereignty and Carl Schmitt: Geographies of the Nomos* (London: Routledge, 2011), 106, 107.
24 Margaret Cohen, "The Chronotopes of the Sea," in Franco Moretti (ed.), *The Novel*, vol. 2 (Princeton, NJ: Princeton University Press, 2006), 659.
25 Susan Buck-Morss, *Dreamworld and Catastrophe: The Passing of Mass Utopia in East and West* (Cambridge, MA: MIT Press, 2000), 61, 62; Peter Osborne, *The Politics of Time: Modernity and Avant-Garde* (London: Verso, 1995).
26 Stella Ghervas, *Conquering Peace: From the Enlightenment to the European Union* (Cambridge, MA: Harvard University Press, 2021). See also Legg's discussion of Schmitt's "loathing" of the League of Nations as an expression of the transition of hegemonic power from the European to the American spheres of influence, in "Interwar spatial chaos?", 112–17.
27 De la Torre and López Torres are the most precocious in this assemblage. Unlike Brull and the authors I discuss in Chapter 2, they did not have a university education. Brull was a diplomat, poet, and translator who lived in Madrid and Paris in the 1920s. He published *La casa del silencio* (Madrid, 1916), with an introduction by Pedro Henríquez Ureña; *Poemas en menguante* (Paris in 1928), *Canto Redondo* (Paris, 1934), and *Poëmes* (Brussels, 1939), prefaced by Paul Valéry. De la Torre was an accomplished singer and socialite from a prominent intellectual family, and the younger sister of the award-winning writer Claudio de la Torre. López Torres was a politically engaged working-class poet and critic.
28 On the *ultraísta* art scene, Polish artists in Madrid, and Malinowska, see Andrew A. Anderson, *El movimiento ultraísta. Orígenes, fundación y lanzamiento de un movimiento de vanguardia* (Madrid/Frankfurt am Main: Iberoamericana/Vervuert, 2017), 678–93.

29 *Heraldo de Madrid*, April 27 and May 4, 1926. The quotations are from the May 4 chronicle.
30 *Versos y estampas* includes sixteen prose poems, each followed by a short verse poem. A longer poem, "Intermedio" ("Romance del buen guiar"), separates the book in two parts, with the final verse poem, "y 17," serving as a coda. See Catherine G. Bellver, *Absence and Presence: Spanish Women Poets of the Twenties and Thirties* (Lewisburg, PA: Bucknell University Press, 2001), 86. In his bilingual edition of de la Torre's poems, Carlos Reyes translates *Versos y estampas* as *Sketches and Verses*. A literal translation of the title would render "Verses and prints," "Verses and images," or "Verses and pictures." I follow Reyes's translations and page numbers: Josefina de la Torre, *Poemas de la isla: Poems by Josefina de la Torre*, trans. Carlos Reyes (Spokane, WA: Eastern Washington University Press, 2000). For a complete edition of de la Torre's early poems, see Fran Garcerá (ed.), *Poesía completa. Volumen I (1916–1935)* (Madrid: Torremozas, 2020).
31 Marjorie Perloff, *The Futurist Moment: Avant-Garde, Avant Guerre, and the Language of Rupture* (Chicago: University of Chicago Press, 2003), 41.
32 Perloff, *The Futurist Moment*, 42.
33 Fran Garcerá, "'Me gusta dibujar. Juego al *tennis*. Me encanta conducir mi auto': Josefina de la Torre, poeta de la Edad de Plata," in Josefina de la Torre, *Poesía completa I*, 15, 18–19. See also Selena Millares, "Órbita literaria de Josefina de la Torre: Una poeta entre dos generaciones," in *La última voz del 27. Actas del Seminario Josefina de la Torre Millares* (Las Palmas de Gran Canaria: Gobierno de Canarias, 2008), 59–88; and Alberto García-Aguilar, "El guion como texto literario: la escritura cinematográfica de Claudio y Josefina de la Torre," PhD Thesis (Universidad de La Laguna, 2022).
34 Gerardo Diego, *Antología de Gerardo Diego. Poesía Española Contemporánea*, ed. Andrés Soria Olmedo (Madrid: Taurus, 1991), 616–17. See also Bellver, *Absence and Presence*; and *Bodies in Motion: Spanish Vanguard Poetry, Mass Culture, and Gender Dynamics* (Lewisburg, PA: Bucknell University Press, 2010). For an account of de la Torre's literary and professional activities from 1936 (dubbing Marlene Dietrich's voice, and acting in theater and movie roles), see Garcerá, "'Para mejor amarte en cada vena': Plenitud profesional e íntima de Josefina de la Torre," in Josefina de la Torre, *Poesía Completa. Volumen II (1936–1989)* (Madrid: Torremozas, 2020), 7–35.
35 Whitney Chadwick and Tirza True Latimer, "Becoming Modern: Gender and Sexual Identity after World War I," in Chadwick and Latimer (eds.), *The Modern Woman Revisited: Paris Between the Wars* (New Brunswick, NJ: Rutgers University Press, 2003), 3–19.
36 Lázaro Santana, "Introducción," in Josefina de la Torre, *Poemas de la isla* (Islas Canarias: Gobierno de Canarias, 1989), 15 (my emphasis).

37 Almudena de la Cueva and Margarita Márquez Padorno, *Mujeres en Vanguardia: La Residencia de Señoritas en su Centenario (1915–1936)* (Madrid: Residencia de Estudiantes, 2015), 24–77.
38 Eugenio Padorno, "Josefina de la Torre, ¿última voz del modernismo canario?" *La última voz del 27. Actas del Seminario Josefina de la Torre Millares* (Las Palmas de Gran Canaria: Gobierno de Canarias, 2008), 21–35.
39 Bellver, *Absence and Presence*, 85.
40 Juan Manuel Trujillo, "Poetisas Canarias: Josefina de la Torre," *El País*, June 9, 1928. Included in Trujillo, *Prosa reunida*, ed. Sebastián de la Nuez (Santa Cruz de Tenerife: Cabildo Insular, 1986), 112.
41 Alan Kramer, *Dynamic of Destruction: Culture and Mass Killing in the First World War* (Oxford: Oxford University Press, 2007), 267.
42 Fernando Rodríguez y Rodríguez de Acuña, *Formación de la Economía Canaria (1800–1936)* (Islas Canarias: Idea, 2003), 36. See also Peter N. Davies, *Fyffes and the Banana: Musa Sapientum: A Centenary History, 1888–1988* (London: Athlone, 1990), 128–32; and Luis Gabriel Cabrera Armas, "The Ports of the Canary Islands: The Challenges of Modernity," in Miguel Suárez Bosa (ed.), *Atlantic Ports and the First Globalisation, c. 1850–1930* (London: Palgrave Macmillan, 2014), 23–4.
43 Antonio Blanch, *La poesía pura española. Conexiones con la cultura francesa* (Madrid: Gredos, 1976), 8, 19, 21. Guillén, Salinas, Alberti, and Lorca published in the literary series "Los poetas" in *Revista de Occidente*. See José-Carlos Mainer, *La Edad de Plata (1902–1939): Ensayo de interpretación de un proceso cultural* (Madrid: Cátedra, 2009), 192.
44 Pedro Salinas, "Isla, preludio, poetisa," in de la Torre, *Poesía completa I*, 103. Quotes and references are from this edition of Salinas's prologue.
45 Anne McClintock, *Imperial Leather: Race, Gender and Sexuality in the Colonial Contest* (New York: Routledge, 1995), 1, 4. See also Ada Ferrer, *Insurgent Cuba: Race, Nation, and Revolution, 1868–1898* (Chapel Hill: University of North Carolina Press, 1999); and Susan Martin-Márquez, *Disorientations: Spanish Colonialism in Africa and the Performance of Identity* (New Haven, CT: Yale University Press, 2008).
46 Sebastian Balfour, *Deadly Embrace: Morocco and the Road to the Spanish Civil War* (Oxford: Oxford University Press, 2002), 4.
47 Trujillo, "Carta de Madrid: Poesía eres tú, Josefina de la Torre," *La Tarde*, October 4, 1934. Included in Trujillo, *Prosa reunida*, 118.
48 Santana, "Introducción," 17. See also Bellver, *Absence and Presence*, 84n.4.
49 Sylvia Molloy, *Poses de fin de siglo: Desbordes del género en la modernidad* (Buenos Aires: Eterna Cadencia, 2012), 153, 155, 155n.4.
50 For a wide-ranging discussion of the beloved as a passive object that

is reduced to the poetic first person, see Leo Spitzer's piercing critique of Salinas's love poetry: "El conceptismo interior de Pedro Salinas," *Revista Hispánica Moderna* 7, 1/2 (1941): 33–69.
51 Domingo López Torres, *Obras Completas*, ed. C. B. Morris and Andrés Sánchez Robayna (Santa Cruz de Tenerife: Cabildo de Tenerife, 1993), 77. Subsequent references to López Torres's work are from this edition. *Diario de un sol de verano* remained unpublished until 1987. Only two of the thirty-one verse and prose poems that make up the book were published during López Torres's lifetime. Sánchez Robayna suggests that the extant manuscript may be unfinished or in draft form. See his "Introducción," in López Torres, *Diario de un sol de Verano*, ed. Sánchez Robayna (La Laguna: Universidad de La Laguna/Instituto de Estudios Canarios, 1987), 13, 21.
52 Guillermo Díaz-Plaja, *Historia de la poesía lírica española* (Barcelona: Labor, 1948), 397–8. See also Martinón, "La poesía de Domingo López Torres," in Sánchez Robayna (ed.), *Canarias, las vanguardias históricas* (Las Palmas de Gran Canaria: CAAM/Gobierno de Canarias, 1992), 272–3.
53 Vicente Huidobro, *Altazor. Temblor de cielo*, ed. René de Costa (Madrid: Cátedra, 1989), 63.
54 López Torres, *Obras Completas*, 109. Morris discusses López Torres's commitment to radical politics and participation in the surrealist debate over "art in the service of the Revolution." "Poesía y prosa: estudio crítico," in López Torres, *Obras*, 19–37. See also Martinón, "La poesía de Domingo López Torres," 274–5.
55 Cited in Buck-Morss, *Dreamworld and Catastrophe*, 55.
56 Martin Puchner, *Poetry of the Revolution: Marx, Manifestos, and the Avant-Gardes* (Princeton, NJ: Princeton University Press, 2006), 106.
57 Mainer, *La Edad de Plata*, 211.
58 Boris Groys, *The Total Art of Stalinism: Avant-Garde, Aesthetic Dictatorship, and Beyond*, trans. Charles Rougle (Princeton, NJ: Princeton University Press, 1992), 33–7. See also Matthew Cullerne Bown, *Art under Stalin* (New York: Holmes & Meier, 1991), 89–99.
59 Buck-Morss, *Dreamworld and Catastrophe*, 61.
60 There are echoes in *Diario* of Juan Ramón's *Diario de un poeta recién casado* (1916), Alberti's *Marinero en tierra* (1925), and Lorca's *Romancero gitano* (1928). See Domingo Pérez Minik, *Facción española surrealista de Tenerife* (Barcelona: Tusquets, 1975), 149. See also Sánchez Robayna, "Datos para una biografía," in López Torres, *Obras Completas*, 13.
61 Morris, "Poesía y prosa," 50.
62 Marc Cluet, ed., *Le Culte de la jeunesse et de l'enfance en Allemagne, 1870–1933* (Rennes: Presses Universitaires de Rennes, 2003).
63 On the diary as a literary genre, and on Juan Ramón's uses of *verso libre* and prose in his *Diario*, see Michael P. Predmore, "Introducción,"

in Juan Ramón Jiménez, *Diario de un poeta reciencasado (1916)* (Madrid: Cátedra, 2017), 24–39.
64 Cohen, "The Chronotopes of the Sea," 659.
65 Trinidad Barrera, *Las vanguardias hispanoamericanas* (Madrid: Síntesis, 2006), 66.
66 Ricardo Larraga, *Mariano Brull y la poesía pura en Cuba* (Miami: Universal, 1994), 158n.68. Brull publishes some of his first avant-garde texts in *Revista de Avance*, including "El regreso," a version of a poem by Welsh metaphysical poet Henry Vaughan, 1/1 (March 15, 1927), 9; and between 1927 and 1930 several poems from *Poemas en menguante*. See Klaus Müller-Bergh, "Introducción," in Mariano Brull, *Poesía reunida* (Madrid: Cátedra, 2000), 24.
67 Cecilia Manzoni ed., *Vanguardias en su tinta: Documentos de la Vanguardia en América Latina* (Buenos Aires: Corregidor, 2007), 109–12, 126–9. For a comprehensive study of the cultural politics of the Cuban avant-garde, see Manzoni, *Un dilema cubano: nacionalismo y vanguardia* (La Habana: Casa de las Américas, 2001). *Revista de Avance*, as the journal has been known since it first appeared, is in fact a subtitle. The main title corresponded to each year of publication, thus: *1927. Revista de Avance*, and so on, between 1927 and 1930.
68 Brent Hayes Edwards, *The Practice of Diaspora: Literature, Translation, and the Rise of Black Internationalism* (Cambridge, MA: Harvard University Press, 2003), 3, 322n.10.
69 Pascale Casanova, *The World Republic of Letters*, trans. M. B. DeBevoise (Cambridge, MA: Harvard University Press, 2004), 135.
70 Silvia Molloy, *La Diffusion de la littérature hispano-américaine en France au XXe siècle* (Paris: Presses Universitaires de France, 1972), 101–3. Jorge Guillén made a Spanish version of *Le Cimetière marin (The Graveyard by the Sea)* (1920) for *Revista de Occidente* in 1929. See Paul Valéry, *El cementerio marino. Edición bilingüe*, trans. Jorge Guillén (Madrid: Alianza, 1967). See also C. Day-Lewis's English translation, *The Graveyard by the Sea: Paul Valéry: "Le Cimetière Marin"* (London: Martin Secker & Warburg, 1946).
71 Orlando Figes, *The Europeans: Three Lives and the Making of a Cosmopolitan Culture* (London: Penguin, 2020), 356.
72 Müller-Bergh, "Introducción," in Brull, *Poesía reunida*, 47.
73 Ángel Rama, *The Lettered City*, ed. and trans. John Charles Chasteen (Durham, NC: Duke University Press, 1996), 112. José Eduardo González, *Appropriating Theory: Ángel Rama's Critical Work* (Pittsburgh, PA: University of Pittsburgh Press, 2017), 147.
74 See Pedro Henríquez Ureña, *Literary Currents in Hispanic America* (Cambridge, MA: Harvard University Press, 1945), 190.
75 Müller-Bergh argues that Brull's "onomatopoeic games and strike-throughs created a style and diction that differed from Futurist and Dada iconoclastic exercises" ("Introducción," 58). Brull explored the

resources of *creacionismo* well beyond *Poemas en menguante* and *Canto redondo*. In 1936 he published "Avión," a poem that evokes the semantic and phonic games of Spanish baroque and contemporary authors, including Góngora, Ramón Gómez de la Serna, Luis Palés Matos, and Nicolás Guillén.
76 Brull, *Poesía reunida*, 209.
77 The resonances with Juan Ramón's poetic universe are evident. See Predmore's discussions of an extensive network of symbols in Juan Ramón's *Diario* that include *niño*, *sueño*, and *mar*, among others. *La poesía hermética de Juan Ramón Jiménez: El "Diario" como centro de su mundo poético*, trans. Fernando G. Salinero (Madrid: Gredos, 1973).
78 Brull, *Poesía reunida*, 210.
79 Vicky Lebeau, *Childhood and Cinema* (London: Reaktion, 2008), 16.
80 J.-B. Pontalis, *Avant* (Paris: Gallimard, 2012), 114.
81 Cintio Vitier, *Lo cubano en la poesía* (1958), *Obras*, vol. 2 (La Habana: Letras Cubanas, 1998), 270, 272.
82 Chris Bongie, *Exotic Memories: Literature, Colonialism, and the Fin de Siècle* (Stanford, CA: Stanford University Press, 1991), 15.
83 Ferrer, *Insurgent Cuba*, 202.
84 Casanova's translator renders "La liberté de l'esprit" as "Spiritual freedom." Casanova, *The World Republic*, 13.
85 Casanova, *The World Republic*, 17.
86 Valéry, "Freedom of Mind," in *Reflections on the World Today*, trans. Francis Scarfe (London: Thames and Hudson, 1951), 186.
87 Brull, *Poëmes*, trans. Mathilde Pomès and Edmond Vandercammen (Bruxelles: Les Cahiers du Journal des Poètes, 1939).
88 Brull, *Poëmes*, 8, 14.
89 Derrida, *Archive Fever*, 2.
90 Valéry, "Preface," in Brull, *Poëmes*, 5–6. A Spanish version of the preface appeared in the Cuban journal *Espuela de Plata*, directed by José Lezama Lima, in the Spring of 1940. See Müller-Bergh, "Introducción," in Brull, *Poesía reunida*, 159.
91 Pedro Carlos González Cuevas, "Hispanidad," in Javier Fernández Sebastián and Juan Francisco Fuentes (eds.), *Diccionario político y social del siglo XX español* (Madrid: Alianza, 2008), 617–23. See also James G. Carrier (ed.), *Occidentalism: Images of the West* (Oxford: Clarendon, 1995).
92 Priscilla Wald, *Contagious: Cultures, Carriers, and the Outbreak Narrative* (Durham, NC: Duke University Press, 2008), 111, 112.
93 Schmitt, *The Concept of the Political*, trans. and ed. George Schwab (Chicago, IL: University of Chicago Press, 1996), appeared in 1927, and in revised form in 1932. *Theory of the Partisan* (1963) revises and extends the arguments of *The Concept of the Political*, introducing a more flexible understanding of political enmity that reflects a

transformed world order after World War II. See Chantal Mouffe, *The Democratic Paradox* (London: Verso, 2005), 49–57; and Gabriella Slomp, "The Theory of the Partisan: Carl Schmitt's Neglected Legacy," *History of Political Thought* 26/3 (Autumn 2005): 502–19.

Chapter 2: Male Regressions: The Non-Europeans

1 Cándida Maldonado de Ortiz, *Antonio S. Pedreira: Vida y obra* (San Juan, PR: Universidad de Puerto Rico, 1974), 47; Adolfo E. Jiménez Benítez, *Historia de las revistas literarias puertorriqueñas* (San Juan, PR: ZOÉ, 1998), 40. David González Ramírez, "Introducción," in Ángel Valbuena Prat, *Paisaje, mar, reinos interiores. Ensayos sobre la poesía canaria* (Islas Canarias: Idea, 2008), 7–19; Daniel Duque, "Prólogo: Ángel Valbuena Prat y la Escuela Lejana," in Ángel Valbuena Prat, *Historia de la Poesía Canaria* (Las Palmas de Gran Canaria: Fundación Caja Canarias/Idea, 2003), 5–17.
2 Jean Laplanche and Jean-Bertrand Pontalis, *The Language of Psychoanalysis*, trans. Donald Nicholson-Smith (London: Karnac, 1973), 386–8.
3 Edward W. Said, *Freud and the Non-European* (London: Verso, 2003), 14, 18.
4 I draw for my use of notions of regression on a general understanding of the term in Freud's texts, and on Michael Balint's distinction of "benign" and "malignant" forms of regression in *The Basic Fault: Therapeutic Aspects of Regression* (Chicago, IL: Northwestern University Press, 1992), 119–58.
5 See, in particular, Richard Rosa, *Los fantasmas de la razón: Una lectura material de Hostos* (San Juan, PR: Isla Negra: 2003). See also Oscar Montero, *José Martí: An Introduction* (New York: Palgrave Macmillan, 2004); and Laura Lomas, *Translating Empire: José Martí, Migrant Latino Subjects, and American Modernities* (Durham, NC: Duke University Press, 2008).
6 Arcadio Díaz Quiñones, *Sobre los principios: Los intelectuales caribeños y la tradición* (Bernal: Universidad Nacional de Quilmes, 2006), 357; Aníbal González, "La (sín)tesis de una poesía antillana: Palés y Spengler," *Cuadernos Hispanoamericanos* 451–2 (1988): 59–72; and Francisco-J. Hernández Adrián, "Spengler atlántico: Región y raza en Pedro García Cabrera y Luis Palés Matos," in Belén Castro Morales (ed.), *Actas del Congreso Internacional Pedro García Cabrera*, vol. 2 (Islas Canarias: Universidad de La Laguna, 2007), 442–61.
7 The expression *"juventud letrada"* (educated or lettered youth) appears in the last chapter of the book. Antonio S. Pedreira, *Insularismo* (Río Piedras, PR: Edil, 1992), 152. See also Díaz Quiñones, *Sobre los principios*, 351.

8 Gilles Deleuze and Félix Guattari, *Kafka: Toward a Minor Literature*, trans. Dana Polan (Minneapolis: University of Minnesota Press, 1986); Anne Garland Mahler, *From the Tricontinental to the Global South: Race, Radicalism, and Transnational Solidarity* (Durham, NC: Duke University Press, 2018), 36–58.
9 Iris Bachmann, "Creoles," in Martin Maiden, John Charles Smith, and Adam Ledgway (eds.), *The Cambridge History of the Romance Languages*, vol. II (Cambridge: Cambridge University Press, 2013), 401. See also Bachmann, *Die Sprachwerdung des Kreolischen. Eine diskursanalytische Untersuchung am Beispiel des Papiamentu* (Tübingen: Gunter Narr Verlag, 2005).
10 Michel-Rolph Trouillot, "Culture on the Edges: Creolization in the Plantation Context," in Yarimar Bonilla, Greg Beckett, and Mayanthi L. Fernando (eds.), *Trouillot Remixed: The Michel-Rolph Trouillot Reader* (Durham, NC: Duke University Press, 2021), 211. See also Michaeline A. Crichlow and Patricia Northover, *Globalization and the Post-Creole Imagination: Notes on Fleeing the Plantation* (Durham, NC: Duke University Press, 2009), 15–33.
11 Díaz Quiñones, *Sobre los principios*, 66–7.
12 Françoise Lionnet and Shu-mei Shih (eds.), *Minor Transnationalism* (Durham, NC: Duke University Press, 2005).
13 The manifesto appears on the front page of the daily *La Prensa*, in Santa Cruz de Tenerife, on February 1, 1928. It is signed by ten men, starting with Juan Manuel Trujillo, Agustín Espinosa García, and Ernesto Pestana Nóbrega. "Primer manifiesto de *La Rosa de los Vientos*," in Pilar Carreño Corbella (ed.), *Escritos de las vanguardias en Canarias, 1927–1977* (Santa Cruz de Tenerife: Instituto Óscar Domínguez de Arte y Cultura Contemporánea, 2003), 47. See also Nilo Palenzuela, "El proceso de las revistas: de 'La Rosa de los Vientos' a 'Índice,'" in Andrés Sánchez Robayna (ed.), *Canarias: Las vanguardias históricas* (Las Palmas de Gran Canaria: CAAM/Gobierno de Canarias, 1992), 19–38.
14 Cecilia Manzoni (ed.), *Vanguardias en su tinta: Documentos de la Vanguardia en América Latina* (Buenos Aires: Corregidor, 2007), 111.
15 Nigel Townson, "The Contested Quest for Modernization: 1914–36," in Adrian Shubert and José Álvarez Junco (eds.), *The History of Modern Spain: Chronologies, Themes, Individuals* (London: Bloomsbury, 2018), 73–4.
16 See the essays included in a special issue dedicated to Agustín Espinosa, "Bajo el signo de Espinosa," in *Revista de Filología de la Universidad de La Laguna* 42 (2021).
17 Ramón Feria, *Signos de Arte y Literatura* (Madrid: El Discreto, 1936), 34.
18 José Luis Rodríguez Jiménez, *La extrema derecha española en el siglo XX* (Madrid: Alianza, 1997), 134–43. See also Stanley G. Payne,

Fascism in Spain, 1923–1977 (Madison: University of Wisconsin Press, 1999), 51–65.
19 Palenzuela, "Introducción," in Agustín Espinosa, *Lancelot 28°-7° [Guía integral de una Isla Atlántica]* (Islas Canarias: Cabildo de Lanzarote, 2002), xxii. I will quote from this edition of *Lancelot, 28°-7°*.
20 See Palenzuela's persuasive reading of two texts by Espinosa, *Lancelot, 28°-7°* and *Crimen*, via the Bergsonian *durée*, simultaneism, and Cubism, in "Agustín Espinosa. El movimiento de una recepción," *Revista de Filología de la Universidad de La Laguna* 42 (2021): 19–34. See also Beatriz Martínez López, "Repensando a Espinosa: su papel en los debates sobre la reivindicación estética del cubismo y la producción plástica de Picasso en el contexto cultural canario (1920–1930)," *Revista de Filología de la Universidad de La Laguna* 42 (2021): 95–113.
21 Karl Baedeker, *The Mediterranean: Seaports and Sea Routes, including Madeira, the Canary Islands, the Coast of Morocco, Algeria, and Tunisia* (Leipzig: Karl Baedeker, 1911), 28, 29.
22 See Jennifer Guerra Hernández's comments on the conscription of Canarian soldiers during the "Guerra de África," or "Guerra del Rif," *Canarias ante la guerra de Marruecos (1909–1927). Miradas desde el Atlántico* (Las Palmas de Gran Canaria: Cabildo de Gran Canaria, 2019), 112–31.
23 Svetlana Alpers, *The Art of Describing: Dutch Art in the Seventeenth Century* (London: Penguin, 1989), 122.
24 Vicente Huidobro, "Le Créationnisme," in *Manifestes* (Paris: Revue Mondiale, 1925), 31–50.
25 Susan Martin-Márquez, *Disorientations: Spanish Colonialism in Africa and the Performance of Identity* (New Haven: Yale University Press, 2008), 8–9.
26 Alberto García-Aguilar, "Agustín Espinosa, espectador del espacio insular: la influencia del cine en *Lancelot, 28°-7°* (1929)," *Revista de Filología de la Universidad de La Laguna* 42 (2021): 159–76. For a study of "dream-house" references among Spanish avant-gardists see C. B. Morris, *This Loving Darkness: The Cinema and Spanish Writers, 1920–1936* (Oxford: Oxford University Press, 1980).
27 Jorge Aguiar Gil, "Pedro García Cabrera: Biologismo, determinismo, organcismo," in *Actas del Congreso Internacional Pedro García Cabrera*, vol. 2, 375.
28 Hans Ulrich Gumbrecht, *Atmosphere, Mood, Stimmung: On a Hidden Potential of Literature*, trans. Erik Butler (Stanford, CA: Stanford University Press, 2001), 5.
29 Edward W. Said, *Orientalism* (London: Penguin, 2003), 49, 50.
30 Edward W. Said, *Culture and Imperialism* (New York: Vintage, 1994), 9.

31 Martin-Márquez, *Disorientations*, 8, 9. See also Roberto Dainotto, "Orientalism, Mediterranean Style: The Limits of History at the Margins of Europe," in *Europe (In Theory)* (Durham, NC: Duke University Press, 2007), 172–217.
32 Lorca uses the expression "*lo mitológico gitano*" in a 1926 letter to Jorge Guillén. See Allen Josephs and Juan Caballero, "Introducción," in Federico García Lorca, *Poema del Cante Jondo. Romancero gitano* (Madrid: Cátedra, 1998), 82–4.
33 Guerra Hernández, *Canarias ante la guerra*, 130–1; Martin-Márquez, *Disorientations*, 162–3; Sebastian Balfour, *Deadly Embrace: Morocco and the Road to the Spanish Civil War* (Oxford: Oxford University Press, 2002), 203–33.
34 Giorgio Agamben, *Homo Sacer: Sovereign Power and Bare Life*, trans. Daniel Heller-Roazen (Stanford: Stanford University Press, 1998), 7.
35 "Negritos" was published in *La Libertad* on June 17, 1921. A related chronicle, "Más negritos," appeared on July 1, 1921. I quote from Guillén, *Desde París* (Barcelona: Seix Barral, 2000), 69–72, 72–7.
36 Sandra Khor Manickam, "Africans in Asia: The Discourse of 'Negritos' in Early Nineteenth-century Southeast Asia," in Hans Hägerdal (ed.), *Responding to the West: Essays on Colonial Domination and Asian Agency* (Amsterdam: Amsterdam University Press, 2009), 69.
37 José Ortega y Gasset, *La deshumanización del arte y otros ensayos de estética* (Madrid: Espasa, 1999), 84. For a less literal rendition of this passage than my own, see Helene Weyl's translation, *The Dehumanization of Art and Other Essays on Art, Culture, and Literature* (Princeton, NJ: Princeton University Press, 1968), 45.
38 Martin-Márquez, *Disorientations*, 49–50.
39 Heike Malinowski, 'La revue "Social" et les Minoristes. Espace littéraire et modernité culturelle dans le Cuba des années vingt,' in Thomas Bremer and Ulrich Fleischmann (eds.), *Alternative Cultures in the Caribbean* (Frankfurt: Vervuert, 1993), 193–203. See also Roberto González Echevarría, *Alejo Carpentier: The Pilgrim at Home* (Ithaca, NY: Cornell University Press, 1977), 35–6.
40 Originally published in *Carteles*, April 10, 1928. I quote from Carpentier, *Obras Completas de Alejo Carpentier*, vol. 8, ed. María Luisa Puga (México: Siglo XXI, 1985), 212 (Carpentier's emphases). This edition misprints the year of publication (1922 instead of 1928).
41 Robin D. Moore, *Nationalizing Blackness: Afrocubanismo and Artistic Revolution in Havana, 1920–1940* (Pittsburgh, PA: University of Pittsburgh Press, 1997), 203.
42 David Luis-Brown, *Waves of Decolonization: Discourses of Race and Hemispheric Citizenship in Cuba, Mexico, and the United States* (Durham, NC: Duke University Press, 2008), 193.
43 Emily A. Maguire, *Racial Experiments in Cuban Literature and Ethnography* (Gainesville: University Press of Florida, 2011), 1.

44 Ramón Chao, *Conversaciones con Alejo Carpentier* (Madrid: Alianza, 1998), 216. See also Rosalie Schwartz, "Cuba's Roaring Twenties: Race Consciousness and the Column 'Ideales de una raza'," in Lisa Brock and Digna Castañeda Fuertes (eds.), *Between Race and Empire: African-Americans and Cubans before the Cuban Revolution* (Philadelphia, PA: Temple University Press, 1998), 104–19; María Antonieta Henríquez, *Alejandro García Caturla* (La Habana: Unión, 1998), 42–58; Carmen Vásquez, "Alejo Carpentier: Los artículos de *Le Cahier*," *La Torre: Revista de la Universidad de Puerto Rico* 27–8 (1993): 673–94; and Müller-Bergh, "Alejo Carpentier: Autor y obra en su época," *La Torre: Revista de la Universidad de Puerto Rico* 15 (1990): 275–6, 279.

45 Stephan Palmié, *Wizards and Scientists: Explorations in Afro-Cuban Modernity and Tradition* (Durham, NC: Duke University Press, 2002), 30–1. See also Anke Birkenmaier, *The Specter of Races: Latin American Anthropology and Literature between the Wars* (Charlottesville: University of Virginia Press, 2016), 19–46; and Thomas Bremer, "The Constitution of Alterity: Fernando Ortiz and the Beginnings of Latin-American Ethnography out of the Spirit of Italian Criminology," in *Alternative Cultures*, 119–29.

46 Carpentier, "Un ballet afrocubano," in *Obras Completas*, vol. 1, ed. Puga (México: Siglo XXI, 1983), 266. See also Caroline Rae, "In Havana and Paris: The Musical Activities of Alejo Carpentier," *Music & Letters* 89/3 (2008): 373–95. Quotes and references are from Carpentier, *El milagro de Anaquillé*, *Obras Completas*, vol. 1, 269–77.

47 Robin D. Moore, "The *Teatro Bufo*: Cuban Blackface Theater of the Nineteenth Century," in Donna A. Buchanan (ed.), *Soundscapes from the Americas: Ethnomusicological Essays on the Power, Poetics, and Ontology of Performance* (New York: Routledge, 2014), 26, 27.

48 Lester D. Langley, *The Banana Wars: United States Intervention in the Caribbean, 1898–1934* (Lexington: University Press of Kentucky, 1983).

49 Vera M. Kutzinski, *Sugar's Secrets: Race and the Erotics of Cuban Nationalism* (Charlottesville: University Press of Virginia, 1993), 45–6. See also Jorge R. Bermúdez, *De Gutenberg a Landaluze* (La Habana: Letras Cubanas, 1990), 222–5; Salvador Bueno, *Costumbristas Cubanos del siglo XIX* (Caracas: Biblioteca Ayacucho, 1985); and José Antonio Portuondo, "Landaluze y el costumbrismo en Cuba," *Revista de la Biblioteca Nacional José Martí* 1 (1972): 51–83.

50 Fernando Ortiz, *Revista Bimestre Cubana* XV/1 (1920): 5–26. See also Carpentier, *Music in Cuba*, ed. Timothy Brennan, trans. Alan West-Durán (Minneapolis: University of Minnesota Press, 2001), 272–4; and Miriam Escudero, "El 'Día de Reyes' de Federico Mialhe: La importancia del grabado para el estudio de la iconografía musical cubana decimonónica," *Cuadernos de Iconografía Musical* 1/1 (2014): 61–89.

51 Carpentier, Écue-Yamba-Ó, *Obras Completas*, vol. 1, 184–93.
52 Maguire, *Racial Experiments*, 200n.24.
53 Frank Janney, *Alejo Carpentier and His Early Works* (London: Tamesis, 1981), 27.
54 Luisa Campuzano, "El 'syndrome de Merimée' o la españolidad literaria de Alejo Carpentier," in *Carpentier entonces y ahora* (La Habana: Letras Cubanas, 1997), 44.
55 Jean Franco, *The Decline and Fall of the Lettered City: Latin America in the Cold War* (Cambridge, MA: Harvard University Press, 2002), 161, 166.
56 Mary Louise Pratt, *Imperial Eyes: Travel Writing and Transculturation* (New York: Routledge, 2008), 192.
57 A note on the title page of *El milagro de Anaquillé* explains: "Premiered in Cuba after the Revolution, with music by Amadeo Roldán." Carpentier, *Obras Completas*, vol. 1, 263; see also "Un ballet afrocubano," 265–7.
58 Carpentier, "Un ballet afrocubano," 266; Rae, "In Havana and Paris," 384.
59 Said, *Culture and Imperialism*, 186, 189.
60 Quotes in English and references are from Antonio S. Pedreira, *Insularismo: An Insight into the Puerto Rican Character*, trans. Aoife Rivera Serrano (New York: Ausubo, 2005). To preserve linguistic nuance, I occasionally insert words or passages from the original Spanish in square brackets, citing from *Insularismo* (Río Piedras, PR: Edil, 1992). I have consulted, but do not cite from, Mercedes López-Baralt's excellent edition, which amends occasional typographic errors: *Insularismo. Ensayos de interpretación puertorriqueña*, 2nd ed. (San Juan, PR: Plaza Mayor, 2006).
61 See "Cronología," in Pedreira, *Insularismo*, ed. Mercedes López-Baralt, 23–30. See also Maldonado de Ortiz, *Antonio S. Pedreira*; Díaz Quiñones, "Pedreira en la frontera," in *El arte de bregar: Ensayos* (San Juan, PR: Callejón, 2000), 96–102; and Richard Rosa, "Business as Pleasure: Culture, Tourism, and Nation in Puerto Rico in the 1930s," *Nepantla: Views from South* 2/3 (2001): 449–88.
62 Balfour, *The End of the Spanish Empire, 1898–1923* (Oxford: Oxford University Press, 1997), 64.
63 Lillian Guerra, *Popular Expression and National Identity in Puerto Rico: The Struggle for Self, Community, and Nation* (Gainesville: University Press of Florida, 1998). See also Juan Flores, *Insularismo e ideología burguesa en Antonio Pedreira* (La Habana: Casa de las Américas, 1979).
64 John Oliver La Gorce, "The Gate of Riches: Amazing Prosperity Has Been the Lot of Ponce de León's Isle under American Administration," *National Geographic* 46/6 (December 1924): 599, 601–2, 622.

65 John D. Perivolaris, "'Porto Rico': The View from *National Geographic*, 1899–1924," *Bulletin of Hispanic Studies* 84/2 (2007): 198, 208–9.
66 Édouard Glissant, *Poetics of Relation*, trans. Betsy Wing (Ann Arbor: University of Michigan Press, 1997), 11.
67 Katie Trumpener, "Puerto Rico Fever: Douglas Sirk, *La Habanera* (1937) and the Epistemology of Exoticism," in Sigrid Bauschinger and Susan Cocalis (eds.), *"Neue Welt"/"Dritte Welt": Interkulturelle Beziehungen Deutschlands zu Lateinamerika und der Karibik* (Tübingen: Francke, 1994), 115–39.
68 Lara Putnam, "Borderlands and Border Crossers: Migrants and Boundaries in the Greater Caribbean, 1840–1940," *Small Axe* 43 (2014): 7–21. See also Barry Carr, "Identity, Class, and Nation: Black Immigrant Workers, Cuban Communism, and the Sugar Insurgency, 1925–1934," in Shalini Puri (ed.), *Marginal Migrations: The Circulation of Cultures within the Caribbean* (Oxford: Macmillan, 2003), 77–108.
69 Díaz Quiñones, *La memoria rota. Ensayos sobre cultura y política* (Río Piedras, PR: Huracán, 1993), 59; and *Sobre los principios*, 135n.153.
70 On Creole discourses around the trope of the *jíbaro* in the first half of the nineteenth century, see Francisco Scarano, "The *Jíbaro* Masquerade and the Subaltern Politics of Creole Identity Formation in Puerto Rico, 1745–1823," *American Historical Review* 101/5 (1996): 1398–431; and Lillian Guerra, *Popular Expression and National Identity in Puerto Rico: The Struggle for Self, Community, and Nation* (Gainsville: University Press of Florida, 1998), 52–66, 79–121.
71 J. R. McNeill, *Mosquito Empires: Ecology and War in the Greater Caribbean, 1620–1914* (Cambridge: Cambridge University Press, 2010), 27–30.
72 Paulo Drinot, "Introduction," in Paulo Drinot and Alan Knight (eds.), *The Great Depression in Latin America* (Durham, NC: Duke University Press, 2014), 8.
73 Ramón E. Soto-Crespo, *Mainland Passage: The Cultural Anomaly of Puerto Rico* (Minneapolis and London: University of Minnesota Press, 2009), 7, 8.
74 Díaz Quiñones, "Pedreira en la frontera," 96.
75 Juan Pablo Fusi, "Reencuentros culturales: una relación compleja," in Fusi and Antonio López Vega (eds.), *Diálogos atlánticos: Cultura y ciencia en España y América en el siglo XX* (Barcelona: Galaxia Gutenberg, 2021), 40–1.
76 Díaz Quiñones, "Ramiro Guerra y Sánchez (1880–1970) y Antonio S. Pedreira (1898–1939): el enemigo íntimo," in *Sobre los principios*, 354n.58.
77 Luis Hernández Aquino, *Nuestra aventura literaria: Los ismos en la poesía puertorriqueña, 1913–1948*, 2nd ed. (San Juan, PR: Editorial Universitaria, 1966), 7–8. See also Hugo J. Verani, *Las vanguardias*

literarias en Hispanoamérica (Manifiestos, proclamas y otros escritos) (México: Fondo de Cultura Económica, 1990), 20; and Mercedes López-Baralt *El barco en la botella: La poesía de Luis Palés Matos* (San Juan, PR: Plaza Mayor, 1997), 123.
78 Hernández Aquino, *Nuestra aventura literaria*, 97, 109–11. See also Samuel Román Delgado, "El Atalayismo; innovación y renovación en la literature puertorriqueña," *Revista Iberoamericana* 59/162–3 (1993): 93–100.
79 Chantal Mouffe, *Agonistics: Thinking the World Politically* (London: Verso, 2013), 7.
80 José Martí, *Selected Writings*, ed. and trans. Esther Allen (New York: Penguin, 2002), 295, 288.
81 Priscilla Wald, *Contagious: Cultures, Carriers, and the Outbreak Narrative* (Durham, NC: Duke University Press, 2008), 12–13.
82 Ortega y Gasset, *The Modern Theme*, trans. James Cleugh (New York: Harper, 1961), 58; *El tema de nuestro tiempo. El ocaso de las revoluciones. El sentido histórico de la teoría de Einstein* (Madrid: Calpe, 1923), 94.
83 Díaz Quiñones, *Sobre los principios*, 370; Eileen J. Suárez Findlay, *Imposing Decency: The Politics of Sexuality and Race in Puerto Rico, 1870–1920* (Durham, NC: Duke University Press, 1999), 202–3.
84 Suárez Findlay, *Imposing Decency*, 171. See also Laura Briggs, *Reproducing Empire: Race, Sex, Science, and U.S. Imperialism in Puerto Rico* (Berkeley: University of California Press, 2002), 74–108; and María de Fátima Barceló-Miller, "Halfhearted Solidarity: Women Workers and the Women's Suffrage Movement in Puerto Rico During the 1920s," in Félix V. Matos Rodríguez, and Linda C. Delgado (eds.), *Puerto Rican Women's History: New Perspectives* (Armonk, NY: M.E. Sharpe, 1998), 126–42.
85 On a Caribbean genealogy of W. E. B. Du Bois's "color line" and ethno-racial categories in Puerto Rico, see Sidney W. Mintz, *Three Ancient Colonies: Caribbean Themes and Variations* (Cambridge, MA: Harvard University Press, 2010), 1–4, 174–81.
86 Mintz, *Three Ancient Colonies*, 1.
87 Claudia Milian, "Latinos and the Like: Reading Mixture and Deracination," in John Morán González (ed.), *The Cambridge Companion to Latina/o American Literature* (New York: Cambridge University Press, 2016), 198. On Spanish exiles, see in particular Lena Burgos-Lafuente, "*Tiempo de isla*: Pedro Salinas y los trópicos típicos," *Revista de Estudios Hispánicos* 44 (2010): 107–26; "*Los amarres de la lengua*: Spanish Exiles, Puerto Rican Intellectuals, and the Battle over Spanish, 1942–2016," in Cecilia Enjuto-Rangel, Sebastiaan Faber, Pedro García-Caro, and Robert Newcomb (eds.), *Transatlantic Studies: Latin America, Iberia, and Africa* (Liverpool: Liverpool University Press 2019), 126–43; and "*¿Qué es entonces una isla?*: ruinas, islas

y escritura en el Caribe de María Zambrano," *Journal of Spanish Cultural Studies* 16/4 (2015): 375–96.

Chapter 3: Islands of Desire: A Poetics of Antillean Fragmentation

1 Fredrick B. Pike, *Hispanismo, 1898–1936: Spanish Conservatives and Liberals and Their Relations with Spanish America* (Notre Dame, IN: University of Notre Dame Press, 1971), 294.
2 Lilyan Kesteloot places Guillén under the rubric "L'École haïtienne, 1928–1932" and as a precursor of the *négritude* movement in her *Anthologie négro-africaine: Panorama critique des prosateurs, poètes et dramaturges du XXe siècle* (Vanves: EDICEF, 1992), 69. See also Josaphat B. Kubayanda, *The Poet's Africa: Africanness in the Poetry of Nicolás Guillén and Aimé Césaire* (New York: Greenwood, 1990); René Depestre, "Hello and Goodbye to Negritude," in Manuel Moreno Fraginals (ed.), *Africa in Latin America: Essays on History, Culture, and Socialization*, trans. Leonor Blum (New York/Paris: Holmes & Meier/UNESCO 1984), 251–72; and Jean-Claude Bajeux, *Antilia retrouvée: Claude McKay, Luis Palés Matos, Aimé Césaire, poètes noirs antillais* (Paris: Éditions Caribéennes, 1983).
3 Frank Andre Guridy, *Forging Diaspora: Afro-Cubans and African Americans in a World of Empire and Jim Crow* (Chapel Hill: University of North Carolina Press, 2010); David Luis-Brown, *Waves of Decolonization: Discourses of Race and Hemispheric Citizenship in Cuba, Mexico, and the United States* (Durham, NC: Duke University Press, 2008); and Brent Hayes Edwards, *The Practice of Diaspora: Literature, Translation, and the Rise of Black Internationalism* (Cambridge, MA: Harvard University Press, 2003).
4 Alejandra Bronfman, *Measures of Equality: Social Science, Citizenship, and Race in Cuba, 1902–1940* (Chapel Hill: University of North Carolina Press, 2004); Alejandro de la Fuente, *A Nation for All: Race, Inequality, and Politics in Twentieth-Century Cuba* (Chapel Hill: University of North Carolina Press, 2001); Robin D. Moore, *Nationalizing Blackness: Afrocubanismo and Artistic Revolution in Havana, 1920–1940* (Pittsburgh, PA: University of Pittsburgh Press, 1997); Antonio Benítez-Rojo, *The Repeating Island. The Caribbean and the Postmodern Perspective*, trans. James E. Maraniss (Durham, NC: Duke University Press, 1996), 112–49; and Vera M. Kutzinski, *Sugar's Secrets: Race and the Erotics of Cuban Nationalism* (Charlottesville: University Press of Virginia, 1993).
5 Petrine Archer-Straw, *Negrophilia: Avant-Garde Paris and Black Culture in the 1920s* (New York: Thames and Hudson, 2000); Bennetta Jules-Rosette, *Black Paris: The African Writers' Landscape* (Urbana:

University of Illinois Press, 1998); Vera M. Kutzinski, *Sugar's Secrets*; Mariana Torgovnick, *Gone Primitive: Savage Intellects, Modern Lives* (Chicago, IL: University of Chicago Press, 1990).
6 Moore, *Nationalizing Blackness*, 49.
7 Kutzinski, *Sugar's Secrets*, 196.
8 Kubayanda, *The Poet's Africa*, 35. On critiques of Eurocentric history from a Caribbean viewpoint, see Alain Blérald, *Négritude et Politique aux Antilles* (Paris: Éditions Caribéennes, 1981), 41–56. On Maeztu and his generation of Spanish fascist intellectuals, see Stanley G. Payne, *Fascism in Spain, 1923–1977* (Madison: University of Wisconsin Press, 1999), 51–65; and Javier Krauel, *Imperial Emotions: Cultural Responses to Myths of Empire in* Fin-de-Siècle *Spain* (Liverpool: Liverpool University Press), 124–46.
9 Kubayanda, *The Poet's Africa*, 38.
10 Cecilia Manzoni, *Un dilema cubano: nacionalismo y vanguardia* (La Habana: Casa de las Américas, 2001), 141–81.
11 Theodor W. Adorno, *The Jargon of Authenticity*, trans. Knut Tarnowski and Frederic Will (Evanston, IL: Northwestern University Press, 1973); and "Spengler after the Decline," in *Prisms*, trans. Samuel and Shierry Weber (Cambridge, MA: MIT Press, 1983), 72.
12 Nicolás Guillén, *Sóngoro Cosongo: Poemas mulatos* (La Habana: Ucar, García y Cía, 1931).
13 Allen Josephs and Juan Caballero, "Introducción," in Federico García Lorca, *Poema del Cante Jondo. Romancero Gitano* (Madrid: Cátedra, 1998), 13–121. Miguel García-Posada, "Introducción" and "Prólogo," in García Lorca, *Obras Completas*, vol. 1, ed. García-Posada (Barcelona: Círculo de Lectores/Galaxia Gutenberg, 1996), 9–28, 29–51.
14 I quote and translate from Josephs and Caballero's transcription of an interview with Cabrera in García Lorca, *Poema del Cante Jondo. Romancero Gitano*, ed. Josephs and Caballero (Madrid: Cátedra, 1998), 243. See also García-Posada, in García Lorca, *Obras Completas* I, 914–17, and Josephs, "Lydia and Federico: Towards a Historical Approach to Lorca Studies," *Journal of Spanish Studies: Twentieth Century* 6/2 (Fall, 1978): 123–30. On Lorca's friendship with Chacón y Calvo, see Roger Tinnell and Yara González Montes, "Epistolario de José María Chacón y Calvo a Federico García Lorca," *Hispanic Research Journal* 1/1 (2000): 65–85. On Lorca's visit to Cuba in 1930, see Ciro Bianchi Ross, *García Lorca, pasaje a La Habana* (La Habana: Pablo de la Torriente, 1999).
15 Josephs and Caballero, "Introducción," 13–18, 84–5; *Revista de Avance* 5/45 (1930): 104–10.
16 On "Son de negros en Cuba," see García Lorca, *Poeta en Nueva York*, ed. María Clementa Millán (Madrid: Cátedra, 1990), 233–6. For accounts of these encounters, see Carlos del Toro González, *Fernando Ortiz y la Hispanocubana de Cultura* (La Habana: Fundación Fernando

Ortiz, 1996), and Bianchi Ross, *García Lorca*. On Fernández de Castro's influential position in the Minorista group and friendship with Carpentier, see Luis Álvarez, *Alejo Carpentier: La facultad mayor de la cultura* (La Habana: ICAIC / Fundación Alejo Carpentier, 2016), 71–3.
17 Juan Antonio Gaya Nuño, *La Pintura Puertorriqueña* (Soria: Centro de Estudios Sorianos / C.S.I.C., 1994). See also Catherine Den Tandt's argument on the tensions between competing *jibarista* and *afrocaribeño* referents: "All That Is Black Melts into Air: *Negritud* and Nation in Puerto Rico," in Belinda Edmondson (ed.), *Caribbean Romances: The Politics of Regional Representation* (Charlottesville: University Press of Virginia, 1999), 76–91. On Cuban *costumbrismo* and related trends, see Salvador Bueno, *Historia de la Literatura Cubana* (La Habana: Editorial Nacional de Cuba, 1963), 183–94, 213–32; and Bueno (ed.), *Costumbristas Cubanos del siglo XIX* (Caracas: Biblioteca Ayacucho, 1985).
18 On *jitanjáfora* and onomatopoeia in *poesía negra*, Marinetti, Mayakovsky, and the Dadaists, see Luis Íñigo-Madrigal, "Introducción," in Guillén, *Summa poética*, ed. Íñigo-Madrigal (Madrid: Cátedra, 1997), 28–30.
19 I quote and translate from "Orquestación diepálica" and "Abajo," in Mercedes López-Baralt, *La poesía de Luis Palés Matos* (San Juan: Universidad de Puerto Rico, 1995), 398–406. All other translations of Palés's poems are from Luis Palés Matos, *Selected Poems: Poesía Selecta*, trans. Julio Marzán (Houston, TX: Arte Público, 2000).
20 Palés Matos, "El Dadaísmo," *La Semana*, San Juan, Puerto Rico, I, 5/21–30 (May 20, 1922), reproduced in López-Baralt, *La poesía de Luis Palés Matos*, 399–401.
21 López-Baralt, *La poesía de Luis Palés Matos*, 400.
22 López-Baralt, *La poesía de Luis Palés Matos*, 401.
23 Cinzia Sartini Blum, *The Other Modernism: F. T. Marinetti's Futurist Fiction of Power* (Berkeley: University of California Press, 1996), 81. See also Whitney Chadwick and Tirza True Latimer, "Becoming Modern: Gender and Sexual Identity after World War I," in Chadwick and Latimer (eds.), *The Modern Woman Revisited: Paris Between the Wars* (New Brunswick, NJ: Rutgers University Press, 2003), 3–19.
24 Marjorie Perloff, *The Futurist Moment: Avant-Garde, Avant Guerre, and the Language of Rupture* (Chicago, IL: University of Chicago Press, 2003), 56–7.
25 Carlos J. Alonso, *The Spanish American Regional Novel: Modernity and Autochthony* (Cambridge: Cambridge University Press, 1990), 1–37.
26 Sartini Blum, *The Other Modernism*, 85.
27 Ángel Valbuena Prat, "Sobre la poesía de Luis Palés Matos, y los temas negros," in Palés Matos, *Tuntún de pasa y grifería*, 75–86. This essay appears as the prologue to the first edition of *Tuntún* (1937). Valbuena

Prat had published another essay on Palés, "En torno a los temas negros," *Hostos,* Puerto Rico (March 1929).
28 Walter Benjamin, "The Work of Art in the Age of Its Technological Reproducibility," in *Selected Writings, Vol. 3, 1935–1938,* ed. Howard Eiland and Michael W. Jennings, trans. Edmund Jephcott, Howard Eiland et al. (Cambridge, MA: Harvard University Press, 2002), 122.
29 Stuart Hall, "Negotiating Caribbean Identities," *New Left Review* 209 (1995): 4.
30 Dash, *The Other America: Caribbean Literature in a New World Context* (Charlottesville, VA: University Press of Virginia, 1998), 23, 24, 25.
31 Anne McClintock, *Imperial Leather: Race, Gender and Sexuality in the Colonial Contest* (New York: Routledge, 1995), 40.
32 Lydia Platón Lázaro, *Defiant Itineraries: Caribbean Paradigms in American Dance and Film* (New York: Palgrave Macmillan, 2015), 40.
33 On the poetics of fragmentation, *dis-*membrement, and *re-*membering, see Dash, "Desmembrar y remembrar: la poética del cuerpo en la literatura caribeña," trans. Elaine Menar, *La Torre: Revista de la Universidad de Puerto Rico* 11 (1989): 483–91; and, with particular insistence on Césaire and Glissant, "Farming Bones and Writing Rocks: Rethinking a Caribbean Poetics of (Dis)Location," *Shibboleths: Journal of Comparative Theory* 1/1 (2006): 64–71.
34 Antonio Benítez-Rojo, *The Repeating Island: The Caribbean and the Postmodern Perspective,* trans. James E. Maraniss (Durham, NC: Duke University Press, 1996), 25.
35 On *errance*/errancy, see Dash, *The Other America,* 86, 146. On "the question of roots," see Hall, "Negotiating Caribbean Identities," 3–14. See also Aníbal González, "La (sín)tesis de una poesía antillana: Palés y Spengler," *Cuadernos Hispanoamericanos* 451-2 (1988): 59–72.
36 López-Baralt, *La poesía de Luis Palés Matos,* 570–1, 598–600.
37 Alejo Carpentier, *Music in Cuba,* ed. Timothy Brennan, trans. Alan West-Durán (Minneapolis: University of Minnesota Press, 2001), 269; *La Música en Cuba* (1946) (México: Fondo de Cultura Económica, 1972), 306.
38 Moore, *Nationalizing Blackness,* 88, 89.
39 "Thick-Lipped Cullud Boy" in Langston Hughes and Ben Frederic Carruthers's rendition. Unless noted otherwise, translations and references are from Guillén, *Cuba Libre. Poems by Nicolás Guillén,* trans. Hughes and Carruthers (Los Angeles: Anderson & Ritchie, 1948), included in *The Collected Works of Langston Hughes,* vol. 16, ed. Arnold Rampersad (Columbia: University of Missouri Press, 2003).
40 Guillén, *Páginas Vueltas. Memorias* (La Habana: Ediciones Unión, 1982), 77–8.
41 Guillén, *Páginas Vueltas,* 83.
42 Kutzinski, *Sugar's Secrets,* 239n.31.

43 Shane Graham, *Cultural Entanglements: Langston Hughes and the Rise of African and Caribbean Literature* (Charlottesville: University of Virginia Press, 2020), 66. For clarification on Hughes's presumed influence (literary or other) on Guillén, see Kutzinski, *The Worlds of Langston Hughes: Modernism and Translation in the Americas* (Ithaca, NY: Cornell University Press, 2012), 81–5.
44 Moore, *Nationalizing Blackness*, 210.
45 Guillén, *Páginas Vueltas*, 80.
46 Kutzinski, *Sugar's Secrets*, 152–3. See also Guridy, *Forging Diaspora*, 117–24; and de la Fuente, *A Nation for All*, 162–3.
47 Kutzinski, *Sugar's Secrets*, 13.
48 Guillén, *Sóngoro Cosongo*, 47 (my translation).
49 Judith Butler, "Performative Agency," *Journal of Cultural Economy* 3/2 (2010): 155.
50 Emilio Bejel, *Gay Cuban Nation* (Chicago, IL: University of Chicago Press, 2001), 41–6.
51 Bill Ashcroft, *Post-Colonial Transformation* (London: Routledge, 2001), 47.
52 Kaja Silverman, *Male Subjectivity at the Margins* (New York: Routledge, 1992), 42–51.
53 Guillén, *El son entero. Suma poética, 1929–1946* (Buenos Aires: Pleamar, 1947), 55 (my translation in this paragraph).
54 Guillén, "West Indies Ltd.," in *El son entero*, 70–80 (my translation).
55 James Robbins, "The Cuban 'Son' as Form, Genre, and Symbol," *Latin American Music Review / Revista de Música Latinoamericana* 11/2 (1990): 186. See also Moore, *Nationalizing Blackness*, 97–104.
56 Burgos published her second book, *Canción de la verdad sencilla*, in San Juan in 1939, while *El mar y tú. Otros poemas*, appeared posthumously in Puerto Rico in 1954. "Poemas dispersos," "Poemas políticos," and other poems that had not appeared in a book or remained unpublished, figure in Burgos, *Obra poética II*, ed. Juan Varela-Portas de Orduña (Madrid: La Discreta, 2009).
57 Michel-Rolph Trouillot, *Silencing the Past: Power and the Production of History* (Boston, MA: Beacon, 1995), 18.
58 See the essays included in a special issue dedicated to Julia de Burgos, in *CENTRO: Journal of the Center for Puerto Rican Studies* 26/2 (2014).
59 Luis Lloréns Torres, "Cinco poetisas de América (Clara Lair, Alfonsina Storni, Gabriela Mistral, Juana de Ibarborou, Julia de Burgos)," *Puerto Rico Ilustrado* 144 (November 13, 1938). Cited in López Jiménez, "Julia de Burgos: las rutas posibles," in Burgos, *Obra poética I*, ed. Varela-Portas de Orduña (Madrid: La Discreta, 2008), 13.
60 On Burgos's "political poems," see López Jiménez, *Julia de Burgos: la canción y el silencio* (San Juan: Fundación Puertorriqueña de las Humanidades, 2002), 74–5. For an overview of Burgos in Puerto Rican

popular culture and criticism, see López Jiménez, "Julia de Burgos: las rutas posibles," in Burgos, *Obra poética I*, 9–24.
61 Lloréns Torres, *Canción de las Antillas*, ed. Ángel Náter (San Juan, PR: Tiempo Nuevo, 2015), 94–5, 100. See Den Tandt's discussion in "All That Is Black."
62 Quotes and references are from *Song of the Simple Truth: Obra Poética Completa: The Complete Poems of Julia de Burgos*, ed. and trans. Jack Agüeros (Willimantic, CT: Curbstone, 1997). For original versions in Spanish, see Burgos, *Obra poética I*.
63 Rita Catrina Imboden, "'Por tierra, mar y estrella': Configuraciones espaciales y búsqueda del sentido en la poesía de Julia de Burgos," in Burgos, *Obra poética II*, 23. See also López Jiménez, *Julia de Burgos*, 77–124.
64 López Jiménez contextualizes this reference to sugar-cane workers within the 1933–4 sugar-cane strike. *Julia de Burgos*, 85–6.
65 Arcadio Díaz Quiñones, *El almuerzo en la hierba: Lloréns Torres, Palés Matos, René Marqués* (Río Piedras: Huracán, 1982), 19–70.
66 Langston Hughes, *The Collected Poems of Langston Hughes*, ed. Arnold Rampersad and David Roessel (New York: Vintage, 1995), 23.
67 Aimé Césaire, *Journal of a Homecoming: Cahier d'un retour au pays natal*, ed. Abiola Irele, trans. N. Gregson Davis (Durham, NC: Duke University Press, 2017), 101, 103.
68 Iris M. Zavala, "Julia de Burgos: poesía y poética de liberación antillana," in Burgos, *Obra poética I*, 39.
69 Jack Agüeros translates this title as "Ay, Ay, Ay, of the Kinky-Haired Negress." I follow Varela-Portas de Orduña's punctuation in Burgos, *Obra poética II*, 71, and offer my own translation of the title.
70 López Jiménez and López-Baralt read the poem as a rejection of the voyeuristic constructions of Black female subjects in Palés's Afro-Caribbean poems. López Jiménez, *Julia de Burgos*, 73–6.
71 López Jiménez, *Julia de Burgos*, 73.
72 Vladimir Mayakovsky, *Selected Poems*, trans. James H. McGavran III (Evanston, IL: Northwestern University Press, 2013), 207, 208, 209.
73 Antonio S. Pedreira, *Insularismo: An Insight into the Puerto Rican Character*, trans. Aoife Rivera Serrano (New York: Ausubo, 2005), 57–67. Benjamin, "The Work of Art," 122.
74 See Juan Carlos Quintero-Herencia's original readings of Burgos's *El mar y tú. Otros poemas* (1954) and "Río Grande de Loíza": "*Es yo misma borrando las riberas del mar*: Teoría de la imagen (archipiélago) en Julia de Burgos," *CENTRO: Journal of the Center for Puerto Rican Studies* 26/2 (2014): 254–87.
75 Lena Burgos-Lafuente, "*Yo, múltiple*: las cartas de Julia de Burgos," in Julia de Burgos, *Cartas a Consuelo* (San Juan, PR: Folium, 2014), xxv. See also Vanessa Pérez Rosario, *Becoming Julia de Burgos: The Making of a Puerto Rican Icon* (Urbana: University of Illinois Press, 2014), 58.

76 Patricia A. Morton, *Hybrid Modernities: Architecture and Representation at the 1931 Colonial Exposition, Paris* (Cambridge, MA: MIT Press, 2000), 129.
77 Morton, *Hybrid Modernities*, 130, 174.
78 José Esteban Muñoz, *Cruising Utopia: The Then and There of Queer Futurity* (New York: New York University Press, 2009), 169. For a series of extended explorations of disidentification, see Muñoz, *Disidentifications: Queers of Color and the Performance of Politics* (Minneapolis: University of Minnesota Press, 1999).

Chapter 4: Carceral, Island, Nation: Cuban Romances in Photography and Fiction

1 Carleton Beals, *The Crime of Cuba* (Philadelphia, PA: J. B. Lippincott, 1933). I quote from the second, 1934 edition.
2 There are competing versions of Carpentier's birthplace. In his interviews with Ramón Chao, Carpentier states squarely that he was born in Havana on December 26, 1904. See Chao, *Conversaciones con Alejo Carpentier* (Madrid: Alianza, 1998), 313. See also Roberto González Echevarría, "Introducción," in Alejo Carpentier, *Los pasos perdidos* (Madrid: Cátedra, 1985), 17–20.
3 Ernest Hemingway, *Men Without Women* (New York: Charles Scribner's Sons, 1927).
4 Regina Kunzel, *Criminal Intimacy: Prison and the Uneven History of Modern American Sexuality* (Chicago, IL: The University of Chicago Press, 2008), 57.
5 Jules R. Benjamin, "The Machadato and Cuban Nationalism, 1928–1932," *The Hispanic American Historical Review* 55/1 (Feb 1975): 66–91. See also Gillian McGillivray, *Blazing Cane: Sugar Communities, Class, and State Formation in Cuba, 1868–1959* (Durham, NC: Duke University Press, 2009), 188–225.
6 Walker Evans, "The Reappearance of Photography," in Alan Trachtenberg (ed.), *Classic Essays on Photography* (New Haven, CT: Leete's Island, 1980), 185.
7 Evans, "The Reappearance of Photography," 188.
8 Gilles Mora and John T. Hill, *Walker Evans: The Hungry Eye* (New York: Harry N. Abrams, 1993), 70.
9 Evans, letter to Hanns Skoller, May 19, 1932, cited in *Walker Evans at Work: 747 Photographs Together with Documents Selected from Letters, Memoranda, Interviews, Notes: With an Essay by Jerry L. Thompson* (New York: Harper & Row, 1982), 74.
10 See Erika Billeter, *Canto a la realidad: Fotografía latinaomaericana, 1860–1993* (Barcelona: Lunwerg, 2003), 30–44; and Esther Gabara,

Errant Modernism: The Ethos of Photography in Mexico and Brazil (Durham, NC: Duke University Press, 2008), 6–9.
11 Cited in *Walker Evans at Work*, 82.
12 Evans, letter to Hanns Skoller, May 19, 1932, cited in *Walker Evans at Work*, 74.
13 Cited as "Tape: Boston interview, 8/4/71" in *Walker Evans at Work*, 82.
14 Cited in *Walker Evans at Work*, 82.
15 The table of contents lists Evans's image titles under "Illustrations / At the End of the Book," and a note on the title page states: "31 Aquatone Illustrations from Photographs by Walker Evans." See Gilles Mora and John T. Hill (eds.), *Walker Evans: Havana 1933* (New York: Pantheon, 1989), 6–7. Evans sought to secure authorial control of the commissioned sequence, as he did eight years later for the sequence included in "Book One" of *Let Us Now Praise Famous Men* (1941). Unlike the Cuban images, the photographs in *Famous Men* are neither numbered nor captioned. See Jessica May, "'The World of an Artist': Walker Evans's American Photographs," in Sharon Corwin, Jessica May, and Terri Weissman, *American Modern: Documentary Photography by Abbott, Evans, and Bourke-White* (Los Angeles: University of California Press, 2010), 60–82.
16 Svetlana Alpers, *Walker Evans: Starting from Scratch* (Princeton, NJ: Princeton University Press, 2020), 112.
17 Mora and Hill, *Walker Evans*, 6.
18 Alan Trachtenberg, *Reading American Photographs: Images as History, Mathew Brady to Walker Evans* (New York: Hill and Wang, 1989), 244.
19 Susan Buck-Morss, *Dreamworld and Catastrophe: The Passing of Mass Utopia in East and West* (Cambridge, MA: MIT Press, 2000), 61.
20 David Luis-Brown, *Waves of Decolonization: Discourses of Race and Hemispheric Citizenship in Cuba, Mexico, and the United States* (Durham, NC: Duke University Press, 2008), 167–8.
21 Hugh Thomas, *Cuba: A History* (London: Penguin, 2010), 344.
22 Beals, *The Crime*, 382. On the "banana wars," see Lester D. Langley, *The Banana Wars: United States Intervention in the Caribbean, 1898–1934* (Lexington: University Press of Kentucky, 1983).
23 Cited in Mora and Hill, *Walker Evans*, 5.
24 Mora and Hill, *Walker Evans*, 5.
25 Ana María Dopico, "Picturing Havana: History, Vision, and the Scramble for Cuba," *Nepantla: Views from the South* 33 (2002): 458, 457.
26 Marlon B. Ross, "Trespassing the Colorline: Aggressive Mobility and Sexual Transgression in the Construction of New Negro Modernity," in Jani Scandura and Michael Thurston (eds.), *Modernism, Inc.: Body, Memory, Capital* (New York: New York University Press, 2001), 49.

27 Gilles Mora, "Havana, 1933: A Seminal Work," trans. Christie McDonald, in *Walker Evans*, ed. Mora and Hill, 22–3.
28 Robin Moore, "Representations of Afrocuban Expressive Culture in the Writings of Fernando Ortiz," *Latin American Music Review / Revista de Música Latinoamericana* 15/1 (1994): 32–54.
29 Frederick B. Pike, *The United States and Latin America: Myths and Stereotypes of Civilization and Nature* (Austin: University of Texas Press, 1992), 258–96.
30 Alpers, *Walker Evans*, 112.
31 William Seabrook, *The Magic Island* (New York: Harcourt, Brace & Co., 1929). See also J. Michael Dash, *Haiti and the United States: National Stereotypes and the Literary Imagination* (New York: St. Martin's Press, 1997), 25, 59.
32 Trachtenberg, *Reading American Photographs*, 285.
33 See Shawn Michelle Smith, "The Evidence of Lynching Photographs," in Dora Apel and Shawn Michelle Smith, *Lynching Photographs* (Berkeley: University of California Press, 2007), 10–41; and Luis Duno Gottberg, *Solventando las diferencias: La ideología del mestizaje en Cuba* (Madrid/Frankfurt am Main: Iberoamericana/Vervuert, 2003), 113–15.
34 *Documentary and Anti-Graphic Photographs: Manuel Alvarez Bravo, Henri Cartier-Bresson, Walker Evans* (Paris: Maison Internationale de la Photographie/Fondation Henri Cartier-Bresson; Lausanne: Musée de l'Élysée, 2004), 74.
35 Luis Araquistáin, *La agonía antillana. El imperialismo yanqui en el mar Caribe. Impresiones de un viaje a Puerto Rico, Santo Domingo, Haití y Cuba* (Madrid: Espasa-Calpe, 1928). Araquistáin borrows extensively from the Cuban historian Ramiro Guerra y Sánchez's *Azúcar y población en las Antillas* (1927). See Arcadio Díaz Quiñones, *Sobre los principios: Los intelectuales caribeños y la tradición* (Bernal: Universidad Nacional de Quilmes, 2006), 343–4.
36 Benjamin, "The Machadato," 72.
37 Carpentier, *¡Écue-Yamba-Ó! Novela afrocubana* (Madrid: Editorial España, 1933). Quotes and references are from *¡Écue-Yamba-Ó!, Obras Completas de Alejo Carpentier*, vol. 1, ed. María Luisa Puga (México: Siglo XXI, 1983), 21–193. On the photographic illustrations included in the novel, and for an extensive discussion of ethnography in Carpentier, see Anke Birkenmaier, *Alejo Carpentier y la cultura del surrealismo en América Latina* (Madrid/Frankfurt am Main: Iberoamericana/Vervuert, 2006), 25–85.
38 Carpentier, "Prólogo," *¡Écue-Yamba-Ó!, Obras Completas*, vol. 1, 23–8. See also Chao, *Conversaciones*, 215–17; and Luis Álvarez, *Alejo Carpentier: la facultad mayor de la cultura* (La Habana: ICAIC/ Fundación Alejo Carpentier, 2016), 70–4.
39 Birkenmaier, *Alejo Carpentier*, 25–7.

40 Birkenmaier, *Alejo Carpentier*, 53.
41 Melanie Nicholson, *Surrealism in Latin American Literature: Searching for Breton's Ghost* (New York: Palgrave Macmillan, 2013), 41, 44.
42 Chao, *Conversaciones*, 219–43.
43 Margarita Serje and Erna von der Walde, "Introducción: una edición cosmográfica," in José Eustasio Rivera, *La vorágine: Una edición cosmográfica*, ed. Serje and Von der Walde (Bogotá: Universidad de los Andes, 2023), xvi. On *La vorágine* as a model for *¡Écue-Yamba-Ó!* see Chao, *Conversaciones*, 30–2.
44 Beals, *The Crime*, 84.
45 Ada Ferrer, *Insurgent Cuba: Race, Nation, and Revolution, 1868–1898* (Chapel Hill: University of North Carolina Press, 1999), 7–10, 195–202.
46 Frantz Fanon, *The Wretched of the Earth*, trans. Richard Philcox (New York: Grove Press, 2004), 3.
47 Pedro Barreda, *The Black Protagonist in the Cuban Novel*, trans. Page Bancroft (Amherst: University of Massachusetts Press, 1979), 34.
48 Vicky Unruh, *Latin American Vanguards: The Art of Contentious Encounters* (Berkeley: University of California Press, 1994), 144.
49 Robert Redfield, "The Folk Society," in Richard Sennett (ed.), *Classic Essays on the Culture of the Cities* (Englewood Cliffs, NJ: Prentice-Hall, 1969), 180–205.
50 The *ñáñigos* are members of the all-male Abakuá secret society. Stephan Palmié, *Wizards and Scientists: Explorations in Afro-Cuban Modernity and Tradition* (Durham, NC: Duke University Press, 2002); and "*Ecué*'s Atlantic: An Essay in Methodology," *Journal of Religion in Africa* 37 (2007): 275–315.
51 Fernando Ortiz, *Hampa afro-cubana. Los negros brujos (apuntes para un estudio de etnología criminal)* (1906). I cite from a later edition (Madrid: Editorial América, 1917). For discussions of this and other works by Ortiz, see Emily A. Maguire, *Racial Experiments in Cuban Literature and Ethnography* (Gainesville: University Press of Florida, 2011); Duno Gottberg, *Solventando las diferencias*, 117–55; and Palmié, *Wizards and Scientists*, 214–17.
52 Maguire, *Racial Experiments*, 84.
53 Echevarría, *Alejo Carpentier: The Pilgrim at Home* (Ithaca, NY: Cornell University Press, 1977), 38–52.
54 Carlos Montenegro, *Hombres sin mujer y otras narraciones*, ed. Imeldo Álvarez (La Habana: Letras Cubanas, 2001).
55 Imeldo Álvarez, "Órbita y sentido de la obra narrativa de Carlos Montenegro," in Montenegro, *Hombres sin mujer*, v–xl.
56 Eduardo Cadava, *Emerson and the Climates of History* (Stanford, CA: Stanford University Press, 1997), 4.
57 Merian C. Cooper, and Ernest B. Schoedsack, dirs., *King Kong*, feat. Fay Wray, Robert Armstrong, and Bruce Cabot, music by Max Steiner (RKO Radio Pictures, United States, 1933).

58 Buck-Morss, *Dreamworld and Catastrophe*, 174.
59 Buck-Morss, *Dreamworld and Catastrophe*, 176.
60 Buck-Morss, *Dreamworld and Catastrophe*, 324n.14.
61 Buck-Morss, *Dreamworld and Catastrophe*, 178, 324n.13.
62 Ortiz, *Hampa afro-cubana*, 34.
63 Fernando Coronil, "Introduction to the Duke University Press Edition: Transculturation and the Politics of Theory: Countering the Center, Cuban Counterpoint," in Ortiz, *Cuban Counterpoint: Tobacco and Sugar*, trans. Harriet de Onís (Durham, NC: Duke University Press, 1995), xliv.
64 Emilio Bejel, *Gay Cuban Nation* (Chicago, IL: University of Chicago Press, 2001), 89.
65 Elizabeth Partridge, *Restless Spirit: The Life and Work of Dorothea Lange* (New York: Viking, 1998), 5.
66 Mora and Hill, *Walker Evans*, 5.
67 Claudia Milian, *Latining America: Black-Brown Passages and the Coloring of Latino/a Studies* (Athens: University of Georgia Press, 2013), 89.
68 Vicky Lebeau, *Psychoanalysis and Cinema: The Play of Shadows* (London: Wallflower, 2001).
69 Edward Dimendberg, *Film Noir and the Spaces of Modernity* (Cambridge, MA: Harvard University Press, 2004), 21–85.

Chapter 5: Surrealism and the Islands: The Practice of Dislocation

1 José-Carlos Mainer, *La Corona hecha trizas (1930–1960)* (Barcelona: Promociones y Publicaciones Universitarias, 1989), 33; Miguel Pérez Corrales, *Entre islas anda el juego (Nueva literatura y surrealismo en Canarias, 1927–1936)* (Teruel: Museo de Teruel, 1999), 118. See also María T. Pao, "Agustín Espinosa's *Crimen*: The Avant-Garde Narrator as Transgressor," *Bulletin of Spanish Studies* LXXX/4 (2003): 427–47. Quotes, references, and translations follow Agustín Espinosa, *Crimen*, ed. Pérez Corrales (Santa Cruz de Tenerife: Interinsular Canaria, 1985).
2 Philippe Forest, *Aragon* (Paris: Gallimard, 2015), 254.
3 Louis Aragon, "Fragments d'une Conférence," *La Révolution surréaliste* 4 (July 15, 1925): 24.
4 Robert Short, "The Politics of Surrealism, 1920–36," in Raymond Spiteri and Donald LaCoss (eds.), *Surrealism, Politics and Culture* (Aldershot: Ashgate, 2003), 21.
5 Juan Manuel Bonet, *Diccionario de las vanguardias en España (1907–1936)* (Madrid: Alianza, 2007), 584–5.
6 On Gutiérrez Albelo in particular, see Isabel Castells Molina, *Un*

"*chaleco de fantasia*" *(1930–1936): La poesía de Emeterio Gutiérrez Albelo* (Las Palmas de Gran Canaria: Cabildo Insular, 1993).

7 José-Carlos Mainer, *Literatura y pequeña burguesía en España (Notas 1890–1950)* (Madrid: Cuadernos para el Diálogo, 1972), 193.
8 Jordana Mendelson and Estrella de Diego, "Political Practice and the Arts in Spain, 1927–1936," in Virginia Hagelstein Marquardt (ed.), *Art and Journals on the Political Front, 1910–1940* (Gainesville: University Press of Florida, 1997), 199.
9 Nilo Palenzuela, "Travesías históricas de *Gaceta de Arte*," in *Gaceta de Arte y su época, 1932–1936* (Islas Canarias: Gobierno de Canarias/CAAM, 1997), 97.
10 Eduardo Westerdahl, "El arte en 'Gaceta de Arte'," in *Gaceta de Arte: Revista internacional de cultura*, 1932–1935, fac. ed. (Vaduz: Topos Verlag, 1981), ix.
11 Palenzuela, "El proceso de las revistas: de 'La Rosa de los Vientos' a 'Índice,'" in Andrés Sánchez Robayna (ed.), *Canarias: Las vanguardias históricas* (Las Palmas de Gran Canaria: CAAM/Gobierno de Canarias, 1992), 26.
12 Derek Sayer, *Prague, Capital of the Twentieth Century: A Surrealist History* (Princeton, NJ: Princeton University Press, 2013), 15.
13 Paul Éluard, *Lettres à Gala: 1924–1948*, ed. Pierre Dreyfus (Paris: Gallimard, 1984), 283.
14 Henri Béhar, *André Breton: Le grand indésirable*, rev. ed. (Paris: Fayard, 2005), 316.
15 Henceforth I give the volume and page number of the Pléiade edition of André Breton's works, *Œuvres complètes*, 4 vols., ed. Marguerite Bonnet et al. (Paris: Gallimard, "Pléiade," 1988–2008). The third and fouth bulletins were published in Brussels (August 1935) and London (September 1936). Georges Sabbag (ed.), *Bulletin international du surréalisme, avril 1935–septembre 1936*, fac. ed. (Lausanne: L'Âge d'Homme, 2009). The Tenerife bulletin figures in the 1981 facsimile edition of *Gaceta de Arte*, 147–55. For the full text of Breton's interview with Índice, see Breton, *Œuvres* 2: 445–50, and Bonnet's notes in *Œuvres* 2: 1587–90. See also Palenzuela, "El proceso de las revistas," 19–38; and the facsimile edition of *Índice*, long believed to have been a single-issue journal: *Índice: Revista de cultura*, ed. Isidro Hernández Gutiérrez (Santa Cruz de Tenerife: TEA/Tenerife Espacio de las Artes, 2019).
16 Domingo Pérez Minik, *Facción española surrealista de Tenerife* (Barcelona: Tusquets, 1975). A Spanish translation of Breton's text appears initially in Buenos Aires as part of a "Contribución surrealista especial para 'Sur'": "El castillo estrellado," *Sur* 19 (April 1936): 69–99. The French version, "Le Château étoilé," figures in *Minotaure* 8 (June 1936): 25–40.
17 Pérez Minik, *Entrada y salida de viajeros* (Santa Cruz de Tenerife: Caja General de Ahorros de Canarias, 2008), 85, 88–9.

18 Hugh Thomas, *The Spanish Civil War*, 3rd rev. ed. (London: Hamish Hamilton, 1977), 125.
19 Pérez Minik, *Facción*, 85.
20 Cited in Pérez Minik, *Facción*, 86–7. See also Espinosa, *Textos (1927–1936)*, ed. Alfonso Armas Ayala and Miguel Pérez Corrales (Santa Cruz de Tenerife: Aula de Cultura, 1980), 270.
21 Short, *The Age of Gold: Surrealist Cinema* (London: Creation, 2003), 141.
22 Pérez Minik, *Facción*, 87.
23 *La Part du jeu et du rêve: Óscar Domínguez et le surréalisme, 1906–1957* (Paris/Marseille: Hazan/Musées de Marseille, 2005), 188–94.
24 Federico Castro Morales, "Teoría y momentos del paisaje," in *Islas raíces: Visiones insulares en la vanguardia de Canarias* (Islas Canarias: Fundación Pedro García Cabrera/Gobierno de Canarias, 2005), 269–70. See also Pilar Carreño, "Deseo en el laberinto: Óscar Domínguez en sus sueños iniciales," in Sánchez Robayna (ed.), *Canarias: Las vanguardias históricas*, 219.
25 Óscar Domínguez, *Cueva de guanches* (1935), oil on canvas, 81 x 60 cm. Museo Nacional Centro de Arte Reina Sofía, Madrid.
26 Roberto Dainotto, *Europe (In Theory)* (Durham, NC: Duke University Press, 2007), 86.
27 Laurence Benaïm, *Marie Laure de Noailles: La vicomtesse du bizarre* (Paris: Grasset, 2001), 415. On Charles de Noailles's financing of *L'Âge d'or*, see Luis Buñuel, *My Last Sigh*, trans. Abigail Israel (New York: Alfred A. Knopf, 1983), 114–26.
28 Carreño, "Deseo en el laberinto," 230–1.
29 Hal Foster, "Compulsive Identity," *October* 57 (Summer 1991): 20.
30 Felipe Fernández-Armesto, *Before Columbus: Exploration and Colonisation from the Mediterranean to the Atlantic, 1229–1492* (Philadelphia: University of Pennsylvania Press, 1987), 207–12; *The Canary Islands after the Conquest: The Making of a Colonial Society in the Early Sixteenth Century* (Oxford: Clarendon, 1982).
31 Yoke-Sum Wong, "Beyond (and Below) Incommensurability: The Aesthetics of the Postcard," *Common Knowledge* 8/2 (Spring 2002): 352.
32 Amanda Boetzkes, *The Ethics of Earth Art* (Minneapolis: University of Minnesota Press, 2010), 145.
33 J.-B. Pontalis, "Le rêve, entre Freud et Breton," in *Entre le rêve et la douleur* (Paris: Gallimard, 1977), 53.
34 Pérez Corrales, "Introducción," *Crimen*, 24. See also the essays included in a special issue dedicated to Agustín Espinosa, "Bajo el signo de Espinosa," *Revista de Filología de la Universidad de La Laguna* 42 (2021).
35 Jean Starobinski, "Freud, Breton, Myers," in *La Relation critique* (Paris: Gallimard, 2001), 381. On Dalí's starry-eyed visit to Freud

in Hampstead in 1938, see David Lomas, *Narcissus Reflected: The Myth of Narcissus in Surrealist and Contemporary Art* (Edinburgh: Fruitmarket Gallery, 2011), 27.

36 Walter Benjamin, "Review of Soupault's *Le Cœur d'or*," in Benjamin, *Selected Writings, Vol. 2, Part 1, 1927–1930*, ed. Michael W. Jennings, Howard Eiland, and Gary Smith, trans. Rodney Livingstone et al. (Cambridge, MA: Harvard University Press, 1999), 66.

37 The Paris surrealists had published their "récits de rêves" in the journals *Littérature* and *La Révolution surréaliste*. See Breton, *Œuvres* 1: 149–55, 180, 887–90, 1209, 1674.

38 Benjamin, "Review of Soupault's *Le Cœur d'or*," 67.

39 See the discussion of *Lancelot 28°–7°* in Chapter 2. I quote and translate from Espinosa, *Lancelot 28°–7° [Guía integral de una Isla Atlántica]*, ed. Nilo Palenzuela (Islas Canarias: Cabildo de Lanzarote, 2002).

40 Espinosa, "Elegía a Ernesto Pestana," *La Gaceta Literaria* 111 (August 1, 1931): 3; Nilo Palenzuela, "Introducción," in Pestana Nóbrega, *Polioramas* (Santa Cruz de Tenerife: Instituto de Estudios Canarios/Universidad de La Laguna, 1990), 7; Sebastián de la Nuez Caballero, "Una revista de vanguardia en Canarias: *La Rosa de los Vientos* (1927–1928)," *Anuario de Estudios Atlánticos* 11 (1965): 197–202.

41 Jacques Derrida, "Freud and the Scene of Writing," in *Writing and Difference*, trans. Alan Bass (London: Routledge, 1978), 259–60.

42 Pérez Corrales, *Agustín Espinosa, entre el mito y el sueño*, vol. 1 (Las Palmas de Gran Canaria: Cabildo Insular, 1986), 444; *Crimen*, 97–101.

43 Henri Lefebvre, *The Production of Space*, trans. Donald Nicholson-Smith (Oxford: Blackwell, 1991), 293–7, 298.

44 Lefebvre, *The Production of Space*, 18.

45 Pérez Corrales, *Agustín Espinosa*, vol. 2, 459–71.

46 Benjamin, "The Author as Producer," in Benjamin, *Selected Writings, Vol. 2, Part 2, 1931–1934*, ed. Michael W. Jennings, Howard Eiland, and Gary Smith, trans. Rodney Livingstone et al. (Cambridge, MA: Harvard University Press, 1999), 770.

47 Michael Löwy, *Fire Alarm: Reading Walter Benjamin's "On the Concept of History"*, trans. Chris Turner (London: Verso, 2016), 11.

48 Foster, "The Artist as Ethnographer?", in George E. Marcus and Fred R. Myers (eds.), *The Traffic in Culture: Refiguring Art and Anthropology* (Berkeley: University of California Press, 1995), 302.

49 Foster, "The Artist as Ethnographer?", 302.

50 Maria Gough, "Paris, Capital of the Soviet Avant-Garde," *October* 101 (Summer 2002): 77.

51 Pestana Nóbrega, *Polioramas*, 41.

52 Marjorie Perloff, *The Futurist Moment: Avant-Garde, Avant Guerre, and the Language of Rupture* (Chicago: University of Chicago Press, 2003), 16–17.

53 Serge Fauchereau, *De Chirico et Savinio: Image métaphysique et image surréaliste* (Paris: L'Échoppe, 2009), 17.
54 Foster, *Compulsive Beauty* (Cambridge, MA: MIT Press, 1993), 27.
55 Benjamin Péret, "La nature dévore le progrès et le dépasse," *Minotaure* 10 (Hiver 1937): 20–1. Foster, *Compulsive Beauty*, 232n.16.
56 Krauss, "The Photographic Conditions of Surrealism," in *The Originality of the Avant-Garde and Other Modernist Myths* (Cambridge, MA: MIT Press, 1986), 90.
57 Krauss, "The Photographic Conditions," 89–90.
58 Yvonne Duplessis, *Le Surréalisme* (Paris: Presses Universitaires de France, 1950), 84.
59 Pao, "Agustín Espinosa's *Crimen*," 447.
60 On Espinosa's reflections around "the problem of finding contemporary images of the Republic," see Miriam M. Basilio, *Visual Propaganda, Exhibitions, and the Spanish Civil War* (New York: Routledge, 2017), 15. See also José Álvarez Junco, *Mater dolorosa. La idea de España en el siglo XIX* (Madrid: Taurus, 2016), 457–64; and *Dioses útiles. Naciones y nacionalismos* (Barcelona: Galaxia Gutenberg, 2016), 174–82.
61 Louis Aragon, Benjamin Péret, and Man Ray, *1929* (Paris: Allia, 2004), 45.
62 Jane Livingston, "Man Ray and Surrealist Photography," in Rosalind E. Krauss and Livingston, *L'Amour fou: Photography and Surrealism* (New York: Abbeville, 1985), 135–45; Vincent Gille, "Lives and Loves," in Jennifer Mundy (ed.), *Surrealism: Desire Unbound* (Princeton, NJ: Princeton University Press, 2001), 160.
63 Breton, *Manifestoes of Surrealism*, trans. Richard Seaver and Helen R. Lane (Ann Arbor: University of Michigan Press, 1969), 39. *Mad love (L'Amour fou)*, trans. Mary Ann Caws (Lincoln: University of Nebraska Press, 1987), 49.
64 Gerardo Diego, *Poesía Española. Antología: 1915–1931* (Madrid: Signo, 1932), 322–4; Federico García Lorca, *Poeta en Nueva York*, ed. María Clementa Millán (Madrid: Cátedra, 1990), 178n.1.
65 See Beatriz Gómez Gutiérrez, "Les symboles d'un bestiaire mythique," in "Les mythes et leurs métamorphoses dans l'œuvre d'Agustín Espinosa (1897–1939)," PhD thesis (Université Paris IV, 2008), 413–48.
66 I discuss Margaret Cohen's notion of "island time" in Chapter 1. See Cohen, "The Chronotopes of the Sea," *The Novel*, vol. 2, ed. Franco Moretti (Princeton, NJ: Princeton University Press, 2006), 659.
67 Malcolm Turvey, *The Filming of Modern Life: European Avant-Garde Film of the 1920s* (Cambridge, MA: MIT Press, 2011), 164.
68 Benjamin, "Surrealism: The Last Snapshot of the European Intelligentsia," in *Selected Writings, Vol. 2, Part 1*, 208–9.
69 Margaret Cohen, *Profane Illumination: Walter Benjamin and the*

Paris of Surrealist Revolution (Berkeley: University of California Press, 1993), 3.
70 Benjamin, "Surrealism," 210.
71 Pérez Corrales includes the fragments, "El traje de novio," "Oda a María Ana, primer premio de axilas sin depillar de 1930," and "El mar," in Espinosa, *Crimen*, 121–8.
72 Pérez Corrales, "Introducción," 11–12, 11n.12.
73 Mainer, *La Edad de Plata*, 210–15.
74 Pérez Corrales, "Introducción," 13–19.
75 Susan Martin-Márquez, *Disorientations: Spanish Colonialism in Africa and the Performance of Identity* (New Haven: Yale University Press, 2008), 18–38; Samuel Llano, *Whose Spain? Negotiating "Spanish Music" in Paris, 1908–1929* (Oxford: Oxford University Press, 2013), 161–91.
76 See José Pierre's "Notice" in Breton, *Œuvres* 2: 1419–20, 95.
77 Breton, *Mad Love*, 41.
78 Breton, *Œuvres* 4: 349. The quote is from the 1928 edition, which Breton expands considerably in the 1945 and 1965 editions.
79 Pedro García Cabrera, "La concéntrica de un estilo en los últimos congresos," *Gaceta de Arte* 31 (November 1934), 2. Included in *Obra selecta*, vol. 3, ed. Nilo Palenzuela and Rafael Fernández Hernández (Madrid: Verbum, 2005), 80.
80 Philippe Soupault, *Last Nights of Paris*, trans. William Carlos Williams (New York: Full Court Press, 1982), 41–2. See Clive Scott's insightful analysis of Soupault's text in *Street Photography: From Atget to Cartier-Bresson* (London: I. B. Tauris, 2007), 174–8, 182–3.
81 Cohen, *The Novel and the Sea* (Princeton, NJ: Princeton University Press, 2010), 119.
82 Derrida, "Freud and the Scene of Writing," 259–60.
83 Domínguez, *Máquina de coser electro-sexual*, 1934, oil on canvas, 99 x 80 cm, private collection.
84 José Pierre, "Óscar Domínguez o el triunfo del fantasma," in Óscar Domínguez: Antológica 1926-1957 (Las Palmas de Gran Canaria: CAAM/Gobierno de Canarias, 1995), 20; Emmanuel Guigon, "Nostalgia del espacio," in *Óscar Domínguez: Antológica 1926–1957*, 35.
85 Jan-Werner Müller, *A Dangerous Mind: Carl Schmitt in Post-War European Thought* (New Haven, CT: Yale University Press, 2003), 88.
86 *Índice* 2 (April 1935): 9, 16.
87 Pérez Corrales, "Introducción," 21–5.
88 José Alcaraz Abellán, Luis Alberto Anaya Hernández, Sergio Millares Cantero, and Miguel Suárez Bosa, "La Guerra Civil en Gran Canaria," in Miguel Ángel Cabrera Acosta (ed.), *La Guerra Civil en Canarias* (La Laguna: Francisco Lemus, 2000), 19–46.
89 Pérez Corrales, "Introducción," 20, 25.

90 C. Brian Morris, "De vientos a tempestades: los dos números de *Índice* (marzo y abril de 1935)," in *Índice: Revista de cultura*, 21.
91 Carreño, "Deseo en el laberinto," 230.

Chapter 6. Difficult Dialogues: Surrealism in the Francophone and Hispanic Caribbean

1 László Moholy-Nagy, dir., *Impressionen vom alten Marseiller Hafen (Vieux Port)* (1929).
2 Tamar Garb, "Gauguin and the Opacity of the Other: The Case of Martinique," in Belinda Thomson (ed.), *Gauguin: Maker of Myth* (London: Tate, 2010), 25; Claude McKay, *Romance in Marseille*, ed. Gary Edward Holcomb and William J. Maxwell (New York: Penguin, 2020), 29. See in particular Holcomb and Maxwell, "A Note on the Text," xli.
3 Throughout this chapter I give the volume and page number of the Pléiade edition of André Breton's works, *Œuvres complètes*, 4 vols., ed. Marguerite Bonnet et al. (Paris: Gallimard, "Pléiade," 1988–2008). See Bonnet, "Chronologie," in André Breton, *Œuvres 2*: lxiii; and Béhar, *André Breton*, 375–7.
4 Rosemary Sullivan, *Villa Air-Bel: The Second World War, Escape, and a House in France* (London: John Murray, 2006), 181–211, 300–2, 328–39; Martica Sawin, *Surrealism in Exile and the Beginning of the New York School* (Cambridge, MA: MIT Press, 1995), 104–47; Peggy Guggenheim, *Out of This Century: Confessions of an Art Addict* (London: André Deutsch, 1979), 227–9.
5 *Wifredo Lam: Cartografía íntima* (Madrid: Círculo de Bellas Artes, 2003), 40–1. See also Jean-Louis Paudrat, "Biography," in Catherine David (ed.), *The EY Exhibition: Wifredo Lam* (London: Tate, 2016), 203–7.
6 Sullivan, *Villa Air-Bel*, 297.
7 Sawin, *Surrealism in Exile*, 130–5. See also Adam Biro and René Passeron (eds.), *Dictionnaire général du surréalisme et de ses environs* (Paris: Presses Universitaires de France, 1982), 122, 226; and Sullivan, *Villa Air-Bel*, 322–3. A definitive version of the *Jeu* is reproduced in the New York-based surrealist journal *VVV*, 2–3 (March 1943).
8 Étienne-Alain Hubert, "*Fata Morgana*. Notice," in Breton, *Œuvres 2*: 1786–7. See also Annick Louis, "La traduction dans la revue *Lettres françaises* (1941–1947) de Roger Caillois," in Roland Béhar and Gersende Camenen (eds.), *Scènes de la traduction France-Argentine* (Paris: Rue d'Ulm, 2020), 97–116.
9 Breton, *Œuvres 2*: 1185.
10 Breton, *Œuvres 2*: 1187.
11 Breton, "Crisis of the Object *(1936)*," in Breton, *Surrealism and*

Painting, trans. Simon Watson Taylor (Boston: Museum of Fine Arts, 2002), 275–81.
12 Béhar, *André Breton*, 382–3, 387–8.
13 Claude Lévi-Strauss, *Tristes Tropiques* (Paris: Plon, 1955), 9–34.
14 Lévi-Strauss, *Tristes Tropiques*, trans. John Weightman and Doreen Weightman (London: Penguin, 2011), 24.
15 Quotes and references are from Breton, *Martinique: Snake Charmer*, trans. David S. Seaman (Austin: University of Texas Press, 2008). Occasional inserts in French are from Breton, *Martinique charmeuse de serpents: Avec textes et illustrations d'André Masson*, Œuvres 3: 365–410.
16 Breton, Œuvres 3, 1262–3.
17 Marguerite Bonnet, "Notice" on *Martinique charmeuse de serpents*, in Breton, Œuvres 3: 1256.
18 Breton, "Prestige d'André Masson," *Minotaure* 12–13 (May 1939): 13.
19 Cited in Bonnet, "Notice," in Breton, Œuvres 3: 1258.
20 Serge Fauchereau, *Avant-Gardes du XXe siècle: Arts & littérature, 1905–1930* (Paris: Flammarion, 2016), 116. On collage and *papier collé* as techniques of gluing, see Mark Antliff and Patricia Leighten, *Cubism and Culture* (New York: Thames & Hudson, 2001), 159–96.
21 Louis-Philippe May, *Histoire économique de La Martinique (1635–1763)* (Paris: Marcel Rivière, 1930). Breton, Œuvres 3: 393.
22 Mireille Rosello, "*Martinique, charmeuse de serpents*: 'Changer la vue' sous les Tropiques," *L'Esprit Créateur* 36/4 (Winter 1996): 64, 66.
23 W. S. Van Dyke, dir., *White Shadows in the South Seas*, feat. Monte (Gerard Montgomery) Blue and Raquel Torres (Cosmopolitan Productions, United States, 1928); Frederick O'Brien, *White Shadows in the South Seas* (New York: The Century Co., 1919). In one of his Mexico conferences, on Buñuel's *Un Chien andalou*, Breton lists *Ombres blanches* among other films that appear recurrently in texts where he discusses the cinematographer: Chaplin's films, *Peter Ibbetson, Battleship Potemkin*, and *L'Âge d'Or*. Œuvres 2: 1263–7.
24 Breton, "Introduction to the Discourse on the Paucity of Reality," trans. Richard Sieburth and Jennifer Gordon, *October* 69 (Summer 1994): 134, 143.
25 Gregson Davis, *Aimé Césaire* (Cambridge: Cambridge University Press, 1997), 13.
26 Alain Blérald, *Négritude et Politique aux Antilles* (Paris: Caribéennes, 1981), 15.
27 Blérald, *Négritude et Politique*, 29–38. See also Patrick Chamoiseau, and Raphaël Confiant, *Lettres créoles: Tracées antillaises et continentales de la littérature: Haïti, Guadeloupe, Martinique, Guyane, 1635–1975* (Paris: Gallimard, 1999), 159–63.
28 V. Y. Mudimbe, *The Invention of Africa: Gnosis, Philosophy, and the*

Order of Knowledge (Bloomington: Indiana University Press, 1988), 83. See also Davis, *Aimé Césaire*, 7, 8.
29 Leo Frobenius, *Kulturgeschichte Afrikas: Prolegomena zu einer historischen Gestaltlehre* (Zürich, Phaidon, 1933), published in French as *Histoire de la civilisation africaine*, trans. H. Back and D. Ermont (Paris, Gallimard, 1936).
30 Davis, *Aimé Césaire*, 8–9.
31 Gerard Aching, *Masking and Power: Carnival and Popular Culture in the Caribbean* (Minneapolis: University of Minnesota Press, 2002), 21–2.
32 Kora Véron, *Aimé Césaire* (Paris: Seuil, 2021), 138–40.
33 Aimé Césaire, "Ma poésie est née de mon action." Interview with Francis Marmande, *Le Monde des livres*, March 17, 2006. Cited in Véron, *Aimé Césaire*, 139.
34 Svetlana Boym, *The Future of Nostalgia* (New York: Basic Books, 2001), xv, xvi.
35 Patricia M. Northover and Michaeline A. Crichlow, "Notes on the Journey toward the Future: Négritude, Abject Blackness, and the Emancipatory Force of Spectrality," *The South Atlantic Quarterly* 115/3 (July 2016): 548.
36 A. James Arnold, "Introduction," in Césaire, *The Original 1939 Notebook of a Return to the Native Land. Bilingual Edition*, trans. and ed. Arnold and Clayton Eshleman (Middleton, CT: Wesleyan University Press, 2013), xi. Quotes and references are from this edition. I have consulted Césaire, *Journal of a Homecoming: Cahier d'un retour au pays natal*, ed. F. Abiola Irele, trans. N. Gregson Davis (Durham, NC: Duke University Press, 2017) for exegetical clarification on several passages.
37 Virgilio Piñera, *La isla en peso. The Whole Island*, trans. Mark Weiss (Exeter: Shearsman Books, 2010), 6–7.
38 In the 1939 version, the third stanza is a single sentence, "L'affreuse inanité de notre raison d'être," which in the 1956 version appears appended at the end of a rewriting of the stanza. Arnold and Eshleman translate "l'affreuse inanité" as "the dreadful inanity," while Davis renders "the appalling emptiness." Césaire, *Journal of a Homecoming*, 79.
39 Césaire, *Resolutely Black: Conversations with Françoise Vergès* (Cambridge: Polity, 2020), 1.
40 Davis, "Translator's Preface," in Césaire, *Journal of a Homecoming*, xiii.
41 Arnold and Eshleman in Césaire, *The Original 1939 Notebook*, 60.
42 Gary Wilder, *Freedom Time: Negritude, Decolonization, and the Future of the World* (Durham, NC: Duke University Press, 2015), 29–32; Chamoiseau and Confiant, *Lettres créoles*, 158–9.
43 Garb, "Gauguin and the Opacity of the Other," 24.

44 Arnold and Eshleman, "Notes on the Translation," in Césaire, *The Original 1939 Notebook*, 62.
45 Kaiama L. Glover, *Haiti Unbound: A Spiralist Challenge to the Postcolonial Canon* (Liverpool: Liverpool University Press, 2017), xi.
46 "Aimé Césaire, la voix de la fraternité," *À Voix nue*, 1976. Radio interview with Édouard Maunick, France Culture, November 16, 2020.
47 Césaire, "Entretien avec Aimé Césaire par Jacqueline Leiner," in *Tropiques*, vol. 1, fac. ed. (Paris: Jean-Michel Place, 1978), v.
48 René Ménil, "Pour une lecture critique de *Tropiques*," in *Tropiques*, vol. 1, xxv–xxxv; Césaire, "Entretien," v–xxiv.
49 Véron, *Aimé Césaire*, 89.
50 Quotes and references from the *Tropiques* essays are from Suzanne Césaire, *The Great Camouflage. Writings of Dissent (1941–1945)*, ed. Daniel Maximin, trans. Keith L. Walker (Middleton, CT: Wesleyan University Press, 2012). Occasional inserts in French are from Césaire, *Le Grand Camouflage. Écrits de dissidence (1941–1945)*, ed. Daniel Maximin (Paris: Seuil, 2009). The original essays appeared in *Tropiques: Revue culturelle* (in the double 6–7, February 1943, issue, *Tropiques: Revue trimestrielle*): "Léo Frobenius et le problème des civilisations," 1 (April 1941), 27–36; "Alain et l'esthétique," 2 (July 1941), 53–61; "André Breton, poète ...," 3 (October 1941), 32–7; "Misère d'une poésie. John Antoine-Nau," 4 (January 1942), 48–50; "Malaise d'une civilisation," 5 (April 1942), 43–9; "1943: Le surréalisme et nous," 8–9 (October 1943), 14–18; "Le grand camouflage," 13–14 (1945), 267–73.
51 Hans-Jürgen Heinrichs, *Leo Frobenius: Anthropologue, explorateur, aventurier*, trans. Catherine and Marie-Pierre Emery (Paris: L'Harmattan, 1999), 101–48.
52 Christina Kullberg, *The Poetics of Ethnography in Martinican Narratives: Exploring the Self and the Environment* (Charlottesville: University of Virginia Press, 2013), 38.
53 Gerard Aching, "In Hazardous Pursuit of Chance: Mapping the Surrealists' Caribbean Sojourn (1941)," in María T. Pao and Rafael Hernández-Rodríguez (eds.), *¡Agítese bien! A New Look at the Hispanic Avant-Gardes* (Newark, DE: Juan de la Cuesta, 2002), 189–211.
54 Breton, *Œuvres* 1: 753 (my translation); and *Œuvres* 2: 687. *Mad love (L'Amour fou)*, trans. Mary Ann Caws (Lincoln: University of Nebraska Press, 1987), 19.
55 Wilder, *Freedom Time*, 107–12; Paul Butel, *Histoire des Antilles françaises* (Paris: Perrin, 2007), 462–7.
56 Wilder, *Freedom Time*, 29–32.
57 Anny-Dominique Curtius, *Suzanne Césaire: Archéologie littéraire et artistique d'une mémoire empêchée* (Paris: Karthala, 2020), 56–7.
58 Curtius, *Suzanne Césaire*, 59.
59 Béhar, *André Breton*, 388; Breton, *Œuvres* 4: xxii–xxiii.

60 Eric Paul Roorda, *The Dictator Next Door: The Good Neighbor Policy and the Trujillo Regime in the Dominican Republic, 1930–1945* (Durham, NC: Duke University Press, 1998), 1–5, 21–2. See also Richard Lee Turits, *Foundations of Despotism: Peasants, the Trujillo Regime, and Modernity in Dominican History* (Stanford, CA: Stanford University Press, 2003), 80–8; and Vicente Llorens, *Memorias de una emigración: Santo Domingo, 1939–1945* (Barcelona: Ariel, 1975), 86–96.

61 Richard Lee Turits, "A World Destroyed, A Nation Imposed: The 1937 Haitian Massacre in the Dominican Republic," *Hispanic American Historical Review* 82/3 (August 2002): 591–2.

62 Breton, interview with Eugenio F. Granell, *La Nación*, Ciudad Trujillo, May 28, 1941. See Breton, *Œuvres* 3: 121–5, 1201–2; Béhar, *André Breton*, 382–3, 387–8; and Llorens, *Memorias de una emigración*, 39–41, 73–4.

63 Quotes and references are from Eugenio F. Granell, *Isla cofre mítico* (San Juan, PR: Editorial Caribe, 1951).

64 Julien Gracq, *André Breton* (Paris: Librairie José Corti, 1948); Malcolm de Chazal, *Sens-plastique* (Paris: Gallimard, 1948); Granell, *Isla cofre mítico*, 11–18, 32.

65 Granell, *Isla cofre mítico*, 21, 24–5, 35–6.

66 Cinzia Sartini-Blum, "Incorporating the Exotic: From Futurist Excess to Postmodern Impasse," in Patrizia Palumbo (ed.), *A Place in the Sun: Africa in Italian Colonial Culture from Post-Unification to the Present* (Berkeley: University of California Press, 2003), 146–55.

67 Quotes and references are from Helena Benitez, *Wifredo and Helena: My Life with Wifredo Lam, 1939–1950* (Lausanne: Acatos, 1999). Holzer divorced Lam in 1951. Benitez is her new married name.

68 For a queer reading of Cabrera, see Sylvia Molloy, "Disappearing Acts: Reading Lesbian in Teresa de la Parra," in Emilie Bergmann and Paul Julian Smith (eds.), *Entiendes? Queer Readings, Hispanic Writings* (Durham, NC: Duke University Press, 1995), 230–56. See also José Quiroga's chapter, "Queer Desires in Lydia Cabrera," in *Tropics of Desire: Interventions from Queer Latino America* (New York: New York University Press, 2000), 76–123.

69 Maguire, *Racial Experiments*, 48–51. Fernando Coronil, "Introduction to the Duke University Press Edition: Transculturation and the Politics of Theory: Countering the Center, Cuban Counterpoint," in Fernando Ortiz, *Cuban Counterpoint: Tobacco and Sugar*, trans. Harriet de Onís (Durham, NC: Duke University Press, 1995), ix–lxix.

70 Alejo Carpentier, "Wifredo Lam en Nueva York," *Información* (June 21, 1944): 14. Cited in *Wifredo Lam: Cartografía íntima*, 43.

71 Lowery Stokes Sims, *Wifredo Lam and the International Avant-Garde, 1923–1982* (Austin: University of Texas Press, 2002), 71, 73–4, 79–80.

72 I quote and translate from Benjamin Péret, "Prefacio," in Césaire,

Retorno al país natal. Prefacio de Benjamin Péret. Ilustraciones de Wifredo Lam. Traducción de Lydia Cabrera (La Habana: Molina y Cía, 1943). Lourdes Arencibia's edition includes both Cabrera's text and Arencibia's translations of later versions of *Cahier: Retorno al país natal*, trans. Lydia Cabrera and Lourdes Arencibia (Zamora: Fundación Sinsonte, 2007).
73 Péret, "La nature dévore le progrès et le dépasse," *Minotaure* 10 (1937): 20–1.
74 Emily Maguire, "Two Returns to the Native Land: Lydia Cabrera Translates Aimé Césaire," *Small Axe* 42 (2013): 126.
75 Maguire, "Two Returns," 127.
76 Katerina Gonzalez Seligmann, "Cabrera's Césaire: The Making of a Trans-Caribbean Zone," *MLN* 134 (2019): 1038.
77 Seligmann, "Cabrera's Césaire," 1054.
78 Charles Forsdick, "Translation in the Caribbean, the Caribbean in Translation," *Small Axe* 48 (2015): 158.
79 Sims, *Wifredo Lam*, 75. Julia P. Herzberg, "Wifredo Lam: The Development of a Style and World View, The Havana Years, 1941–1952," in *Wifredo Lam and His Contemporaries, 1938–1952* (New York: The Studio Museum in Harlem, 1992), 40.
80 Sawin, *Surrealism in Exile*, 124–5; Benitez, *Wifredo and Helena*, 19, 38; Sullivan, *Villa Air-Bel*, 297.
81 Herzberg, "Wifredo Lam," 39.
82 Sims, *Wifredo Lam*, 33.
83 Véron, *Aimé Césaire*, 263–72.
84 Langston Hughes, "White Shadows in a Black Land," *The Crisis* 39/5 (May 1932): 157; J. Michael Dash, *Haiti and the United States: National Stereotypes and the Literary Imagination*, 2nd ed. (New York: St. Martin's Press, 1997), 52.
85 Pierre Mabille, *Le Miroir du merveilleux* (Paris: Le Sagittaire, 1940), reissued with a preface by Breton and drawings by Masson (Paris: Minuit, 1962). See the English translation of the 1962 edition, *Mirror of the Marvelous: The Surrealist Reimagining of Myth*, trans. Jody Gladding (Rochester, VT: Inner Traditions, 1998). On Mabille's relations with the Paris surrealists, see Remy Laville, *Pierre Mabille: Un compagnon du surréalisme* (Clermont-Ferrand: Faculté des Lettres et Sciences Humaines, Université Clermont-Ferrand II, 1983), 15–38. For Breton's response to the book, see Bonnet, "Chronologie," in Breton, *Œuvres* 2: lxii.
86 Mabille, "La Jungle," *Tropiques* 12 (January 1945), 183. I cite from "The Jungle," in David (ed.), *The EY Exhibition*, 178.
87 Dewitt C. Peters, "Founders of the Art Center," in Marie-José Nadal-Gardère, and Gérald Bloncourt, *La Peinture Haïtienne: Haitian Arts*, trans. Elizabeth Bell (Paris: Nathan, 1986), 35, 37.
88 Étienne-Alain Hubert, "Chronologie," in Breton, *Œuvres* 3: xxix.

Michael Richardson, "Introduction," in *Refusal of the Shadow: Surrealism and the Caribbean*, trans. Krzysztof Fijalkowski and Richardson (London: Verso, 1996), 20.
89 Richardson, "Introduction," 20–1.
90 Richardson, "Introduction," 21.
91 Dash, *Culture and Customs of Haiti* (Westport, CT: Greenwood Press, 2001), 104–5.
92 Nadal-Gardère and Bloncourt, *La Peinture Haïtienne*, 73.
93 Llorens, *Memorias de una emigración*, 74–5. On Aristy's work more broadly in the context of Trujillo's regime, see Anne Garland Mahler, "South-South Organizing in the Global Plantation Zone: Ramón Marrero Aristy, the *novela de la caña*, and the Caribbean Bureau," *Atlantic Studies* 16/2 (2019): 236–60.
94 Dash, *Culture and Customs*, 99–103. See also Anke Birkenmaier, *The Specter of Races: Latin American Anthropology and Literature between the Wars* (Charlottesville: University of Virginia Press, 2016), 86–93.
95 François Leperlier, "La Solution Poétique," in Clément Magloire-Saint-Aude, *Dialogue de mes lampes et autres textes: Œuvres completes*, ed. Leperlier (Paris: Jean Michel Place, 1998), 11–12, 16–17.
96 Magloire-Saint-Aude, *Dialogue de mes lampes*, 36, 56. For an extensive discussion of the trope of opacity in Magloire-Saint-Aude, see Stéphane Martelly, *Le Sujet opaque: Une lecture de l'œuvre poétique de Magloire-Saint-Aude* (Paris: L'Harmattan, 2001), 72–80, 91–111.
97 McKay, *Romance in Marseille*, 29. Césaire, *The Great Camouflage*, 46.

Epilogue: Preface to the 1950s

1 Karl Marx and Friedrich Engels, *The Communist Manifesto*, trans. Samuel Moore (London: Penguin, 2002).
2 References are to Alejo Carpentier, "On the Marvelous Real in America," in Lois Parkinson Zamora and Wendy B. Faris (eds.), *Magical Realism: Theory, History, Community*, trans. Tanya Huntington and Parkinson Zamora (Durham, NC: Duke University Press, 1995), 75–88.
3 T. J. Demos, *The Exiles of Marcel Duchamp* (Cambridge, MA: MIT Press, 2007), 199.
4 Demos, *The Exiles*, 203.
5 On the process of the Haitian Revolution and Haitian Independence, see especially Jean Casimir, *The Haitians: A Decolonial History*, trans. Laurent Dubois (Chapel Hill: University of North Carolina Press, 2020); and Eduardo Grüner, *The Haitian Revolution: Capitalism, Slavery, and Counter-Modernity*, trans. Ramsey McGlazer (Cambridge: Polity, 2020). See also Susan Buck-Morss, *Hegel, Haiti, and Universal*

History (Pittsburgh, PA: University of Pittsburgh Press, 2009); Sibylle Fischer, *Modernity Disavowed: Haiti and the Cultures of Slavery in the Age of Revolution* (Durham, NC: Duke University Press, 2004); and Laurent Dubois, *A Colony of Citizens: Revolution and Slave Emancipation in the French Caribbean, 1787–1804* (Chapel Hill: University of North Carolina Press, 2004).
 6 For two critiques of Carpentier's attacks on European Surrealism, see Michael Richardson, "Introduction," in *Refusal of the Shadow: Surrealism and the Caribbean*, trans. Krzysztof Fijalkowski and Richardson (London: Verso, 1996), 12–13; and René Ménil, "Sur la théorie du 'réel merveilleux'," in *Antilles déjà jadis précédé de Tracées* (Paris: Jean Michel Place, 1999), 284–8. See also María del Pilar Blanco, *Ghost-Watching American Modernity: Haunting, Landscape, and the Hemispheric Imagination* (New York: Fordham University Press, 2012), 34–41; María Clara Bernal Bermúdez, *Más allá de lo real maravilloso: El surrealismo y el Caribe*, 2nd ed. (Bogotá: Ediciones Uniandes, 2021); and Alicia Llarena, *Realismo Mágico y Lo Real Maravilloso: una cuestión de verosimilitud* (Gaithersburg, MD/Las Palmas: Hispamérica/Universidad de Las Palmas de Gran Canaria, 1997), 273–302.
 7 Jean Franco, *The Decline and Fall of the Lettered City: Latin America in the Cold War* (Cambridge, MA: Harvard University Press, 2002), 161–2.
 8 Franco, *The Decline and Fall*, 166.
 9 Jacques Roumain, *Le Sacrifice du tambour-Assôtô(r)* (Port-au-Prince: Bureau d'Ethnologie de la République d'Haïti, 1943). See Anke Birkenmaier's important discussions in *The Specter of Races: Latin American Anthropology and Literature between the Wars* (Charlottesville: University of Virginia Press, 2016), 75–110.
10 Franco, *The Decline and Fall*, 167.
11 Franco, *The Decline and Fall*, 167–8.
12 Jonas Mekas, "A Few Notes on Maya Deren," in Shelley Rice (ed.), *Inverted Odysseys: Claude Cahun, Maya Deren, Cindy Sherman* (Cambridge, MA: MIT Press, 1999), 131.
13 Annette Michelson, "The Art of Moving Shadows," in *On the Eve of the Future: Selected Writings on Film* (Cambridge, MA: MIT Press, 2017), 45–6.
14 Sarah Keller, *Maya Deren: Incomplete Control* (New York: Columbia University Press, 2014), 135.
15 Lydia Platón Lázaro, *Defiant Itineraries: Caribbean Paradigms in American Dance and Film* (New York: Palgrave Macmillan, 2015), 1.
16 Maya Deren, *Divine Horsemen: The Living Gods of Haiti* (Kingston, NY: McPherson, 1983), 5. See Platón Lázaro's illuminating discussions in *Defiant Itineraries*, 113–53. On two hypothetical explanations for Deren's postponement of the montage and production stages, see

Massimiliano Mollona, "Seeing the Invisible: Maya Deren's Experiments in Cinematic Trance," *October* 149 (Summer 2014): 178–9.
17 Platón Lázaro, *Defiant Itineraries*, 29.
18 Mollona, "Seeing the Invisible," 162.
19 Michel Leiris, "Préface," in Alfred Métraux, *Le Vaudou haïtien* (Paris: Gallimard, 1958), 7, 9. See also Étienne Barilier, *Alfred Métraux ou la terre sans mal* (Lausanne: Presses Polytechniques et Universitaires Romandes, 2019).
20 Sidney W. Mintz, "Introduction to the Second English Edition," in Métraux, *Voodoo in Haiti*, trans. Hugo Charteris (New York: Schocken, 1972), 3. See also Birkenmaier, *The Specter of Races*, 93–8.
21 James Clifford, "On Ethnographic Surrealism," in *The Predicament of Culture: Twentieth-Century Ethnography, Literature, and Art* (Cambridge, MA: Harvard University Press, 1988), 148.
22 Aimé Césaire, *Discourse on Colonialism*, trans. Joan Pinkham (New York: Monthly Review, 2000), 32.
23 Tendayi Sithole, *The Black Register* (Cambridge: Polity, 2020), 68.
24 Ramón Chao, *Conversaciones con Alejo Carpentier* (Madrid: Alianza, 1998), 177.
25 Mollona, "Seeing the Invisible," 179.
26 Arjun Appadurai, *Modernity at Large: Cultural Dimensions of Globalization* (Minneapolis: University of Minnesota Press, 1996), 64–5.

Index

Page numbers in *italics* denotes an illustration

1929 (pornographic "calendar") 193
 see also Aragon, Louis; Péret, Benjamin; Ray, Man

Abakuá order 73, 76, 283n50
 see also ñáñigo(s)
Abd el-Krim *see* rifeños
Abstract Expressionism 237
Aching, Gerard 217–18
Adorno, Theodor W. 6, 105
aesthetic(s)
 affiliations with *poesía negra* in Palés 107
 of *arte nuevo* 47
 avant-garde 226
 avant-gardism 74
 "collage aesthetic" (Perloff) 109
 condensation in *Martinique charmeuse de serpents* 211
 conditions in 1930s Puerto Rico 131
 contexts of Atlantic Hispanism 105
 of cultural appropriation 75
 of Domínguez's *Cueva de guanches* 180
 and ethical tenets of 1924 *Manifesto* 184
 Evans as enabler 136
 Harlem Renaissance 117
 hispanismo in Maeztu 104
 internationalist in Cuban avant-garde 48
 memories of African lives in Burgos 128
 nativist in Palés 108
 norms set by Paris 78
 photographic/film
 cinematic montage in *Crimen* 191
 of composition and social decomposition in Buñuel 204
 of the Great Depression 148
 of lynching photographs 144
 practices and poetics of photomontage in *Crimen* 198
 and political divides of the Spanish Republic 43

aesthetic(s) (cont.)
 Rousseau as precursor to
 Surrealism 214
 in Surrealism
 Espinosa's mobilization of
 ideology 190
 of perception 180
 of subversive performance
 188
 symbolist and *postmodernista*
 41
 transactions with metropolitan
 Hispanism 60
 transfiguration in *Crimen* 204
 twentieth-century ideology 206
 universalism in *La Rosa de los
 Vientos* 174
 of variations in *Crimen* 199
aestheticization
 of "minor" and excluded
 communities 75
 of politics in Palés 110
 of scene in Palés's "Candombe"
 113
aesthetico-political
 attitudes in Hispanic Atlantic 32
 commitments, insular journals,
 and manifestos 3
 demands of Atlantic Hispanism
 57
 disarticulated and *rearticulated* 8
 disruption 5
 energy 17
 experience 6
 national, regional, and insular
 demands 2
 performances in 1930s
 Antilleanist discourses 103
 potential of Afro-Cuban
 performances 75
 processes in Puerto Rican and
 Caribbean avant-gardism 86
 regime in *Lancelot 28°–7°* 70
 reinvention in *El milagro de
 Anaquillé* 78

reorientation of Antillean poetics
 133
affirmation *see* (self-)affirmation
Africa/African(ness)/Africanized
 and "anachronistic space"
 (McClintock) 111
 ancestors in *¡Écue-Yamba-Ó!*
 154
 backward in Salinas 37
 British colonialism in 37
 in *Cahier* 218, 222–4
 Castilian dominance 65
 displaced
 constructions of 13
 in the diaspora 58
 images onto Afro-Caribbeans
 110
 and Europe in Salinas 37–8
 fantasies of distant 55
 gendered discourses of 13
 interests in Maeztu 104
 invention of (Mudimbe)
 291n28
 and Latin America, exodus
 of French writers and
 ethnographers to 248
island(s)
 as extension of Occidental
 "world literature" 203
 insular appendix 189
 island-nation 14
mask(s)
 Black and White (*Noire et
 blanche*) 193
 Les Demoiselles d'Avignon
 (Clifford) 252
 in *El milagro de Anaquillé* 76,
 83–4,
 in "The Negro Speaks of Rivers"
 128
 and "non-European" Hispanism
 58–60
"scramble for Africa" 30, 180
 Berlin Conference (1884–5)
 30

signifier 58
 in Suzanne Césaire's reading of
 Frobenius (Kullberg) 225
 in *Tropiques* 217
 in *Tuntún*
 Black 114
 environment, pastiche of 112
 sublimated space 114
 symbols of origins, 113
 timeless difference 115
 "welding" with Europeans
 (Ortiz) 163
 see also North Africa
African American/Afro-American,
 60, 85, 102–3, 128, 253,
African war *see* wars
Africanism 252
Afro-Antilleanism/Afro-Antillean
 32, 113
 poetry 107, 108
Afro-Caribbean
 exoticism 78
 nationhood 58
 poetry 101–3, 107
 racialized female bodies in
 102–3
Afro-Cuban(s)
 avant-gardism 106
 in New York and Paris 73
 culture 14
 and *¡Écue-Yamba-Ó!* 75–80
 folklore 73–4
 oppression endured by 73
Agamben, Giorgio 70
L'Âge d'or (film) *see* Buñuel, Luis
agonistic/agonism 4–5, 89
 and avant-garde 4
 distinction between antagonism
 and 4
 Mouffe on politics and 89
 and Pedreira 89
 "third dimension" in
 Insularismo 95
 see also Mouffe, Chantal;
 antagonism(s); antagonistic

Aguiar Gil, Jorge 66
Alain (Émile-Auguste Chartier)
 System of the Fine Arts (*Système
 des Beaux-Arts*) 225–6
Alberti, Rafael 34, 172, 205
 Marinero en tierra 197
Aleixandre, Vicente 172
allergy/allergies/allergic
 reaction 41, 53–4
 Allergie 53
 allergische Reaktion 53
 critical hypersensitivity 41
 cultural allergens 54
 discursive 65
 tropical 53–5
Alonso, Dámaso 43
Alpers, Svetlana 64, 138, 143
alterity 187, 188
 exotic 50
 in Freud 57
Altolaguirre, Manuel 34, 172
Álvarez Bravo, Manuel 137, 142
 The Daydream 144
anachronism 188
anachronistic space 111
andalucismo 107, 197
aniñamiento 39
antagonism(s)
 cosmopolitan 8
 cultural and political in the
 1927–37 period 54
 distinction between agonism
 and 4
 fundamental principles of enmity
 and (*La Habanera* and
 Schmitt) 55
 in *ismos* 11
 political and cultural in
 Insularismo 94
 and political enmity 22
antagonistic 4–5, 30, 88, 89, 123
anticlericalism
 among French and Spanish
 surrealists 192
 Southern European 192

anti-fascism
 fighters in Burgos's "Ochenta mil" 126
 hemispheric and Atlantic allies' rebellion 224
 resistance 17
Antilleanism/Antillean(ist)/Antilleanity
 1930s discourses 103
 "agony" in *La agonía antillana* 146
 archipelago, Black and *mulato* subjects 124
 daily life survival, "minoritarian subjects" 133
 in *¡Écue-Yamba-Ó!*
 character and tradition 151
 male reproductive 156
 environments, capitalist exploitation in 127
 landscape constructions 126
 poetic(s)
 aesthetico-political reorientation of 133
 of fragmentation 101–33
 nationalist and 102
 new in 1930s 132
 pan-Antillean 124
 provincial *costumbrismo* and 109
 and Puerto Rican anticolonial declaration 130
 Spenglerian, pan-Caribbean, nationalist 114
 in "West Indies Ltd." 122
 see also Afro-Antilleanism/Afro-Antilliean; Afro-Caribbean; Afro-Cuban(s)
Antilles 8
 in *Cahier* 220–1, 224
 Lesser Antilles in *Cahier* 222
Appadurai, Arjun 254
Aragon, Louis 175, 187, 193
 Les Dernières Nuits de Paris 201
 Passage de l'Opéra 196
 Le Paysan de Paris 201
 talk at Residencia de Estudiantes, Madrid 172
 Une Vague de rêves (*A Wave of Dreams*) 172
 see also 1929 (pornographic "calendar")
Araquistáin, Luis
 La agonía antillana 146
archaic
 authority 24
 as avant-garde construction 31
 in *Crimen*
 childhood scenes 195
 regressions 201
 empowerment of the mapper 64
 fantasies of premodern and precolonial innocence 110
 insularity
 fantasy of (Salinas) 37
 national myth of (*El milagro de Anaquillé*) 75
 island(s)/insularity 10, 13, 24, 28, 31, 37, 69, 75, 103
 in *La Habanera*: resignation 29; social life 54; social order 55
 resignation 29
 social life 54
 social order 55
 lure of the 58
 navigation, registers of (*Fata Morgana*) 209
 Puerto Rican autochthony 103
 social world in Carpentier's Afro-Cuban texts 149
 Spain 194
 universe of bourgeois imagination 192
 world of symbols in Spengler (Adorno) 105
archipelago(s)/archipelagic
 in Aimé Césaire radio interview 224

antagonisms 5
"archipelagic trope" (Ellis) 9, 10
assemblage of cultural
 islandscapes 239
Atlantic
 cultural production 9
 neo-Kantianism and
 universalist genealogies 6
 Surrealism, group
 performances (Villa Air-Bel)
 239
 universalist discourses and
 idea of "old Europe" 4
of avant-garde and surrealist
 experience 9
in Burgos (Quintero-Herencia)
 279n74
Canarian 62–3, 67–8
Caribbean
 alternative versions 9
 Black and *mulato* subjects
 reshape 124
 figures of the (Dash) 257n24
 passages and routes 123
 place of Martinique 216
 social and economic territories
 123
 and translation of Martinique
 238
 and cosmopolitan carceral space
 158
Dada diaspora 209
dependence 127
Espinosa's provenance 188
exclaves, *disassembling* 15
faraway in films and literary
 texts 215
flexible notion of Caribbean and
 Atlantic 7
frame 10
in Glissant 10
of Hispanic avant-gardism 41
Hispanic and Francophone
 Caribbean and Canary
 Islands 1

insularity, material conditions
 of 103
of Lesser Antilles 222
linguistic 158
and littoral spaces of Atlantic
 avant-gardism 254
meta-archipelagos/archipelagic
 Caribbean 123
 Caribbean or *polynésie* 223
 Hispanism's Atlantic 5
movement or *detour* (Carpentier
 in Haiti) 253
new scenario for surrealist
 experiences 16
of the North (*La Habanera*) 24
pan-American 166
pan-Hispanic 97
perspectives on "the world" 87
relationality 32
relationships, Surrealism on
 Martinique 245
thinking 4, 7–8
translation of Benjamin's
 "critical constellation" 7
see also island(s); islandscape(s)
archive fever 23, 28
archive(s)/archival
 amnesia 30
 Caribbean 15
 Crimen 204
 Derrida's dual notion of 52
 insular 15
 La Habanera 23–4
 local 15, 29
 meaning 23–4
 sensory 190
 visual 75
Arnold, A. James 219
Arrecife *see* Lanzarote
arte negro 70–1, 244
arte nuevo 2, 47
Ashcroft, Bill 119
assemblage(s)
 of abjection in *Cahier* 219
 archipelagic 239

Index

assemblage(s) (*cont.*)
 of colonial history and stories in *Cahier* 219
 creacionista 234
 of fragments in *Crimen* 182, 184, 188
 of genres 13
 in *Martinique charmeuse de serpents* 215
 mock-surrealist in Prologue to *The Kingdom of This World* 248
 and montage in *Crimen* 191
 of parts in *¡Écue-Yamba-Ó!* 154
 of surrealist objects in *Crimen* 198
 textual 12, 66, 188
 see also *disassembling* of insular archives
atalayismo/atalayistas 87, 88, 94
 "Grupo Atalaya" 88
 see also González Alberty, Fernando
Ateneo de Santa Cruz 174, 197, 205
Atget, Eugène 136–7, 179, 190, 289n80
Au Brûler des Loups (Marseille) 208
"author as producer" 185–6
automatic writing technique 182

Bachmann, Iris 59
Baedekers (travel guides) 63
Baker, Josephine
 La Sirène des Tropiques (film) 31, 38
Balfour, Sebastian 37–8, 80
Ballagas, Emilio 107
banana wars *see* wars
bananas
 Canary Islands
 Domínguez family export business and Paris 178
 export sales decrease (1914–19) 36
 exports to Europe 36
 plantations in Tenerife (Duday in Rentschler) 24
 motif in *Cahier* 219
 Puerto Rico
 Black labor migrants in circum-Caribbean industries (Drinot) 85
 Martin's photographic captions 82
Barr Jr., Alfred H. 207
Barreda, Pedro 152
Basquiat, Jean-Michel 253
Baudelaire, Charles 193, 209, 221, 227
Bauhaus 16, 136, 174, 206
Beals, Carleton
 The Crime of Cuba 14, 134, 137–39, 141–4, 151, 156
Beevor, Antony 259n7
Béhar, Henri 175
Bejarano, Carmela 106
Bejel, Emilio 119, 164
La Belle et la bête 179
Belle Époque 190, 191, 194, 201
belles-lettres 47, 48
Bellver, Catherine 36, 261n30
Benitez, Helena *see* Holzer, Helena
Benítez Rojo, Antonio 113
 The Repeating Island 9
Benjamin, Jules 146
Benjamin, Walter 5–6, 7, 182, 183, 188
 "The Author as Producer" 16, 185–7, 188
 on photography 18
 review of Soupault's *Le Cœur d'or* 182
 "Surrealism Essay" 16, 195–6
Berlin 24–5, 206
 Conference *see* Africa/African(ness)/Africanized, "scramble for Africa"

biological analogy, literary device 66
biopolitics/biopolitical 7, 13, 70
 arrangements in Caribbean plantation cultures 165
 entanglements in archipelagic insularity 103
 and necropolitical in Atlantic colonialisms 7
 and necropolitics, biopower 8
 see also necropolitics
Birkenmaier, Anke 150, 282n37, 297n9
Bizet, Georges
 Carmen 29
Black and White (*Noire et blanche*) *see* Ray, Man
Black art *see arte negro*
Black Atlantic movement *see* Negritude
Black avant-gardism 107, 119, 133
 Jorge Guillén's attitude to 70–1
Black Caribbean poetics 101–3, 107
Black Cubans 79, 107
 cosmopolitan white intellectuals and 152
 and feast of the Día de Reyes 75
 in Guillén's poems 116–17, 120
 in *Hombres sin mujer* 158
Black experiences 13–14
Black female body
 in Burgos 130–1
 in *Tuntún* 111–2, 113
Black internationalism 3, 47, 109, 123, 230
Black women
 representation in Guillén's poems 119, 120, 124
blackface 74
Blanch, Antonio 36
Blérald, Alain 216
Bloncourt, Gérald 243
Boetzkes, Amanda 180

Bonaparte, Pauline 247
Bongie, Chris 9, 50
Bosch, Juan 131
Boym, Svetlana
 nostalgia 218
Brassaï (Gyula Halász) 179, 190
Brecht, Bertolt 186–7
 Epic Theater 187
 Umfunktionierung 186
Breton, André 15, 16, 42, 150, 174, 177, 179, 201, 244, 245
 and Aimé Césaire 213
 Clair de terre 182
 Communicating Vessels (*Les Vases communicants*) 182, 212
 and daughter Aube 207–9
 "Le Dialogue créole" 215
 and dreams 182
 Fata Morgana 209–10, 212, 233, 235, 239–40
 Gracq's biography of 233
 and Granell's *Isla cofre mítico* 233, 234
 Haitian talks and lectures 241–3
 Mad Love (*L'Amour fou*) 175–6, 185, 191, 194, 198, 209, 212, 226, 227, 233
 Martinique charmeuse de serpents 210–16, 233, 240, 245, 249–50
 and Masson 211, 213–15, 233, 239–40, 245
 Nadja 201, 212, 227
 "Prestige d'André Masson" 211
 "Prolegomena to a Third Surrealist Manifesto or Not" 247
 and psychoanalysis 182
 relationship with Lamba 198, 209
 Le Revolver à cheveux blancs 198
 "Sans connaissance" 198

Breton, André (*cont.*)
 stays at Villa Air-Bel awaiting transfer to United States 207
 Le Surréalisme et la peinture 200
 Surrealist Manifesto (*Manifeste du surréalisme*) (1924) 182, 184, 192, 193, 194, 227
 Suzanne Césaire's essay on 227
 and *Tropiques* 217, 224
 travels to
 Canary Islands (1935) 172
 Haiti (1945) 241–2
 Martinique (1941) 210–12
 Mexico (1938) 210
 New York (1941) 210, 232, 247
 Prague (1935) 174–5
Breton, Elisa 241, 242
Britton, Celia 7
Brosses, Charles de
 coined word *polynésie* 233
 Histoire des navigations aux terres australes 223
Brull, Mariano 10, 13, 32, 33, 46–53
 Canto Redondo 51
 cosmopolitanism of 47, 49
 as "ecumenical Cuban" 48
 as *homme de lettres* 33, 48
 "Infant Eyes" ("Ojos niños") 49
 "Island in profile" ("Isla de perfil") 50–1
 member of Cuba's political elite 48
 metaphysics of purity 50
 "My eternity and the sea" ("Mi eternidad y el mar") 49
 "Old Eyes" ("Ojos viejos") 49–50
 "Palma Real" / "Palme Royale" 52
 "Piedra" / "Grêle" 52
 Poemas en menguante 13, 47, 48–9
 Poëmes 13, 46, 52–3
 use of *jitanjáfora* 49
 see also Valéry, Paul
Brussels 33, 52, 193
 Minotaure exhibition (1934) 175
Buck-Morss, Susan 31–2, 44, 139, 162–3
Bulletin international du surréalisme 175
 second, third, and fourth bulletins 175, 204–5, 285n15
Buñuel, Luis 172, 178–9
 L'Âge d'or (*The Golden Age / La Edad de Oro*) (film) 179, 182, 185, 192, 204, 205
 screening in Montmartre (1930) 177
 screening in Tenerife (1935) 177, 205
 Un Chien andalou (film) 182, 211, 291n23
 Tierra sin pan (film) 179
Burgos, Julia de 13, 102, 103–4
 "Dawnings" ("Amaneceres") 126
 distancing strategies 132
 earning of critical acclaim 124–5
 "Eighty Thousand" ("Ochenta mil") 126
 "From the Martín Peña Bridge" ("Desde el Puente Martín Peña") 126
 and islandscapes 125–7
 "My Symbol of Roses" ("Mi símbolo de rosas") 126
 Poema en veinte surcos 14, 101, 104, 124–7, 131
 recognized as Puerto Rico's "national poet" 125
 "Río Grande de Loíza" 126, 128–31
 travels to Havana and New York (1940) 131
 as *ultramoderna* (Lloréns) 125
 "Woe Woe Woe to you, Black

Hair" ("Ay ay ay de la grifa negra") 104, 130, 131
Burgos-Lafuente, Lena 131, 273n87
Butler, Judith 119

Cabaret Voltaire *see* islands
Cabrera, Lydia 16, 102, 106, 107
 Cuentos negros de Cuba 106, 235
 El Monte 106
 and ñáñigo and Santería ceremonies 243
 queer readings of 294n68
 Retorno al país natal 237–40
 see also Péret, Benjamin; ñáñigo(s)
Cadava, Eduardo 160
Cahier d'un retour au pays natal see Césaire, Aimé
Campa, Román de la 9
Campuzano, Luisa 77
Canary Islands/Islanders 11, 33, 57, 96
 and Josefina de la Torre's *Versos y estampas* 33–41
 as exterior frontier of Caribbean culture 5
 as non-European and non-African 96
 visit to by Paris surrealist group 175–7, *176*, *178*
 and World War I 33
 see also wars
Canary Islands Surrealism 172, 184
 and *Gaceta de Arte* 172–4
cannibal 227–8
Capitaine Paul-Lemerle (boat) 210
carceral *see* prisons/prison narratives
Carpentier, Alejo 8, 9, 10, 11, 13, 14, 16, 56, 57, 58, 59, 115, 238
 Afro-Cuban poems and librettos for ballets 74–5
 arrest and escape 72, 150
 attack on surrealist movement 248, 249
 background 56, 135
 collaboration with composers 73
 concern with Black Cuban subjects 107
 on Cuban music and performances in Paris 72–3, 79
 distancing from Surrealism 150
 ¡Écue-Yamba-Ó! 14, 74, 75, 107, 134–5, 149–57, 164, 165, 167, 235, 246
 disavowal 150
 draft 150, 153, 158
 homosexual desires and acts 157
 masculinity and emasculation 156
 specter of homosexual contagion 156
 editor of *Revista de Avance* 72
 in Haiti 247–8, 250, 253
 hallucinatory poetics 154
 identification with Black characters 152
 on *The Jungle* (Lam) 236, 250
 and Lam in Havana (1942) 235
 and Lorca in Madrid (1933) 107
 magical realism (*realismo mágico*) (Franco) 248–9
 marvelous real (*lo real maravilloso*) 16, 247–8, 249, 250
 in Ménil 297n6
 El Milagro de Anaquillé 13, 56, 74, 75–80, 96, 97, 145, 149, 150, 153, 157, 271n57
 La Música en Cuba (*Music in Cuba*) 250, 277n37
 Parisian chronicles for *Carteles* and *Social* 72
 Prologue to *The Kingdom of this World* 246–50

Carpentier, Alejo (*cont.*)
 La Rebambaramba 75
 use of ethnography 150
 voyeuristic scene in
 ¡Écue-Yamba-Ó! 155
Carteles (weekly illustrated
 magazine) 72
Cartier-Bresson, Henri 137, 142,
 143
Casal, Julián del 3
Casanova, Pascale 47, 52
Castile, 89–90
 Castilian "descent" of Puerto
 Rican "belles" 81
 Castilian dominance 65
 and Castilian as signifiers 90
 in Unamuno (*Insularismo*) 90
"El castillo estrellado" ("Le
 Château étoilé") 285n16
Castro Morales, Federico, 178
Catholicism
 and Espinosa's *Crimen* 192–4
 and Lorca's *Poeta en Nueva
 York* 194
Cendrars, Blaise
 La Prose du Transsibérien 33,
 189
Cernuda, Luis 36, 43
Césaire, Aimé 16, 101, 224, 229
 background 216
 Cahier d'un retour au pays natal
 16, 128, 213, 216–24, 231,
 236
 Discours sur le colonialisme
 (*Discourse on Colonialism*)
 217, 253
 embarks for Martinique 216
 in Haiti 229
 and Lam 235–6
 and Negritude 217, 231
 as a playwright 219
 political positions 240
 time spent in Paris 216
 translation of *Cahier* by Cabrera
 237–9, 240

 and *Tropiques* 224
 vacation in Šibenik 218
Césaire, Suzanne 16, 102, 213,
 224–5
 "Alain and Esthetics" 225–6
 "André Breton, Poet" 227, 233
 contributions to *Tropiques*
 225–6
 "The Great Camouflage"
 229–31, 236
 in Haiti 229
 "Leo Frobenius and the Problem
 of Civilizations" 225
 "The Malaise of a Civilization"
 228
 "1943: Surrealism and Us"
 228–9
 "Poetic Destitution" 227–8
Chacón y Calvo, José María 106
Chao, Ramón 259n18
Chartier, Émile-Auguste *see* Alain
Chazal, Malcolm de
 Sens-plastique 233
Un Chien andalou (film) *see*
 Buñuel, Luis; Dalí, Salvador
Christophe, Henri 248
Ciudad Trujillo *see* Santo Domingo
civilizations
 and Frobenius 217, 225, 228
Claudel, Paul 193
Clavijo y Fajardo, José 68
Clifford, James 252
climate
 aesthetic
 among exiled surrealists,
 dialogic 232–3
 Cadava's definition 160
 Caribbean picturesque and
 carceral temporality 161
 in *Hombres sin mujer* 158
 Stimmung as (Gumbrecht) 66
 visual, of tropical "South
 Seas" in Evans 137
 hemispheric
 of Great Depression 85

intellectual
 of Germanophilic 1920s 66
 of late 1920s and early 1930s 59
 political
 in Cuba, racist (Seligmann) 239
 Espinosa's reaction to 67, 189
 in Evans's Cuba portfolio 165
 Ortega's neo-Kantian engagements 6
 and projection of *L'Âge d'or* in Tenerife 177
 in "West Indies Ltd." 122–3
 tropical
 and Black internationalism in "West Indies Ltd." 123
 of excessive sexuality in *Hombres sin mujer* 161
Cohen, Margaret 31, 45, 196, 201
collage 34, 63, 113, 114, 211–12
"collage aesthetic" (Perloff) 109
Colonial Exposition, Paris (1931) 132
colonialism 67
 Aimé Césaire on 253
 in British in Africa 37
 critique of United States in *El Milagro de Anaquillé* 77
 economic 14, 103
 European 47, 64, 111, 245
 in *La Habanera* 28, 29–30
 Said on 67
color line 95, 138, 142, 143, 149, 162, 166
 see also Du Bois
Columbus, Christopher 81, 234
"common symbolic space" 4–5
Commune (journal) 187
Communicating Vessels (*Les Vases communicants*) *see* Breton, André
Congo, river 128
Conrad, Joseph
 Heart of Darkness 111
 An Outcast of the Islands 111

constellation(s)/constellate(d) 5–6, 7, 8, 78, 101, 183, 200, 236, 254
contagion 90–1, 135
convulsive
 beauty 193, 198
 and poetry in Suzanne Césaire 227–8
 destruction of exoticist frames 202
Cook, Captain James
 Voyages 214
Cooper, Merian 162, 259n11
 King Kong (film) 162–3
Copenhagen
 Cubist-Surrealist show (1935) 175
La Coquille et le Clergyman (film) *see* Dulac, Germaine
Coronil, Fernando 164
cosmopolitanism/cosmopolitan 2, 4, 8, 10–14, 16, 39, 44, 68, 135, 165, 172, 254
 ambivalent 60–1
 American (Evans and Hemingway) 138
 in Antillean discourses 103
 Atlantic 38, 40
 avant-garde and Surrealism 32, 103, 119, 136, 165–6, 172–3, 197, 201, 210
 Black 119, 166
 and Brull 47–9
 in Domínguez and Espinosa 188
 in *¡Écue-Yamba-Ó!* 149, 155
 interpreter or "ethnographer" 152
 white intellectuals 152
 errancy (Glissant) 121
 Eurocentric 174, 232, 264n71
 European 206, 244, 253, 255n8
 Evans as witness 136
 fragmented field of exchanges 9
 in Guillén 123–4
 in *Hombres sin mujer* 158,

cosmopolitanism/cosmopolitan (*cont.*)
 homme de lettres 33
 images of modern women 39, 119
 and international styles 109
 liberal (*Revista de Occidente*) 62
 in Palés (Valbuena Prat) 109–10
 pastiche 78
 in Pedreira 80, 87, 89
 postwar 32, 65, 166, 209, 235
 Republican 173
 socialist 43
 universalism 47
costumbrismo 75, 107, 109, 189
costumbrista 78, 79, 84, 109, 189
counter-universalism 47
creacionismo/creacionista 11, 32, 42, 44, 51, 58, 70, 97, 109, 264n75
 and *Lancelot 28°–7°* 13, 62–5, 67–9, 234
 création see Reverdy, Pierre
"Le Créationnisme" *see* Huidobro, Vicente
Creole languages 59
Creoles/Creolism 84, 90
 Insularismo and national identity of 89
Crevel, René
 Mon corps et moi 193
Crichlow, Michaeline 7, 218
Crimen see Espinosa, Augustín
criollismo 88, 90, 91
criollo(s)/criollista
 criollista Hispanism (Lloréns Torres) 125
 European-descended (Pedreira) 84
 fraternity of professional Hispanists (Pedreira) 95
 islanders, Afro-Caribbean and 124
 paisaje (Landaluze, Carpentier) 75, 79
 poesía criollista 107, 127

Cuba 14, 60
 blackface stage entertainment 74
 in *¡Écue-Yamba-Ó!* 134, 149–57
 and Evans's Cuban portfolio 14, 134, 137–9, 141–9, 165, 166–7
 and Guillén's Black poems 115–20
 in *Hombres sin mujer* 134, 158–65
 Machado's dictatorship and forcing out of power 14, 47, 72, 119, 136, 137, 139, 149
 and *mulata* 102–3
 nationalism 9, 32
 and Platt Amendment 51
 and *poesía pura* concept 46–53
 representation in *West Indies Ltd.* 121
 romances in photography and fiction 134–67
 and United States 51, 73, 105, 141, 142, 151
 see also Black Cubans; Minoristas, Cuban
Cuban music
 performed in Paris 72–3
 and *son* 115–16
Cuban painters 234
Cuban Revolution (1895) and United States (Dopico) 142
Cubism/*cubismo* 3, 11, 32
Cubo-Futurism 32
Curtius, Anny-Dominique 230

Dada/Dadaism/Dadaist 3, 32, 63, 71, 87, 88, 102, 107–9, 136, 172, 174, 186, 192, 209, 251
Dainotto, Roberto 178, 269n31
Dalí, Salvador 172, 179, 180, 181, 182–3, 185, 192, 195, 204
 Un Chien andalou (film) 182, 211

visits Freud in Hampstead (1938) 286n35
Damas, Léon-Gontran 216, 217
Darío, Rubén 3, 11–12
 "Juventud, divino tesoro" 93
Dash, Michael 2, 110, 241, 243, 277nn33, 35
Davis, Gregson 216, 220
De Chirico, Giorgio 179, 182, 190–1, 201
death drive theory 191
décadentisme 221
décalage and *disarticulation* (Edwards; Maguire) 238
décalcomanie (Domínguez)
 décalcomanies du désir (Breton) 179
 gouache technique 178
Delanglade, Frédéric 208
Delaunay, Sonia
 La Prose du Transsibérien 33
Deleuze, Gilles 12, 59
Demos, T. J. 246–7
deracination (Milian) 95, 97
Deren, Maya 8
 Divine Horsemen: The Living Gods of Haiti (film footage) 16, 250–4
Dermée, Paul 62
Derrida, Jacques 23–4, 28, 52, 202
 archive fever 28
 arkhē 23–4, 28, 52, 55
Desnos, Robert 72, 150
Dessau (German Reich) 174
determinism, geographic and biological 13, 14
detour see Glissant, Édouard
Diaghilev, Sergei 78
Diario de la Marina (daily newspaper) 116
Diario de un sol de verano see López Torres, Domingo
Dictionnaire abrégé du surréalisme 179
Díaz Plaja, Guillermo 42

Díaz Quiñones, Arcadio 60, 61, 83, 87, 92
Diego, Estrella de 173
Diego, Gerardo 34–5, 36, 43
 Poesía Española. Antología (Contemporáneos) 34
 see also Torre, Josefina de la
Diego Padró, José I. de 56–7, 108
diepalismo/diepalista(s) 87, 107–9
Díez-Canedo, Enrique 33
Dimendberg, Edward 166
disarticulation (Deleuze) 12
 see also Edwards, Brent Hayes; Maguire, Emily
disassembling of insular archives 15
Discours sur le colonialisme see Césaire, Aimé
disidentification 132–3, 253
dislocation
 in cross-Caribbean displacements 253
 in Espinosa
 of author's consciousness as producer 188
 Crimen as practical experiment in 204
 and relocation of fragments in *Crimen* 199
 in insular avant-garde practices 4
 in Schmitt 30
disorientation
 author and image of compass in Pedreira 80
 authors' in pan-Hispanic archipelago 97
 in Espinosa's project 67
 and reorientation in cross-Caribbean displacements 253
 resonance with notion in *Lancelot 28°–7°* 64
 see also Martin-Márquez, Susan; orientation(s); reorientation
Döblin, Alfred 136

Domínguez, Antonio Andrés 178
Domínguez, Óscar 16, 171, 172, 182, 188, 205
 background 178
 Composición surrealista II 178
 construction as *homo meridionalis* 178–9
 Cueva de guanches 178, 180–1, 202
 exploration of the souvenir in his paintings 180, 183, 204
 and *Gaceta de Arte* 178
 Máquina de coser electro-sexual 202
 stays at the Villa Air-Bel in Marseille as exile-in-transit 207, *208*
 suicide (1956) 176
 themes of paintings 179
 traits 181
 trip to Paris (1925) 171
 and Vicomtesse de Noailles 179
Dominican Republic 173, 243–4
 American invasion and occupation of 232, 241
 massacre of Haitians (1937) 232
 "ritual events"/*fiestas rituales* 243–4
 Trujillo's presidency 232
Dopico, Ana María 142
Douglass, Frederick 138
dreamworlds 13, 28, 51, 126, 214
Drinot, Paulo 85
Du Bois, W. E. B. 138
 in Mintz 95
 "My Mission" 47
 see also color line
Duchamp, Marcel *241*
Duday, Bruno 24
Dulac, Germaine 195
Duplessis, Yvonne 192

economic colonialism 14, 103
¡*Écue-Yamba-Ó! see* Carpentier, Alejo

La Edad de Oro (film) *see* Buñuel, Luis
Edwards, Brent Hayes 47, 238
Éluard, Paul 174, 192, 227
Emergency Rescue Committee 207
Engels, Friedrich *see* Marx, Karl
Epic Theater 187
Ernst, Max 180, 192, 204, 209
errance see Glissant, Édouard
Espinosa, Agustín 16, 58, 96
 and alterity 188
 as an avant-garde intellectual 197
 background and childhood 56, 190, 197
 creacionista perspective/images 62, 63, 65, 69
 and *crime passionnel* 183
 Crimen 16, 171, 182–5, 187–91, 192–205
 death 205
 and *Gaceta de Arte* group 188
 joins fascist Falange organization 205
 Lancelot 28°–7° 13, 56, 61–70, 96–7, 183, 184, 189, 203, 234
 as president of the Ateneo de Santa Cruz 197, 205
 public denouncement of 205
 and *Stimmung* 66–7
 see also Lanzarote; *lanzaroteños*
Espuela de Plata (journal) 265n90
Estimé, Léon Dumarsais 242
ethnocultural/ethnoracial
 boundaries in avant-garde poetics and *poesía negra* 103
 images of the Antilles 101
 inferiority in *La Habanera* 27
 Spengler's theories 14
 tensions, gendered island as space of 14
 in *Tuntún*
 development and Spenglerian poetics 110

social and sexual differences, national belonging 113
speechless image 115
ethnography/ethnographic
 in avant-garde journals 7
 in *Cahier* 219
 in Carpentier and Deren 250
 in Césaire, Aimé and Senghor 217
 in Césaire, Suzanne 228, 231
 in Clifford 252
 curiosity 81
 in *¡Écue-Yamba-Ó!* 149–50, 152
 fieldwork 132
 and French writers 248
 in Frobenius's vision 225
 gaze 13
 and Haiti in Deren 251
 in *Hombres sin mujer* 165
 knowledge 10, 228
 in Lam 236, 239
 lens in *El milagro de Anaquillé* 75, 77–9
 in Ortiz 74–5
 pastiche 25
 pose in *Lancelot 28°–7°* 69
 in Prologue to *The Kingdom of this World* 249
 pseudoethnographies 111
 and racism in Cuban and international contexts 73
 style and picturesque in Evans 136-7
 and tourist exoticism 39
 in *Tuntún* 111-4
 see also Birkenmaier, Anke; Clifford, James; Coronil, Fernando; Kullberg, Christina; Maguire, Emily; Mintz, Sidney
L'Étudiant noir (journal) 217
Europe/European
 avant-gardism 10, 246, 248, 249
 Ortega's critique of 71–2
 colonialism 47, 64, 111, 245
 indictment of by Césaire 253
 non-European 10, 12, 13, 22, 46, 55, 57–61, 62, 70, 96, 116, 117, 210, 226, 253, 254
 see also Said, Edward
Evans, Walker 136–40
 access to Havana 165–6
 American Photographs 144
 background 134
 Beggar with Outstretched Arm on Street 146, 147
 botanical compositions 136–7
 Brooklyn photographs 143
 Citizen in Downtown Havana 139, *140*, 165, 166
 correspondence with Beals 141, 166
 Cuban portfolio (*The Crime of Cuba*) 14, 134, 137–9, 141–9, 165, 166–7
 Havana: Country Family 147, 148, *148*
 and Hemingway 138
 and Minorista group 141
 Mother and Children in Doorway 146–8, *147*, 165
 photographs of Tahiti 136–7
 Public Spectacle 148–9
 Woman Behind Barred Window 144–6, *145*, 167
exclave 12, 15, 17, 60, 96, 254
exoticism/exotic 10, 15, 41, 50, 72, 107, 125, 214, 227–8
 Afro-Caribbean 78
 and Domínguez 181
 ekphrastic 10
 metropolitan 231
 misogynistic 132
 romantic 2
 self- 8, 67, 112
 tourist 39
 in *Tuntún* 109, 110, 111, 114, 115

expresión
 in Henríquez Ureña 11
 in Pedreira 80
Expressionism 87
 Abstract 237
 northern European 3

Falange/Falangists/*falangistas* 24, 204, 205
Fanon, Frantz 57, 151
 The Wretched of the Earth 57
fascism/fascist/*fascista*
 advance of troops in North Africa (*Cahier*) 223
 in Canary Islands
 Espinosa joins Falange in Las Palmas 205
 extremes, antagonistic attitudes 4
 regime, cultural space recolonized by 25
 collaborationist state, Régime de Vichy 224
 conservative or proto-fascist *new man* 95
 European, waxing decade of 25
 in Germany
 ideals and colonialist dominion in Atlantic 26
 in *La Habanera*
 film's cultural "sensitivity" 54
 production conditions of Spanish Civil War 30
 propaganda, fictional construction of 54
 in Spain
 alliances with Catholic Church, monarchy, and state 193
 avant-gardism of Giménez Caballero in *La Gaceta Literaria* 62
 regime, repression of cultures of avant-gardism by 28
 overturn of Republic 188
 victory in April 1939 223
 in Tenerife
 army, control of island by 24
 authorities 25
 Catholic groups attack *L'Âge d'or* 177
 Domínguez vacationing when fascists took control 205
 insurgent forces, island under jurisdiction of 25
 Pérez Minik calls local bishop 177
 regime, support by Swedish and German consuls 25
 see also anti-fascism; Falange/Falangists/*falangistas*; Maeztu, Ramiro de
Fata Morgana see Breton, André
Fauchereau, Serge 191, 212
feminization
 of islandscapes in Pedreira's *Insularismo* 85
Feria, Ramón 11, 62
Fernández de Castro, José Antonio 107, 141, 242, 276n16
Fernández Granell, Eugenio 8, 16, 232–4, 245
 interviews Breton in Ciudad Trujillo 232–3
 Isla cofre mítico 233–4, 245
Ferrer, Ada 51
fetish(es)
 annotations in *Tuntún* 111
 in *Crimen*
 anxieties and animals 195
 in Domínguez and Espinosa 179, 183
 fixation on portrait 183–4
 maritime and militaristic 204
 images of working men by *diepalistas* 108
 Mayakovsky by López Torres 43
 youth and Sadean violation among surrealists 198

"field of islands" *see* Glissant, Édouard
Fignolé, Jean-Claude 223
First Congress of the Writers' Union (1934) 44
First International Surrealist Exhibition (1932; Prague) 174
 see also Second International Surrealist Exhibition (1935; Tenerife)
Flaherty, Robert J.
 Moana (film) 31, 137
Florida 223
folk society 153
Folke Nelson, Viktor
 Prison Days and Nights 135
Forest, Philippe 172
Forsdick, Charles 239
Fort-de-France 16, 166, 210, 212–13, 216, 224–5, 235, 240, 242
Fortunate Islands 233
Foster, Hal 179, 187, 188, 191
Foucault, Michel 15
Fra Angelico
 Paradises 214
France
 German occupation of 246
 intervention in the Moroccan War 172
 signs Armistice with Nazi Germany 224
 taking control of Martinique by Free France forces (1943) 228
Franco, General Francisco 24–5, 205, 223, 245
Franco, Jean 78, 248–9
Frankétienne 223
French Communist Party 172
French Surrealism 16, 172, 185, 192, 213, 214, 215, 250
Freud, Sigmund 57, 179, 182, 209

 see also psychoanalysis/ psychoanalytical
Frobenius, Leo 7, 224, 228
 Histoire de la civilisation africaine 217
 morphology of cultures 225
 publications supported by Ortega 66
 in Suzanne Césaire 225
Fry, Varian 207
Fuerteventura 63, 179
 see also Unamuno, Miguel de
Futurism/*futurismo* 11, 32, 33, 42, 87, 88, 102, 150
 Italian 3, 108, 109, 234
 Russian 43

Gaceta de Arte (group) 56, 172–3, 175, 178, 183, 187–8, 203, 205, 232
Gaceta de Arte (journal) 6, 16, 172, 173, 174, 182
La Gaceta Literaria (journal) 6, 56, 183
Gaceta de Tenerife (daily newspaper) 177
Galerie Pierre (Paris) 234, 235
Galey, Matthieu 179
Garb, Tamar 222
García Cabrera, Pedro 11, 172, 183, 200–1
García Lorca, Federico 8, 33, 34, 36, 43, 44, 102, 105–7, 117, 124, 132, 172, 192, 221, 262n43
 assassination of 106
 and Carpentier meet in Madrid 107
 and *Crimen* 185
 and Espinosa 197
 and Lydia Cabrera 105–6
 "La casada infiel" 106
 Mariana Pineda 197–8, 199
 meets Guillén and Cuban Minoristas in Havana 107

García Lorca, Federico (*cont.*)
 lo mitológico gitano 69
 "Niña ahogada en el pozo"
 ("Girl drowned in the
 well") 194
 Poema del cante jondo 197
 Poeta en Nueva York 106–7,
 117, 185, 194
 Romancero Gitano 49, 105–6,
 197, 263n60
 "Son de negros en Cuba" 107
 see also andalucismo
Gauguin, Paul 206
 Martinique Landscape
 (*Végétation tropicale*) 222
 Noa Noa 44–5
gaze/gazing
 adolescent male in *Diario de un
 sol de verano* 41
 "ambivalent surrealist gaze" in
 Carpentier (Nicholson) 150
 and child in Brull 49–50
 in *Cahier* 128
 in *Crimen* 203
 ethnographic 13
 in Evans
 over Havana and citizens 143
 in *Mother and Children in
 Doorway* 146
 and pan-American archipelago
 of competing masculinities
 166
 photography and narrative
 143
 in *La Habanera* 27
 in *The Jungle* 236
 libidinal in *poesía negra* 103
 nascent insular in *Versos y
 estampas* 39, 41
 in *Tuntún*
 descriptive and pastiche of
 African environment 112
 internalized colonial, absence
 of interpellating 111
 poetic 115

white (Anglo and Hispanic)
 avant-garde 167
gender policing
 in *Insularismo* 92
gendered island 14
"generation of 1898" 80
"generation of 1927" 34, 36,
 43–4, 49, 80, 102
"generation of 1930" 108
Germanophile Hispanism 103, 132
Ghervas, Stella 32
Gilroy, Paul 256n20
Glissant, Édouard 4, 81, 254,
 277n33
 archipelagic *movement* or *detour*
 253
 "archipelagic thinking" 10
 Un Champ d'îles (*A Field of
 Islands*) 2
 deconstructive analyses 10
 detour 121, 236, 245, 253
 errance/errantry/errancy 7, 8, 81,
 114, 121
 "field of islands" 4, 7–8
 "mystic relation" to land
 (Kullberg) 225
 Poetics of Relation 256n15
 see also archipelago(s)/
 archipelagic; opacity
 (Glissantian); relation(s)/
 relational/relationality
"global linear thinking" (Schmitt)
 30
Glover, Kaiama L. 223
Goebbels, Joseph 24
The Golden Age (film) *see* Buñuel,
 Luis
Gómez de la Serna, Ramón 11,
 173, 183, 193, 264n75
González Alberty, Fernando 88
 see also atalayismo
González, José Eduardo 48
Gough, Maria 188
Gracq, Julien
 André Breton 233

Graham, Shane 117–18
Granada
 in *Crimen* 182, 196–7, 199, 201
 University of 56
Granell, Eugenio *see* Fernández Granell, Eugenio
"The Great Camouflage" *see* Césaire, Suzanne
Great Depression 82, 83, 85
Les Griots (journal) 244
Grosz, George 43
Guadeloupe 210, 223, 232
 in "Guadeloupe W. I." (Guillén) 123
guajiros 79
Guattari, Félix 59
Guberina, Petar 218
Guerra Hernández, Jennifer 268n22
Guerra y Sánchez, Ramiro
 Azúcar y población en las Antillas 282n35
Guggenheim Foundation 251–2
Guggenheim, Peggy 207
Guigon, Emmanuel 202
Guillén, Jorge 36, 43, 269n32
 "Más negritos" 70, 71
 "Negritos" 70–1
 Parisian chronicles 70–2, 79, 262n43
 translator of Valéry's *Le Cimetière marin* 264n70
Guillén, Nicolás 8, 9, 10, 13–14, 102–5, 107, 114, 115–24, 130, 131, 217, 253
 critical reception of early poems 117–18
 exclusion of female agency 124
 "Guadeloupe, W. I." 123
 and Hughes 117–18
 impact of *Romancero gitano* on *Motivos de son* 105
 meets Lorca in Havana 107
 Motivos de son 14, 101, 105–6, 115, 116–17, 118

"Negro Bembón" 118, 120
"Nocturne in the Docks" ("Nocturno en los muelles") 121–2
"Palabras en el Trópico" 120, 121
representation of Black women in poems of 119, 120, 124
and *son* 115–16
Sóngoro Cosongo: Poemas mulatos 14, 101, 104, 105, 115, 118, 119
West Indies Ltd. 14, 101, 114, 116, 118, 120–4
"West Indies Ltd." 122–3
see also García Lorca, Federico; *interpolation*
Güiraldes, Ricardo
 Xaimaca 45
Gumbrecht, Hans Ulrich
 Stimmung 66
Gutiérrez Albelo, Emeterio 172

La Habanera (film) 13, 21–30, 22, 23, 27, 31, 41, 53–5, 82, 241
 Canary Islanders as extras on 54, 55
 and colonialism 28, 29–30
 ending of 27–8
 fictional island as a microcosm of tropical corruption in 55
 filming of on Tenerife 24–5, 26
 islands in 13, 27, 28, 31
 plot 21–3
 portrayal of Puerto Rico 13, 21–8, 55
 Spanish Civil War and production of 24–5, 30
 "Spanish" gender hierarchies in 29
 and tropical allergies 54
 and tropical romance genre 25, 27
 see also Leander, Zarah; Sirk, Douglas

Haggard, H. Rider
 King Solomon's Mines 111
Haiti 223, 229, 240, 253
 American occupation of 240–1
 in Breton's talks and lectures 241–3
 Carpentier's trip to 247–8, 250, 253
 Centre d'Art (Port-au-Prince) 242
 in *Divine Horsemen* 250–4
 in *¡Écue-Yamba-Ó!* 153–4
 election of Estimé as President 242
 first exhibition of Haitian painting (1944) 242
 in "The Great Camouflage" 229–30
 in Hughes's "White Shadows in a Black Land" 240–1
 Lam's visit and exhibition 241–2, 243
 in Prologue to *The Kingdom of This World* 247–50
 vaudou ceremony 243
Haitian Revolution 15, 103, 223, 231, 247, 249
 see also James, C. L. R.
Hall, Stuart 110
Harlem (New York) 3, 73, 142, 253
Harlem Renaissance 80, 117, 146, 206–7, 217
Havana 16, 46, 47, 73, 102, 107, 141
 avant-garde circles in 56
 in Evans's Cuban portfolio photographs 134–5, 142–9, 165
 Lam settles in 235
 performances of *son* 116, 122
Heartfield, John 186
Hemingway, Ernest 135, 138, 141
Henri, Florence
 Self-Portrait 191

Henríquez Ureña, Pedro 11–12, 256n14
 Charles Eliot Norton lectures (Harvard, 1940–1) 12
 Ensayos 258n30
 introduces Brull's *La casa del silencio* 260n27
 Seis ensayos en busca de nuestra expresión 11
Heraldo de Madrid (daily newspaper) 32
Heredia Girard, José-Maria de 227
Heredia, José M. (José María Heredia y Heredia) 151
Hernández Aquino, Luis 26
Hérold, Jacques 207, *208*
Herzberg, Julia P. 240
Hill, John T. 136, 137, 138–9, 142
Hine, Lewis 136, 137
Hispanic American literature 89
Hispanism/*hispanismo*/*hispanistas* 56, 57–8, 60, 88–90, 96, 117, 121, 133, 245
 Atlantic 115, 119
 authoritarian 95
 avant-garde 59
 cosmopolitan 124
 criollista 125
 Germanophile 103, 132
 institutional 132
 Madrid/Paris axis of traditional 58
 metropolitan 60
 and Pedreira 95, 96
 in *poesía negra* 102
 serving of elitist and reactionary purposes 90
 uprooted 104–9
historical determinism 13
historical materialism 6
Holzer, Helena 16, 207–8, *208*, 234–6, 239–40, 241, 243
homo europaeus (Dainotto) 178
homo meridionalis (Dainotto) 178–81

homoeroticism 45, 103, 124, 161, 183, 197
 and *diepalistas* 108
 in Guillén 124
homophobic panic 91
homosexuality/homosexual
 in *¡Écue-Yamba-Ó!* 156–7
 in *Hombres sin mujer* 158, 159, 162, 163, 164–5
 perversions, *andalucismo* in *Crimen* 197
homosocial
 appreciation and internalized colonial gaze 111
 bonding 103
 desire 165
 empowerment 91
 and homoerotic renditions of novel West Indies imaginary 124
 perspective (Benjamin) 185
 port scenes in late *modernista* texts and avant-garde 112
 and racist fantasy of Atlantic Hispanism 115
 structures in Guillén's early Afro-Cuban poems (Kutzinski) 119
Hostos (journal) 57
Hostos, Eugenio María de 56, 58, 93, 234
Hound and Horn (journal) 136
Hughes, Langston 117–18, 124, 165, 217
 "The Negro Speaks of Rivers" 128
 "White Shadows in a Black Land" 240–1
Huidobro, Vicente 42
 Altazor 42
 "Le Créationnisme" 64
L'Humanité (daily newspaper) 172
Humboldt, Alexander von 9, 177
Hyppolite, Hector 242

ideology/ideological
 aesthetic in Brull 53
 "*aniñamiento ideológico*" (ideological infantilization) (Molloy) 39
 and archival amnesia in *La Habanera* 30
 avant-garde 1
 Bauhaus 206
 and colonial ambivalence in *Lancelot 28°–7°* 61
 colonialist in Salinas 40
 debates around *poesía negra* 102
 exoticist, colonial, Eurocentric in *Martinique charmeuse de serpents* 215
 geocultural of the Spanish South in *Crimen* 189
 in *hispanidad* and Hispanism 53, 57–60, 89, 101, 105, 131, 133
 of imperialism and colonialism (Said) 67
 in *Insularismo*
 conservatism 80
 limits of insularity 97
 metaphorical play 87
 of the nation 91
 nationalist of US in Puerto Rico 81
 poles in Caribbean colonialism 90
 press and photography in US-Spain war (Perivolaris) 81
 Marxist in Grosz (López Torres) 43
 of *mestizaje* in Burgos 131
 nationalist in *Hombres sin mujer* 160
 Nazi 23
 of "pure poetry" (Blanch) 36
 racist in Parisian context 77–8
 rectification and Schmitt's logic in *La Habanera* 54

ideology/ideological (*cont.*)
 seduction, "jargon of authenticity" (Adorno) 105
 and Surrealism in *Crimen* 190, 192
 transformations in 1920s and '30s Atlantic 28, 253
"Ile a Tortue" (Il Latòti/Île de la Tortue, Haiti) 252
imperialism 67, 123
 bourgeois 217
 European 71, 234
 renewal of a discursive 60, 61
 Said on 67
 Spanish 71, 79, 180, 234
 United States 14, 74, 75, 78, 115, 149, 151, 153, 156
index(es)/indexical
 in Brull 51
 in Burgos 126, 128
 in *Cahier* 219
 in Cubist collage and early avant-gardism 212
 in *Crimen* 201
 in Domínguez 181
 in *¡Écue-Yamba-Ó!* 154
 of the exotic island in *Tuntún* 110, 112–3
Índice (journal, Puerto Rico) 56, 87
Índice: Revista de cultura (journal, Tenerife) 175, 205
Insularismo see Pedreira, Antonio S.
intellectuals, new generation of 48
International Bulletin of Surrealism 205
International Congress for the Defense of Culture (1935) 44
interpolation in Guillén (Ashcroft) 119–20
intrahistoria see Unamuno, Miguel de
island(s) 9, 12
 archaic 13, 24, 28, 31
 as archaic, regressive, and "primitive" spaces 10
 of Cabaret Voltaire by Lake Zurich 209
 as defamiliarized or depreciated object in Brull 51
 in Deleuze 12
 "diaries" 44–5
 in *Diario de un sol de verano* 42, 44–5
 and Domínguez's paintings 181
 in Espinosa's *Crimen* 185, 200, 202
 in European/Western literary traditions 31
 gendered 14
 Granell on 233
 in *La Habanera* 13, 27, 28, 31
 and Hispanism 57
 as material and allegorical prisons 165
 as passive objects of aesthetic and technological modernity 30
 plurality of 2
 in *Poema en veinte surcos* 124, 126
 portrait as fantasy object in Brull 51
 representation of in films 31
 as a space of temporal origins 31, 45
 subtropical garden in *Lancelot 28°–7°* 69
 time 31, 45
 Western projections as archetypes of exotic alterity 50
 see also archipelago(s)/archipelagic
islandscape(s)
 in *Cahier* 221, 222
 in Caribbean avant-gardism and translation 239
 concentrationary 26

in *Crimen* 183, 189, 204
decaying 31
in Domínguez 179, 202, 204
feminization of 85
feminized and manicured 85
and local color 54
"*paisaje criollo*" (Landaluze) 75, 79
portscapes and 39
rural 83
see also archipelago(s)/ archipelagic
ismo(s) 2, 10–12
cosmopolitan 10–14
in Gómez de la Serna 257n29
in Hernández Aquino 259n12
in López Torres 46
in Pedreira 86, 88
in Puerto Rico 26, 87
isthmus 12
Italian Futurism 3, 108, 109, 234
Itkine, Sylvain 208

James, C. L. R.
The Black Jacobins 6
Jameson, Fredric 5, 7
Jammes, Francis 227
Le Jeu de Marseille 208–9, 239
jibarismo 83, 84, 127
jíbaro(s) 26, 81, 82, 83, 84, 94, 107
Jiménez, Juan Ramón 3, 36, 44, 49, 263n63
Diario de un poeta recién casado 49, 263n60, 265n77
Juan de la Cruz (Juan de Yepes Álvarez) 49
Juan Ismael (Ismael Ernesto González Mora) 172, 179

Kafka, Franz 59
Keyserling, Hermann von 7, 59, 89
King Kong (film) 162–3, 259n11
Koselleck, Reinhart
"futures past" 6

Kramer, Alan 36
Krauss, Rosalind
"The Photographic Conditions of Surrealism" 191–2
Kubayanda, Josaphat B. 104–5
Kullberg, Christina 225
Kunzel, Regina 135
Kutzinski, Vera M. 103, 119

La Gorce, John Oliver 81
Lam, Helena *see* Holzer, Helena
Lam, Wifredo 8, 16, 102, 207–9, 208, 232, 233, 234–7, 237, 238, 244, 250
and Aimé Césaire 235–6
"Carnets de Marseille" 235
Carpentier's view of 236, 250
and Cuba 235
exhibition in Haiti (194) 243
exhibitions in Paris and New York (1939) 234–5
illustrates Breton's *Fata Morgana* 209, 235, 239–40
participates in *Le Jeu de Marseille* 208–9
The Jungle 181, 236–7, 237
Lam Paintings exhibition (1944) 229
Mabille's essay in *Tropiques* 242
visit to Haiti 241–2
Lamba, Jacqueline 15, 174, 207, 209
Lancelot 28°-7° *see* Espinosa, Agustín; Lanzarote
Landaluze, Víctor Patricio de 75
Lange, Dorothea
Migrant Mother 165
Lanzarote 60, 63, 201
and Africa 63
Arrecife 62, 65, 66
and Clavijo y Fajardo 68
in *Lancelot 28°-7°* 13, 58, 62–70
lanzaroteños 65, 70, 96
Larraga, Ricardo 46

Las Palmas 36, 39, 41, 68, 205
Latin American avant-garde 3, 11–12, 197
Latin American women poets 39
Lautréamont, Comte de (Isidore Lucien Ducasse) 190, 193, 209, 221
League of Nations 32, 48
Leander, Zarah 21, 24–5, 27
Lebeau, Vicky 49–50, 166
Leconte de Lisle, Charles Marie René 227
Lefebvre, Henri 185
Legg, Stephen 30–1
Légitime Défense group (1932) 216–17
　"Manifeste de légitime défense" 217
　Ménil and Léro as members of 217
Leiris, Michel 252
Léro, Étienne 217
Lescot, President Élie 229, 242
letrados 48, 58
Levant 64
Lévi-Strauss, Claude
　Tristes Tropiques 210
Lezama Lima, José 46, 50, 265n90
　see also *Orígenes*
La Libertad (daily newspaper) 70
litocronismo (Sabato) 179
Litoral (journal) 34, 105
Littérature (journal) 182, 287n37
Llarena, Alicia 297n6
Lloréns Torres, Luis 57, 87–8, 93, 109, 124–5, 131
　"Canción de las Antillas" 125
Llorens, Vicente 243–4
Lombroso, Cesare 74
　physiognomy 152
López Baralt, Mercedes 271n60
López Jiménez, Ivette 127, 130
López Torres, Domingo 13, 32, 41–6, *176*, 205
　background 42

and decline of Russian avant-gardism 43
　Diario de un sol de verano 41–6
　executed by fascists 205
　"Landscape with camels" 45–6
　"Notas: Maiakovsky"' 42
　Surrealism as new direction for 45
Lorca *see* García Lorca, Federico
Löwy, Michael 7, 185–6
Lugo-Ortiz, Agnes 15
Luis-Brown, David 73, 139
Lycée Schœlcher (Fort-de-France) 224
Lyotard, Jean-François
　The Postmodern Condition 9

Mabille, Pierre 207, 232, 241–2, 243
　Le Miroir du merveilleux 242
Machado, President Gerardo 14, 47, 72, 119, 136, 137, 139, 149
Mad Love (*L'Amour fou*) *see* Breton, André
Madrid
　Café de Pombo 106
　reading by Josefina de la Torre and Brull (1926) 32–3
　Residencia de Estudiantes 33, 35, 80, 102, 172
　Residencia de Señoritas 35
　Universidad Central 197
Maeztu, Ramiro de 104
magical realism (*realismo mágico*) *see* Carpentier, Alejo
Magloire-Saint-Aude, Clément 10, 16, 244
　Dialogue de mes lampes 244
　Tabou 244
Maguire, Emily 73, 76, 157, 238, 239
Mainer, José-Carlos 43, 173
Mallarmé, Stéphane 36–7, 40–1, 49, 51, 221
　"Prose pour des Esseintes" 37
Mallo, Maruja 172

Mallorca 234
mambises 151
Mañac, Jorge 107
Mánes Gallery (Prague) 174
Manickam, Sandra Khor 71
Manifesto (1924) *see* Breton, André: *Surrealist Manifesto* (1924)
mapmakers 64
Margenat, Alfredo 88
Marian, Ferdinand 21
Mariana Pineda see García Lorca, Federico
Marinetti, Filippo Tommaso 42, 108–9, 133
Marrero Aristy, Ramón 244, 296n93
Marseille 173, 206–10
 exiles traveling to New York 210
 refugees at the Villa Air-Bel 207–9, *208*
Martí, José 3, 58, 131, 151, 234
 "Our America" ("Nuestra América") 90
Martin, Charles 81, 82
Martin-Márquez, Susan 64, 67
 see also disorientation
Martinique 128, 210–16, 245
 and Breton's *Martinique charmeuse de serpents* 210–16, 233, 240, 245, 249–50
 and Césaire's *Cahier* 216–24
 control by Free France forces (1943) 228
 eruption of Mount Pelée (1902) 215
 and "The Great Camouflage" (Suzanne Césaire) 228, 229, 230–1
 and Masson 211
 poetry 227, 228
 and *Tropiques* 224–32
Martinique charmeuse de serpents see Breton, André; Martinique; Masson, André

Maruyama, Masao 119
marvelous real (*lo real maravilloso*) *see* Carpentier, Alejo
Marx, Karl, and Friedrich Engels
 The Communist Manifesto 1
Marxism/Marxist 6, 43, 66, 105, 131, 186
massacre *see* Dominican Republic; *rifeños*, popular repudation of massacre
Masson, André 16, 211–12, 214, 215, 232, 240, 245, 249–50
Matisse, Pierre 240
Matos Paoli, Francisco
 Cardo labriego 127
Maunick, Édouard 223
May, Louis-Philippe
 Economic History of Martinique (*Histoire économique de La Martinique, 1635–1763*) 212
Mayakovsky, Vladimir 42–3
 "150.000.000" 131
McClintock, Anne 37, 110–11
McKay, Claude 217
 Banjo: A Story without a Plot 146
 Romance in Marseille 206–7
Mekas, Jonas 250–1
Melville, Herman
 Typee 215
Mendelson, Jordana 173
Mendieta, Ana 253
Menéndez Pelayo, Marcelino
 Historia de la poesía hispano-americana 60
Menéndez Pidal, Ramón 105
Ménil, René 213, 224
Mérimée, Prosper 24
mestizaje/mestizo 22, 79, 114, 130–1
Métraux, Alfred 252
 La Vaudou haïtien 252
Mexican *muralismo* 12
Mexico 89, 106, 131, 134, 210, 240

Mialhe, Pierre Toussaint Frédéric 75
Miami 240
Michelson, Annette 251
El Milagro de Anaquillé see Carpentier, Alejo
Milian, Claudia 95, 165
"minor transnationalism" (Lionnet and Shih) 60–1
Minorismo, Cuban 141, 249, 253
Minoristas, Cuban 14, 46–7, 61, 105, 134, 141–2, 149, 152, 160, 173, 235
 "Al levar el ancla" ("Lifting the anchor") 47, 61
 "Declaración del grupo minorista" 47
 interest in Black culture and cultural politics 74
 racial politics 47
Minotaure (exhibition) 175
Minotaure (journal) 211, 242
Mintz, Sidney 95, 252
Miranda Archilla, Graciany 87
Miró, Joan 172, 233–4
Mistral, Gabriela 3
Moana (film) *see* Flaherty, Robert J.
modernism 2–3
modernismo 2–3, 11, 65
modernistas 108
Modotti, Tina 137, 142
Moholy-Nagy, László 206
 Impressionen vom alten Marseiller Hafen (Vieux Port) (film) 206
Mollona, Massimiliano 252, 253
Molloy, Sylvia 39
MoMA (Museum of Modern Art, New York) 12, 207, 237
montage, textual 188, 199, 200
Montenegro, Carlos 134, 135
 Hombres sin mujer 14, 134, 157–65, 167
Montmartre *see* Paris
Montparnasse, Kiki de (Alice Ernestine Prin) 193

Moore, Robin 73, 74, 102, 115–16, 143
Mora, Giles 136, 137, 138–9, 142
Morales, Tomás 3
Morne Rouge (Le Morne-Rouge, Martinique) 236
morphology see Frobenius, Leo; Spengler, Oswald
Moroccan War *see* wars
Morris, C. B. 44, 205
Morton, Patricia 132
Moscow
 First Congress of the Writers' Union (1944) 44
 Moscow/Berlin/Paris axis 185
 Prague as door to 174
 in Vertov's *Man with a Movie Camera* 206
Mouffe, Chantal 4–5, 89
 agonistic perspective, "adversary" 89
 antagonism and agonism 4-5
Mount Pelée, Martinique 215, 230, 236
Mount Teide, Tenerife 177, 233
Mudimbe, V. Y. 217
"Mulata-antilla" 132, 167
 Palés's poem 114–15
mulata(s) 102–3, 107, 119, 120, 198
 in *Tuntún* 114–15, 130
mulato/mulatto(s) 109–15, 117, 118, 124, 151, 152
Müller, Jan-Werner 30
Müller-Bergh, Klaus 46, 48
El Mundo (daily newspaper) 57
Munkácsi, Martin 137, 142
Muñoz, José Esteban 133
Murnau, Friedrich Wilhelm 31
 Tabu: A Story of the South Seas (film) 31, 137
música guajira 116

Nadja see Breton, André
"naked cities" 166

ñáñigo(s) 76, 153, 235, 243
 see also Abakuá order
Nardal sisters, Paulette and "Jane" (Jeanne) 216
National Geographic (magazine) 81
nativismo/nativist 107, 108
Nau, John-Antoine 227
Nazi films 23, 25
 and *La Habanera* 21–30, 53–4
 and melodrama genre 25
necropolitics 7, 8
 see also biopolitics/biopolitical
negrismo (Luis-Brown) 73
"Negrito"/"Negrillo" (Manickam) 71
Negritude/*négritude* 101, 104–5, 231, 240
 African and Caribbean 6
 in *Cahier* 216, 217, 219, 223
"The Negro Speaks of Rivers" see Hughes, Langston
neocolonialism 3, 73, 79, 86, 107, 151
neo-Kantianism 6
New Directions in Prose and Poetry (journal) 209
New Objectivity (*Neue Sachlichkeit*) 186
New Orleans 166
New York 240
 and Afro-Cuban avant-gardism 73
 New School for Social Research 207, 210
 surveillance and containment in 54
 traveling of exiles to 16, 210, 246–7
Nezval, Vítezslav 174
Nicholson, Melanie 150
Noailles, Charles de 179
Noailles, Marie-Laure Vicomtesse de 179
nomos 30–1
non-European see Europe/European

North Africa 96, 203, 223
 in *Lancelot 28°–7°* 62–9
Northover, Patricia 7, 218
Nozière, Violette 193, 198
 see also Ray, Man

Obin, Philomé 242
object(s)
 beloved as passive in Salinas's love poetry (Spitzer) 262n50
 cultural intertexts of cinematic 30
 of desire
 defilement and violation of selves and 199
 or horror in Domínguez 181
 and remembrance in *Crimen* 195
 river as addressee and in "Río Grande de Loíza" 130
 in *Tuntún* 115
 voyeuristic in *¡Écue-Yamba-Ó!* 155
 external in *Lancelot 28°–7°* 65
 fantasy in Brull 51
 improvised erotic in *¡Écue-Yamba-Ó!* 157
 insular in Domínguez 179
 island as refracted in Brull 51
 islands as passive 30
 magical occurrence of in Benjamin's "profane illuminations" 196
 modern space-object in Cendrars's *Prose du Transsibérien* 189
 object-signs in *Tuntún* 114
 poetic in Espinosa and Huidobro 64
 "primitive" in avant-garde 130
object(s), surrealist
 Domínguez, Óscar
 fetishized in *Crimen* and 183
 object-symbols and islandscapes 204
 paintings and 203
 and pictorial hallucinations 204

object(s), surrealist (*cont.*)
 insular condition 231
 locomotives as transitional 191
 in Masson 215
 memory-objects in *Fata Morgana* 209
 moveable series of in Breton 210
 sinister assemblage of in *Crimen* 198
 of violation (Krauss) 191–2
 wartime aesthetico-political 211–2
O'Brien, Frederick 214
O'Brien, Mary-Elizabeth 25, 26
Occidental/Occidentalism 11, 53, 203
Ombres blanches (film) *see* Van Dyke, W. S.
opacity (Glissantian)
 in Guillén 118
 in Magloire-Saint-Aude 244
 and translation 238
Ordnung (Müller on Schmitt) 30
organicism/organicist 13, 14, 113, 164, 225
Orient/Orientalist (discourse)/orientalizing
 in *Crimen*
 crime of sordid overtones 198
 imaginary of the Andalusian south 197
 in *Lancelot, 28°–7°*
 accents and oblique references 68
 African island as South and 64, 203
 archipelago in tourist guide 63
 Hotel Oriental 66
 overtones in *Diario de un sol de verano* 45
 in Said's *Orientalism* and Martin-Márquez 67
 and tropics in *Martinique charmeuse de serpents* (Rosello) 213

Orientalism 67, 197
 see also Dainotto, Roberto; Martin-Márquez, Susan; Said, Edward
orientation(s)
 African of Lanzarote 63
 Caribbean and North American 17
 and location of avant-garde movements 10
 see also disorientation; reorientation
Oriente Province (Cuba) 122
Orígenes (journal and group) 46, 49, 50
Ortega y Gasset, José
 La deshumanización del arte (*The Dehumanization of Art*) 71–2
 and Germanophilia 59, 66, 132, 163, 174
 neo-Kantian engagements 6
 in *Insularismo* 59, 89, 91–2, 93
 in *Lancelot, 28°–7°* 66
 La rebelión de las masas (*The Revolt of the Masses*) 162–3
 Revista de Occidente
 circle 11, 59, 62, 174
 journal 6, 66, 105, 106, 174
 and Spengler 55, 66
 El tema de nuestro tiempo (*The Modern Theme*) 91–2
Ortiz, Fernando 74, 75, 107, 143, 163–4
 Contrapunteo cubano del tabaco y el azúcar 235
 Cuban Counterpoint 164
Ortnung (Müller on Schmitt) 30
Osborne, Peter 31

Paalen, Wolfgang 210
palabras 120, 124
Palenzuela, Nilo 62, 173, 183, 168n20

Palés Matos, Luis 13, 56, 88, 103, 107–8, 125
 "Abajo" 108–9
 "Black Majesty" 113
 "Black Town" 112–13
 "Candombe" 113
 and cosmopolitanism 109, 110
 "El Dadaísmo" 108
 on Dadaists 108
 diepalista experiments 107
 "Mulata-antilla" 114–15
 "Orquestación diepálica" 108
 poesía antillana 115
 Tuntún de pasa y grifería (*Tuntún*) 14, 101, 104, 109–15
 Valbuena Prat's essay on 109
 view of revolutionary attitudes 109
Palmié, Stephan 74, 283n50
pan-Americanism/pan-American 26, 130, 142, 158, 166, 230
panoptical time 110–11
Pao, Maria T. 192
Paris 58
 and Afro-Cuban avant-gardism 73
 Colonial Exposition (1931) 132
 Cuban music and performances in 72–3, 79
 International Congress for the Defense of Culture (1935) 44
 Montmartre 73, 177, 178
 surrealists 171, 172, 174, 175, *175*, 182, 183, 221, 242
 "chance encounter" with members of *Tropiques* (1941) 226
 forced exile 16, 246
 in Martinique 214
 migration to New York and other destinations 16, 246–7
 relations with Tenerife surrealist group 178
 and Tenerife axis 16
 visit Canary Islands 175–7, *176*, 178
Pedreira, Antonio S. 11, 58, 59
 "Aclaraciones y crítica" chronicle in *El Mundo* 56
 and the agonistic 89
 anti-avant-gardist 92
 anxiety about isolation and insularity of Puerto Rico 90–1
 Aristas 56
 and *atalayistas* 88
 background 56–7, 80
 Bibliografía puertorriqueña 56
 founding member of *Índice* 56
 Hostos, ciudadano de América 56
 Insularismo 13, 56, 59, 80–96, 127, 129, 131, 228
 and Ortega 59
 portrayal of women 92–4
 and Unamuno 89–90, 91, 93, 96
Péret, Benjamin 15, 174, *176*, 178, 191, 193, 204–5, 240
 "Prefacio" 237–8
 see also 1929 (pornographic "calendar"); *Retorno al país natal*
Pérez Corrales, Miguel 184, 205,
Pérez Minik, Domingo 8, 11, 174, 175–7, *175*, *176*
 "De André Breton a Óscar Domínguez" 176–7
Perivolaris, John 81
Perloff, Marjorie 33, 109, 189
Perls Galleries (New York) 234–5
Pestana Nóbrega, Ernesto 62, 183, 189, 200
Pétain, Maréchal 212, 224
Peters, Dewitt C. 242
pharmakon 234
Philippines 38, 60, 71
Philoctète, René 223

photographs/photography 7, 14, 47–8, 135, 157
 Benjamin on 186–7
 Deren's fieldwork in Haiti 251
 Evans's Cuban portfolio 14, 134, 136–49, 140, 145, 147, 148, 165–7
 Martin's Puerto Rico in *National Geographic* 80–3
 and Surrealism 183, 191–2, 193, 201
 Atget's and Brassaï's 179, 190
 in New York 240, *241*
 Paris surrealists in Tenerife 174, *175*, *176*, *176*
 at Villa Air-Bel 207–9, *208*
 in *Tuntún* 111, 112, 115
photomontage 187, 188
 and Espinosa's *Crimen* 198, 199
physiognomy see Lombroso, Cesare
Picabia, Francis 108
Picasso, Pablo 43, 172, 178, 181, 192, 195, 235
 Les Demoiselles d'Avignon 181, 252
Pierre, José 202
Pierre Matisse Gallery (New York) 239, *241*
Pineda y Muñoz, Mariana de (*Mariana Pineda*) 197
Piñera, Virgilio
 "La isla en peso" 220
Pirquet, Clemens von 53
plantation island
 and Césaire's *Cahier* 223
plantations 7
 and Afro-American culture 60
Platón Lázaro, Lydia 112, 251, 252
Platt Amendment (1901) 51
Poema en veinte surcos see Burgos, Julia de
poesía criollista 107, 127
poesía negra 101–4

tensions between avant-garde poetics and 103
and *Tuntún* 109–15
poesía pura (pure poetry) 36, 37, 46–53
La poesía sorprendida (journal) 46, 49, 173, 232
poetry/poetics
 diepalista 107–8, 109
 Martinican 227, 228
 pure *see poesía pura*
 Surrealist 185, 227, 233, 238
 see also Afro-Antilleanism/Afro-Antillean; Afro-Caribbean; *individual names*
Pointe-à-Pitre (Guadeloupe) 123, 210, 232
politics/political
 and notion of agonism 89
 relationship with life 70
 Schmitt's concept of the 55
Pontalis, J.-B. 50
popularismo/neopopularismo (Díaz Plaja) 42, 49
Port-au-Prince 16, 166, 240, 242–3
postcard, colonial 180
postcolonial 1, 4, 6, 9, 10, 30, 48, 104, 115
postmodern 9, 10
postmodernistas 35, 41, 108, 109, 125
Prados, Emilio 34, 43, 172
Prague surrealist group 174–5
Pratt, Mary Louise 78
La Prensa (daily newspaper) 267n13
Presidente Trujillo (boat) 232
Primo de Rivera, General Miguel 61
prisons/prison narratives 135, 164
 carceral
 affects 162
 atmosphere 159
 banter 165

cosmopolitan dimension 158
environment/environments 159–60, 163
experience 167
homosexual desires 163
insularity/island 165, 223
island-nation 167
literary traditions 159
margins of island life 120
myse-en-abyme 155
non-spaces 120
overexposed space 142
sexual deviants 157
space/spaces 135, 157, 158, 165
temporality and climate 161
traces of experience 149
voices 163
world 159
in *¡Écue-Yamba-Ó!* 154–7
in *Hombres sin mujer* 157–65
islands as material and allegorical 165
sex in 135
tropical island 135–6
profane illuminations (Benjamin) 7, 195–6, 248
La Prose du Transsibérien see Cendrars, Blaise; Delaunay, Sonia
prostitute/prostitution
in *Crimen* 197, 198, 199
in Evans's Cuban portfolio 139
in *Insularismo* 92–3
Protest of the Thirteen (1923) 134
psychoanalysis/psychoanalytical 7, 182, 228
see also Freud
Puchner, Martin 1, 43
Puerto de la Cruz (Tenerife) 182, 189
Puerto-Rican avant-gardists 26, 56, 94, 107
Puerto Rico 60, 107
discovery by Columbus 81

Great Depression 83
in *La Habanera* 13, 21–8, 55
in *Insularismo* 59, 80–95
jibarismo/jíbaro 83, 84, 127
Martin's photographs 81, 82
nationalism 11, 13
in *Poema en veinte surcos* 124, 127, 131
prostitution 92
in "Río Grande de Loíza" 128–30
sugar industry 81
in *Tuntún* 14, 109–15
and United States 81, 83, 93, 95
women 92–3, 95
youth 93, 94
pure poetry *see poesía pura*
purism 32

Les Quatre Vents (journal) 209
queer(s) 120, 133
in Muñoz 280n78
readings on Lydia Cabrera by Molloy and Quiroga 294n68
women and 120
Quintero-Herencia, Juan Carlos 279n74

race 13, 14
and Burgos's poems 131
and Martí's "Our America" 90
radio broadcasting culture 122
Rama, Ángel 48
Ray, Man 193
Black and White (*Noire et blanche*) 193
cover image for *Violette Nozière* 193
Monument to de Sade 191
see also 1929 (pornographic "calendar")
Redfield, Robert 153
Regenerationism 80
regionalismo 61, 65, 79

regression/regressive 10, 50, 96, 110
 archaic 58, 201
 gendered and male 61
 in Hispanism 55, 56, 58
 historical 111
 islands 57, 61, 103
 primitive 162
relation(s)/relational/relationality 6, 70, 71, 80, 84, 89, 93, 102, 107, 138, 148, 161, 178, 185, 251, 252
 antagonism and agonism in Mouffe 4–5
 archipelagic 32, 239, 245
 "Cuban-American Treaty of Relations" (1903) 141
 experience of insular spacetime 41
 in Glissant's sense 8, 120, 181, 216, 223, 225, 239
 hemispheric and trans-Atlantic 5
 insular-metropolitan 15
 modes of non-European 254
 power 108
 race 157
 race and gender 167
 in Schmitt (Legg) 30–1
Rentschler, Eric 24, 27
reorientation 4
 of cultural semantics of the written press in *Lancelot, 28°–7°* 63
 of imaginary of timeless insularity in Josefina de la Torre 37
 of negative adverb of non-Europeanness 58
 of scopophilia in *Diario de un sol de verano* 46
 see also disorientation; orientation(s)
Retorno al país natal see Cabrera, Lydia; Péret, Benjamin
Reverdy, Pierre
 création 42

Revista de Avance (journal) 6, 46, 47, 72, 74, 87, 104, 134, 141, 149, 160, 173, 232, 249
Revista de Occidente (journal) *see* Ortega y Gasset, José
La Révolution surréaliste (journal) 172, 287n37
La Revue Indigène (journal) 244
La Revue du monde noir (journal) 216
Revue Nègre 248
Reyes, Alfonso 11
 coins term *jitanjáfora* 49
Ribera Chevremont, Evaristo 88
Richardson, Michael 242–3
rifeños, popular repudation of massacre 69
 Abd el-Krim 61
Rimbaud, Arthur 193, 221, 227, 233
Río Grande de Loíza 126, 129
"Río Grande de Loíza" *see* Burgos, Julia de
river
 and Hughes 128
 in "Río Grande de Loíza" 129–30
Rivera, José Eustasio
 La vorágine 150–1
Robert, Admiral Georges 228
Rodó, José Enrique 11–12
 Ariel 93
Rodríguez Castro, Malena 26
Roh, Franz 248
Roldán, Amadeo 73, 78
 Obertura sobre temas cubanos 73
Roosevelt, Eleanor 207
Roosevelt, Franklin D.
 "First Inaugural Address" (1933) 143
 "Good Neighbor Policy" 143
roots/rootedness 7
La Rosa de los Vientos
 group 57, 65

journal 61–2, 174, 183, 184, 190, 197
"Primer manifiesto de *La Rosa de los Vientos*" 61–2, 184
Rosello, Mireille 213–14
Rosenberg, Fernando 255n7
Rosenthal, Angela 15
Ross, Marlon B.
 racial trespassing 142
Roumain, Jacques 252
 Le Sacrifice du Tambour-Assoto(r) 249
Rousseau, Henri (*le Douanier Rousseau*)
 The Snake Charmer (*La Charmeuse de serpents*) 214
Russian avant-gardism 43
Russian Revolution 32
Ruttman, Walter
 Berlin: Symphony of a Metropolis (*Berlin: Die Sinfonie der Großstadt*) (film) 206

Sabato, Ernesto 179
Said, Edward W. 57, 78–9
 Culture and Imperialism 271n59
 Orientalism 67
 see also Orientalism
Saint-Domingue (Haiti) 248
Saint-Pierre (Martinique) 215, 236
Salinas, Pedro 8, 33, 38, 39, 40, 46, 51–2
 Burgos-Lafuente on 273n87
 on Europe and Africa *see* Africa
 "Isla, preludio, poetisa" 36–7, 38, 41
 Spitzer on 262n50
Salon-de-Provence 207
Sánchez Robayna, Andrés 263n51
Sander, August
 Antlitz der Zeit 136
Santa Cruz de Tenerife 25, 41–2, 43, 44, 175

Ateneo de Santa Cruz 174, 178, 197, 205
Numancia theater 177
Santana, Lázaro 35
Santo Domingo (Ciudad Trujillo) 16, 46, 210, 232, 235, 242, 243
San Zanón hurricane (1930) 232
Sartini Blum, Cinzia 108, 109
Schmitt, Carl 4, 30–1, 54–5, 88, 260n26
 The Concept of the Political 265n93
 The Nomos of the Earth in the International Law of the Jus Publicum Europaeum 30
 Theory of the Partisan 265n93
Schoedsack, Ernest 162, 259n11
 King Kong (film) 162–3
scopophilia
 deferred and reoriented in *Diario de un sol de verano* 46
Scott, David
 Conscripts of Modernity 6
Second International Surrealist Exhibition (1935; Tenerife) 15, 174, 175, 178, 204–5
 see also First International Surrealist Exhibition (1932; Prague)
(self-)affirmation
 genetic and cultural in *Tuntún* 110
 Martinican, and surrealist hallucination in Suzanne Césaire 226–7
 nationalist, atmosphere of in *Lancelot 28°–7°* 62
 of pan-European universalism in Brull 51
 Puerto Rican in *Insularismo* 84, 95–7
 in *Versos y estampas* 41
 of visionary poetic idealization in *Tuntún* 113

self-exoticism 8, 67, 112
Seligmann, Katerina Gonzalez 238–9
Senghor, Léopold Sédar 216, 217
sequential method 138, 139
Serje, Margarita 150–1
sex
 in Montenegro's *Hombres sin mujer* 161
 in prison autobiographies 135
sexual control
 in Pedreira's *Insularismo* 92
Shakespeare, William
 The Tempest 68, 69
shipwreck motif
 in *Crimen* 201–3
 topos in *Insularismo* 87
Short, Robert 172, 177
siboneyismo 107
Sierck, Detlef 24 *see* Sirk, Douglas
Silverman, Kaja 120
La Sirène des tropiques (film; dir. Henri Étiévant, Henri, and Mario Nalpas) 31
 see also Baker, Joséphine
Sirk, Douglas 8, 13, 22, 23, 24, 25, 26, 27, 29, 54, 55, 79, 241
 see also La Habanera
Siskind, Mariano 257n28
Sithole, Tendaye 253
Skolle, Hanns 137, 138
slave trade/slavery 7, 9, 74, 103, 113, 121, 122, 124, 130, 131, 215, 219, 245
Social (monthly illustrated magazine) 47, 72, 107
El Socialista (weekly newspaper) 42
El Sol (daily newspaper) 66
son 115–16, 120, 122–3
Soto-Crespo, Ramón E. 87
Soto Vélez, Clemente 87–8
Soupault, Philippe 182, 201
 Le Cœur d'or 182
 Les Dernières Nuits de Paris 201

La Souriante Madame Beuet (film)
 see Dulac, Germaine
souvenirs
 and *Crimen* 188, 189, 191, 199, 201, 204
 exploration of in Domínguez's paintings 180, 183, 204
 of Spanish Civil War 203–5
Soviet avant-gardism 3, 32, 44
Spain 60, 61, 72, 80, 96, 104
 and Africa 61, 64, 104
 and fascism 188
 and imperialism 71, 79, 180, 234
 and Moroccan War 37–8, 61–2, 68, 172, 203, 205, 248
 and Orientalism 67
 and Primo de Rivera's regime 61–2
 and Regenerationism 80
 Spanish avant-gardism 32, 34, 105, 132, 203
Spanish Civil War *see* wars
Spanish Republic 25, 26, 43–4, 55, 80, 173, 188, 192, 193, 204
Spanish Surrealism 171, 172, 192, 193
 and Paris group's visit to the Canary Islands 175–6
 see also individual names
Spengler, Oswald 3, 7, 14, 55, 59, 66, 85, 103, 110, 114–15, 151–2, 164
 The Decline of the West 104, 104–5
 morphology 152
 see also Adorno, Theodor W.
Spitzer, Leo 262n50
Starobinski, Jean 182
Steiner, Ralph 137, 142
Stevenson, Robert Louis 33
 In the South Seas 45
 Treasure Island 42, 201
Stimmung (Gumbrecht) 66–7
Storni, Alfonsina 3, 39

Suárez Findlay, Eileen 92
sugar/sugarcane
 in *Cahier* 220
 in *¡Écue-Yamba-Ó!* 150–1, 152–3, 155
 industry
 in Evans 144, 146, 165
 and film technology 74
 migrant sugar workers 83
 in Puerto Rico 80–5
 US domination in Cuba (Luis-Brown) 73
 landscape
 in *Hombres sin mujer* 160–1
 in Mialhe and Landaluze 75–6
 and mulata (Kutzinski) 103
 rural islandscape 83
 in Mintz 252
 novels (*novelas de la caña*) 157
 in Ortiz 164
 in *Poema en veinte surcos* 126–7
 and slavery (Trouillot) 124
 sugar islands 224
 in *Tuntún* 113–4
 in *West Indies Ltd.* 121–2
Surrealist Manifesto see Breton, André

Tabu: A Story of the South Seas (film) *see* Murnau, Friedrich Wilhelm
Tacoronte (Tenerife) 178, 180, 181
Tahiti *see* Evans, Walker
Tallet, José Zacarías 107
Tanguy, Yves *241*
La Tarde (daily newspaper) 197
Tarzan the Ape Man (film) 111
Teige, Karel 174
Tenerife
 and *Crimen* 200, 201
 fascists take control of (1936) 205
 filming of *La Habanera* on 24–5
 Second International Surrealist Exhibition (1935) 174
 and Spanish Civil War 24, 25
 visit by Paris surrealists 175–7, *176*
 Tenerife surrealist group 15, 16, 171–205
textual montage 188, 199, 200
Third Reich 23, 24
Thomas, Hugh 139, 177
Torre, Claudio de la 34, 36, 260n27
Torre, Guillermo de 11, 173
 Literaturas europeas de vanguardia 11
Torre, Josefina de la 10, 13, 32, 33–41, 41, 102
 acts of seeing in poems of 33
 biography and childhood 34–5, 36, 39–40, 41
 in Diego's *Antología* 34–5
 early commentators 38–9
 features and themes of poems 36, 37
 and "generation of 1927" group 34
 and Residencia de Estudiantes, Madrid 34
 Salinas's critical outlook on poetics of 36–7, 38, 39, 40
 sea as a protagonist in poems of 37
 Trujillo's review of poems 38, 39
 Versos y estampas 33–41, 45, 51
Townson, Nigel 61
Trachtenberg, Alan 139, 144
train(s)
 in *Crimen* 189, 191
 in De Chirico's paintings 190–1
 in *Mad Love* 191
 in *La Prose du Transsibérien* 189
 and surrealists 191
transculturation 164
translation process 238, 238–9
Tretyakov, Sergei 186

Tropiques (journal) 6, 102, 173, 212–13, 217, 224–32, 242, 245
 mission 224
 Suzanne Césaire's essays for 225–31
Trouillot, Michel-Rolph 15, 60, 124
Trujillo, Juan Manuel 36, 38-9, 62, 183, 267n13
Trujillo, President Rafael 232
 regime of 245, 296n93
Trumpener, Katie 22–3, 29, 82
Tuntún de pasa y grifería (*Tuntún*) see Palés Matos, Luis
Turits, Richard Lee 232
Turvey, Malcolm 195
"Typhoid Mary" case (Wald) 54
Tzara, Tristan 108

Uexküll, Jacob von 66
ultraísmo 11, 44, 87, 183
Umfunktionierung (Benjamin) 186, 188, 203
Unamuno, Miguel de 3, 66, 89–90, 91, 93, 132, 234
 banished to Fuerteventura 203
 on Guillén's Black poems 117
 and Humboldt (Pérez Minik) 177
 intrahistoria 96, 105
United States
 and the Great Depression 85
 invasion and occupation of Dominican Republic 232, 241
 occupation of Haiti 240–1
 see also colonialism; Cuba; imperialism; Puerto Rico
universalism 1, 95, 245
 cosmopolitan 47
 counter- (Edwards) 47
 Eurocentric 41, 227
 French 48, 255n8
 Hispanism and 89, 95, 96,
 literary and aesthetic 13, 40, 108, 127, 174
 and political in Julia de Burgos 127, 131
 metropolitan 53
 pan-European 51
 and regionalism 61
 in Spengler 85
universality 61, 64, 88
Unruh, Vicky 3, 152–3
Urrutia, Gustavo E.
 "Ideales de una raza," *Diario de la Marina* 116, 117

Valbuena Prat, Ángel 66, 132
 Historia de la poesía canaria 68
 involvement with *La rosa de los vientos* 57
 on Palés Matos 109
 participation in *Hostos* (Puerto Rico) 57
Valéry, Paul 36, 47, 48, 49, 226, 248,
 "Freedom of Mind" 265n86
 "La liberté de l'esprit" 51–2
 Preface to Brull's *Poëmes* 52–3, 260n27
Valle-Inclán, Ramón María del 193
Vallejo, César 126
Van Dyke, W. S. 214
 White Shadows in the South Seas (*Ombres blanches*) (film) 31, 137, 214–15, 241
Varo, Remedios 172
Veracruz 166
Véron, Kora 218
Versailles Peace Conference see wars
Vertov, Dziga
 Man with a Movie Camera (film) 206
Viera y Clavijo, José de 68
Villa Air-Bel (La Pomme, Marseille) 207–9, *208*, 239, 245
Vitier, Cintio 50

Volontés (journal) 216
von der Walde, Erna 150–1
VVV (journal) 247

Wald, Priscilla 54, 91
wars
 "banana wars" 75, 141
 colonial 37–8, 194
 Moroccan/African War
 (Guerra del Rif/de
 Marruecos) 35, 37–8, 61–2,
 68, 69, 172, 203, 205, 248,
 268n22
 see also *rifeños*
 interwar period 202
 postwar period 61, 71, 92, 136,
 151, 166, 249, 265n93
 Spanish-American (1898) 38, 58,
 69, 81, 142
 Spanish Civil War 14, 24–5, 26,
 30, 52, 102, 126, 205, 223,
 226, 262n46
 World War I 3, 32, 33–4, 35, 36,
 40, 135, 206, 260n20
 and Josefina de la Torre 40
 Versailles Peace Conference
 (1919) 30
 World War II 15, 25, 52, 92,
 166, 202, 205, 216, 228,
 233, 246, 249, 265n93
Washington 240
 Madrid and 59, 80, 85, 93, 95

West Indies Ltd., "West Indies
 Ltd." *see* Guillén, Nicolás
Westerdahl, Eduardo 11
 as facilitator of intellectual
 exchanges 241–2
 and *Gaceta de Arte* 172–3
 journey through Central Europe
 (1931) 171, 172–4
 photographs of French and
 Spanish surrealists 174, 176
White Shadows in the South Seas
 (film) *see* Van Dyke, W. S.
Wilder, Gary 6
women
 agency of in insular avant-gardist
 texts 102–3
 Black female body in *Tuntún*
 111–12, 113
 portrayal of Black women in
 Guillén's poems 119, 120,
 124
 portrayal in Pedreira's
 Insularismo 92–4
 of the progressive Spanish
 Republic 204
 in Puerto Rico 92–3, 95
Wong, Yoke-Sum 180
World War I *see* wars
World War II *see* wars
world's fairs 132

Zavala, Iris M. 130